BODY HORROR

THE CRITICAL IMAGE

'From today painting is dead': a remark made by the French artist Paul Delaroche on first seeing a daguerreotype in 1839.

'I can see it's the end of chemical photography': a remark made by the British artist David Hockney in 1990 on the likely effect of computer-generated imagery.

The 'Critical Image' series aims to develop the subject area of photographic history, theory and criticism. It explores the historical and contemporary uses of photography in sustaining particular ideological positions. Photography is never a straightforward 'window on the world'; the meanings of photographs remain unstable, depending always on usage. Chemical and lens-based photographs are now antique forms of image production, while pictures made in computers are not strictly photographic since there is no necessary link between images and what-has-been. The series engages with both chemical and digital imagery, though new forms of representation do not obliterate older forms and ways of looking that persist through custom and practice. The term 'representation' is not simply another word for picture or depiction, but hints at the management of vision. Representation is not just a matter of what is shown but who has permission to look at whom, and to what effect. The series looks beyond the smooth narratives of selected 'masters', styles and movements. It aims to discuss photographic meanings produced within the complex social formation of knowledge. To situate photography in its intellectual context, the series cuts across disciplinary boundaries and draws on methods widely used in art history, literature, film and cultural studies.

SERIES EDITOR
John Taylor
Department of History of Art and Design
Manchester Metropolitan University

Already published
Jane Brettle and Sally Rice (eds) *Public bodies – private states: new views on photography, representaion and gender*

John Roberts *The art of interruption: realism, photography and the everyday*

John Taylor *A dream of England: landscape, photography and the tourist's imagination*

BODY HORROR

photojournalism, catastrophe and war

JOHN TAYLOR

NEW YORK UNIVERSITY PRESS
Washington Square, New York

First published in the U.S.A. in 1998 by
NEW YORK UNIVERSITY PRESS
Washington Square,
New York, N.Y. 10003

New York University Press edition published by
special arrangement with Manchester University Press,
Oxford Road, Manchester, M13 9NR, UK.

CIP data available from the Library of Congress

ISBN 0-8147-8239-6 (clothbound)
ISBN 0-8147-8240-X (paperback)

Designed and typeset by Lionart
Printed in Great Britain
by Redwood Books, Trowbridge

Contents

Acknowledgements

I have been thinking about the use of gruesome photographs in the press for long enough. Consequently I would like to thank those who helped me to finish this book, in particular my colleagues in the Department of History of Art and Design at Manchester Metropolitan University for their support during a term's sabbatical in 1995. I am pleased to have had the additional support of the department's Research Group and for a significant grant from its budget to pay for copyright fees.

I owe a debt to those who took time to read and comment on my book in its early stages. In particular I want to thank David Peters Corbett not only for his astute remarks on my first complete draft but also for suggesting, as only a friend would, that I begin writing again even though the book was practically finished as far as I was concerned. Special thanks to my long-distance friend Laura U. Marks for her detailed commentary, and her patience with the workings of my brain, which she claims is wired for a language other than English.

A number of other friends and colleagues have been extremely generous with their time and advice. Louise Purbrick read the whole of the script, made crucial suggestions and was supportive even when sharing an office with me. Katharine Reeve, my former editor at Manchester University Press, also read the whole of the first draft, and her advice confirmed my suspicion that I had more work to do. Simon Faulkner read the chapter on the Gulf War and generously gave me some useful references from his own research.

I owe a debt of gratitude to many other people, though some of them may be surprised to hear of it. James Aulich for the loan of books and an ear; Martin Bell; David Brittain for *Decisive Moments*; Lindsay Brooks – who perhaps wisely avoided reading my script – for being herself; Julio Etchart, who combines modesty with courage; Christine Frisinghelli and Manfred Willmann for enabling me to test my ideas in Graz; Frits Giertsberg; David Greysmith; H. K. Henisch and Bridget A. Henisch for press cuttings and encouragement from the USA; Detlef Hoffmann for inviting me to try things out in Bielefeld; Ken Lennox; Jan-Erik Lundström; Eamonn McCabe; Stephen Mears;

Simon Meddings for comic relief and Lionart; Ian Muir-Cochrane for his insight into what guides television producers; Ray Offord; Gertrud Sandquist; Hripsimé Visser and Bas Vroege; Steve Yates. I should also like to thank the librarians in the Art and Design Section of the All Saints Library at the Manchester Metropolitan University for their friendliness and quiet efficiency as well as Gemma Marren for her editorial work. Last, but by no means least, I want to thank Stephanie Sloan for her cool head, and my editor, Matthew Frost, for his big heart. As always, the responsibility for errors and omissions remains the author's alone.

Since I am not a picture researcher, I have no doubt tried the patience of my contacts in photographic agencies. I should like to thank Ian Blackwell at Popperfoto; Judith Caul at the *Guardian*; Judith Clarke at Sygma; Dale Eru at Network; Katrina Finch at ITN; Debbie Fleetwood at the *Guardian*; Stephen Hennessy at Mirror Syndication International; Mike Hollingshead at Associated Press; staff at Magnum; Rachel Mann-Davis at the *Observer*; David Parry and Geoff Ross of Ross Parry; staff at Reportage Pictures; staff at Rex Features; Denise Rickard at Still Pictures; Sally Ryall at Colorific; Karen Sherlock at Amnesty International; Milica Timotic at 'PA' News; Paul Venskunas at News International. I have made every attempt to obtain permission to reproduce copyright material. If any due acknowledgement has not been made, I invite copyright holders to inform me of the oversight.

1

Introduction

Body horror and the press

Fright makes the blood run cold, the senses faint, the sinews stiffen. Horror may electrify the body, forcing screams and fits. Disgust can provoke involuntary physical signs such as tics, winces or grimaces. Revulsion induces no more than a shudder, or it may entirely engross individuals in nightmares and even madness. Many children in Rwanda who saw or took part in the mass killings of 1994–95 suffered their own mental torment; children and old people in Bosnia and Serbia were driven insane by years of war from 1992 to 1995. Children and adults immediately touched by the sight of killing are likely to be stricken beyond everyday grief by the suddenness and brutality of events. These terrors may have lasting effects and disable people for the remainder of their lives. Horror might become a total state of being, as it was for 'Private E', who saw such things in the First World War that his eyes never ceased to bulge from his head in terror.[1]

Horror is a strongly aversive emotion that denies 'all strategy, all option'.[2] It is 'a peculiar blend of fear and disgust,'[3] an affront and a threat which people may share, though among survivors and viewers it may remain private, becoming something that cannot be communicated. There is no precise way of anticipating what will repel and frighten people, and no way of counting the many sources of fear and loathing. In his vision of torture in *Nineteen Eighty-four*, George Orwell put these words into the mouth of Winston Smith's tormentor. 'The worst thing in the world,' said O'Brien, 'varies from individual to individual. It may be burial alive, or death by fire, or by drowning, or by impalement, or fifty other deaths. There are cases where it is some quite trivial thing not even fatal.'[4]

Personal decisions about the nature of 'the worst thing in the world', which may not even be fatal, will depend on numerous factors, including the nature of any individual's historic being, when and where they live, as well as on their changing physical condition

and frame of mind. When do children first experience horror? What do they find repulsive? Are children of different ages, races and social classes appalled by different things? Perhaps the worst thing in the world is different for boys and girls? Are men and women likely to describe horrors differently, given their different experiences in life? Old illnesses that may have afflicted those living in past ages no longer exist in developed Western societies, but they recur among the poor or in polluted regions, and new plagues and virulent diseases threaten contemporary bodies, creating an underlying strain of fear. Given the myriad chances of life experienced by countless individuals, it seems unlikely that there will be fixed ideas about what is the worst thing in the world.

If what revolts individuals may vary, there is a consensus on horror in the West concerning the decay and dismemberment of the body. There is a constant remembrance and warding off of death. The body flourishes at first but then it folds and falls away. Even if it is well nourished and cared for, it is always unravelling itself in time. Julia Kristeva, in her *Powers of Horror*, describes how life is continuously holding off and at the same time turning towards death. Kristeva writes that her own body reminds her of the closeness of death, since it is constantly seeping acrid or sickly fluids. This defilement, 'this shit,' in itself does not signify death, since it is 'what life withstands, hardly and with difficulty, on the part of death'.[5] Blood, pus and sweat are at the border of her condition as a living being, and her body extricates itself from that border. She describes how the edges of the body eventually lose that degree of clarity, until the body empties or turns inside out: 'Such wastes drop so that I might live, until, from loss to loss, nothing remains in me and my entire body falls beyond the limit – *cadere*, cadaver.'[6] Though falling beyond the limit of life is an inevitable process, the horrors of mortality and morbidity are expressed differently in various times and places; the consensus on horror is shaped by and within cultural formations and is always subject to historical change.

One way of communicating and reinforcing a historical consensus on mortality is through the various branches of news broadcasting and publishing. The media widely publicise certain experiences as both 'universally' horrible and newsworthy: gruesome, sudden death in accidents, disasters, massacres, murders, disease and war. The press reports these incidents every day, turning traumatic events into stories in words and pictures within the conventions of public display. Horror stories are only one strand of news, but they appear in all daily newspapers, where they repeat and reinforce beliefs about the universal dread of cruel death.

Just as no one can be certain of the absolute nature of horror, no one can prescribe the reactions of individual browsers or gawpers who stare at photographs of awful events. The British press routinely uses pictures of shocking incidents, so that it is quite common to see images of the human body at the limits of endurance. Grief, agony and death are seen to be written on the bodies of others; pain and terror are graphically represented in pictures and words. Even so, news photographs are probably not the most revolting images ever published.

Images of bodies *in extremis* are regular subjects of entertainment in various media and are popular in the press, where their use is nonetheless more circumspect than in books, journals and exhibitions. When I was editing *Ten.8* magazine I commissioned Roberta McGrath to write an article called 'Medical police'.[7] The article referred to several photographs of gross physical deformities housed in the Royal Society of Medicine and the archives of the Medical School at the University of Leeds that no newspaper would wish to print. Though integral to McGrath's argument about the place

of 'documentary reality' in nineteenth-century ideas about normal and abnormal bodies, photographs of people with gross tumours and men with three legs and double sets of genitalia disturbed the editorial and design team. The undated photographs were probably taken in the 1870s, at any rate before medical photography had completely distanced itself from the conventions of ordinary portraiture. These images are full of incidental detail and the deformed patients were active subjects. They wore their own clothes and stared hard at the camera (and continue to 'eye' whoever looks at their faces).

The gazing patient (in this case) presents a challenge to onlookers: 'the face … imparts a command – Thou shall not kill'.[8] The look of distant observation is replaced by the shared gaze, rescuing the beheld's sense of self. The 'I–it' relation is supplanted by the 'I–thou' relation in which the eyes in the image invite onlookers to refuse to take part, whether by neglect or indifference, in further subjugation. As McGrath states, this type of photography is anomalous because professional medical photographers sought personal anonymity in patients, instructing them to avert their eyes and so turning individuals into types or specimens. The simple device of requiring patients to look away from the camera allowed doctors and other observers to stare at their deformities, in life and in photographs, without challenge or embarrassment, which is an invitation or 'appeal to the sadistic'.[9] Recognising the problems and challenges of both 'I–it' and 'I–thou' relations, the editorial group responsible for *Ten.8* could not agree at first whether such pictures should be printed at all.

In the end, the group abandoned notions of decency observed in the press and put these medical monstrosities on display in the bookstalls of galleries and college libraries, as well as sending them through the post to unsuspecting subscribers. The decision to print the photographs depended on McGrath's use of them in an academic debate. This allowed the pictures to overcome the ordinary experience of 'proper' documentary photography without altogether dispelling what McGrath called the 'malicious pleasure' of looking at disfigurement and mortality from a safe distance. The compromise was to print them relatively small, and all the same size. While that may not have lessened the impact of the photographs for some viewers, their scale and equality enabled the editorial group to justify to itself that its business was to illustrate someone else's argument. For some reasons of squeamishness or correctness which were never resolved, the group did not want to indulge voyeurism; it considered, quite properly, prurience and sensation to lack moral seriousness.

Newspapers, for different reasons, do not ransack archives or agencies for their most terrible pictures. Some images of bodily harm never enter the news industry's systems of value or exchange: military, forensic, medical, police, and fire-service photographic records are generally closed to the public and their images are not available for commercial distribution. At the same time, newspapers do not usually delve into the archives of hospitals such as the Frognall Medical Centre at Queen Mary's Hospital or research centres like the Wellcome Institute in London that sell pictures of diseases, operations and their aftermath. The pictures in these archives are unlikely to appear in the press because they are not current news: but editors do not reproduce contemporary images in a similar vein, because some viewers might find them a visual assault and an affront. The press is not dedicated to forcing its audience to view horrific imagery and has no use for it in a regular moral or improving agenda of its own. In a similar fashion, this book makes no attempt to reproduce the most gruesome pictures imaginable; it is not intentionally a collection of horrors. Rather, it charts how in practice

the press usually represents grisly events in a restrained, polite 'voice', and considers what it means when the industry shows photographs of the obscenity of extremes or the pornography of death.[10]

Though there may be a correspondence between a life as lived, a life as experienced and a life as told, no one should assume the correspondence or fail to draw the distinction between them. Many experiences, including the terror of final conscious moments, remain unrepresented and can only be guessed at in hearing cries or seeing people die. Accounts of death and catastrophe differ quite obviously from the experiences themselves and even from witnessing the scene for oneself. Stories of disasters are unable to represent the horror of events as individuals knew them. Reality is always lost in the acts of picturing and describing, which means that agony and death are never fully present in photographs. This does not prevent newspapers from contributing to public knowledge of historical, actual events, nor does it prevent them from discussing and picturing how bodies were marked or how they died. The questions raised by newspaper practice are not so much the gap between reality and its depiction as the types or styles of representation. This latter term is perhaps often misunderstood to mean no more than 'picture', 'image', 'drawing', or 'painting'. However, its meaning is more complicated and suggestive than merely being a synonym for a type of depiction. 'Representation' is an appeal to vision, but it also hints at the management of bodies and looking. Griselda Pollock writes, 'What is at stake in representation is not so much a matter of what is shown as it is of who is authorized to look at whom with what effects.'[11] Photographs in the newspaper industry are representations, then, not simply in the ordinary sense of pictures but also in terms of the authorisation of looking at particular subjects with certain ends in view. Consequently, representation is linked with guidelines, with governance, with acceptability. The questions hanging over press photography are related to subject matter, but how those questions are resolved is affected by beliefs about taste, decency and squeamishness in the production of news.

The issue is the knowledge created by images of disaster and death supplied by agencies, picture libraries or archives and used in the news industry. The exposure of events in the daily press nurtures what John Keane, in *Reflections on Violence*, calls 'public spheres of controversy'.[12] Keane's public spheres have four effects: they help keep alive memories of times when terrible things were done to people; they heighten awareness of current cruelty; they canvass and circulate judgements about whether violence is justified; they encourage people to find remedies for savagery. His remarks on the importance of public controversy do not specify a role for photojournalism, but photographs deepen the authenticity of the press's written accounts. News photographs remain as permanent as the papers themselves, stored in libraries or transposed to microfilm and compact discs. The photographic record of violence in these papers restores to sight some semblance of old catastrophes and war.

News, shame and restraint

Newspapers review and illustrate disasters every day. Photography in the press brings shocking events into homes, schools, and libraries, and displays them on every street and on shop counters. The industry as a whole always remains open to censure for sensationalism in both story lines and some kinds of intrusive photography. The press stands accused of overlooking ethics and morals to 'get the story' on behalf of an

entrenched bureaucracy closely tied 'to the demands of surviving in a market-led economy'.[13] Despite such reservations about the news industry and problems concerning photography and realism, this book is a contribution to the debate that photojournalism may make a difference to perceptions of history and obligation by recording and providing evidence within the overall, complex structure of news.

The term 'photojournalism' implies all photography used in journalism, which could encompass a range of practices and journals much wider than the daily press. The use of the term here is somewhat narrower, confined largely but not exclusively to photographs in the press used to depict actual events and illustrate hard, factual news of these events. Viewers looking at photographs believe that *'the thing has been there'*.[14] Though differently expressed and often debunked, the notion that photography is a 'window on the world' has survived. The belief has not been snuffed out despite the constant reminders that photography is at most a trace and not the thing itself.

John Keane lists some of the horrors of 'this long century of violence', which have been reasonably well represented in photojournalism: 'Genocidal wars, fire-bombed cities, nuclear explosions, concentration camps, orgies of private bloodletting'.[15] He asks, 'Should we too not feel ashamed?' I am intrigued by the possibility that viewers looking at photographs of violence, despite their meagre value as evidence, may recognise their moral and ethical implications. The press, though accused from its earliest days of 'inaccurate, irresponsible, scurrilous and sensationalist reporting',[16] is one place where the representation of violence in photographs at least allows readers to face horror and the possibility of shame.

Photographs depict what-has-been.[17] They bring events into the public realm of newspapers. Those sections of a newspaper that propose to deal with public matters – and they are not the whole of any paper – use photographs as proof. The press relies heavily on photography to illustrate the fact of news: the medium appears to offer viewers a present and tangible semblance of the past. Some uses of photography have unusual authority in representing material objects; they allow vision to persist, seeming to freeze the passage of time. They invite viewers to reflect not only on the status of photographic evidence but also on their own relation to the reality it represents.

When the press uses photography in this fashion it claims to show what has really happened. This use is standard. The press may also use photography to expose moral and ethical problems. This use is rarer, because the press is not a schoolbook for national social behaviour. The press adopts the rhetoric of 'public interest' while having no special or consistent agenda. This means that actuality photographs of hideous events do not necessarily elicit – nor are intended to elicit – humanitarian concern for the welfare of suffering fellow human beings. It remains impossible to be sure exactly which pictures, if any, release guilt, shame and empathy, or encourage direct action. Viewers may respond to photographs only at the levels of curiosity or aesthetic distance. After all, newspapers do not set out to shame their readers. Shame, if it arises at all, may do so incidentally among those who feel even remotely some responsibility for what they read and see in press reports.

Rather than feeling ashamed, readers (or, more strictly, viewers) of newspapers or this book may take pleasure from peering at photographs of bodies in distress. The reproduction of pictures in this book separates them from their primary source or historical setting. This increased distance from even the reports of events (which are themselves reviews of what is past) may implicate the reader in voyeurism, that type of

prurient looking or intrusive, secret gawking with dubious intent. The book reproduces news photographs of bodily harm, and however much it aims to 'mediate and transgress' voyeurism these pleasures cannot be eliminated altogether.[18] It is impossible to deny that horror is fascinating, and viewers may be spellbound. The public nature of such pictures – 'public' in the sense of being readily available or familiar to readers of newspapers – means that the images are already objects of curiosity.

The press's appeal to curiosity is not enough to describe the impact of photography on public knowledge. The press makes a wider contribution to knowledge even though it does not encompass all or even most of what makes up the public realm. After all, the realm of newspapers is narrow, and is insufficient by itself to constitute the everyday knowledge of even its most dedicated readers. A contemporary sense of common knowledge is likely to be varied and fractured, formed through numerous means of communication from television, radio, satellite, fax, telephone, the internet and so on. These systems enable controversial matters to be broadcast, aired and discussed. The position of photography within these means of communication may be to figure in the reconstruction of historical memory, comprising a public presence of past events that may fuel commentary, disquiet and shame.

However, the importance of photojournalism relates less to shame than to the main burden of the news industry. This book proposes that the function of photography in the press is not to contribute to public controversy relating to shame or action; what is more important, the press follows and shapes the debate on what it is proper to see and to display in public spaces, and it does so according to a sense of public decency. This question seems to dominate how the press uses photojournalism. The press is not an unrestricted or unregulated horror show of bodies in distress, dying or dead. Pictures of bodily harm in the press are not as bad as they might be: commercial success is not clearly served by the relentless publication of photographs that provoke visceral reactions and disgust among readers and viewers. No newspaper offers an unrelieved diet of such pictures. On the contrary, reporting curtails or constrains hideous sights. The industry works within largely self-imposed limits that exclude the most detailed, close-up and disgusting photographs.

The press's limits are determined normally by taste and tone, which are either defined in media guidelines or worked out in practice and enforced by self-regulation. For the most part, voluntary restraint is in keeping with the press's image of itself as a public voice that both mirrors and sustains general notions about decency and propriety. Restraint also conceals certain unpalatable truths. In the Gulf War these limits were defined earlier and more sharply by military and government censorship, and were consequently even more successful at colouring the daily record of events.

Governing or censoring the publication of news photographs has implications for knowledge in liberal democracies. Certain kinds of deliberate gaps in the photographic record not only shape the meanings of terrible events but also imply gaps in knowledge filled by news that does not disturb so much as settle minds. The subject of this book is the moral responsibility attached to publishing and seeing photographs of violence, and the moral sleep and historical amnesia that can exist when such imagery goes unseen or unreproduced. The absence of journalists, reports and photographs of an event hints at structured indifference and the washing of hands. Journalists may be absent for any number of causes, though government and military control in wartime or distance and indifference to far-away events are the main reasons why events go unreported. In

addition, the press may choose to absent itself, or carefully limit what it decides to print. Indeed, the press's squeamishness or careful regard for good taste may hinder its role in reporting controversial matters. As the former BBC reporter Martin Bell has written, 'in a world where genocide has returned in recent years to haunt three continents we should remind ourselves that this crime against humanity requires accomplices – not only the hatred that makes it happen, but the *indifference that lets it happen*'.[19] On balance, it is more important to have reports and see images of horrors than to risk forgetting them.[20]

Martin Bell and all other journalists, editors and those engaged in deciding what is fit to print must be selective, but the grounds of this choosing and refusing are often (in Bell's words) 'vague and variable'.[21] At its simplest, the common practice of self-censorship in the press has a number of related aims: to satisfy readers' expectations, to forestall new legislation, and to bolster the truth-value of written reports. When published, its pictures of terrible sights can strike readers and viewers with unusual and uncomfortable force, though alarming reports are not a direct threat to their own bodily integrity or to their mental stability. For most people the reality of horror as it appears in news and press photographs can be shocking, but is not likely to drive them insane. Unspeakable acts always happen somewhere else, and to other people. They are not a permanent state, nor disabling; they may even be entertaining or boring.

Every photographic image is a sign, above all, of an investment in sending a message.[22] So what is the investment in reproducing images of disaster, death and war? The most obvious use of bad news and photographs that are to some degree freakish or show human bodies in states of misery and decay is that they encourage people to buy newspapers. They satisfy plain voyeurism, fascination and sadism. Gruesome pictures are sensational to look at, a feast for morbid eyes. As I shall discuss in chapter 2, 'Caught looking', and chapter 6, 'Disaster tragedy', such photographs may allow a thrill of revulsion to pass through readers who are themselves in no danger. Such stories may be read in complementary ways: they provide moments of identification and reflection, moments of rejection and denial, and moments to be inquisitive about the dreadful fates of others. These reactions are often aroused by mortal terrors of the flesh. They are not insignificant reflexes, nor should they be stigmatised as simply unworthy or shameful.

The shape of the book

As John Keane makes clear, no one can be certain how empathy with the violated happens; certainly, it may be a less common reaction to horror than either indifference or fascination. In chapter 2, 'Caught looking', I discuss the fascination of photographs of bodily harm. There are many ways in which horrible photographs reach a wide audience, especially through books and exhibitions. People's interest in them cannot be dismissed as simply prurient, as if photographs stir morbidity where none existed before. The publication of such pictures may be justified as warnings and invitations to respond – but no one can be certain how they will be received. This lack of stability in meaning, or the ease with which photographs slip from one context to another, altering meaning as they go, is in itself considered to be dangerous: the representation of actual violence in the press is a matter of self-regulation based on current ideas about propriety. Nevertheless, gruesome images in public places are caught up in the attempt to regulate fictional violence in film and on television, especially when it appears that children may be

'exposed' and somehow spoiled.

I discuss Sontag's view that photography blunts morality and has an 'analgesic' effect which numbs onlookers to the point of indifference.[23] Photographs of incidents from the 'slaughter bench of history', she argues, induce general pathos and sentiment, and promote a form of stupidity: shots of atrocities become familiar, then dull the senses and may corrupt them. Whatever the feelings aroused, she argues, photographs can never become the source of ethical or political knowledge. I also enquire into the widespread claim that the analgesic effect of photography combines with its superabundance and induces so-called 'compassion fatigue'.

In chapter 3, 'Why look?', I examine the idea that representations of horror cannot be separated from aesthetic pleasure or even from beauty. What is revolting can also afford intense aesthetic pleasure. This may sound perverse, but it informs the use (by Georges Bataille) of a series of photographs of a Chinese torture in which a man is dismembered in public. I admit that pictures of catastrophe can overpower 'objective vision' and 're-enchant the world' through spectacle, which joins together the real and the fantastic.[24] Yet, despite the pleasures of shocking photographs, I argue that it matters morally and ethically whether or not we regard the depicted horrors as fact or fantasy.

Chapter 4, 'Press, photography and evidence', looks at two practices. It describes the shape of the newspaper industry, and how different titles supply and support what editors presume to be the common sense of its readers. The main function of any title is to encourage its readers to identify with the product, with the coverage of news and its gloss or slant. This is the normal professional practice of journalists, and they use the practice of photographers to anchor their stories in some visible reality 'out there'. Both practices complement one another, especially in the way that news appears to be a mixture of sensationalism and squeamishness. In other words, the press never says or shows as much as it might, or as much as may be found in other systems of providing knowledge. Instead, news is a particularly guarded product, suitable for home viewing, generally following and responding to accepted guidelines on what it is appropriate to see in public. Chapter 4 examines various ways in which photography may fit into the 'hard news' sections of reportage, those sections which provide graphic accounts of real events that may sometimes prick the consciences of readers.

Chapter 4 also looks at one supposition. Photography is often imagined to be evidence that something has happened. This guarantee is extremely unstable. If the practices of the news industry and journalism are under constant review, then judgements about the veracity, authenticity and uses of documentary photography are even more the subject of enquiry and doubt. The chapter discusses how photographic evidence is an effect of its use rather than something which belongs to it naturally, or is inherent in it as a trace of the real, like a footprint or a death mask. Consequently, the truth-value of photography is something which is bestowed upon it by convention and by use, so that various sections of the press may use the same or similar images to underpin quite different kinds of knowledge.

Chapter 5, 'Press shock', introduces some of the ways looking is constrained, and how picture editors and journalists take part in this everyday process of polite, public exchange. I discuss how publishing gruesome images and limiting what is seen provide a measure of decorum and propriety in public spaces. The limits of horror in published photographs also indicate the uses of squeamishness, or the rejection (for the public good) of whatever may be disgusting and disagreeable. In other words, though observing

manners and feeling squeamish can be personal attributes, they are also conventional. I sketch out some of the guidelines provided for television and press journalists when representing the frightful or the morbid, and the limits of documentary photography in representing death.

Chapter 6, 'Disaster tragedy', examines how horror is basic to those human-interest stories which arise from bad luck or bad management. I discuss different types of heartbreaking stories and consider how the news industry uses the authenticity of documentary photography to bolster, anchor or improve stories of actual catastrophic events. My interest is not so much in the great differences that exist among British newspapers, particularly between the popular tabloid and the 'quality' broadsheets, as in how human-interest stories are widely read across all the titles. The evident polarisation between tabloids and broadsheets is due not to the market demands of divergent elite and mass audiences but to economic pressures within the industry: popular papers maximise their circulation by appealing to undifferentiated, 'universal' audiences, whereas broadsheets resist the mass market, since it would jeopardise their advertising value.[25] These economic pressures and the different methods of addressing imagined readers disguise the continuity of human-interest news among newspapers, and how closely this type of news depends on the phenomenal harm of bodies. Most news is pictured according to the unvoiced, unwritten and only slowly changing rules of polite looking as picture editors and designers interpret them. Generally, pictures of British people who have been killed are either not published or not seen in detail.

In chapter 7, 'Murder', I discuss how such stories are among the most favoured news reports because they mix together so many contradictory impulses: they measure evil and innocence, frenzy and restraint, passion and deliberation. These brutal killings may be considered a subset of heartbreak human interest, but I examine some of the qualities of murder stories which mark them out as different from tales of disaster and catastrophe. Reports make murder unimaginably savage and terrifying. At the same time, murder stories reinforce ideas about civil society. Readers wait to see murder's mystery eventually banished by reason and by law. These stories underline the essential stability of the country despite the presence of crazed 'loners' and cruel mass murderers. The photographic records of these killings follow definite patterns of restraint and euphemism.

In chapter 8, 'Foreign bodies', I discuss the way the press represents both killing and murder. Dead strangers are not treated with the same caution as dead Britons. Their reporting is marked by a tone of indifference which is absent in home news (though there are exceptions). The greater the killing, and the closer it comes to massacre and even genocide, as in Rwanda, the greater the distance that separates British newspaper readers from the people who are the objects of news.[26] Much of Africa, according to popular Western representations, is a dread, intemperate region of flood and drought, or filth, famine and disease.[27] The 'bloodbath' in Rwanda, for instance, is deemed 'Hopeless, helpless, horror beyond belief'.[28] This type of story line gives the impression that greed and cruelty, poverty and brute incomprehension of human worth are basic to Africa (and can apply to the Third World in general). Such stories are accompanied by photographs of refugees, corpses, mobs.[29]

In contrast to reactions of weariness and disgust, press reports on foreign killings may blame Western countries for not responding adequately or decisively to help those trying to escape from war, making the problems worse.[30] The story lines on overseas disasters

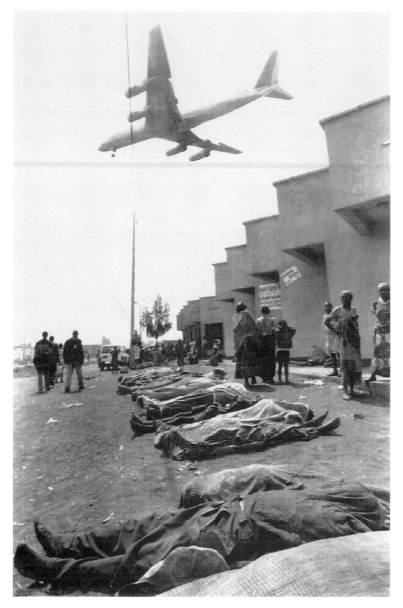

Rwanda. Has the First World failed the Third? Corpses line the streets of Goma in Zaire as an aid plane prepares to land. *Guardian*, 27 July 1994. Michel Euler/AP

often attack Western indifference or the tendency to act too late, as in the *Guardian*'s use of Michel Euler's photograph (reproduced here) taken in Goma in Zaire (renamed the Democratic Republic of Congo in May 1997). An aid plane flew above the dead lying in the street, and the headline ran 'Has the First World failed the Third?' (27 July 1994). Reports sometimes call for intervention, and often comment favourably on aid when it is at last given.[31] These stories are illustrated by pictures of mass migration and starving or hopeless individuals, though they also use photographs of aid workers and soldiers

protecting orphans or removing corpses.[32]

I contend in chapter 8 that the supposed 'analgesic' effect of photography is not an effect of photography by itself. After all, photography is part of a whole social and economic system which promotes or at least fosters indifference by creating distance between members of the same society, let alone outsiders. If photography fails to sustain fellow feeling, and even produces its opposite, it does so because the scope of old, discredited ideas about humanitarianism is limited. Many people may be 'with' others, but few will be 'for' others to the extent that they are utterly careless of themselves. In the extreme, such selflessness is inimical to society, and is reserved perhaps only for saints.

Chapter 9, 'The body vanishes…', looks at the photographic representation of the body at war, one major sign of horror in the twentieth century. I consider how the destruction of bodies tends to be left out of war reports in the press. This absence may have had its beginnings in censorship on the grounds of national or military security, but it has real implications for what history is remembered. In this account of figuring the body in the conjoint era of photography and mechanised warfare I have narrowed my enquiry to how 'the body vanishes' in the Gulf War of 1991.

My aim is to show some ways in which photographic publicity makes sense of warfare on the home front, and how war is contained and made fit for public consumption. The reality of war could never be conveyed to civilians. It was not simply a matter of the limits of representation: photography was in the hands of the military authorities; it was a tool of persuasion or propaganda, and so always constrained. Its purpose was to relay acceptable information about widely publicised ways of soldiering to those who did no more than read about the war in print.

Such reports are always significant. They record military and political developments; more than that, they signify readers' distance from the war, emphasise their lack of responsibility for causing the war, and underline that civilians in democracies lack authority to influence military events to any great extent. War photography is part of this process, demanding attention but denying authority. I examine the type of knowledge produced by a home-front industry which tended to overlook that people died in unknown numbers and in horrible ways.

Not surprisingly, news management intensifies in war and other military conflicts involving British forces. Increased news handling and sharper self-regulation combine to shield civilians from horror. Sometimes the dictates of good taste go so far that war is more than sanitised: in a climate of squeamishness and decorum, war may appear to be 'pretty'. When the demands of taste dominate and shape news reports there is a consequent muffling of controversy and 'dumbing down' of knowledge.

In the final chapter I summarise some of my main arguments regarding the balance between polite and impolite representations. I conclude that the idea and practice of civility require the depiction of harsh realities and brutal facts. Consequently there is a role for documentary styles, whatever they may now be called. Documentary defines civility. The meaning of 'civil' is not confined to restraint in manners: it includes facing the depiction of, for example, allied war crimes, as also the Holocaust. The use of horror is a measure of civility. The absence of horror in the representation of real events indicates not propriety so much as a potentially dangerous poverty of knowledge among news readers. What else can it mean when reports are polite in the face of atrocity and war?

Notes

1 Joanna Bourke, *Dismembering the Male. Men's Bodies, Britain and the Great War* (London, Reaktion Books), 1996, p. 108.
2 William Ian Miller, *The Anatomy of Disgust* (Cambridge, Massachusetts, Harvard University Press), 1997, pp. 25–6.
3 *Ibid.*, p. 90.
4 George Orwell, *Nineteen Eighty-four* (Harmondsworth, Penguin Books), 1954, pp. 227–8.
5 Julia Kristeva, *Powers of Horror. An Essay on Abjection* (New York, Columbia University Press), 1982, p. 3.
6 *Ibid.*, p. 3.
7 Roberta McGrath, 'Medical police', *Ten.8*, 14 (1984) 13–18.
8 Margaret Olin, 'Gaze', in Robert S. Nelson and Richard Shiff (eds), *Critical Terms for Art History* (Chicago, University of Chicago Press), 1996, p. 217.
9 McGrath, 'Medical police', p. 15.
10 Geoffrey Gorer, *Death, Grief, and Mourning in Contemporary Britain* (London, Cresset Press), 1965, pp. 169–75.
11 Griselda Pollock, 'Feminism/Foucault – surveillance/sexuality', in Norman Bryson, Michael Ann Holly and Keith Moxey (eds), *Visual Culture. Images and Interpretations* (Hanover, New Hampshire, Wesleyan University Press), 1994, p. 15.
12 John Keane, *Reflections on Violence* (London, Verso), 1996, pp. 165–6.
13 Richard Keeble, *The Newspapers Handbook* (London, Routledge), 1994, p. 24.
14 Roland Barthes, *Camera Lucida. Reflections on Photography* (London, Jonathan Cape), 1982, p. 76.
15 Keane, *Reflections on Violence*, p. 185.
16 Raymond Snoddy, *The Good, the Bad and the Unacceptable* (London, Faber and Faber), 1992, p. 11.
17 Roland Barthes, *Image/Music/Text* (New York, Hill and Wang), 1977, p. 44.
18 Annie E. Coombes and Steve Edwards, 'Site unseen: photography in the colonial empire: images of subconscious eroticism', *Art History*, 12:4 (1989) 510.
19 Martin Bell, 'TV news: how far should we go?', *British Journalism Review*, 8:1 (1997) 16; Martin Bell, 'Here is the war – live by satellite', *Guardian*, 8 March 1997.
20 Paula Rabinowitz, *They must be Represented. The Politics of Documentary* (London, Verso), 1994.
21 Bell, 'Here is the war – live by satellite'.
22 Allan Sekula, 'On the invention of photographic meaning', in *Photography against the Grain. Essays and Photoworks 1973–83* (Halifax, Nova Scotia, Press of the Nova Scotia College of Art and Design), 1984, pp. 5–6.
23 Susan Sontag, *On Photography* (New York, Farrar Straus and Giroux), 1977, p. 110.
24 Don Slater, 'Photography and modern vision: the spectacle of "natural magic"', in Chris Jenks (ed.), *Visual Culture* (London, Routledge), 1995, p. 236.
25 James Curran, Angus Douglas and Garry Whannel, 'The political economy of the human-interest story', in Anthony Smith (ed.), *Newspapers and Democracy. International Essays on a Changing Medium* (Cambridge, Massachusetts, MIT Press), 1980, p. 316.
26 Martin Shaw, *Civil Society and Media in Global Crises. Representing Distant Violence* (London, Pinter), 1996.
27 Colin Smith, 'Troops block exit from cholera hell', *Sunday Times*, 24 July 1994.
28 Annabel Heseltine, 'Hopeless, helpless, horror beyond belief', *Sunday Times*, 8 May 1994.
29 Chris McGreal, 'Eight indicted for Rwanda genocide', *Guardian*, 13 December 1995.
30 Chris McGreal, 'Beyond despair', *Guardian*, 27 July 1994.
31 Rupert Cornwell and Robert Block, 'Clinton launches Rwanda rescue', *Independent*, 23 July 1994.
32 Julian Bedford and Chris McGreal, 'Massacre survivors on forced march', *Guardian*, 24 April 1995.

2

Caught looking

It's rude to stare

Caught looking at gruesome photographs, the viewer is haunted by voyeurism and its implied sadism. Such pictures stage the grisly and taboo, a fantastic array of human flesh tormented and destroyed. In photographs, these horrors are treasure recovered from the wreck, remnants of exotic endings unveiled before survivors' eyes.

In contemporary times, and in relation to horrible events, it is considered morbid and unhealthy for 'unembarrassed witnesses' to watch from curiosity, to feast their eyes on the misery of others, even in photographs.[1] The common knowledge that to stare is rude and that gawping is shameful surrounds censorship and every voluntary aversion of the eyes from whatever is loathsome and might also be exciting.

Photography offers opportunities for different types of looking. Introducing the camera changes the nature of looking for photojournalists, who do not avert their eyes from frightful scenes but bring them into focus and work quickly to frame and compose them. The professional use of the camera lens allows photographers to look at indecent subjects. This is not without personal cost or trauma, though photographers usually survive. In 1971 Horst Faas was present when Bengalis bayoneted to death some East Pakistani guerillas in Dacca; he took pictures of the scene because he considered that it was his 'job to report all that happened'.[2] Once the torture and murder started, it was more important to report it than walk away. Faas was trembling so much that he could not change his film, but he had to stay, watch and work at creating the record. Photojournalists like Faas are a breed apart from ordinary photographers: they are messengers and eye witnesses who often risk death, sometimes enjoy public admiration for carrying out the journalist's 'duty' to the public record, and may carry a public burden of shame for what they have dared to see.[3] In 1969 the war photographer Larry Burrows wondered whether he had the right to capitalise on the grief of others, but felt justified if

he could contribute to the understanding of what they were going through. However, the burden of witnessing catastrophe and war can prove too much to bear: some photographers wish themselves dead and others, such as Bradley Arden and Kevin Carter, have committed suicide (see their photographs on pp. 82 and 135).

Photography in the press creates unease because it invites viewers to pore over sights that the photographer saw perhaps for only a few seconds; it invites viewers to stare at the scenes with impunity. This is in complete contrast to viewers' likely response in real life, where they would look the other way and not risk being accused of intrusive, indecent or secret gawping. Photography is a screen in two senses: it displays something that is distant, and it is a defence against affront and the threat of engagement. It encourages audiences to use a range of looks such as peeping and glimpsing which can be impolite in public places. Its realism or link with what-has-been combined with the permission to look becomes a source of wonder and anxiety. At the same time, photography in newspapers is limited by what amounts to a set of unwritten guidelines about polite and impolite looking. For newspapers to observe their own guidelines on propriety is not to say they are determining how their pictures will be received. A glance at a photograph may turn into a stare. Audiences may look at everything printed in photographs for a long time without risk of censure and may be stirred improperly by what they read in detail, replay on the video tape and pore over at leisure. No one can be certain how photographs will be received.

Published photographs offer viewers the opportunity to stare at and become enthralled by forbidden or taboo subjects, including physical torment and macabre deaths. Such images invite prolonged, uncontrolled staring and may release unwelcome fears and desires. Some people may prefer to run the risk of seeing real horror for themselves, but most people see it reproduced at some remove of distance and time. Photographs of murders and deformities are for sale and appear in many books and exhibitions.[4] Photographs of death and destruction are open to prolonged, solitary gawping in books which may have serious intentions but which also offer the opportunity to stare at others' miseries. Grisly photographs are found in books on 'true life' crime like Luc Sante's *Evidence*, which is a collection of 'startling,' 'brutal', and 'poetic' pictures taken by the New York City Police Department between 1914 and 1918.[5] Almost every one of the fifty-five images depicts a body or a murder scene.

Photographs of horrific scenes are easily packaged as reputable. For instance, in her exhibition catalogue *Looking at Death* (1993) Barbara Norfleet treats grotesque imagery of beheading and dismemberment culled from Harvard University collections in a thoughtful and tentative manner.[6] Norfleet is chiefly concerned to say that she 'tried to choose the least revolting' of all the images in the archive to illustrate her chapter 'Death by violence'. Her choices introduce into the public realm pictures of severed heads, scenes of crime and men hanged by accident or design. She states that viewers should look so that they 'will fully understand' what people can do to each other or 'what fate might befall us'.[7]

Though Norfleet puts this material on display, she also proposes that gruesome photographs should 'continue to be hidden because they are so disturbing, so horrifying'.[8] The catalogue's chapter 'Death by violence' includes medical and police photographs which were originally records 'concerned with evidence and truth, not with art, not with sensation'.[9] Norfleet argues that the photographs were never placed in the archives with the intention to shock or fascinate onlookers who would read them outside

the university setting. She admits that outside the archive, even in the exhibition, forbidden or rarely seen subjects do 'encourage voyeurism'. She also maintains that placing the material in an art gallery alters this tendency: it lessens the visceral impact of photography and so overcomes baser instincts or the desire to see. For all that, the opportunities for prurience in museums and galleries are legion. In museum exhibits and displays, researchers and viewers may be unembarrassed to see representations of the destruction of others, safeguarded by the practice, or disguise, of scholarship.

Many other books containing imagery of death and disaster make no pretence of being scholarly and are intended to appeal to the same instinct that attracts readers to catastrophe stories in the press. Some have been compiled from newspaper cuttings, including Dan Perkes's *Eyewitness to Disaster* (1976)[10] and Sandy Lesberg's *Violence in our Time* (1977).[11] Such collections of relentlessly harsh photography, easily available in public places, may achieve such wide distribution that they become victims of their own success. For example, in December 1996 a fourteen-year-old boy bought an American book called *Death Scenes – a Homicide Detective's Scrapbook* in Tower Records in Birmingham. The book depicts a man with his brains shot away, a decapitated child, dismembered corpses, a boy and girl blown to bits by dynamite, and victims of car accidents, strangulation, starvation and gross physical deformity.[12] Though freely available, for some this book clearly overstepped the bounds of decency in the depiction of murder and accident victims in Britain. An unnamed person broke the 'story' to the *Guardian*, which ran the headline ' "Snuff" book of real corpses on sale in pop culture shop'.[13] The following day the manager of Tower Records withdrew *Death Scenes* from sale, though it remained available in art environments such as the bookshop of The Photographers' Gallery in London. The book had the misfortune to appear in public and then in the press at a time of continuing controversy over children's access to representations of violence. Earlier that month Virginia Bottomley, Secretary of State for National Heritage, asserted that there was too much violence on television. Her complaints were not directed at news programmes, or depictions of actual violence, but at the fact that a third of children aged ten to twelve had watched violent, Adult Viewing films such as *The Silence of the Lambs*, *Pulp Fiction* and *Reservoir Dogs* which had been granted age '18' certificates by the British Board of Film Classification before their release on film and subsequently on video.[14] Bottomley also complained that there was far too much violence in children's animated films, though according to a survey published by Sheffield University the definition of violence was so wide that a league table of programmes containing the most violent acts showed a 'Tom and Jerry' cartoon in tenth place. Furthermore, this type of animated violence amounted to 1.39 per cent of screen time over a twenty eight day period.[15] Despite this, the continuing attack on fictional television and film violence continues. It has produced no new legislation but has kept the pressure on programme makers to 'maintain proper standards'.[16]

Apart from isolated cases like *Death Scenes*, books tend not to receive so much attention as more public forms of address such as photojournalism, but especially television, film and video.[17] Some books representing death and injury in graphic form derive from the collections of career photojournalists. Instead of aiming to excuse impolite staring at the misfortunes of others, the work of photojournalists is more obviously concerned with the status and position of press photography as public record: Don McCullin's *The Destruction Business* (1971)[18] and *Sleeping with Ghosts* (1994)[19] are records of killing, madness and deprivation from many parts of the world, including

Cyprus, Biafra, Vietnam and Britain.[20] In the hope of persuading people to act against murder and injustice, McCullin has allowed his work to be used by Amnesty International (*Independent*, 15 February 1997). The work of Philip Jones Griffiths, gathered over many years, is presented in a series of brutal, provocative comparisons in his exhibition and book *Dark Odyssey* (1996).[21] He places a photograph of Hiroshima next to one of the Brussels Atomium with its built-in restaurant; an image of a beggar in New York commands the same interest as the amputees of South Korea. According to art critic William Feaver, Griffiths 'upholds the committed photojournalism that thrived before the onset of universal tourism and round-the-clock coverage via satellite'.[22]

The French photographer Gilles Peress took pictures in Iran during the ayatollahs' revolution in 1979–80 which he later published in *Telex Iran* (1984):[23] the images, taken through car windows and screens, are 'decentred and unstable', demonstrating that he was 'lost in another culture that he could not read'.[24] The violence is unseen. In contrast to *Telex Iran*, Peress's photographs of misery and bodily harm in *Farewell to Bosnia* (1994)[25] and mutilation and death in *The Silence* (1995)[26] concerning the Rwandan massacres appear to engage with the wretched conditions of people in the manner of eye-witness photojournalism. But this is no guarantee of an engaged audience response. It is impossible to tell whether any of these books, or others in a similar vein like Alex Webb's *Under a Grudging Sun*, in which he gets 'under the very skin of woe in Haiti', will be objects of gloating, anxiety or warning, or mark a new political awareness.[27] The awakening of conscience is an unlikely response to photographs: as Martha Rosler points out, 'a private person [may] support causes', but documentary photography 'is a little like horror movies, putting a face on fear and transforming threat into fantasy, into imagery. One can handle imagery by leaving it behind. (*It is them, not us*).'[28] Whether intended or not, the mass production of this imagery in books and the press caters for voyeurs.[29]

Photography is often seen as a first site of indifference if not its cause. Photographs can induce a guarded look, a quick turn of the page or a long, unembarrassed stare. Photographs demand this kind of attention because the authority of the medium arises from the still current belief in its ability to trace the real, which in turn is the basis of its claim to truth-value. Yet, whatever the system of realism, there is so much and no more that can be mined from photography. In a picture of an old cottage the image may reveal the crack in a pane of glass, a spider's web that trapped a leaf, and a water butt with its black, oval surface. Picturesque details such as ageing and weathering are familiar enough in photographs which may otherwise be poor in information, showing nothing of work and ownership of land or house. Photographs can show the worn stone of a threshold, but can only hint at how the wearing happened, and cannot represent at all the experiences of those coming and going. Even putting the house's occupants in the frame reveals almost nothing about them, other than the fold of their clothes and their composure before the camera. Photographs are equivalent to flints or to shards of pottery on ancient sites. Like all artefacts spirited away from their original surroundings, photographs mean next to nothing on their own.

The instability of photographic meaning, the opportunity to stare, combined with the passing nature of daily news may bring the press into a special kind of disrepute. According to Julian Stallabrass, editor of the *New Left Review*, media academics and commentators reject documentary because they believe it to be seriously compromised by its liberalism, optimism and unsustainable claims of objectivity.[30] He argues that documentary photography seems unsuited to a consumer society. The trend in

commercial news is to strip such photography of its once critical function, producing images only of the novel, sensational or bloody for entertainment. Accordingly, some cultural historians interested in visual forms may overlook the press or hold it in low esteem precisely because news appears to be conventional in form, ephemeral in effect or merely fascinating. Consider the fate of gruesome pictures, which are readily available in daily newspapers. There they are glanced at, or pored over, and then discarded, like the reports of the same incidents. The supposed triviality of the press is part of the general denigration of the mass media, the popular forms that shape knowledge about reality into narratives and amusements. According to Fredric Jameson, the 'visual is *essentially* pornographic, which is to say that it has its end in rapt, mindless fascination'.[31] Consequently, he claims, pornographic films are only realising the potential of films in general, 'which ask us to stare at the world as though it were a naked body'. Jameson argues that the world is 'now mostly a collection of products of our own making ... that you can possess visually, and collect images of'. This is the idea of 'film-as-Medusa', in which the paralysing spectacle turns the tables on viewing subjects, turning them into fascinated and enraptured objects commonly known as 'couch potatoes'.

In Jameson's view, reservations about the pornographic nature of the visual are in a long line of criticisms which assault the uncritical reception of mass media, including film and photography, by commodified audiences.[32] The intellectual movement against the proliferation of photographic realism is driven by this belief that the visual-ends-in-mindless-fascination. It has produced a wealth of censoring legislation, particularly against picturing sex in photography and film.[33]

Censoring groups believe mass-produced photographic realism is more encouraging or at least permissive of voyeurism and sadism than other systems of pictorial representation such as fine art painting or print. These groups attribute this type of authority to photographs because chemical (but not digital) images, and some kinds of film and television, have a necessary, causal link with the actual world; they represent it with unique verisimilitude.[34] This resemblance of the object and its sign means that photographs of any event resemble its appearance more closely than any etching or sketch. The faithfulness of the photograph as trace, index or evidence, though compromised by its use, puts onlookers in the privileged position of standing in the place of the actual, earlier eye witness. This combination of realism and distance from the objects in view allows watchers to indulge in voyeurism. It also fixes viewers in an act of looking and seeing which, according to Jameson, is not only rapt but also mindless.

Shock photos and moral insignificance

Reviewing an exhibition of Shock-photos at the Galerie d'Orsay, Barthes wrote that photographs of executions are not terrible in themselves: dismay, alarm or nausea comes from looking at them 'from inside our freedom'.[35] The horror of executions seen in photographs is naturally tempered by viewers' satisfaction at having survived long enough to look at their reproduction in museums, but that is not Barthes's point. He states that placing an image of a crowd of soldiers beside one of a field of skulls fails to shock viewers because they have nothing to think about: in creating the juxtaposition 'someone has shuddered for us; reflected for us, judged for us; the photographer has left us nothing – except a simple right of intellectual acquiescence'.[36] According to Barthes, this crudely aesthetic formulation defeats imagination and

reflection, and fails to disturb the viewer.

Susan Sontag makes a similar point against the 'lovely composition and elegant perspective' of Lewis Hine's photographs of exploited children in turn-of-the-century American mills and mines. She writes that 'the medium which conveys distress ends by neutralizing it' because it makes everything aesthetically pleasing.[37] According to Sontag, photography cannot yield moral intelligence. It can produce sentimental responses, but it can make a dent in public opinion only if there is 'an appropriate context of feeling and attitude'.[38] Photographs are unable to establish moral positions, though they can reinforce those that exist. In other words, the only photographs which are seen or recognised as having any moral dimension are those which support or confirm known points of view; otherwise editors and others will fail to recognise their relevance. What decides the moral effect of photography is the prior, recognised existence of 'a relevant political consciousness'.[39] But this is actually destroyed by photography. The 'mental pollution' which addles the minds of 'image-junkies' (the inevitable product of industrial societies) leads to a kind of moral torpor. The 'public' can be affected morally by photographs only if they have 'emotional charge', if they are informed by and express a morally relevant politics. Without a politics, 'photographs of the slaughter-bench of history will most likely be experienced as, simply, unreal or as a demoralizing emotional blow'.[40] Looking at photographs of terrible events without political consciousness results in denial of the reality of the vision, or a more or less deeply felt depression which is adjusted into seeming callous indifference. Atrocity becomes familiar; the repulsive seems ordinary, remote or inevitable. After all, ' "it's only a photograph" ', which can represent the surface but gives no direct access to reality.[41] In the end, photography can goad conscience but it can never provide 'ethical or political knowledge'.[42]

Meagre though they are as evidence, Sontag does not condemn all photographs. Despite the usual lack of 'relevant political consciousness', she contends, it is better to have photographs of certain crimes and atrocities than nothing at all. An event known through photographs becomes more real than it would be if none existed – but only for the more or less limited time that an ethical reference point exists and retains its emotional charge. Sontag sets the reality of the Vietnam War against the unreality of the Gulag Archipelago, 'of which we have no photos'.[43] Despite her belief that photographs of atrocities can do no more than lay claim to morality by stirring emotions which are certain to fade, Sontag also contends that some photographs did not suffer this fate *when she saw them*. They stirred emotions which remained sharp, and they led to knowledge: her key example is her own revelatory first encounter with photographs of Bergen-Belsen and Dachau which she came across by chance in a bookstore in Santa Monica in July 1945. Sontag was shocked by these images because they were not 'banal'; indeed, they were 'the photographic inventory of ultimate horror'.[44]

In this case Sontag reserves 'the prototypically modern revelation – a negative epiphany' for herself, and presumably for other contemporaries, without any justification. Sontag decides that the mix of shock and moral outrage she feels looking at Holocaust imagery does not fade *for her*, but easy access to these grisly photographs makes it too familiar *for other people*. She effectively denies that photographs of the Holocaust can ever strike the same chord with future generations, because they are no longer 'novel'. After repeated exposure such scenes become less real. She writes, 'After thirty years, a saturation point may have been reached. In these last decades, "concerned" photography has done at least as much to deaden conscience as to

arouse it.'[45] Photographs of past atrocities, according to this view, cannot be novel, even to someone viewing them for the first time. They are decidedly of the past, so the viewer's sense of any responsibility diminishes even more quickly than fascination.

Consider for a moment that Sontag's view is correct, that photographs have the potential to produce strong feelings that dwindle with the age of the photograph. Even if the point is conceded, moral authority lies not in photography but in people, as Sontag herself recognises when she sees what the Nazis did in her lifetime. The moment was one of self-recognition – the loss of belief in the innocence of her world through seeing what was both repugnant to her and yet forever part of her. She cannot easily forget the lacerating moment, nor lay all the blame elsewhere.

Sontag does not explain more fully the consequences of her 'negative epiphany', but goes on attacking photography for its inability to narrate and interpret reality. Registering light waves reflected by objects induces a feeble moral grip, because it does not expose desires, choices and motivation.[46] Understanding is based not on how something looks but on how it functions and is explained in time: 'Only that which narrates can make us understand.'[47]

This argument depends on photographs existing by themselves, but they always exist in some context or other. Visual and verbal realms of experience are not totally separated from, or antithetical to, one another. As Victor Burgin notes, 'Seeing is not an activity divorced from the rest of consciousness,' and language, in some form, usually enters the experience of viewing photography.[48] Documentary photographs in the press rarely stand alone. They are almost always accompanied by headlines, captions, and stories which guide readers in how to view them. The fate of photography depends not so much on the content of the image itself as on its placement, on the extent that it is moved from one setting to another, and the way it is used to narrate events, or to support newspaper stories.[49] The importance of context and direction in lending meaning to photographs does not necessarily save them from Sontag's reservations. On the contrary, her pessimism about photography may even be deepened by looking at images in their larger framework. Some uses enable viewers to denigrate the medium even further, providing the most negative and now orthodox perceptions of documentary imagery and how it functions in the press.

Glut, analgesia and compassion fatigue

Too many photographs of disgusting events are supposed to reduce audiences to indifferent voyeurs and produce 'compassion fatigue'.[50] These ideas of surfeit, voyeurism and compassion fatigue form an alliance against press photography based on three dubious assumptions: that a surfeit of photography is the same as a glut of knowledge; that photography is a kind of analgesic injected into passive audiences; that the combination of glut and analgesia produces 'compassion fatigue', a special case of inertia that can be blamed on the media. The phrase 'compassion fatigue' also claims the moral high ground. It hints at an earlier stage when compassion was intense but which has simply become spoiled by the abundance and voyeurism of media coverage.

In brief, the so-called surfeit of photography hides the way that some channels of information remain narrow. The surfeit disguises the economic organisation of information and its technologies which advances new and profitable ways of restricting access to information and makes it 'an ever-more scarce commodity'.[51] The logic of

consumption in industrial societies means that despite the abundance of photographs there is an ecology of images organised around access and costs. Getting access to information, or just seeing sights, is becoming increasingly difficult and expensive. For instance, shortly after the Gulf War of 1991 the Pulitzer Prize journalist Jean Heller wanted to see two pictures taken by a Russian commercial satellite company, Soyuz Karta. They were the only independent pictures of what the US and British governments declared was a massive build-up of Iraqi troops on the main road leading through Kuwait to Saudi Arabia. Heller persuaded the *St Petersburg Times* in Florida to pay $3,200 for the two satellite pictures, but no trace of the supposed 265,000 Iraqi troops and 1,500 tanks could be found in the photographs. The satellite pictures 'proved' the allegation was a lie, part of the propaganda against Iraq.[52] Heller's detective work and the price of the photographs indicate that the medium, specifically when it contradicts the official history and may be morally disturbing or politically inconvenient, is likely to be more difficult to obtain than easily brought to light.

The ecology of images, the way they are stored, marketed and sold, converges with the way that press (and broadcasting) managers restrain horror on behalf of 'citizens' who they assume would prefer not be disturbed.[53] The most abundant imagery is the visual equivalent of polite speech. It contains horror-as-fun among its licensed entertainments and diversions. The media then advertise their own professional decisions about the rhetoric of politeness or the anxieties of decorum as if they were a national consensus.

Claiming to speak to their publics in every High Street and news-stand across the country, editors are careful to choose pictures of bodily harm from within a narrow range and from well-tried sources. Pictures are taken by staff photographers, freelances, frame-grabbed from television networks and hired from commercial picture agencies.[54] Editors are unwilling to take risks or spend money on news photographers.[55] The number of producers is relatively small, but the distribution agencies ensure that copies of photographs reach editors' electronic picture desks. They then enter a system of monetary exchange in which the right to look is bought and sold on a daily basis, with a single image sometimes reproduced over many years.

Freelance photographers lodge their images with national and international picture agencies like Associated Press, Magnum and Reuters which undertake to collate and distribute their clients' work, and collect fees for its use. Similarly, photographs housed in private collections and national archives command fees for the right of reproduction. Curiosity, the right to look, news value and finance are intimately linked. The central artefact of this system in the nineteenth century and for most of the twentieth 'is not the camera but the filing cabinet', or its electronic equivalent.[56] The life of news photographs begins outside the filing cabinet, once they are printed in the press or sold in mainstream publications available in public spaces, including bookshops and libraries. Obviously the quantity of photographs reveals no more about their reception than the number of library books or television channels reveals about how readers and viewers use them. The so-called surfeit is actually controlled by editorial decisions about what is newsworthy and how it may be illustrated in accordance with a newspaper's sense of its market.

The illusion of photographic glut is joined to the notion that photography is an analgesic. According to Sontag, when viewers are faced with revolting pictures they follow a well worn track from the emotion of shock to accommodation and finally to indifference. She maintains that 'our ability to stomach this rising grotesqueness in

images (moving and still) and in print has a stiff price. In the long run, it works out not as a liberation of but as a subtraction from the self: a pseudo-familiarity with the horrible reinforces alienation, making one less able to react in real life'.[57]

This inability to react in real life apparently touches photographers too. Sontag writes, 'Photographing is essentially an act of non-intervention.'[58] Since photographers cannot intervene in events, part of the horror of 'memorable coups of photojournalism' which include images of death 'comes from the awareness of how plausible it has become, in situations where the photographer has the choice between a photograph and a life, to choose the photograph'.[59] The photographer's supposed distance from suffering, with all that it implies for moral abrogation, is nothing compared with the distance of viewers, or the 'tourists of reality' who consume photography. Even if photographs create sympathy, they also cut it off; they stir the senses but their 'realism creates a confusion about the real' which, in the long run, has the inevitable 'analgesic' effect even if the pictures are 'sensorially stimulating'.[60] The analgesic effect of shocking pictures is so well known, apparently, that charities can only exceptionally rely on imagery of gruesome sights to elicit sympathy or, more important, to induce action. If photographs are too repulsive, and seen too often, people will not respond, as if they have been anaesthetised.

Sontag's views on the morally deadening effects of photography have been developed by Jean Baudrillard, who argues that audiences are seduced, captured and held hostage by media images of violence. Yet the media do not even show anything real which is happening in the world. They simulate reality, or advertise it, redescribing it in a new form. According to Baudrillard, 'image alone counts', and its purpose is to promote the 'easy' life. That means forgetting the horrors and crimes of the past, and showing no pity to the poor or disenfranchised. He states that the ultimatum issued in the name of wealth and efficiency wipes poor people off the map. The system requires that '"poor people must exit" … And rightly so, since they show such bad taste as to deviate from the general consensus.'[61] The role of the media is central to this amnesia, coupled with their ability to divert attention, manage or massage crises into non-existence, and to advertise and repeat the 'must exit' logic in which some people deserve to die.

Baudrillard charges that photographs of past events, even of terrible massacres of world significance, are unintelligible. He suggests that the Holocaust cannot be understood 'because such basic notions as responsibility, objective causes, or the meanings of history (or lack thereof) have disappeared, or are in the process of disappearing. We shall never know whether Nazism, the concentration camps or Hiroshima were intelligible or not: we are no longer part of the same mental universe'.[62] If that is so, photography can serve no purpose other than feeding doubtful pleasures to ravenous eyes.

John Keane rejects Baudrillard's 'extravagant thesis' that the media turn horror into light entertainment because they suppose audiences to be 'stupid misanthropes'.[63] Keane argues that this flies in the face of considerable evidence that audiences experience moral revulsion at, avoid or discuss the violent images which they see. He writes that 'The crying of those who have been violated,' as in Nick Ut's photograph of the screaming, napalmed girl fleeing from her bombed village in Vietnam in 1972, 'sometimes – or often – triggers questions about responsibility among those who see or hear the grief of those who cry.'[64] 'Empathy with the violated happens, but why and when and for how long remains utterly unpredictable. All that is known is that it happens, and that to the extent that it does we can speak of a hidden, potentially civilizing dialectic within the growing

trend towards ever-increasing media coverage of virtually all forms of violence'.[65] At least two reactions are possible: guilt, which is self-regarding and unproductive; shame, which may invoke the desire to avert the eyes or turn the page but which is also likely to raise questions, bring improvements and encourage interaction with the violated.

Photography always retains this potential, no matter when or where it is seen, because its meaning is unstable and changes with circumstances. Some environments are more didactic than others, but that does not mean they will make audiences more aware of their obligations. By the same token, the meanings of photographs cannot be altogether confined by conservative uses. Some images which later turned out to be politically effective appeared initially in newspapers which had put them to no new ends or radical politics. A famous example is Eddie Adams's picture of General Loan summarily executing a Vietcong suspect in a street in Saigon on 1 February 1968. It was by no means certain that this image would be important, or that it would have been released if it had not been a rare image of a bullet fired into a living man's head. The Associated Press sold the image so widely mainly because it was unusual and not because it might have a moral dimension. Sales were based on 'the oldest journalistic instincts' of a close-up of 'one man shooting another at "the instant the bullet slammed into the victim's head, his features in a grimace" as the AP log noted'.[66] In spite of its rarity, even a photograph satisfying old journalistic instincts would not be certain of publication if it did not also suit the press's current assessment of the political scene. Harold Evans, a former editor of *The Times*, reports how in 1962 Dickey Chapelle photographed a Vietcong prisoner about to be executed by his captor, a South Vietnamese soldier with a drawn gun. But this picture was 'universally rejected and published only in an obscure little magazine', probably because in 1962 the war in Vietnam was too small or viewed too favourably for hostile coverage.[67] Evans notes that in early stories about the war picture editors preferred even 'the ersatz excitement of the test firing of a gun' to photographs which depicted soldiers' exhaustion, isolation and despair.[68] If a picture did not suit the official story line it was either not released by the army or not published in the press.

In 1968 Eddie Adams's picture was used in US newspapers, including the *New York Times* and the *Daily News*, as well as in the British *Daily Mirror*, *Guardian* and *Times* to explain and defend what they considered to be General Loan's brutal but understandable revenge against a man who had murdered many Americans and Vietnamese. In 1969 the photograph's meaning shifted when it won a Pulitzer Prize for 'spot news photography' because it was a 'memorable image' in the terms of the news industry. Later still, when the war had become an embarrassment to the United States, the image began to stand for anti-war sentiment. Subsequently, when President Reagan revised the meaning of the war, turning it into the 'noble cause', the photograph's meaning altered too: it was only then that Adams revealed for the first time in an interview for *Newsweek* his unsubstantiated claim that the executed man had killed Loan's friend and his family, which somehow excused the action (15 April 1985). As Robert Hamilton remarks, the photograph did not 'change the course of history', as some have maintained, so much as demonstrate how 'the course of history changes photographs'.[69]

'Compassion fatigue' is the third element often tied to the supposed glut of photography and its so-called 'analgesic' effect. The phrase is so much part of common speech that the condition must be real. To the extent that it exists, it is 'a rational

response of the public to the constant repetition of the same story in the same places', like war or famine in Africa.[70] According to Mort Rosenblum of the Associated Press, 'A basic problem is that no human drama stops the moving eye any longer unless correspondents find some new angle that tugs heartstrings in a new way. And each tug stretches them further' to the point where they become slack.[71]

Once again, it is Sontag who has written the most influential support for the idea that photography contributes to compassion fatigue. She charges that familiarity weakens the quality of feeling, including moral outrage, that people can muster in response to photographs of 'the oppressed, the exploited, the starving, and the massacred'. The more the images of bodies pile up the less people are moved by them. Recent horrors are diminished by knowledge of previous atrocities. She alleges that Don McCullin's photographs of starving Biafrans in the early 1970s had less impact on some people than Werner Bischof's photographs of Indian famine victims in the early 1950s because such images had become banal; photographs of Tuareg families starving in the sub-Sahara that appeared in magazines everywhere in 1973 must have seemed to many 'like an unbearable replay of a now familiar atrocity exhibition'.[72] Sontag insists that the possible moral message of photography depends on its emotional impact, but that its power to arouse dismay or disgust drains away with familiarity, turning horror into routine, or turning shock into boredom and then into forgetfulness. While photographs have an 'emotional charge', Sontag maintains, that 'charge' is unrelated to command or obligation. Most photographs, Sontag writes, do not keep their emotional charge, with 'the possible exception of photographs of those horrors, like the Nazi death camps, that have gained the status of ethical reference points'.[73]

As Sontag admits, not all past atrocities are forgotten. Perhaps photography may contribute to keeping memories alive? Sontag hints that this is not possible. She condemns photography not only for failing to overcome familiarity: 'To suffer is one thing; another thing is living with the photographed images of suffering, which does not necessarily strengthen conscience and the ability to be compassionate. It can also corrupt them.'[74] She declares, 'Images transfix. Images anaesthetize' – a version of 'media effects' in which onlookers can do nothing but become moral imbeciles. Presumably, when the 'ethical reference point' of the Holocaust has diminished with the passage of time, photographs of these significant events will simply 'transfix' and 'anaesthetise'. Following the line of her argument, when the photographs in question record events that have no overarching ethical reference, similar to the diet of incidental shocks that are routine in newspapers, there is nothing to prevent viewers' consciences from being corrupted.

But history and memory never converge on a reference point that is universally accepted as 'ethical'. Before that stage can be reached, questions must be asked about what historians choose to write, and what use they make of memory, since every choice of fact and memory betrays or promotes a political position. As Omer Bartov has written, some historians want to remember Jews and concentrations camps, while others want to remember German soldiers and their defence of the West against Bolshevism.[75] These two positions, which are by no means the only ones available, suggest a difference in emphasis between victim and killer; they suggest a difference in emphasis between, on the one hand, the importance of the Holocaust as genocide and consequently as an ethical reference point for European history and, on the other, the resurgence of nationalism which seeks to write the Holocaust into Jewish history rather than into that of Germany.

This struggle is by no means settled. It was to the fore in 1996 when Daniel Goldhagen published his controversial book *Hitler's Willing Executioners*, which provided evidence that 'ordinary Germans' participated in crimes without coercion.[76]

The struggle for German history and the role of the country's citizens and soldiers in committing atrocities was also evident in reactions to an exhibition which toured Germany in 1996–97. 'The War of Annihilation: Crimes of the Wehrmacht, 1941–44' sparked violence in Bavarian towns and in Munich. The show displayed official photographs by Gerhard Gronefeld of Wehrmacht soldiers executing Serb partisans: 'Where the partisan is, is the Jew, and where the Jew is, is the partisan.' Gronefeld had worked as a photographer for the *Berliner Illustrierte* before the war, and took images of atrocities in Serbia, Russia and Poland because he felt that unless the scenes were captured on film no one would believe they had happened. He disobeyed orders and kept the films, burying them in his parents' garden in Soviet-occupied Rheinsberg, partly out of fear of the Russians. When he exhibited the images he was accused of faking them.[77]

While admitting army complicity in the slaughter, Germany's Defence Ministry refused to condemn its soldiers, laying the bulk of the blame on specifically Nazi agencies. But the exhibition consisted of letters and snaps taken by ordinary soldiers. By the time the exhibition reached Munich in March 1997 it had already been on a lengthy tour of Germany. During the tour more and more ex-servicemen and their families contributed material hidden away since 1945 that revealed how the army had been used systematically as state executioner. The show provoked riots, demonstrations and arrests, as well as a political storm, but the critics were 'unable to challenge the authenticity of the photos and letters'.[78] The exhibition also suggested that the victorious allies were not blameless in this sudden revelation of the extent of German complicity in atrocities: it had suited the allies to divide Germans into evil Nazis and ordinary, honourable soldiers. The Allies had been only too ready to cover up crimes, and not pursue the judiciary, clergy and medical profession for their involvement in National Socialism, in case a wholesale and unwieldy hunt destroyed the infrastructure of the country.

What these books and exhibitions demonstrate is the contemporary state of the debate over the Holocaust, and the way that no one can simply assume it was ever an agreed and settled reference point, or that it will become one, or will remain a central point of ethical thinking in Western democracies. The Holocaust may be obscene, inhuman and horrible; it may be fantastical and nauseating; it may appear no more than 'attractive, stimulating, *interesting*'.[79] Its meanings remain multiple and shifting, and the function of photography as evidence is bound together in these shifts, decided by whoever makes them.

Photography cannot define the Holocaust. But to talk of photography's 'analgesic' effect is to blame it undeservedly in a process of forgetting and rejecting in which other factors are more powerful. The so-called analgesia of photography is no stronger than other methods of diverting pain and bleak recollections. After all, it is difficult to deny that the passage of time itself induces forgetfulness, if not disregard. As generations pass, they take their suffering with them. It then becomes a struggle and a burden for following generations to keep alive the memorials, let alone restore and maintain the historic sites of crimes inflicted on their forebears. In time, the burdens are shuffled off and old memorials fall into disrepair and disuse. Who is to say with any certainty that in time current 'ethical reference points' will not pass away and be forgotten? The process is already advanced with the grim events of the previous century, is beginning to quicken

with the First World War, and may in time happen to the reference points of the Second World War. Käthe Kollwitz's statues of mourning parents at the Vladso German military cemetery in Flanders may, as Thomas Laqueur imagined, experience the fate of so many statues since the nineteenth century: they may 'find a home in some museum, without context, assimilated into an art-historical narrative, and admired, like the Elgin marbles, for their aesthetic qualities'.[80] Since the passage of time obscures so much suffering, and makes terror so distant that the Roman Colosseum where thousands died is now a picturesque antiquity, it is difficult to imagine how photographs of horrors may stop or even slow down this process of forgetting, or prevent 'ethical reference points' from becoming no more than intriguing subjects of historical enquiry. It seems disproportionate to lay so much blame on photography's failure in this regard when the whole tendency of generations passing is to loosen their connections with the sufferings of those who were unfortunate enough to live in the past. At times, some living people wilfully condemn those others, not all of them long dead, to obscurity. Forgetfulness is not the fault of photography but of those who choose not to respond to shameful incidents, or refuse to acknowledge their existence.

Sontag knows she cannot save even the Holocaust by means of photography: sooner or later records of atrocity cease to fascinate or interest and so they are discarded. Why is Sontag so determined that photography must be corrupting? Her argument against photography is at root a left-liberal critique of (American) post-industrial consumer society in which 'The freedom to consume a plurality of images and goods is equated with freedom itself'.[81] The abundance and diversity of photographs, according to Sontag, reinforce a view of social reality 'as consisting of small units of an apparently infinite number ... Through photographs, the world becomes a series of unrelated, freestanding particles, and history, past and present, a set of anecdotes and *faits divers*.'[82] The sheer number of images is a sign of the atomised experience of contemporary life. When audiences are beguiled by the 'astounding diversity' of images, she implies, they are responding to 'the logic of consumption'.[83] This logic is dispiriting and destructive, since the accumulation of a world of fragments – in photographs, social units, a succession of interludes – renders nothing other than itself.[84] Forgetfulness, analgesia, moral corruption are fundamental to this world: the press is but another means of gathering and recycling sets of anecdotes which can never be ethical or political knowledge.

The force of Sontag's critique derives in part from its 1970s melancholia. As I mentioned in the introduction, John Keane, writing almost twenty years later than Sontag, puts forward a more optimistic view of critical distance and the moral responsibility of 'public spheres of controversy'.[85] To recapitulate: these public spheres keep memories of crime alive; they sharpen awareness of current incivilities; they invite people to judge whether or not violence is justified; they encourage people to find remedies for incivility.[86] Keane's spheres of controversy modify the attacks on photography without being able to dispel them. The public debate, so far is it appears in newspapers, is still constrained by the laws and rules of self-regulation which surround the press.

The modifications I would make to the points of view of Sontag and other critics of photography stem from Keane's ideas about the contribution of publicity to public knowledge. The accent in the remaining chapters is upon the kind of knowledge photographs in the press may produce besides indifference, fascination or numbness. The inflections to these well established radical criticisms stem from considering press practice

and its role in shaping public limits to looking: the ecology of images, their euphemism and the bowdlerisation of events all come together to inform actions and understanding. Though photographs may block some meanings they release or reinforce others; though photographs may blunt morality, their use in newspapers supports a sense of propriety which impinges on morality and does not simply blunt it; though the visible may be essentially pornographic it is not bound to end in mindless rapture. Photographs in newspapers have specific, varied purposes and are but one part of a story-telling industry. Attacks on photography must stand alongside the press's own reasons for self-restraint. For the moment I shall leave undisturbed the idea that looking is dangerous because it either disturbs or simply fascinates, and ask why anyone should want to look at horror anyway.

Notes

1 V. A. C. Gatrell, *The Hanging Tree. Execution and the English People 1770–1868* (Oxford, Oxford University Press), 1994, p. 242.
2 Max Kozloff, *Photography and Fascination* (Danbury, New Hampshire, Addison House), 1979, pp. 14–15.
3 Phillip Knightley, 'Access to death', *British Journalism Review*, 7:1 (1996) 6–11.
4 David L. Jacobs, 'The art of mourning: death and photography', *Afterimage*, 24:1 (1996) 8–11.
5 Luc Sante, *Evidence* (New York, Farrar Straus and Giroux), 1992.
6 Barbara P. Norfleet, *Looking at Death* (Boston, Massachusetts, David R. Godine), 1993.
7 *Ibid.*, p. 30.
8 *Ibid.*, p. 30.
9 *Ibid.*, p. 30.
10 Dan Perkes, *Eyewitness to Disaster* (Mapplewood, New Jersey, Hammond), 1976.
11 Sandy Lesberg, *Violence in our Time* (New York, Peebles Press International), 1977.
12 Sean Tejaratchi (ed.), *Death Scenes. A Homicide Detective's Scrapbook* (Portland, Oregon, Feral House), 1996.
13 John Ezard, '"Snuff" book of real corpses on sale in pop culture shop', *Guardian*, 16 December 1996.
14 Andrew Culf, 'Children's diet of 18-rated films', *Guardian*, 13 December 1996.
15 Andrew Culf, 'Violence takes up 1.39pc of TV', *Guardian*, 21 December 1996.
16 Marianne Macdonald, 'Bottomley wields stick on TV violence', *Independent*, 11 December 1996.
17 See David Edgar, 'Shocking entertainment?', *Guardian*, 1 March 1997; David Gauntlett, *Video Critical. Children, the Environment and Media Power* (London, John Libbey), 1997; Annette Hill, *Shocking Entertainment. Viewer Response to Violent Movies* (London, John Libbey), 1997.
18 Don McCullin, *The Destruction Business* (London, Open Gate Books), 1971.
19 Don McCullin, *Sleeping with Ghosts. A Life's Work in Photography* (London, Jonathan Cape), 1994.
20 Phillip Knightley, 'The loneliness of the long-distance lens', *British Journalism Review*, 2:1 (1990) 49–52.
21 Philip Jones Griffiths, *Dark Odyssey* (New York, Aperture), 1996.
22 William Feaver, 'Art', *Observer*, 22 December 1996.
23 Gilles Peress, *Telex Iran* (Paris, Contrejour), 1984.
24 Ian Walker, 'Documentary fictions?', *Photography in the Visual Arts, Art & Design* (September 1995) 31; see Max Kozloff, 'Gilles Peress and the politics of space', in the author's *Lone Visions, Crowded Frames. Essays on Photography* (Albuquerque, University of New Mexico Press), 1994, pp. 170–7.
25 Gilles Peress, *Farewell to Bosnia* (New York, Scalo), 1994.
26 Gilles Peress, *The Silence* (New York, Scalo), 1995.
27 Alex Webb, *Under a Grudging Sun. Photographs from Haiti Libéré 1986–88* (London, Thames and Hudson), 1989; see Kozloff, *Lone Visions*, p. 188.
28 Martha Rosler, 'In, around, and afterthoughts (on documentary photography)', in Richard Bolton (ed.), *The Contest of Meaning. Critical Histories of Photography* (Cambridge,

Massachusetts, MIT Press), 1989, p. 306.

29 See also Michael Lesy, *Wisconsin Death Trip* (London, Allen Lane), 1973; Joel-Peter Witkin,
 Harm's Way (Santa Fe, New Mexico, Twelvetree Press), 1994; Val Williams and Greg
 Hobson, *The Dead* (Bradford, National Museum of Photography, Film and Television),
 1995.

30 Julian Stallabrass, 'Sebastião Salgado and fine art photojournalism', *New Left Review*, 223
 (1997) 135.

31 Fredric Jameson, *Signatures of the Visible* (London, Routledge), 1992, p. 1.

32 See Theodor W. Adorno, *The Culture Industry. Selected Essays on Mass Culture* (London,
 Routledge), 1991; Herbert Marcuse, *One-dimensional Man* (London, Routledge), 1991; Neil
 Postman, *Amusing Ourselves to Death* (London, Methuen), 1987.

33 See Annette Kuhn, *Cinema, Censorship and Sexuality 1909–25* (London, Routledge), 1988;
 Carole S. Vance, 'The pleasures of looking: the Attorney General's Commission on
 Pornography versus visual images', in Carol Squiers (ed.), *The Critical Image. Essays on
 Contemporary Photography* (Seattle, Bay Press), 1990, pp. 38–58; Linda Williams, *Hard
 Core. Power, Pleasure, and the 'Frenzy of the Visible'* (London, Pandora), 1990; Abigail
 Solomon-Godeau, 'Reconsidering erotic photography: notes for a project of historical
 salvage', in the author's *Photography at the Dock. Essays on Photographic History,
 Institutions, and Practices* (Minneapolis, University of Minnesota), 1991, pp. 220–37;
 Pamela Church Gibson and Roma Gibson (eds), *Dirty Looks. Women, Pornography, Power*
 (London, British Film Institute), 1993; Elizabeth Anne McCauley, 'Braquehais and the
 photographic nude', in the author's *Industrial Madness. Commercial Photography in Paris
 1848–71* (New Haven, Yale University Press), 1994, pp. 149–94.

34 See André Bazin, 'The ontology of the photographic image', in *What is Cinema?* vol. 1
 (Berkeley, University of California Press), 1967, pp. 9–16; Rosalind F. Krauss,
 'Photography's discursive spaces', in the author's *The Originality of the Avant-garde and
 other Modernist Myths* (Cambridge, Massachusetts, MIT Press), 1986, pp. 131–50; W. J. T.
 Mitchell, *Iconology. Image, Text, Ideology* (Chicago, University of Chicago Press), 1986,
 pp. 59–61.

35 Roland Barthes, *The Eiffel Tower and other Mythologies* (New York, Hill and Wang), 1979,
 p. 71.

36 *Ibid.*, p. 71.

37 Susan Sontag, *On Photography* (New York, Farrar Straus and Giroux), 1977, p. 109.

38 *Ibid.*, p. 17.

39 *Ibid.*, p. 19.

40 *Ibid.*, p. 19.

41 *Ibid.*, p. 21.

42 *Ibid.*, pp. 23–4.

43 *Ibid.*, p. 20.

44 *Ibid.*, pp. 19–20.

45 *Ibid.*, p. 21.

46 *Ibid.*, p. 154.

47 *Ibid.*, p. 23.

48 Victor Burgin, *The End of Art Theory. Criticism and Postmodernity* (Basingstoke,
 Macmillan), 1986, p. 53.

49 Roger Hull, 'Emplacement, displacement, and the fate of photographs', in Daniel P. Younger
 (ed.), *Multiple Views. Logan Grant Essays on Photography 1983–89* (Albuquerque,
 University of New Mexico), 1991, pp. 169–92; Nigel Warburton, 'Photographic
 communication', *British Journal of Aesthetics*, 28:2 (spring 1988) 173–81.

50 John C. Hammock and Joel R. Charny, 'Emergency response as morality play: the media,
 the relief agencies, and the need for capacity building', in Robert I. Rotberg and Thomas G.
 Weiss (eds), *From Massacres to Genocide. The Media, Public Policy, and Humanitarian
 Crises* (Cambridge, Massachusetts, World Peace Foundation), 1996, pp. 115–35.

51 Andrew Ross, 'The ecology of images', *South Atlantic Quarterly*, 91:1 (winter 1992) 224.

52 Maggie O'Kane, 'Bloodless words, bloody war', *Guardian Weekend*, 16 December 1995.

53 David E. Morrison, *Television and the Gulf War* (London, John Libbey), 1992, p. 94.

54 F. W. Hodgson, *Modern Newspaper Practice* (Oxford, Focal Press), 1996, pp. 26–9.

55 Bob Bodman, 'Money talks …', *British Journal of Photography*, 7004 (14 December 1994)
 13.

56 Allan Sekula, 'The body and the archive', *October*, 39 (1986) 16.

57 Sontag, *On Photography*, p. 41.

58 *Ibid.*, p. 11.

59 *Ibid.*, pp. 11–12.

60 *Ibid.*, p. 110.
61 Jean Baudrillard, *America* (London, Verso), 1988, pp. 109–11.
62 Jean Baudrillard, *The Transparency of Evil* (London, Verso), 1993, p. 91.
63 John Keane, *Reflections on Violence* (London, Verso), 1996, p. 179.
64 *Ibid.*, p. 182.
65 *Ibid.*, p. 182.
66 Peter Braestrup, *Big Story. How the American Press and Television reported and interpreted the Crisis of Tet 1968 in Vietnam and Washington* (London, Yale University Press), 1978, p. 348.
67 Harold Evans, *Pictures on a Page. Photo-journalism, Graphics and Picture Editing* (London, Heinemann), 1978, n.p.
68 *Ibid.*, n.p.
69 Robert Hamilton, 'Image and context: the production and reproduction of the execution of a VC suspect by Eddie Adams', in Jeffrey Walsh and James Aulich (eds), *Vietnam Images. War and Representation* (Basingstoke, Macmillan), 1989, p. 182; see also Amy Schlegel, 'My Lai: "We lie, they die", or, A small history of an "atrocious" photograph', *Third Text*, 31 (1995) 47–66.
70 Hammock and Charny, 'Emergency response as morality play', p. 124.
71 Cited in Edward R. Girardet, 'Reporting humanitarianism: are the new electronic media making a difference?', in Rotberg and Weiss (eds), *From Massacres to Genocide*, p. 58.
72 Sontag, *On Photography*, p. 19.
73 *Ibid.*, p. 21.
74 *Ibid.*, p. 20.
75 Omer Bartov, *Murder in our Midst. The Holocaust, Industrial Killing, and Representation* (Oxford, Oxford University Press), 1996, p. 122.
76 Daniel Goldhagen, *Hitler's Willing Executioners. Ordinary Germans and the Holocaust* (London, Little Brown), 1996; Imre Karacs, '"Willing Executioners" revives German angst over Holocaust', *Independent on Sunday*, 11 August 1996.
77 Thorsten Schmitz, 'Killings again in the frame', *Guardian*, 26 February 1997.
78 Stephen Plaice, 'What did you do in the war, Vater?', *Guardian*, 1 March 1997.
79 Bartov, *Murder in our Midst*, p. 116.
80 Thomas Laqueur, 'The past's past', *London Review of Books*, 18:18 (1996) 7.
81 Sontag, *On Photography*, pp. 178–9.
82 *Ibid.*, pp. 22–3.
83 *Ibid.*, p. 174 and p. 179.
84 Liam Kennedy, *Susan Sontag. Mind as Passion* (Manchester, Manchester University Press), 1995, p. 93.
85 Keane, *Reflections on Violence*, p. 165.
86 *Ibid.*, p. 166.

3

Why look?

Fear and disgust are responses to images of horrifying events that arise before thought and understanding. Both repugnance and nausea are linked with depictions of pain, decay and death; both imply the possibility of being absorbed and fascinated as well as repelled by pictures of cruelty and savagery. The various responses to representations of death include squeamish or fastidious behaviour, respect, fear, glee or, even, a more intense thrill. Within the varying limits on representing death, people peep, peer or stare unashamedly, out of normal curiosity about mortality. Who is to say what is normal curiosity about death? Who is to determine when staring becomes morbid, and obsessive, or decide that staring at dead objects is more than curiosity and encourages a criminal act of defilement? What is the function of horror in everyday life?

A standard line on horror as a genre in literature and film holds that it allows consumers 'to confront, temporarily and vicariously, their most basic fears and/or unconscious desires'.[1] Horror is cathartic, or serves as cheap therapy. In the fictional modes of writing and filming, monstrosity can be reassuring because the aliens are destroyed, or alarming because they survive despite every effort to kill them.[2]

The grisly in still pictures is also pleasurable and troubling. Elisabeth Bronfen, in her book on death, femininity and the aesthetic, discusses the psychological use of frightening pictures. Bronfen places pleasure and pain together – though taking aesthetic pleasure in pain is elevated and not base, morbid or otherwise pathalogical. She asks, 'How can we delight at, be fascinated, morally educated, emotionally elevated and psychologically reassured in our sense of self by virtue of the depiction of a horrible event in the life of another, which we would not have inflicted on ourselves?' She replies that 'our' pleasure depends on 'their' pain. Such images are delightful because 'we are confronted with death, yet it is the death of the other'. Images of death allow viewers to experience death

by proxy. The aesthetic version of death enables onlookers to die with another and return to the living, a situation impossible in life. She writes, 'Even as we are forced to acknowledge the ubiquitous presence of death in life, our belief in our own immortality is confirmed. There is death, but it is not my own.'[3]

This hints at the excitement and exhilaration of survivors who survey images of corpses, a mixture of emotions arising from the recognition of death still held at a distance, and the continuing absorption in life. The distinction between those who remain alive and those who do not is absolute, but the living are unable to rid themselves of the dead. The desire for the representation of death expresses anxiety about it, and a desire for death as well. It is logically untenable to separate cleanly the 'high' category of life in the animate body from its 'low' opposite in the corpse, although this remains a persistent fantasy.

Bronfen suggests that the depiction of death expresses 'something that is so dangerous to the health of the psyche that it must be repressed and yet so strong in its desire for articulation that it can't be'. In a gesture of compromise the artist (or photographer) deals with the danger by representing death in 'the body of another person and at another site'.[4] The viewer understands that the corpse in the picture stands for something somewhere else, and so what is literally represented is not fully seen at all: 'it's only a picture'. This allows looking at representations of horror to be fascinating, which may lead to surprising, even unwelcome, insights.

The Hundred Pieces

Photographs, being no more than pictures, may temper the shame and excitement of taking pleasure in horror. For some the feelings of shame or pleasure may never diminish. As an example of the latter, I shall consider some photographs of a Chinese execution called the Hundred Pieces carried out in Peking in April 1905. Georges Bataille published this cache of images at the end of *The Tears of Eros*, a book on how death can be the source of intense erotic pleasure.[5] Kate Millett describes the photographs in *The Politics of Cruelty* (1994),[6] where she attacks Bataille for finding the photographs erotic. Like Millett, I too have decided not to reproduce the pictures, and so immediately declare my own voluntary submission to a code of self-censorship which journalists would recognise. At the same time, I shall describe the pictures at some length, which is another accepted journalistic practice when faced with material which is visually repulsive.

Bataille's caption to the series of photographs describes what is taking place, and why. The condemned man, Fou-Tchou-Li, had murdered Prince Ao-Han-Ouan. The Mongolian princes demanded that the convicted murderer should be burned alive, but the agents of the child emperor found that torture too cruel and condemned the accused 'to slow death by *Leng-Tch'e* (cutting into pieces)'.[7] The photographs depict a state execution carried out by officials who take Fou-Tchou-Li and dismember him in public and in a prescribed manner. Everything seems to be orderly. Regardless of that, the death is so cruel and all the actors are so intensely involved that, for Bataille, the images do in fact open on to an exciting disorder of the senses, a conjunction of grotesque murder and sexual delight.

Bataille reproduces four pictures of the execution. A young man who appears to be fully conscious (though Bataille says he has been drugged with opium to prolong the torture) hangs from two crossed poles held in position by a number of men. Others

crowd around, staring down at two executioners. One of them is sawing the man's left leg through the knee. The man has already lost both arms above the elbow, and has had the skin and flesh stripped from his breast, exposing his ribs. Another photograph shows his body at a later stage, when both legs have been severed. A third picture is an enlargement of the first, but shows only the witnesses, who crane their necks, stare and frown, with their mouths open or jaws set in concentration.

Obviously the photographer had more space than the other spectators. He stood in front of the victim, and had a clear view over the shoulders of the executioners. He placed all subsequent viewers in his own privileged position, standing just behind the executioners. It is difficult to know what purpose the photographs served when they were taken. According to Bataille, the photographs were published in part by Louis Carpeaux in *Pékin qui s'en va* in 1913 and by Georges Dumas in *Traité de psychologie* in 1923. One of the pictures was given to Bataille in 1925 by 'Dr. Borel, one of the first French psychoanalysts' and it played 'a decisive role' in [Bataille's] life: he 'never stopped being obsessed by this image of pain, at once ecstatic (?) and intolerable'.[8]

Millett objects to the idea of linking ecstasy with photographs of this scene; Jameson might complain that they encourage rapt fascination. Despite Jameson and Millett, these pictures from 1905 demand a proper 'regard' in the sense of a long look that may turn out to be thrilling. Judgements, or even clear thought, may be compromised and unobtainable from this 'stupefying evidence of *this is how it was*'.[9]

Bataille contemplated his photograph for forty-one years before he published it in 1961. His interest was not in identifying with any of the Chinese bodies – the one being tortured, those making the cuts, or those looking on. For Bataille the interest lay not in China in 1905 but in his own artistic project. He decided that the photographs of the torture were the '*inevitable conclusion to a history of eroticism*'. He was delighted with the photographs because in them 'contraries seem visibly conjoined', torture 'linked to the abyss of eroticism'.[10] He wrote that the photographs' uncomfortable realism, perhaps heightened by their grainy quality, was only the beginning of his aesthetic pleasure. The photographs affected him in a way he found exciting. He wrote that he was so 'stunned' by the 'unspeakable' photographs that he 'reached a point of ecstacy', proving to his own satisfaction the identity of 'perfect contraries – divine ecstasy and its opposite, extreme horror'.[11] Bataille's appeal to aesthetics and not to morality underscores the uncertain, mobile meaning of photographs.

Kate Millett rejects outright Bataille's conscription of sexual arousal to cruelty in the case of the Chinese torture (though, given the evidence to the contrary, perhaps she overstates her position in completely rejecting the role of pain in sexual pleasure).[12] Millett considers Bataille's arousal to be an affect of the man himself, but one which in a permissive time he could broadcast as a cultivated response to the images. She wants to restore the historical moment of the photographs, and to look at what they show, rather than be forced to see them through what she takes to be Bataille's mystifying eyes. Millett claims, strangely, that the 'slender Chinese figure' is 'not even a woman', so how then (she asks) can it be 'an erotic object'? 'Hacked and bleeding, screaming in unimaginable pain, how does one come to imagine such a thing as erotic?' Ultimately, she asserts, the torture turns the condemned man into a woman, or a child. Furthermore, the eroticism of his death for Bataille is tied to his being Chinese, or what she calls 'exotic'. Millett sees what she regards as Bataille's perverse interpretation of the photographs in terms of his masculinity, and in terms of deeply rooted obsessions among Western men with the

Orient as the place to perform and enjoy sadism.[13] Millett rejects these pleasures. 'The cruelty and horror remain in the image as in the fact, but now one must remove from the image the pretension that it is erotic, sexy, pleasurable, sophisticated, an elegant taste, a philosophical *aperçu*.'[14]

Millett admits that her own feelings about the photographs are confused, initially veering from shame and guilt to fascination and curiosity. In the end, the photographs convince her of 'the reality of what is taking place … literally as one might believe something could happen to oneself. Until one can reach that point, until conscious identification takes place, there is a certain inertia which separates the victim from those around him, a separation most advantageous to the state. If we cannot imagine torture, we cannot stop it'.[15] This is the nub of it for Millett, who not only imagines the torture but sees its reality in the believable evidence of the photographs. Reaching the point of identification, she cannot endure Bataille's aestheticism. She concludes that it is an outrage to use the photographs to confuse sexuality and cruelty, a confusion which aids and abets the oppression of women. The ecstacy, she asserts, is Bataille's alone.

Unlike Bataille, who took pleasure in the pictures, Millett looks at the faces of the crowd for evidence of his pleasure, but she sees in them no rejoicing, no bliss, no transcendence. Therefore, for her, Bataille's claims 'fall to the ground'. However, Millett has no suggestions as to how feelings of what she calls 'bliss' and so on might appear on the faces of spectators. Her reading of the photographs proceeds as if feelings, and quite complicated states of mind, can be read off the faces of people in photographs when faces alone, let alone photographs of faces, are notoriously difficult to read in such a direct fashion. Millett can no more read 'bliss' than she can find pain inscribed on the face of the dying man. All she can do, seeing his body already in pieces, is guess that he feels pain – though she cannot guess its extent or nature. Similarly, she cannot know what individuals in the crowd of onlookers were thinking or feeling, nor know from the evidence of the photograph that none in the crowd was taking sexual pleasure in the execution. Faced with Bataille's assertions, which she finds outrageous, Millett has written that something must be wrong with looking at such a scene and imagining it to be first and foremost a place of 'communication with higher forces'.[16] Given the low threshold of squeamishness over executions, her rage when confronted with the photographs is perhaps less surprising than Bataille's erotic delight. Given that the general tendency is to simply turn away from images like these, her identification and desire to act against oppression are unusual.

Millett interprets the photographs as if they were windows that open directly onto the scene, and she scrutinises them for evidence of what Bataille saw and felt. She finds no evidence of pleasure, and so rejects Bataille's point of view. She does not consider that Bataille must have taken pleasure in looking at the photographic reproduction of the event, not the event itself. Indeed, he always referred to the photograph and 'the straightforward image' that evoked 'the most anguishing of worlds accessible to us through images captured on film'. In other words, Bataille did not confuse the original scene with its image, which was what enabled him to be so 'stunned' that he reached 'the point of ecstasy'.[17]

Millett, in contrast, moves from the photographs to the scene as if they are the same, returning to the imagery as if it were reality itself. This confusion has a startling effect. She is shocked, but thinks the fault must lie with her. She is being sentimental or literal-minded, her judgement disarmed by what Sontag calls 'generalized pathos'.[18]

Millett feels personally ashamed – and gripped by what she calls the 'sentimentality, a kind of stupidity, [and] literal mindedness' decried by Sontag, for whom fascinating photographs stir weak emotions among people addicted to the pornography of the visual.[19] Millett concedes that she has weak, visceral reactions to photographs which should be the basis of political arguments. But she rejects the way Bataille joins together ecstasy and horror, which she considers is an example of male sadism set against female masochism, of his power against her powerlessness.

Millett does not argue that this event, recorded in photographs, may be one of Sontag's 'ethical reference points'. She is less concerned with the execution than with Bataille's arousal. Her anger concentrates upon Bataille's use of the dying Chinese man as a cypher for the oppression of her sex. The condemned man of the photograph, first hidden by Bataille and now, in a curious way, neglected in Millett's drift towards debates about men's oppression of women, remains invisible. In addition, the widespread scepticism about the relation of photography to reality, as expressed by Sontag and Barthes, suggests that interpretation must remain at the level of the print or reproduction and not pretend to move through it to understand what-has-been.

Perhaps it is impossible to make the man in the photograph visible in his historical being; perhaps he is trapped by the opaque quality of photography as much as his experience is redescribed by Bataille. Even so, photographs of the Chinese man's unmaking resonates for Western civilisations, though exactly how is unsettled. Bataille's photographs have travelled across cultures and have currency today as part of the author's work. They continue to function according to his wishes, on the borders of death and ecstasy. Outside Bataille, the photographs remain in the rarefied world of art, recently forming 'the centerpiece' of the exhibition '(Dis)member' at a gallery in New York.[20] Millett feels that Bataille's delirium and reverie are a feeble response to what remains a shocking event. Such indifference to what is actually in view seems unacceptable to her. Though she falters and fails to explain her anger at the pictures themselves, she prefigures the outrage that should be felt if photographs of the Holocaust carried captions which brought together death and eroticism, absolved the Nazis of blame, or allowed viewers to doubt or forget what the Nazis did. Her anger reveals that semiosis in photography, though inherent, does not mean that photographs can mean anything whatsoever. If that position is held, the price is moral relativism. In the end, Kate Millett knows it matters what type of history we fabricate using photographs. In other words, her admissions about the complex responses she has to this series of images does not prevent her from also marshalling a number of convincing arguments against Bataille's singular response. Like Bataille, she has been caught looking. As it was for him, so was it for her: she does not end in a reverie or trapped in mindless fascination.

Grisly photographs read in Bataille's chosen manner, in which the Hundred Pieces torture scarcely signifies in itself and is replaced by an aesthetic interpretation of images, allow fantasies and inner erotic life to weigh more heavily in the balance than the facts of the event as far as photographs depict them. Despite her opposition to Bataille, Millett concedes that her sense of reality is not separate from fantasy, and at some level the two are integrated. But, according to her own testimony, the obligation she feels looking at actuality imagery surpasses her own fascination and will not allow her to leave Bataille unchallenged. She is concerned both with the actual torture and with what she maintains is Bataille's fantasy, spun out of something that really happened. She suggests that what she considers to be Bataille's rapt fascination, which seems to block his historical

understanding, is an unacceptable confusion and warping of evidence, which may lead to grotesque transformations of actual events into fictions.

There is no simple or single solution to this problem of looking at these kinds of photographs. The likelihood exists that viewers either reject gruesome pictures or are frequently captivated by them. At the same time, the likelihood also exists that viewers may not wish to see photographs of such scenes on aesthetic grounds, or that they will look at them and think about what the pictures imply for civilisation; perhaps they will act on their convictions. Despite the problems of evidence, photographs may be used to reconstruct something of the historical nature of the episode and enable onlookers to identify with the subjects in view. However, the context is everything. If the setting for what-has-been is primarily aesthetic, or if newspapers deliberately set out to contain the representation of actual horrors for reasons of good taste, decency and squeamishness, then the capacity of photography to 'stun' for more than voyeuristic pleasure is compromised, as is the meaning of the historic record.

Bodies in focus

In the *Twentieth Century Book of the Dead* Gil Elliot writes that the vast number of murdered people is 'the central moral as well as material fact of our time [but] this will not be greatly meaningful unless we can bring the dead into existential focus'.[21] It is not clear who this 'we' may be who would want to focus on the dead or how it is to be done. The press does not exist in order to remember the dead, though recalling their existence and even showing them often constitutes news. It is not at all clear or certain that 'we' journalists or newspaper readers will focus on the dead, and think about what they mean for very long or even at all. The one-time existence of the millions of man-made dead is difficult to fathom. Where are they? The existence of the means of producing these numbers of dead are hard to visualise. Where is the evidence?

The question of evidence and its authenticity depends on the news coming from the body of the journalist-as-witness, and pertaining closely to the body of the person in the story. It achieves authority through the central practices of documentary or actuality reporting, namely their dependence on eye witness and testimony, their reliance on sources and depositions, as also their ability to refute false allegations and denials. At the same time, authentic news is not the same as the real thing. For newspapers to claim authenticity they must come closer than fictional texts to persuading their readers of the presence of the body. Newspapers attempt to convince their readers by offering direct but approximate evidence of the body's sometime physical presence in text and photographs. A basic requirement of all verbal and visual journalism is that readers should endorse its truth-value, which raises the well-known question of authenticity and the capacity of words and images to provide it. Accepting photojournalism as evidence is a matter of convention as well as faith, because even the realism of photography does not provide existential focus: it is a trace of some other time and place, though 'it is not irrefutable evidence'.[22]

The guarantee of authenticity does not rest in photographs themselves but is lent by viewers who accept the claims made by texts that they are proof of what-has-been. Readers infer from the familiar techniques used in texts that photographs authenticate actual, historical moments and do not represent invented scenes.[23] The belief in the truth-value of photography can be very potent, and may lead to unexpected results. For

example, in May 1992 a policeman in Brcko, a small town in northern Bosnia, executed a Moslem man in the street, standing behind him and shooting him in the head. A Serbian photographer from Belgrade, Bojan Stojanovic, took a photograph of this summary killing which was used all over the world. Stojanovic's picture was among the first to show Serbian ethnic cleansing – and its authenticity nearly cost him his life. The photographer was hounded by the Serb authorities, bombed, shot at, threatened, jailed on a trumped-up charge and almost murdered in prison. On his release in January 1993 he fled to Bulgaria. In February that year he heard that his photograph had won first prize in the 'spot news' category of the World Press Photo Awards – a competition for photojournalists, press agencies, newspapers and magazines organised every year since 1955 by the World Press Photo Foundation based in Holland.[24] Accordingly, Stojanovic travelled to Amsterdam for the prize-giving. Once there, he was abducted by two armed Serbo-Croats, and escaped only by jumping from a moving car into a canal.[25]

This story is an example of how documentary photography may be understood to relate to actual, historical events instead of make-believe. Photographs are likenesses, but they do at least refer to an actual persons. Whereas any fictional character may be played by various actors, and no one performance is essentially superior to another, an historical being is always essentially different from its likeness, or description. This separation of the actual from the world of pretence is only the beginning of an attempt to establish exactly what photography authenticates. Dead people in pictures may be actual, but the credos and politics surrounding the photographs may confirm onlookers in any number of viewpoints, including the idea that these deaths are unfortunate, inevitable or even desirable.

Separating fact from fiction

According to Stephen Greenblatt, one of the achievements of poststructuralism has been to challenge the stable difference between the fictive and the actual. But, as he writes, it matters whether a text is fictional or not. It matters, for example, that Thomas Nashe's description of the cruel torture and execution in Rome of the Jew Zadoch in his novel *The Unfortunate Traveller* (1594) is fiction. This is marked in a variety of ways – notably that the eye witness is one of Nashe's characters in the novel and not the author himself.[26] In contrast, Greenblatt understands Edward Scott's account of an equally macabre execution as a factual 'history' because the man who directed it in 1606 published his account seven years later in his *Exact Discourse of the Subtilties, Fashions, Policies, Religion, and Ceremonies of the East Indians*. Scott was the principal agent of the East India Company in Java. Suspecting a Chinese goldsmith of trying to rob the company, he had him tortured to death. The difference between fictional and factual accounts 'fundamentally alters our mode of reading the texts and changes our ethical position toward them'.[27]

Of course, both accounts are deliberate acts of writing, or inscription. Both mediate reality, and neither is the same as imagination, experience or direct observation. Nashe did not need to see for himself a man roasted alive to be able to describe the scene painstakingly, making readers believe that his fictional character was a reliable witness. Writing about the world is different from the world itself, though that is not Greenblatt's point. He is commenting not on Nashe's and Scott's veracity as eye witnesses but on the obligations that writing places on historians. Literature and history make different moral

claims of readers. Both turn bodily agony into inscriptions to be read at leisure. However, Greenblatt argues that factual accounts place a greater moral burden on readers than fictive descriptions, no matter how graphic they are. Scott's work, if read as clo s Nashe's, is disgusting in itself, but it also invites judgements about the ethics of Sco the East India Company. Moreover, those judgements are not confined to the immediate text and its historical moment in early seventeenth-century England, but extend to those who know and use the facts in question. Scott's account has been borrowed and reworked by historians, who have made morally deficient use of it, gliding over the cruel history of capitalism and imperialism which the historian thinks should be 'the history that it most behooves us to tell when we read those terrible sentences'.[28]

Why read the sentences at all? Greenblatt hints that 'we [might] be better off quietly forgetting about them', since reading them is to be implicated in something 'vulgar or lurid'. Yet the author considers it a duty to read such texts, whether we gloat or shudder over them, because to turn the eyes away is to confront nothing and effectively to collaborate with Scott and with all the others like him. By comparing fact and fiction Greenblatt demonstrates that, despite the blurring of boundaries between them, it matters morally and ethically which we are confronting. 'Our belief in language's capacity for reference is part of our contract with the world; the contract may be playfully suspended or broken altogether, but no abrogation is without consequences, and there are circumstances where the abrogation is unacceptable. The existence or absence of a real world, real body, real pain, makes a difference'.[29]

This insistence is significant coming from a 'New Historicist', someone who is not hunting for indisputable, empirical 'facts' but who nevertheless recognises that historians have to deal with reference as a necessary function of language and other forms of representation. They have to confront evidence that is both substantial and verifiable, and are bound to ask, 'How reliable is this evidence? Are there convincing grounds for denying or doubting the documented events? And if there are not such grounds, how may we interpret the motives of those who seek to cast doubt on the historical record?'[30]

The historical record and the status of any type of evidence are always open to question; the relationship between representation and the world is indeterminate. Despite the shifting ground, there are arguments for reference, including an ethics and politics of history. This has implications for shocking photography. Greenblatt's remark that 'Our belief in language's capacity for reference is part of our contract with the world' might be rewritten to refer to photography, since its indexical relation to what-has-been in the world remains part of our understanding of the medium. Though the relation of photography to reality is problematic, along with all representations, the use of photography is nonetheless intimately linked with this ethics and politics of history. The question remains 'Is there a contract between photography and the world, and, if so, what happens when it is broken?'

'Natural' horror?

Literal and metaphorical wounds remain open for ever in photography, but there is no way of ensuring that all viewers will be moved or disgusted by seeing them, or will even recognise them at all as hideous. The history of horror has a public face, and is found everywhere in popular imagery, stories, literature and the arts. Nonetheless, horror is difficult to fathom at the level of individual consciousness, and it proves difficult to

decide exactly how it looks, or why it has proved so enduring and desirable.

In his book on the philosophy of horror Noël Carroll sets out to find a comprehensive, transhistorical account of its appeal. He tries to separate what he calls 'art-horror' from 'natural' horror, or fact from fiction.[31] He defines 'art-horror' as a 'cross-art, cross-media genre whose existence is already recognized in ordinary language', and he separates it from the horror attached to actual events in the real world, including ecological disaster, the threat of nuclear arms or the effects of political ideology. Presumably, Carroll would describe Bataille's *The Tears of Eros* as 'art-horror' and concur with the latter's sublimation of these photographs to his project, which is the only way he renders them visible. Art-horror, Carroll insists, 'is different from the sort that one expresses in saying … "What the Nazis did was horrible,"' which he understands to be 'natural horror'.[32]

Carroll describes how the pleasures of 'art-horror' induce reflex signs of fear like 'shuddering, recoiling, tingling, frozenness, momentary arrests, chilling (hence "spine-chilling"), paralysis, trembling, nausea, a reflex of apprehension or physically heightened alertness (a danger response), perhaps involuntary screaming, and so on'.[33] These bodily reactions are natural, but each of them has meaning within culture and each has different significance in particular situations. Screaming in fright on a roller-coaster ride at a funfair is not the same as screaming in fright moments before a collision on a motorway.

While I accept Carroll's description of the visceral effects of 'art-horror', I cannot sustain his distinction between 'art-horror' and 'natural horror'. I am suggesting not that they are interchangeable, or the same, but that 'natural horror' does not exist. Some events (like floods or earthquakes) can be natural, but responses to them are cultural, and include awe at the ungovernable forces of nature and amazement at their scientific management. Horror is meaningful only because it is historical and cultural. What the Nazis did to the Jews, the gypsies and the mentally ill was not 'natural horror', as Carroll claims, but a managed and organised politics of terror and extermination. Carroll seems to be continuing the task (begun by eighteenth-century philosophers) of distinguishing relatively distant and aesthetic forms of horror in art from the disgusting, murderous experience of harm inflicted on the body by elemental forces, the passage of time, or politics which begs for an historical account.

There is nothing about a text taken in isolation which infallibly distinguishes it as either documentary or fiction.[34] Every aspect of documentary can be simulated in fiction – the look, the evidence and the argument. What distinguishes documentary from fiction is the way that viewers read the texts, what assumptions they make about them, and what they expect from them. These distinctions are notably sharp in relation to photography, which always presents the fragile mortality of those in view. For Barthes, if a photograph speaks of horror, it is because 'it certifies that the corpse is alive, *as corpse*: it is the living image of a dead thing'.[35] Consider what this means for documentary photographs of the Holocaust, which remain on show some fifty years or more after the liberation of the death camps in 1945. The photographs are not windows onto the real thing; what photographs represent is not fully revealed to vision or understanding. What do they signify? Would anyone be justified in moving the death camp photographs from their status as traces of 'what the Nazis did' as a matter of fact into a more shadowy realm, where 'what the Nazis did' is uncertain, unverified, unknown? The photographs of corpses are disgusting, bespeaking an evil crime, but one which must be constantly reiterated for fear that it will become detached from history

and from recognised, attributed responsibility.

Photographs are always seen in one setting or another, and its particular form is what enables them to be understood. Photographs of Holocaust crimes are endangered as well as supported by their surroundings. Contexts and inscriptions are no guarantee of authenticity. When Benjamin asked, 'Will not the caption become the most important part of the photograph?' he recognised that there is no special reason why the caption should name the true place or date of the image, let alone describe the situation accurately.[36] False descriptions of content, or false captions given to photographs, may generate false rumours about who were the perpetrators and who were their victims. The instability of photographic meaning does not alter the reality of past events, but it may conceal crimes. Benjamin felt that witnesses, and authorities writing captions or creating settings in which pictures would achieve meaning, had moral obligations which should compel them to honour the contract between language, photography and the world. 'Is it not the task of the photographer ... to reveal guilt and to point out the guilty in his pictures?'[37]

Photography and inscription mark the persistence of historical memory, and it is this which is constantly fashioned, and therefore open to perpetual warping and twisting away from its primary impulses and uses. The constant threat that whatever passes for history will alter in outline and in detail threatens to upset any attempt to hold on to an original history, or to be certain of the accuracy or endurance of memory. It is easy to break the contract which exists between language, photography and the world, with unacceptable or dangerous consequences. The dominant views of Holocaust crimes may be threatened if photographs are altered in the darkroom or in the computer, or if captions changed to read 'What the Nazis did was efficient, necessary, good' or 'What the Nazis did was comic.'

Photographs of the Holocaust – its buildings, managers, subalterns, civilians, corpses – are not in themselves the worst things in the world, but only because they are images to be looked at from a safe distance. Those photographs are still indices of what happened, and to meddle with the central status of the photographs as witnesses indicates the potential horrors of revision, or what follows when language, photography and events in the world are disconnected, left broken or put together and mobilised in new formations, new histories. In extreme, but nonetheless quite common, cases the absence of photographs may be regarded as absence of proof – as in Pol Pot's massacres in Cambodia, Saddam Hussein's suppression of Kurds and Shias in Iraq after their uprising of 1991, and the Turks' continuing attacks on Kurdish separatists in south-eastern Turkey and northern Iraq. Certainly the absence of photographs is one factor that limits news coverage, and consequently shapes the public record.

Photographs do not stand apart from historical interpretation but are themselves the material stuff which is given in evidence: a caption under photographs of the Holocaust describing the event as 'efficient and good' can be imagined, and it could have currency among neo-fascists and those who deny the Holocaust.[38] The current vigilance against Holocaust revisionism and fascism shows that the struggle for the meaning of a war is never complete. There is nothing inherent in photographs as indices of what-has-been that determines their meaning, and nothing in documentary as a mode which prevents it from becoming part of the cultural fantasies of victors. Photographs of the bombing of Hiroshima and Nagasaki are never stabilised (in mainstream Western publications) as evidence of Allied war crimes. The reality of death camps, atom bombs or massacres is

separate from the instability of photographic meaning, but photographs, capitalising on their indeterminacy, can be used to mislead distant onlookers about what really happened back then and out there.

Looking on

Deciding what to look at and for how long is a matter of judgement, but somehow it is hard to resist looking at events unfolding in front of your very eyes. Drivers slow down and 'rubberneck' as they pass by collisions on the roads. They are intent on catching a glimpse of the scene and satisfying their curiosity without incurring the shame of excessive staring. The look at horrible scenes tends to be not innocent gazing but shameful staring. It is more polite to turn away. Peering, gawping and lingering too long at a scene or over a sight are improper behaviour, and those who go out of their way to visit crashes are reviled in the popular press as 'ghouls'.

The intense media interest in the case of the mass murderers Frederick and Rosemary West meant that No. 25 Cromwell Street where many of the victims' bodies were buried, and where many of the killings may have taken place, was becoming a site for tourists. Local criminals were offering journalists tours of the house by night for £500. Gloucester city council decided to demolish the 'House of Horror' and grind its bricks, rubble and masonry to dust, burn the timbers, throw the few remaining fittings into a furnace and lay a concrete cap on top of the site so that there could be no improper souvenirs.[39] According to the *Guardian*'s crime correspondent, Duncan Campbell, 'We have an ambivalent attitude towards the scenes of atrocities.'[40] He noted that Nazi concentration camps and battlefields are preserved, and places where tortures and executions took place in London are now on sight-seeing tours. He asked, 'Are there some horrors which should be recalled as a tribute to the victims and a warning to resist their attackers, while other atrocities should be landscaped from our memory? ... Is a crime reporter, a detective, a lawyer merely doing their job when they explore the dark side of life, while a member of the public seeking the same access is a sick ghoul?' Campbell admits to feeling curious about the perpetrators of crime, and defends others who indulge this type of widespread curiosity against the 'peepshows and spying and bugging of [Princess Diana, the Duchess of York and media celebrities] who have never done us any harm'.

Curiosity, though, is not so easily contained. It is excited by the morbid, the perverse, the secret and the forbidden in the cases of both privileged lives and extraordinary violence.[41] The market for images of 'famous' people and catastrophe is regulated by the industry itself. Editors decide what to publish, assessing their readers' taste for voyeuristic imagery, and they justify their more controversial decisions as in the 'public interest'.

Until the death of Diana, Princess of Wales, in a car crash in Paris (31 August 1997), editors (especially of tabloid papers) judged that photographs of an intimate nature taken without permission were of public interest. Some unauthorised images may have been prying, but since they were not repulsive editors guessed readers would buy them. But when famous people die violently, editors have to measure the 'interest' in celebrity and death against the public's reverence for the lost 'star'. Following the death of the princess, French agencies began to offer newsdesks across the world pictures taken by the *paparazzi* who had pursued the car. There were no takers in the British press. Editors may have encouraged prurience, but to have published photographs of the dying princess

would have gone so far beyond the usual limits of representing dead celebrities that it might have wrecked the system of self-regulation and ushered in new privacy laws. (Within a week of the crash, and already in discussion with the Press Complaints Commission, which oversees self-regulation, many editors who had used unauthorised photographs rushed to declare that they would respect the privacy of Diana's sons.)

The *paparazzi* taking pictures in the underpass claimed they were doing their job as photojournalists, simply recording events. The *paparazzi* were not expecting a crash, of course, but they seemed culpable because they had initiated the chase. Moreover some of them, allegedly, took gruesome photographs. Their actions, and the obsession with looking, were presented as deeply offensive, if not actually criminal.

Aware of the dangers of spectating, authorities discourage that type of behaviour at the 'scene' of an accident. Any such scene quickly comes under the control of rescuers, investigators and those entrusted with removing the bodies and the debris of disasters. The police tend to keep onlookers at a distance, and use screens to ward them off, since unrestricted viewing might encourage them to interfere, which is distasteful in individuals and dangerous in crowds. But even officials may break the trust invested in them by looting or taking souvenirs – then they are prosecuted as thieves and blamed for what they did, not for what they saw. After all, looking on and even spectating *en masse* in the open is not illegal. It is only when the work of looking becomes staring for enjoyment – or involves photography – that it invokes voyeurism, that despised form of looking, for too long and for dubious pleasure.

Apart from sexual or morbid perversity, another reason why staring and gawping are abhorred, and why there are many attempts to regulate or at least guide the act of looking, is that meeting eyes opens the possibility of obligation. The 'I–it' relation becomes 'I–thou', and identification may lead to complications. Depending on the situation, people are encouraged to avoid eye contact, to look away. Living among strangers or moving through crowds requires 'the art of mismeeting', or 'civil inattention' based on the avoidance of other people's eyes. As Zygmunt Bauman writes in *Postmodern Ethics*, 'The point is to see while pretending that one is not looking. To look "inoffensively", provoking no response, neither inviting nor justifying reciprocation; to attend, while demonstrating disattention. What is required is scrutiny disguised as indifference. A reassuring gaze, informing that nothing will follow the perfunctory glance and no mutual rights or duties are presumed.'[42] The art of mismeeting, or achieving anonymity in crowds, is such a common experience that strangers in urban or metropolitan societies are more often easy to 'read' than unintelligible, even if all that is understood is their inattention, their studied lack of focus, their desire to be left alone. The cloak of anonymity may ward off unsolicited attention but it does not preclude individuals' observations of strangers, nor prevent strangers from observing those around them. The art of mismeeting is a way of ordering anonymity, though it does not secure it: observing others continues more or less intensively, but without obligation. Crowds gather at accidents or murder sites, and some people linger, perhaps, in the hope of catching sight of something more than they have already seen. But crowds also disperse of their own accord, and passers-by often look the other way deliberately, probably less from the fear of obligation than to protect themselves from sudden shock or the possibility of nightmares.

If the decent thing in real life is to look away, this act is not altogether forgotten in viewing pictures. Admittedly, there is more leeway in looking at pictures, since the sense

of obligation and even the possibility of action is weakened by distance in time and place. Moreover, the objects under review are small, flat and merely printed. These meagre, creased or grainy images invite prolonged investigation, if viewers wish to indulge in it, and they also absolve viewers of blame or invite them to accept responsibility.

Though some viewers may be more likely to gawp at pictures than at real events, the cultural norm in Britain is nevertheless to desist from staring, or from any type of prolonged looking at dreadful acts. It is dubious or even dangerous to crane the neck to glimpse some hideous event. For viewers to seek forbidden or explicit pictures of a morbid nature, or for galleries and publishers to promote them, is met with the suspicion that they are indulging in unseemly, shameful acts. To take sexual delight in the representation of acts of cruelty, sadism and murder in the manner of Bataille is less common but even more suspect. The decent thing is to look away, because it is the art of mismeeting that governs behaviour when horror threatens to *'fill the sight by force'*.[43] This is common knowledge, and it helps to explain why photographs of dreadful sights are modified in public places, in publications, newspapers, magazines and in broadcasting.

Notes

1 Kelly Hurley, 'Reading like an alien: posthuman identity in Ridley Scott's *Alien* and David Cronenberg's *Rabid*', in Judith Halberstam and Ira Livingston (eds), *Posthuman Bodies* (Bloomington and Indianapolis, Indiana University Press), 1995, p. 205.

2 See Gregory A. Waller (ed.), *American Horrors. Essays on the Modern American Horror Film* (Urbana and Chicago, University of Illinois Press), 1987; Carol J. Clover, *Men, Women and Chainsaws. Gender in the Modern Horror Film* (London, British Film Institute), 1992; Barbara Creed, *The Monstrous-Feminine. Film, Feminism, Psychoanalysis* (London, Routledge), 1993; Jonathan Lake Crane, *Terror and Everyday Life. Singular Moments in the History of the Horror Film* (London, Sage), 1994.

3 Elisabeth Bronfen, *Over her Dead Body. Death, Femininity and the Aesthetic* (Manchester, Manchester University Press), 1992, p. x.

4 *Ibid.*, p. x.

5 Georges Bataille, *Les Larmes d'Éros* (Paris, Société des Editions Jean-Jacques Pauvert), 1961, pp. 232–5; Georges Bataille, *The Tears of Eros* (San Francisco, City Lights Books), 1992, pp. 204–7.

6 Kate Millett, *The Politics of Cruelty. An Essay on the Literature of Political Imprisonment* (London, Viking), 1994.

7 Bataille, *The Tears of Eros*, p. 204.

8 *Ibid.*, pp. 205–6.

9 Roland Barthes, *Image/Music/Text* (New York, Hill and Wang), 1977, p. 44.

10 Bataille, *The Tears of Eros*, p. 207.(Throughout, italics in quotations derive from the original.)

11 *Ibid.*, p. 207.

12 John Gange and Stephen Johnstone, ' "Believe me, everybody has something pierced in California": an interview with Nayland Blake', in 'Perversity', *New Formations*, 19 (1993) 51–68.

13 See Anne McClintock, *Imperial Leather. Race, Gender and Sexuality in the Colonial Contest* (London, Routledge), 1995.

14 Millett, *The Politics of Cruelty*, p. 167.

15 *Ibid.*, p. 164.

16 *Ibid.*, p. 167.

17 Bataille, *The Tears of Eros*, pp. 205–6.

18 Susan Sontag, *On Photography* (New York, Farrar Straus and Giroux), 1977, p. 71.

19 Millett, *The Politics of Cruelty*, p. 159.

20 Simon Taylor, 'The phobic object: abjection in contemporary art', in *Abject Art. Repulsion and Desire in American Art* (New York, Whitney Museum of American Art), 1993, p. 82.

21 Gil Elliot, *Twentieth Century Book of the Dead* (London, Allen Lane, Penguin Press), 1972, p. 6.

22 Bill Nichols, *Representing Reality. Issues and Concepts in Documentary* (Bloomington and Indianapolis, Indiana University Press), 1991, p. 151.

23 Roland Barthes, *Camera Lucida. Reflections on Photography* (London, Jonathan Cape), 1982, p. 89.

24 For an account of the World Photo Exhibition of 1997 and a defence of photojournalism, see Dennis Hackett, 'Shot from both sides', *Guardian*, 25 October 1997.

25 Hans Moleman, 'Killers focus on a photographer', *Guardian*, 26 April 1993.

26 George Saintsbury (ed.), *Shorter Novels. Elizabethan* (London, J. M. Dent and Sons), 1964, p. 347.

27 Stephen J. Greenblatt, *Learning to Curse. Essays in Early Modern Culture* (New York, Routledge Chapman and Hall), 1990, pp. 12–15.

28 *Ibid.*, p. 13.

29 *Ibid.*, pp. 13–15.

30 Stephen J. Greenblatt, 'Towards a poetics of culture', in H. A. Veeser (ed.), *The New Historicism* (London, Routledge), 1989, p. 4.

31 Noël Carroll, *The Philosophy of Horror, or, Paradoxes of the Heart* (London, Routledge), 1990, p. 194.

32 *Ibid.*, p. 12.

33 *Ibid.*, p. 24.

34 Nichols, *Representing Reality*, p. 24.

35 Barthes, *Camera Lucida*, p. 79.

36 Walter Benjamin, *One Way Street and other Writings* (London, Verso), 1985, p. 256.

37 *Ibid.*, p. 256.

38 Pierre Vidal-Naquet, *Assassins of Memory. Essays on the Denial of the Holocaust* (New York, Columbia University Press), 1992; Deborah Lipstadt, *Denying the Holocaust. The Growing Assault on Truth and Memory* (Harmonsdworth, Penguin Books), 1994.

39 Alex Bellos, 'The house of horror vanishes', *Guardian*, 8 October 1996.

40 Duncan Campbell, 'Ghouls' paradise', *Guardian*, 12 October 1996.

41 Linda Grant, 'Violent anxiety', *Guardian Weekend*, 28 September 1996.

42 Zygmunt Bauman, *Postmodern Ethics* (Oxford, Blackwell), 1993, pp. 154–5.

43 Barthes, *Camera Lucida*, p. 91.

4

Press, photography and evidence

News is a product crafted on a daily basis by the press. Despite the variety of titles in Britain, newspapers share many established industrial and bureaucratic practices. The industry is varied within itself, and competes for its own readerships. At the same time, the industry is under constant pressure from other media, to which it responds in ways that conform to what editors think readers will want or expect. Photography is useful in the industry because it lends some degree of authenticity to eye-witness accounts. Unfortunately, the status of evidence is always in dispute, and none more so than photographic evidence. This chapter looks at the ways in which a varied industry appeals to the common or shared knowledge of its readers, how photography is used to support certain types of belief about what is happening in the world, and how in the end photographic evidence is used to serve group identification rather than any notion of actual or objective truth.

News and identification

The contemporary British press has no special improving programme and no universal ethical stance. The industry as a whole is not engaged in any moral crusade, though individual titles may take up good causes. Throughout 1996 the *Independent* campaigned for victims of child abuse to be given a voice, organising a Christmas appeal for the National Society for the Prevention of Cruelty to Children.[1] More usually, some sectors of the broadsheet press may adopt what it takes to be the moral high ground in relation to political events, notably in its lengthy coverage of the Scott report into the long-running scandal over the way the government relaxed its guidelines on the sale of arms to Iraq at the end of 1988 after the cease-fire in the Iran–Iraq war but hid the fact

from Parliament (see *Guardian*, 16 February 1996), or the way the *Guardian* pursued the former Trade Minister Neil Hamilton, especially, in the parliamentary 'cash for questions' scandal. The *Guardian* later called Hamilton 'A liar and a cheat' in a famous front-page headline after his libel suit against the newspaper had collapsed (1 October 1996). Often a newspaper's enemies (including Hamilton) will go to great lengths to assume the moral high ground in support of their libel actions. They set out to prove the dishonesty of the press but ruin their own reputation when their case fails. Perhaps the most notorious recent example was the disgrace of Jonathan Aitken, the former Minister for Defence Procurement, whose attempt to sue the *Guardian* and Granada Television over their allegations of illegal trade with Saudi arms dealers ended dramatically when he was found to have lied to the court (see all press for 21 June 1997).

Morally uplifting campaigns for charities or sporadic but relentless attacks on parliamentary 'sleaze' are exceptions that prove the general rule: despite its success in exposing corruption, it is not clear that the press contributes very much towards social reform, increases historical sense, or creates responsibility in audiences. Since most news is about people more or less distant from viewers and readers, the moral ties are weak. Morality is conditioned by proximity, and is consequently a feeble force in a society in which all important action is action at a distance. Moral conscience is satisfied by taking responsibility for 'our' nearest and dearest. If what 'we' do or desist from doing has effects on distant places and people, either it remains invisible and thus unworrying, or 'we' believe it to have been taken care of by equally distant but caring agencies. It is not necessarily 'natural' to feel responsibility for events. Morality's pull lessens with distance because it has 'powerful, but short hands'.[2]

Newspapers appear to overcome distance by bringing far-away events into the home. This fact does not necessarily increase the feeling of being 'for' the suffering strangers; indeed, the opposite may be the case. Newspapers are part of the industries of distance. While it is true that the pictures and the stories of mass death place them in the spheres of controversy, it is also true that such reports may emphasise the physical or psychic gap between the act and its consequences. A long chain of dependences weakens the sense of cause and effect. The press's limited forays into issues that engage with social improvement, morality and responsibility mean that the influence and status of documentary photography have shrunk and not expanded. This is not because the historic call for documentary to represent 'truth' is simply outmoded or even eclipsed in an era that distrusts the older, supposed linkage between photography and certainty. The problem for documentary photography stems from its conditions of use in an overwhelmingly conservative press that exercises 'power without responsibility'.[3] The press has not simply co-opted documentary images for other purposes but, it has been argued, news-gathering bureaucracies have managed to 'limit, contain, and ultimately neutralize them'.[4]

It may be true that the contemporary use of documentary photographs in the press does not try to alter conventional systems so much as serve them. Despite that, the arguments developed in this book differ from the view that documentary has lost its ability to invite 'compassion and outrage' and now serves mainly exoticism, tourism, voyeurism and trophy-hunting.[5] What is striking about documentary photography in the press is not so much its negative conservatism as the other kinds of knowledge it produces.

Documentary may invoke compassion, voyeurism and so forth, though it shapes and

informs other considerable forces. Instead of using photography to reform society, the press uses it to illustrate stories which in turn support views on what it is appropriate to see. This does not mean that the press is merely narrow and reticent when dealing with horror, as if there were nothing more to be said. Much more is at stake. Andrew Ross contends that middle-brow culture (which could be said to underpin most if not all mass-media practices) '*is a process of identification, not an act of annexation*. It results in the formation of new audiences, new cultural identities, and new relations of respect and disrespect, not in the pervasive homogenizing of all realms of cultural production and consump. ' In other words, audiences are not simply swamped or embraced by news as a product of middle-class culture, but attach or detach themselves from the news wherever they themselves stand.

The shifting relationship between audience and news means that its managers must be alive to the ebb and flow of audiences' interests and concerns. News presented in a single, unchanging voice assumes a captive or annexed audience, and ends up by losing it. In practice, managers ensure that news is multivocal, and exhibits itself in continuously changing forms, simply to track and attract its multiple, various audiences. At the same time, news comes in a stream: it recurs daily in the different titles of the press, hourly on different radio stations, at dependable times throughout the day on ordinary television channels, and is promised continuously on the BBC's twenty-four-hour television news service.[7] News seems to be ever present and its constant reproduction denies it a historical beginning or end. This familiarity prevents news from capturing audiences or annexing them as if they were territories or islands with known and fixed boundaries. The fickle or moving condition of audiences is a factor in shaping the steady production of news: one encourages the variety of the other, though each must be able to identify the other as an appropriate audience receiving its recognisable news.

Variety does not mean invention. Journalists and editors endlessly reformulate or repackage the news in accordance with current fashions or pressures. However they do this, they always relate new knowledge to something already known. It is presentation to particular groups that encourages audience identification. News changes in its particulars but keeps the structures of stories able to survive cycles of eternal repetition.[8]

Newspapers and knowledge

The press's use of a narrow range of photographs is a condition of narratives built on expectation and ordinary assumptions that news exists as types of stories. After all, the industry can produce daily newspapers only by writing the tales for the new day over the remains of the old. However, the press does not exist in isolation: satellite transmission, cable and television have had a huge impact on the older industry, which has shown a remarkable ability to adapt and survive in the age of broadcasting. The evidence is that newspaper sales have fallen by about 20 per cent since 1981 but that advertisers have not abandoned the medium: the size of the average issue has increased by about 40 per cent, so that newspaper advertising income has grown in real terms.[9] Moreover, though 97 per cent of British households own a television set, national newspapers still reach 85 per cent of the British every week. Even so, the market for both daily and Sunday papers continues to slip away, despite hundreds of thousands of discounted copies, expensive promotion gimmicks, redesigns, changes of editors and claims of renewed investment.[10]

Adapting to a culture of both leisure and news dominated by television has meant a

resurgence of visual images and shorter reports. Even in the serious broadsheet papers, whose sales have risen by 15 per cent since 1982, there are fewer words to each report and the headlines and pictures are bigger: in the 1960s the usual length of a report in *The Times* was eight hundred words, whereas now four to five hundred words are the norm; in addition, the broadsheets produce tabloid sections, tabloid magazines and half-page news digests.[11] Television has affected the kinds of image that the newspapers print; because no staff photographers were present at a newsworthy event, or because images were first made available on cable networks, some pictures are now frame-grabbed from those networks despite their relatively poor quality. The immediacy and normality of television imagery have revived photojournalism. The press now reproduces more and bigger photographic images than ever before, with unrivalled clarity in printing and often in high-quality colour. In spite of the impact of television and important changes in the methods of gathering and printing pictures, still imagery fits into the papers' usual way of telling stories. Photography matches the tendency to read stories for the plot.

Newspapers are full of different types of writing, mixing together factual accounts, reports of conversations, opinion, guesswork, polemic and fabrications. They are also full of different types of picturing, including photographs, photomontages, collages, cartoons, sketches and diagrams. The use of pictures, the choice of words and the layout of the pages depend on past practice and on editors' perceptions of readers. Page layout and the choice of typeface are key signatures of each title, which help to make them instantly recognisable on the news-stands. The British industry is extremely rich in titles, with eleven national dailies in England and Wales and another four in Scotland; there are nine Sunday papers in England and three in Scotland. They run to several sections, magazines and inserts. As if that were not enough, there are numerous local evening and free papers.

Each daily paper has its own market, depending on age, income, education, work and political affiliation. Nevertheless, it is notoriously difficult to define readership, break into the market or hold market share. Several papers have folded in recent years, including *Today* (1986–95), the *Correspondent* (1989–90), the *News on Sunday* (1987) and the *Post* (1988).[12] The market is roughly divided into three groups, which tend to compete for readers internally instead of trying to move across boundaries and appeal to readers in other brackets. It is impossible to be categorical about readers' education, profession or social class, for instance, but some generalities are useful guides to the main body of a newspaper's readers. The 'up-market' or self-styled 'quality' broadsheets include the *Daily Telegraph*, *The Times*, the *Guardian*, and the *Independent*, and are aimed at older, professional men and women. Tabloids including *Today*, the *Daily Express* and the *Daily Mail* are aimed at the large 'middle market' in age and aspiration, and more at women than at men. Down-market tabloids such as the *Daily Star* and the *Sun* are aimed at young working-class men, while the *Daily Mirror* appeals to a wider age range, and to women. Since the latter newspaper was usually referred to simply as the *Mirror*, it decided to drop the word *Daily* from its masthead on 6 January 1997; more significantly, it redesigned its front page to take in more photographs and fewer words, aiming at the fifteen-to-thirty-four-year-olds who for some years had been switching away from papers and on to television, especially on to satellite television.[13] Readership numbers are skewed heavily towards the tabloid press: the *Sun* and *Mirror* alone account for about half the market, while the broadsheets make up only 16 per cent.[14]

Each national paper is distributed across the country but each appeals to different,

specialised and sometimes local audiences. There are great differences in voice and modes of address between the many titles. For instance, on the one hand the broadsheets devote pages to foreign and business news, reviews and commentary on all kinds of public issues and affairs. Because of their format, they are able to print a huge number of words as well as many large photographs. On the other hand, the tabloids are smaller in format, as their name implies, and that limits the length of their stories and the size of their pictures. Their stories tend to be short, limited in vocabulary, and full of bald, no-nonsense statements. They carry much less foreign news, and this is reflected in the numbers of staff foreign correspondents: in 1990–91 the up-market broadsheets employed a hundred and one; the mid-market tabloids employed six; the down-market tabloids employed none at all.[15]

Though tabloid stories are more likely to concentrate on trivial events than the broadsheets, especially if they concern film and television stars or other 'showbiz personalities', the whole industry is interested in gossip, scandals and sleaze. Since the late 1970s the broadsheets have so far replaced foreign news, parliamentary reporting and investigative journalism with trivial stories that 'corruption and misconduct' are less likely to see the light of day.[16] Anthony Sampson, a member of the Scott Trust, which owns the *Guardian*, claimed that stories in the broadsheets are now so trivial that 'the frontier between qualities and popular papers has virtually disappeared'.[17] He may be overstating the case, but favourite tabloid subjects such as media and sporting 'celebrities', scandals in the royal family and especially brutal or notorious murders commonly feature on the front pages of the broadsheets and are given even more coverage in their gossipy pull-out sections. Although it strikes a different tone of voice, the 'quality' press is closer now than ever to the tabloids in choosing to report the same stories in a titillating manner. As Sampson points out, some papers have simply learned the trick of making sensationalism look serious. The *Sunday Times* looks quite different from the *News of the World* but can be surprisingly similar in content, and both are owned by Rupert Murdoch.[18]

According to Sampson, the 'danger' of Murdoch owning the biggest-selling tabloids – the *Sun* and the *News of the World* – as well as *The Times* and *Sunday Times* 'is not so much personal power, as impersonal power': Murdoch has 'no serious policies to put forward for Britain, or any other nation'.[19] Readers should not lose sight of the fact that the press is owned by very few 'media moguls' or 'press barons', and the global network of news media consequently lacks responsibility for any particular country. The relatively small number of (sometimes foreign) proprietors matches the types of advertisers, who fill the press with 'features' on food, fashion, cars and similar products designed for consumption in modern, Western democracies. At the same time, despite their power, media owners and advertisers do not control in detail what newspapers print. The press has relative autonomy, and editors use photojournalism according to well established practices within their industry, not because media tycoons determine what must be shown, even though (like Rupert Murdoch in relation to the *Sunday Times*) they may sometimes demand 'no more starving Third World babies; more successful businessmen around their weekend barbecues'.[20] Such comments and interference may recur, but it is possible to study how the press achieves meaning within its professional practice and contributes towards public knowledge independent of ownership.

The culture of news assumes that there is a readership and that readers constitute a public. Each newspaper aims to reach its own audience, which may be roughly defined

in terms of age, gender and social class, but newspapers also present their views as common sense and so indulge in the fiction that their readers comprise a much wider 'general public'. The varied and ill-defined public knowledge in newspapers may be described as those principles and conventions that make up everyday reality. This assumption of common sense is not necessarily held in common by the whole of the community or even by most of it, nor is it necessarily sensible. It may derive its strength and authority from faith and belief in forces other than reason. The various newspaper titles that comprise the press use both words and pictures together to speak to their publics in recognisable 'voices'. Whatever its market position, a newspaper will adopt a tone of voice, vocabulary and sentence structure that declares its identification with average readers and which adopts a known (if sometimes impolite) form of public address. Even references to slang tend to be standard and widely understood instead of drawing on the 'street talk' of neighbourhoods or gangs that has not yet risen above the horizon of public acceptance. Speaking in a recognisable voice is both limiting and productive. Similarly, publishing photographs is organised around a sense of contemporary, widespread standards of what it is proper to see in newspapers. This practice of restraint is self-serving, but it also enables the papers to contend that they address the public.

My choice here of press photographs to illustrate stories of disasters (and reproduced out of context in this book) is used to support an argument and a critique of the newspaper industry alone and its contribution to knowledge. This decision means that the book passes over important archives, including forensic, medical and police records. In spite of these omissions, the press refers to representations of a hideous nature in so many ways that other visual forms are mentioned where necessary. Similarly, the ubiquity of disgust means that its presence in other media and their rules of display are not the focus of this study. The press's sense of propriety and shock may be measured against television practice and set against the relative excesses of the horror genre in fictional films. What is commonplace in videos and computer programmes or on the internet will not necessarily be appropriate for the press. In addition, newspaper horror comments on and exists alongside historical and contemporary examples of the nauseous and the abject body in art, literature and drama.[21] Indeed, the press draws on its readers' wider knowledge of these matters. The intertextual nature of horror – how it is represented and fostered in different forms and in various systems of narration – means that the press is but one part of an 'interweaving of voices' shared by readers and writers that cross the boundaries of one text to link it with others and with the wider culture.[22] The normal acceptance of horror as a fictional entertainment provides a visually excessive and viscerally explicit background to the much more restrained news coverage of actual grim events and real deaths.

The press tries to separate its stories from other systems of narration through, among other things, format, language and the use of photojournalism. Teams of reporters and editors 'hack' stories from the welter of events on a daily basis. They do not reinvent their methods every time the need arises but draw on an inventory of stereotypes and ways of telling stories established in the industry over time. The style of writing news reports sets out to be significantly unlike fully fictional accounts of catastrophe or tragedy. Similarly, the press's styles of reporting are unlike those used in describing autopsies that seek to describe the immediate cause of a person's death objectively, and signal the fact by using technical terms for body parts and biological change rather than everyday terms that

register disgust, pity or blame. At the same time, the press is similar to other narrating industries in that it reports real events according to methods that already exist within an enduring, professional and bureaucratic system. Unlike autopsies, perhaps, but similar to some kinds of novels or other kinds of fiction, its practice of telling stories 'serves as education, as a validation of culture, as wish fulfilment, and as a force for conformity'.[23]

Though factual and fictional terrors are both represented in the media, it does not mean that they have similar functions. Some of the effects of fear in both artifice and fact are to disturb, disgust and excite. Horror in its fictional mode may be entertainment, but taking pleasure in the horror of factual news has no special, recognised defence. Consequently the restraint in the photographic representation of grisly events in newspapers is determined not by the inherent decency of the papers but by the recognition that squeamishness is proper and ghoulish delight is not.

Permission to look

Questions of propriety exercise picture editors every day as they decide what photographs to publish of the various disasters, murders and wars that constitute the disgusting and disturbing elements of news. The proper conduct of the press in portraying bodily harm is an example of, or an advertisement for, the current interweaving of decorum and squeamishness.

The press's circumspection in reproducing dreadful images is tied to considerations other than good taste or newsworthiness: there is no right to look at any photographs, and looking is neither free nor uncontrolled. Even though professional cameras and agency files are the instruments of private, commercial businesses, what subjects may or may not be seen in documentary photographs is a public issue. Newspapers are for sale in the streets, and lie around in public places as well as in people's homes. Though all individuals will make personal decisions about what to look at, and what to avoid seeing, they will also find themselves coming across pictures unexpectedly in the public transmission of news. Consequently the uses of news photography engage public debates on decency, permissible looking and (in relation to horror) squeamishness. The first news photograph I shall discuss is nothing like as visceral or challenging as the nineteenth-century medical photographs in McGrath's article on 'Medical police' (see pp. 2–3).[24] In many ways it is mundane, but it is indicative of press concerns: gossip, sensation, obsession.

The photograph in question depicted two pickled eyeballs resting at the bottom of a jar. They were disembodied, of course, and sat disconcertingly close together, with their irises pointing in the same direction, 'looking' at the underside of the bottle top. A photograph of these eyeballs provided one ghoulish front-page image for the *Guardian* in 1994. The newspaper also printed different versions in a picture story in its 'Weekend' entertainment magazine. The eyes were newsworthy only because they had been Albert Einstein's, and because they had only recently been discovered.[25] Einstein's personal ophthalmologist Dr Henry Abrams used scissors and forceps to remove them during the post-mortem he and others had performed on Einstein in 1955. Abrams took the eyes secretly and without prior written permission, keeping them in a New Jersey bank vault for forty years. He decided to sell them then in what the newspaper called a 'bizarre auction' that was bound to 'anger' the 'scientific world, which venerates Einstein as one of its greatest figures'. Such indignation chooses to forget that Einstein himself was to

some extent party to the legendary and mythical attributes of his body: he bequeathed his brain to a hospital as a museum object.[26] Dr Abrams maintained that he had saved Einstein's eyes because 'they seem to have such depth' and retained something of what the scientist saw, or something that he knew or understood. Abrams said, 'When you look into his eyes, you're looking into the beauties and mysteries of the world.' He decided to save them because they were 'Godlike' and 'gave the impression that [Einstein] knew everything in the world'.

The interest shown by the doctor and the newspaper in Einstein's eyes indicates several themes that converge and recur in this book. Abrams displayed a confidence in human sight and in the clarity of vision that (though under constant attack from the nineteenth century) is fundamental to Western rational thought.[27] But saving the lights of this 'god' was not an innocent or even rational act: it was theft, and served no purpose in sustaining Einstein's reputation as a scientist. Abrams's action in cutting out the eyes and preserving them indicates two limitations on reason and sight as supreme faculties: the light of reason is easily occluded by other, mystical obsessions and beliefs; the possession of eyeballs, in itself, is not bound to result in clear vision and understanding.

Abrams's surgery raises a number of related issues. Usually, body parts preserved in jars are specimens for specialist study. This example is of no medical use, and was not intended by Abrams to be a sideshow curiosity; his action can be understood mainly as a superstitious and religious act, like preserving the bones of a saint. Once Abrams had made his jar public knowledge, its significance altered again: it became the ambivalent sign of mad science and an object of prurient curiosity. Photographed and published in the press, the dead eyes were then subjected to the prolonged look or the swift glance of the living, who might delight in them or shiver at the horror of eyes cut out of a head and stored in a vault.

Abrams's action was improper, to say the least; it was an unauthorised trespass against and violation of the dead man's body. What the *Guardian* did to Abrams and the eyes, by reporting them both as gossipy 'news' and representing the controversial act and its objects in several photographs, repeated the trespass in a different form. Some people might consider the images in themselves to be in bad taste. They might demand that photographs of eyes in jars, or similar distasteful objects, should be kept away from the public gaze. Others might hold that a strict prohibition on gruesome objects is impracticable and counterproductive in a liberal, democratic society. At the same time, since neither the freedom of speech nor the right to know or to see for oneself is absolute in Western democracies, they might agree to certain guidelines in publishing and broadcasting news that govern or suggest what degrees of trespass or violations of sight are permissible in creating a polite discourse about how to represent death.

The conditions and meanings of horror are as varied as the meanings of photographs, and equally subject to convention. Putting Einstein's eyes in a jar gives them several meanings, depending on where they are held and who views them. They are objects in the laboratory or a forensic museum; they are a modern reliquary; they are items in a freak show. Their photographs in the press, notably in the context of the *Guardian*'s front-page splash and 'Weekend' magazine picture story, put them in that category of curious, visceral or just freakish news. Some may view the photograph of Einstein's eyes with repugnance, while others may feel nothing more than faint disgust or mild curiosity. Grim photographs become something other than the gauge of individual sensibility. 'Bad taste' is a mode of understanding the world, and simply something to be curtailed by

censorship. Bad taste and horror have public significance.

Horror and bad taste share certain features: neither is formless or unreadable and both can also be aesthetically pleasing, refined and avant-garde. However, they are not identical. Bad taste is not necessarily a small offence, though it may be no more than an indiscretion in company, an impoliteness met with silence or a snub. Horror is less than genteel in its appearance and in the responses it provokes. It is usually centred on injury to the body that induces fear and terror in sufferers, and though the misery of sufferers must be given form before it can appear in print, the taste for it is never purely aesthetic. Even when it is tempered by decorum it may yet frighten, disgust or dispirit onlookers.

There is nothing new about propriety and decorum in public places. Both can be traced in modern times to the divisions between 'public' and 'private' spheres that emerged among the English middle class in the late eighteenth and early nineteenth centuries. Doctrines of manliness were separated from those of femininity; work was separated from home; the layout of the house separated genders and social classes; rules of gentility and good manners guided social occasions.[28] These rules may have been variously assimilated, attenuated or abandoned in contemporary times, but rules of good conduct still hold in both public and private spheres of life and they are different in each. Ideas about trespass and invasion of privacy have legislative force in public, for both property and bodily violation; being impolite in public may amount to being disorderly, and infringe the law. Most everyday conduct has no particular legal description, relying instead on social controls, inhibitions, peer pressure and so on.

Impolite looking is difficult to police or enforce by any means other than social disapproval. There are many types of look that are considered rude in public: uncontrolled gawping and staring are discouraged if the object of interest is embarrassed, frightened or dying. Staring in public at real things is tolerated only if the objects are intended to be a spectacle, like sport or art. Staring may be tolerated and invited in private, or in cinemas that offer the illusion of privacy. It is less polite to stare at real people than at their images. It would be improper to stand and stare at a stranger's corpse, but no social stigma attaches to gawping at its picture in the paper. People who buy newspapers do not, by that very act, reveal themselves to be especially morbid. After all, the picture is simply in the newspaper that readers have bought for one of any number of reasons, and they may flick past it without a second glance. Very morbid people are unlikely to use newspapers to satisfy their needs, since the press is so careful about what it puts on show.

Yet once people have bought newspapers they are free to stare at photographs for as long as they like. This unregulated ogling concerns guardians of public taste, including the editors of newspapers, who fear new legislation. But editors' decisions about front-page photographs are shaped by their need to expose their papers on news-stands and to catch the attention of uncommitted readers. Passers-by and browsers peer at eye-catching front pages, and that may encourage editors to publish disturbing or outrageous photographs. They are thus trying to increase their sales to large numbers of people and remain within the consensus on propriety rather than pandering to the freakish obsessions of a few readers.

The fact that films and photographs, once published, are open to unregulated gawping has an effect on the 'free speech' debate in democratic societies. Anxieties about looking are one reason why the British media regulate themselves in matters of good taste and tone, keeping horror under control through numerous small daily acts of

self-censorship aimed at generating and reproducing consensus. The media severely limit the range of gruesome material, which is selected and edited according to the consensus on picturing violence and death to lessen its appeal to the morbid eye.

Photojournalism, reality and ethical space

Truly photographic evidence – which excludes much but not all imagery originated by computer – has concrete and metonymic value in that it shares the order of reality to which it refers. All true (chemically produced) photographic images are made by allowing light reflected from objects to register on a film or other surface coated with photosensitive chemicals. It is a system that makes for a distinctive bond or one-to-one link between object and photograph, commanding attention for meticulous and impersonal representation of the reflective qualities of matter.[29] In 1934 the semiotician C. S. Peirce described a level of visual signification which is pertinent to the relation of chemical photography to reality: the 'indexical' level meant that images resembled objects because they were 'produced under such circumstances that they were physically forced to correspond point by point to nature'.[30] In 1977 Susan Sontag described the relationship as not only 'an interpretation of the real [but] also a trace, something directly stenciled off the real, like a footprint or a death mask'.[31]

Too much emphasis on the indexical nature of the photograph, or the way it registers 'light waves reflected by objects',[32] has had considerable bearing on the myth of photographic truth. The indexical nature of the photograph guarantees 'nothing at the level of meaning'.[33] That a photograph can stand as evidence rests not on a natural or existential fact but on a social, historical process. As John Tagg argues, 'what constitutes evidence has a history ... which implies definite techniques and procedures, concrete institutions, and specific social relations'.[34]

Yet this myth of photographic truth is particularly strong in describing 'documentary' or eye-witness photography, which is the main element of photojournalism. At one very basic level, all photographs are 'documents'. Any photographic image that has an indexical relation to whatever appeared before the lens at the moment of exposure is a 'document of *something*'.[35] But this position is so expansive that no photograph is any more 'documentary' than any other. The indexical bond by itself cannot distinguish, or allow viewers to distinguish, the historical status of the referents that appear in the image. Photographs do not exist as a coherent medium; by themselves they have no identity. They are meaningful only as what John Tagg calls 'currency': the value of images to stand as evidence or register a truth depends on the authority of those who deploy them and guarantee their authenticity. The history of photography 'has no unity. It is a flickering across a field of institutional spaces. It is this field we must study, not photography as such.'[36]

The term 'documentary' has a specific use tied to the possibility of social reform, but the prestige and influence of this idea have variously waxed and waned ever since the 1890s.[37] In its general and specific meanings, documentary photography is linked with discredited ideas about truth and objective records.[38] Although traditional photography (unlike virtual reality) is a 'trace of the real', it provides no guarantee of evidence, and the status of photographs is always being called into question.[39] Consequently, to imagine that 'documentary' photography is a discrete form of practice or a definable body of work is to run into a morass of confusion and ambiguity.

In tandem with its documentary role, photography may allude to subjects by association or metaphor. It can even represent events that never happened (like spiritual or ghost images) or apparently real moments that were staged and invented. Photographic realism is always under suspicion, and documentary truth is easily faked.[40] Consider the furore that accompanied sailor Jim Reynolds's 'confession' that he was the uniformed man kissing a young woman in Alfred Eisenstaedt's famous photograph of VJ Day celebrations in Times Square, New York, on 14 August 1945. Reynolds announced that the picture was not only meticulously posed but had been taken on VE Day – 8 May 1945.[41] Photography disappoints profoundly when there are signs that someone has interfered with the historical moment of image capture by posing or other dodges. In such cases the gap between the model and the copy becomes so great that photography loses altogether what it barely had – its authority as evidence of spontaneous, unbidden reality.

Eisenstaedt's use of photography to construct an appropriate fiction (and the use of language in a fully fictional mode to describe events that never took place) has always been part of newspaper practice. It includes the invented stories of early nineteenth-century newspapers as well as the photomontages, collages and stage-managed shots that appeared in the illustrated papers from the early 1890s onwards. But in twentieth-century practice the press's claim to truth depends on reference to actual events in the real world, even though the industry is not dedicated to facts, reference and reality alone.

Even so, photographs can be chosen and changed to fit the story. Like any system of representation, photography can deny circumstance and expurgate unpleasant reality. Its inherent accuracy and detail of rendering invite censorship, masking and alteration for the sake of decency. There is nothing new about 'retouching' photographs. It was standard practice to strengthen or sharpen the reproduction of black-and-white pictures on low-quality paper, and so it was used to enhance photographic realism and not subvert it by falsification.[42]

Despite these drawbacks and limitations, the press continues to trade on the documentary value of eye-witness photojournalism. The industry uses photographic evidence to counter attacks against the inaccuracy of reports, though the value of such proof is conventional. It is certainly not absolute or even very stable. It is no accident that Benjamin begins his essay 'A Small History of Photography' (1931) with an evocation of fog that surrounds the origins of photography and obscures vision and knowledge.[43] Despite the indexical link between the photograph and what it shows, Benjamin argues, the relation between photography and reality is, curiously, an absence of relation – or no necessary connection and explanation. Referring to Eugene Atget's photographs of deserted streets in Paris, which anticipate surrealist photography, Benjamin wrote that they set the scene for 'a salutary estrangement between man and his surroundings'.[44] There is, in fact, no dependable relation between a photograph and the real thing. There is certainly nothing in photography that makes it like a transparent glass through which viewers glimpse reality. The relation of photography and the real is a (sometimes fragile) convention, what Barthes called a 'reality effect'.[45]

The role of eye-witness photojournalism in depicting the horror of actual events has been under attack for many years. Surprisingly, the reality effect does not always produce more knowledge, and often produces less. According to Barthes the grisly photograph is the one 'about which there is nothing to say'.[46] Photographs of traumas such as 'fires, shipwrecks, catastrophes, violent deaths, all captured "from life as lived"', suspend language and block meaning. The direct trauma makes connotation more difficult.[47] The

greater the trauma in the photograph, the greater are the denotative characteristics of directness, contingency and silence. To determine *this was so* as a ' "flat" anthropological fact' easily defeats the projection of personal involvement or responsibility. According to Barthes, a universal silence must fall over all those confronted by photographs of catastrophe, and lethargy overtake everyone who looks at the *'exorbitant thing'* in photographs. Far from being the source of memories and contemplation, enabling grief to turn into mourning, photography 'excludes all purification, all *catharsis'*.[48] Photography, then, resists meaning. It has no dependable relationship with reality, and offers no explanation. Its flat facts give no guidance on what to think or how to act.

Looking at photographs of his mother, now dead, Barthes considered the denotative and connotative duality of the medium. The photographs were powerful evidence of something taking place in time. Yet the trauma of her death and the denotation of the photographs together meant they produced no meaning for him.[49] He wrote, 'The Photograph is violent: not because it shows violent things, but because on each occasion *it fills the sight by force*, and because in it nothing can be refused or transformed.'[50] Photography may be one of several ways of experiencing the world that leaves one speechless, or lost for words. But photographs of the 'exorbitant thing' are not bound to result in silence, nor is filling the sight by force with imagery of death and trauma sure to end in stupefaction. There is always something to say in response to traumatic photographs, and their denotative silence is always open to assimilation by connotation, signification and language. Indeed, imagery of this sort may create the conditions for understanding; the absence of such pictures for reasons of censorship or self-censorship may stop language and create silence and misunderstanding. I have already outlined some objections levelled against photography as evidence in previous chapters, especially in chapter 2, but even granting its perceived limitations I maintain that actuality photography in newspapers helps to provide readers with a sense of what is real. The shape of that reality stems less from photography than from a fundamental newspaper practice that formulates controversy in the guise of largely polite speech and its equivalent in graphic representation.

The absence of a consistent agenda in journalism does not mean that the press has no part to play in shaping morality. Even if the press has no clear-cut programme of reform, each newspaper title inflects the public record by observing decency in its reports and deferring to squeamishness. What photojournalism covers has implications for historical understanding. The role of photography exposes the way moral concerns and ethical codes exist in everyday public discourse in one of the ordinary industries of the day.[51]

Photographers, editors and readers are all caught in the act of looking, and every act carries various weights of complicity, obligation and shame. It would certainly be a mistake to imagine that photographers set the limits of what is seen because their work is chosen and altered by editors who in turn work within professional guidelines and a sense of their readers' expectations. Photographers are aware of what editors and audiences expect, though they suffer the peculiar pressures of the moment. They are sometimes placed under unusual strain in deciding to record someone else's death. Dying individuals draw photographers into their orbit; they stand together in a special, emotionally charged space, an ethical space. The intensity of obligation, indifference and shame varies greatly according to the degree of the photographer's (and subsequent

viewers') self-consciousness.

According to the film theorist Vivian Sobchack, documentary photographers can occupy any one of a number of ethical spaces when looking at death. Sobchack mostly uses the term 'gaze' to describe different forms of looking, though some of them are more deliberate than others. The form of looking which is least complicit, and therefore least ethically suspect, is the 'accidental gaze'. In that case it is the camera that attends to the death, not the photographer or spectator, as in Abraham Zapruder's footage of the Dallas motorcade which 'unwittingly' filmed the assassination of President Kennedy in 1963 – film that was eventually shown on national television in the United States in 1975.[52] Sobchack argues that viewing and reviewing this and other similar films, and stopping the frames at critical moments, increases audiences' focus and attention but never overcomes the accidental nature of the sight.[53]

Sobchack then describes another five gazes, each with an increasing burden of 'ethical space'. The 'helpless gaze' before death is either distant from the scene, or is legally prevented from intervening, as in the case of executions. This is the type of gaze that Sontag attacks because it 'makes it easy to feel that any event, once underway, and whatever its moral character, should be allowed to complete itself – so that something else can be brought into the world, the photograph'.[54] She argues that, while real people are out there killing themselves or other real people, photographers stay behind their cameras, creating the hermetic, distant and possibly everlasting image-world. Sobchack suggests that the 'helpless gaze' does not carry much responsibility, whereas Sontag holds that a photographer's lack of engagement is in itself a factor in reducing audiences to amoral 'image junkies' when faced with 'another person's pain and misfortune'.[55]

Sobchack's 'endangered gaze' is quite different: it is close to the scene of death, and this personal peril, so long as it is visibly encoded in the film through camera shake, or evidence of hiding from danger, absolves the film maker from the stigma of 'seeking out and gazing at the death of others'.[56] This gaze is sometimes difficult to justify, or sustain, in the flow and force of events and often fails. For instance (citing a report in the *Observer* of 20 June 1976), Sontag notes that Alf Khumalo, a photographer reporting on riots in Soweto, saw police shooting into a crowd of children and began to photograph a dying boy, until a girl attacked him with a brick, and he was lucky to escape alive.[57] The ambiguity of his position and the danger of recording what happens is well captured in this account, which underlines the professional dilemma and ethical ambivalence experienced by some photographers enveloped by violence and unable to maintain their distance.

The 'interventionist gaze' is the most unusual, and the most poignant, ethical representation of a visual encounter with death. Here, photographers confront the agents of death – and some die in the process.[58] Of course, to intervene puts an end to photographing, and there is nothing to say that intervention is automatically a superior ethical position, since participation may involve *helping* the agents of death.

The fifth form of looking is the 'humane stare', which is ideally an ethic of responsibility, but turned this time towards empathy and not intervention. It takes one of two forms. Viewers may be 'hypnotised' by horror when they look, for example, at the incident of General Loan shooting the Vietcong suspect in a Saigon street. The 'hypnotic' nature of this event for the photographer, and subsequently for those who look at the image, suggests 'that there is no tolerable point of view from which to gaze at such a death'.[59] Alternatively, the 'humane stare' may involve photographers working with

dying subjects who are open to the 'probity of the gaze' and collaborate with photographers recording their death. In that case the photographer's stare is ethically simplified, because it is directed by the dying subject, as in the examples of Jo Spence's and Terry Dennett's 'Metamorphosis', which is 'a pre- and post-death' collaborative portrait of Spence (1991–92),[60] and Krass Clement's 'About death', which recorded his mother's dying days and even her cremation.[61] Sobchack points out that these five forms of documentary vision are 'ethical in the face of death, an event which charges the act of looking at it with moral significance'.[62]

This second form of the 'humane stare' suggests the emotional position of the photographer in relation to the subject in view, which is irrelevant in that type of photojournalism where the photographer adopts the role of the uninvolved witness, which is Sobchack's sixth form of looking – the 'professional gaze'. Sobchack's analysis of documentary and ethical space finds that photographers have five forms of looking that are relatively free of prurience but, for her, the 'professional gaze' is mostly contaminated by it. Should journalists save a life or get the story? It is a stark choice, according to Sobchack, between ethical and unethical activities. More important, underlying all these distinctions about the ethical spaces occupied by journalists, her work points towards their institutional practice. Her analysis reveals that the ideology of objectivity and evidence found in all types of documentary journalism can exist only within a professional news apparatus. Documentary reports do not simply bear witness to the responsiveness of humans to the plight of others: above all, these reports serve the needs of press discourse, which includes meeting the expectations of audiences. The ethical space of photojournalism is not only shaped by the practice of photographers, but exists within and is constrained by the larger framework of what editors consider to be newsworthy, and what they imagine readers want to see.

Photography, money and authenticity

Publishing images of the deaths of others is deeply suspect. What could be the motives of such an industry? Are photographers who are in at the death, who may have stalked their prey like Peeping Toms with cameras, waylaying them only at the last and for the sake of a picture, voyeurs feeding a voyeuristic industry? Consider again Vivian Sobchack's sixth ethical space for documentary photographers, the 'professional gaze', when journalists may choose between saving a life or getting the story. Naturally, as the writer herself admits, both choices may be ethical: there is 'responsibility to the human moment' but there is also responsibility to 'the forging of historical consciousness'.[63] These responsibilities may be recognised only if the images are published and so enter the public sphere of controversy. Recognition is never pure or even always possible: the historical consciousness formed by photographs is intimately linked with considerations of money, use and authenticity.

For all that the 'accidental gaze' may be uncontrived and unintentional in capturing death and disasters on film, its products are not innocent or valueless. More likely than not, if the 'accidental gaze' captures events on film which are newsworthy the pictures have commercial value. They suit an industry which pays for signs. Photography, considered to be a universal currency, is an end in itself, like money. This can lead photographers to stand back from the scene and continue to shoot film (as if they were minting money). Given that this type of imagery often enters the news industry, the term

'accidental gaze' can be nothing more than special pleading on the part of the photographer. It usefully describes those who consider themselves to be 'helpless'. But the difference between 'accidental' and 'helpless' photography is not always clear-cut, or without ethical consequences, once the images are considered to be equivalent to money in the bank.

For instance, according to a report in *The Times* of 29 August 1994, tourists near Mont Saint-Michel in France videotaped a woman named Marie-Noelle Guillernée drowning. It was not their intention that she should die but, having filmed her death, they tried to sell their tapes to a television station. They were surprised to discover that their decision to go on filming and not save the woman meant they faced prosecution. The tourists seem to have been transfixed by the opportunity afforded them by their cameras to record the distant event. For these tourists, so it appears, the film of Marie-Noelle Guillernée was tied to its referential function but was also autonomous; it signified not so much a drowning woman as a value that resided elsewhere, possibly on television or in the newspapers and ultimately in their pockets.[64]

The tourists may have misjudged the law in this particular case but they were not behaving irrationally, or without precedent. The practice continues: in 1996 Marinda Gouws, on honeymoon in the Comoro Islands, took a video of the last moments of a hi-jacked jet as it crashed into the sea, killing one hundred and twenty five people. According to the *Mirror*, which reproduced four frames from the tape, she sold it to a television news network for £40,000 (28 November 1996).

The most infamous case of photographers in France possibly breaching the country's 'good Samaritan' law took place when, so it was said, *paparazzi* photographed Princess Diana rather than helping her as she lay dying (see all press for 31 August 1997 and after). The photographers insisted they were just doing their job. However, unlike much photojournalism, the hunt for intimate pictures of the princess and Dodi al-Fayed was always driven by a get-rich-quick ethos: the *Sunday Mirror* was reported to have paid £250,000 for the first rights in Britain to an image it called 'The kiss' (10 August 1997); but images of the 'The crash' were said to be for sale through the Parisian agency LS Presse Diffusion for £600,000 (*Observer*, 7 September 1997). Given the monetary value of these pictures, the world-wide interest in the crash and the potential for a journalistic scoop, it is not surprising that British sensibilities, at least, counted for nothing in this matter: the mainstream Italian media published images of what they called the 'Purported Accident Photo' on the internet, and an American group which collects and distributes disturbing photographs published a graphic image on its web site (*Guardian*, 19 September 1997). Though these images may have been fakes, their publication demonstrates the supposed eagerness for a sighting of the 'true' accident image. Local, national agreements about self-censorship, such as those between the British newspaper industry and the Press Complaints Commission (PCC), have no impact on foreign publishers or on the internet, which is subject to no effective restraints of copyright or libel. In fact, the most likely outcome of talks between Lord Wakeham of the PCC and British editors is to develop a voluntary agreement for newspapers to place what they now publish on the internet under PCC regulation, though this may serve only as a bulwark against foreign interventions into the British press. It will leave the internet and overseas publishers free to continue to mint money whereas the British hold back for reasons of taste, decency and squeamishness – and, of course, for fear of the potential threat of legal action.

The death of the princess and the monetary value of those crash photographs are extreme examples of what remains a daily problem for journalists when deciding how far they should go to obtain the photograph which authenticates the story. To regard video, photography and money together as equivalent, abstract representations is to echo the importance of the sound, solid and authentic which must be separated from the fake, alloyed or counterfeit. Sobchack's six ethical spaces for the photographer share the value of authorship but, more important, they allow professional photographers as eye-witnesses to claim that their representations are authentic.

Not every newsworthy death scene is hunted so ruthlessly, or surrounded by so much anger and dealt with so surreptitiously as the pictures of the dead princess. More often than not, photographers can claim some credit for being in at the kill. Perhaps one of the most famous examples of this type of 'accidental' or 'helpless' capture of the moment of death is Robert Capa's photograph of the 'Death of a Republican soldier' or 'Falling soldier', reputedly taken at the moment the subject was shot on 5 September 1936 in the Spanish Civil War. If the image of the 'Falling soldier' is authentic it enhances Capa's reputation as a knowing and reliable witness of actual events. If the image represents a constructed or faked moment the preparation destroys the basic truth of the event; it impairs Capa's reputation for witnessing; it falsifies the emotions which are stirred by authentic moments, substituting feelings reserved for fakes. Staging the *kind* of thing that happens in battles undermines the credibility of documentary photography 'as a source of indexical evidence about events'.[65] In other words, it does matter whether a photograph traces an actual scene choreographed by the photographer or is a trace of an actual event that happened before the photographer's eyes and without his or her interference. The photograph alone is unable to demonstrate which of the two possibilities actually took place.

The photograph of the 'Falling soldier' (also known as the 'Death of a Republican') was published initially (and undated) in *Vu* on 23 September 1936, then in *Paris-Soir*, *Life* and *Regards* the following year.[66] In this image the soldier is seen collapsing and losing his grip on his rifle.[67] A second image by Capa taken at the same place depicts a man falling, apparently shot, but still clutching his rifle. Uncertainty about the relation of these two images, and whether or not they depict the same man practising the 'moment of death', led Phillip Knightley to contest the authenticity of 'Death of a Republican soldier' in his book *The First Casualty*.[68] Most of the debate surrounding this contentious image concerns its authenticity, highlighting the importance of the actual over the fake. The ethical question is usually reduced to the difference between the photographer as independent witness or as calculating director: was Capa very lucky (in the manner of photojournalists who put themselves in the firing line) or did he stage the scene?

Since the photograph's fame rests partly on its veracity, it is worth examining what ethical concerns are raised by its claim to depict the 'moment of death'. Close observation of both photographs indicated that they depicted two different men, but that in itself did not disprove the veracity of the 'Death of a Republican'. Historians looked for evidence outside the image. Shortly before the sixtieth anniversary of the shooting, a Spanish local historian, Mario Brotons, named the dead man as Federico Borrell Garcia, killed that day and identified by a relative as the man in Capa's picture.[69] Even so, this is hardly conclusive proof of the authenticity of the photograph as the 'moment of death'. Broton's evidence simply reawakened Knightley's hostility. He reported that, according to Capa himself, the photograph was a random snapshot taken by raising the camera above his

head over the parapet of a trench and pressing the button when he heard gunfire.[70] From an ethical point of view it makes no difference whether Capa was standing on the same level as the soldier and deliberately pointing his camera at the man or whether he was sheltering in a trench and held the camera above his head. In either case, the photograph was taken in one of the least troubling ethical modes of the 'accidental' or 'helpless' gaze. Similarly, if Capa actually saw the soldier fall as he took the picture, that again is one of the least ethically troubling positions for the photographer, because he could do nothing to prevent or produce what unfolded before him. Taking this kind of snapshot does not create an ethical dilemma: that begins properly with the decision to publish the image, which means that the whole industry and its audiences are investing in its authenticity.

Capa himself died in 1954, at a time when no one doubted the truth of the picture, and the idea that it was faked has been denied by his brother, Cornell Capa. Knightley himself finds it difficult to believe that Capa took two lucky snaps in succession, and points out that the matter of faking or composing will be settled only when the photographer's agent, Magnum, releases the contact sheet to allow a study of the sequence of images.[71]

But as Caroline Brothers makes clear in *War and Photography*, the negatives of this picture and of others in the series have not survived.[72] More important, Brothers returned to the original publication of the 'Death' image in *Vu* in 1936, where the two images of falling men were first published. The editors captioned the photographs 'How they fell,' indicating that two different militiamen were killed on the same hill. However, in 1937 the editors of *Paris-Soir* captioned the two images as if they depicted one man falling, leaving no doubt that one and the same soldier figured in both of them.[73] After examining the photographs carefully and detailing how the men are dressed, Brothers concludes that the pictures were taken 'within moments of each other', yet since only one body is present in the second image the most likely explanation is that the 'Death' picture was 'staged at least twice, by different soldiers'.[74]

The photograph – if staged – is less interesting as a sign of Capa's witnessing but it remains an important document. The authenticity of the image rests in its representing a contemporary wish for warfare. It is an emblematic image: it suggests that individuals have ideals and are prepared to die for them. It proposed that war remained the arena of individual honour and bravery, and that even paying the ultimate sacrifice furthered the cause. Moreover the photograph suggested that individual soldiers going forward died quickly, and even aesthetically. In the end, the questions surrounding 'Death of a Republican soldier' are never going to be answered by examining the prints or trying to find the negative. The truth of the photograph is not inherent in the image itself but is found or fought over within systems that are subject to historical formation and change.

This emphasis is different from Barthes's idea that 'the photograph possesses an evidential force ... From a phenomenological viewpoint, in the Photograph, the power of authentication exceeds the power of representation.'[75] This is important: authenticity may be all documentary photography can claim. It has no fixed set of issues, no set techniques, no completely defined set of forms, styles or modes. It captures what-has-been. But an even more important question for documentary is its purpose, how it was used to shape an argument, its usage in relations of power. As Tagg argues, the problem of photographic evidence is historical, not existential.[76] Documentary is always engaged in promoting and providing answers to questions about what-has-been, but it achieves

meaning always by way of institutions, practices and professionalisms that bear directly on the social body through 'modes of governance' and through 'relations of dependence and consent'.[77] Documentary, or photography as evidence, reveals points of view held by photographers and editors who make it available; its use helps to confirm beliefs and hopes or sometimes to fashion spheres of controversy for viewers.

A similar but more insidious and dangerous case relating to authenticity and use occured in February 1997. It started when the small student-based Revolutionary Communist Party (RCP) issued a press release concerning a forthcoming article by Thomas Deichmann, a German freelance writer, in their glossy, low-circulation magazine *Living Marxism*. Deichmann's piece cast doubt on the veracity of British accounts of the nature of a Bosnian Serb camp for Muslims in Trnopolje shown on ITN news on 6 August 1992.[78] Deichmann said that he had obtained a copy of the unedited video through the FBI which revealed that the ITN report was 'seriously misleading' because it seemed to present a refugee centre as a 'concentration camp'. The allegations in *Living Marxism*'s press release were printed in the late editions of the *Independent on Sunday*;[79] the following week Ed Vulliamy, the *Guardian* journalist who had accompanied the ITN news crew, refuted Deichmann and *Living Marxism* in the *Observer*.[80] ITN threatened the *Independent on Sunday* with legal action, issued a writ for libel against *Living Marxism* and its editor, Mike Hume, and also sued the magazine's printer and Two-Ten Communications, a subsidiary of the Press Association which carried the defamatory press release promoting the magazine's 'scoop'.[81] Two-Ten Communications later apologised in the High Court to ITN and its reporters for the 'very real distress and damage' and paid their legal costs, though ITN continued to sue *Living Marxism* and its editor for libel.[82] None of this deterred *Living Marxism*, which organised press conferences in London and Bonn, inviting Deichmann to advance his thesis. *Living Marxism* had successfully manipulated the press into accusing ITN and Ed Vulliamy of 'taking liberties with the facts' and lying about the camp at Trnopolje – thus attempting to revise the record of Serb actions in Bosnia.

Deichmann claimed that in this case the Western media, already hostile to the Serbs, set out to mislead the international community into believing that the camp at Trnopolje was a prison, with starving inmates caged behind barbed wire, when in fact it was a collection centre for refugees, 'many of whom went there seeking safety and could leave again if they wished'.[83] Deichmann demonstrated that the journalists were standing inside a compound built years before and surrounded on four sides by barbed wire to protect a barn. He made it clear through maps and photographs that the ITN crew had been standing *inside* the fenced-in compound. They filmed the camp inmates gathered in front of them *through* the wire; the inmates were standing *outside* the compound. There was no barbed wire anywhere else in the camp.

In response, Vulliamy accused Deichmann and Mike Hume of 'revisionism': they had so distorted what the reporters did and what they saw that they had poisoned the 'water supply of history [and] contaminated the reservoir of truth'.[84] What *Living Marxism* never revealed, of course, was its own position, defined by a crude anti-statism: from 1990 the RCP opposed any Western intervention in Serbia, but chiefly as part of its opposition to Western governments. *Living Marxism* never revealed, either, that Deichmann was a witness for the defence of the Bosnian Serb Dusko Tadic, on trial at the International Criminal Tribunal for the Former Yugoslavia in The Hague for murder and other atrocities committed at Trnopolje and Omarska in 1992 (Tadic was found

Daily Mirror, 7 August 1992. MSI/ITN

guilty in May 1997 of crimes against humanity, including killings and beatings, and sentenced to twenty years' imprisonment in July[85]); or that Fikret Alic, whose skeletal body figured largely in the broadcast, also contradicted Deichmann, stating that on 5 August the Muslims were in fact held behind barbed wired, and that some of it was taken down only on 8 August when television crews arrived from Belgrade and Banja Luka.[86]

The story is straightforward in one respect: it demonstrates how documentary pictures are likely to support existing ideas or draw upon common knowledge. The ITN team was led by Penny Marshall, who acknowledged that the media concentrated on the image of the starving Fikret Alic when, in a report lasting five minutes, she had been very careful to show Bosnian Serb guards feeding prisoners, a Muslim child who had come to the camp of his own volition, and she never called the place a 'death camp'. Despite her care, she found later that it was *that* skeletal image which the press and television channels around the world used 'again and again'.[87] Already hostile to the Serbs and their stated policy of 'ethnic cleansing', editors picked on the figure of Alic seen behind barbed wire precisely because it was reminiscent of the Nazis and their similar political aim of so-called 'cleansing'.

It looked as if Muslims were penned behind a barbed wire fence, and the international media (and not only the British tabloids) seized on this to make a symbolic link with the Nazis. The tabloid press 'frame-grabbed' the image (as above) for its front pages and used it to 'prove' that the men were held in a Nazi-style concentration camp. The *Star* and the *Daily Mirror* headlines both used the word 'BELSEN' (7 August 1992).

Above the caption 'Horror of the New Holocaust' the *Mirror* stated that 'The haunting picture of these skeletal captives evokes the ghosts of the Nazis' Belsen concentration camp during the Second World War'. The *Daily Mail* headline was 'THE PROOF'; it too recalled the Nazi camps (7 August 1992). Quite clearly, the ITN footage was taken by the tabloids in particular to recall those 'black and white flickering images from the 50-year-old films' of the Nazi death camps (*Daily Mail*, 7 August 1992).

The Times was less definite in its caption, 'Behind the barbed wire: emaciated and despairing inmates of the camp at Trnopolje, Bosnia, are offered solace by a visiting television crew' (7 August 1992). However, its headline accused the Serbs of executions and beatings in its prison camps, which they were also trying to keep secret.[88] There was no escaping the fact that 'in America, the latest reports about concentration camps have evoked memories of the Holocaust'.[89]

Ed Vulliamy's report on the front and back pages of the *Guardian* was written independently of the television tape. It also did not concentrate on the figure of Alic. It was an account of 'the starvation and human rights abuses being inflicted on the captives' in Trnopolje but especially in Omarska.[90] Vulliamy recorded the cadaverous appearance of the Muslims and recounted how some of them had come to be held there – though most were 'too visibly terrified to talk'. One group had arrived from Kereter that morning. He noted the 'pitifully thin Fikret Alic' who had just come from Kereter, where, Alic said, 'It is worse than here. There is no food.'

Like his television colleagues, Vulliamy never used the term 'concentration camp' to describe Trnopolje, nor did he mention barbed wire. Indeed, the *Guardian* printed the famous image of what it called 'individuals showing signs of cruel confinement' on p. 20; its front-page photograph – also grabbed from television – represented some prisoners under the headline 'Shame of camp Omarska' (7 August 1992). Vulliamy mentioned such 'camps' only because the Bosnian government had named fifty-seven of them and because in response the Bosnian Serbs's president, Radovan Karadzic, had challenged ITN and the *Guardian* to inspect 'whatever you wish to see' in north-east Bosnia. The journalists went from Omarska to Trnopolje, but after the news team had tried to interview 'inmates' they were bundled away for an official briefing. Afterwards Dr Karadzic's 'invitation' collapsed, and they were refused permission to see inside an aluminium shed, sleeping quarters and workshops. Vulliamy argued that the shed and so forth 'conceals some secret': 'it is a secret the international agencies must uncover if the miasma of lies, propaganda, exaggeration, denial, comparisons with the Nazi Holocaust, claims and counter-claims, is to be more than partially penetrated'. He was attempting to clarify what was happening in Bosnia, and was not claiming that it was the same as the Nazi Holocaust. He stated, 'Trnopolje cannot be called a "concentration camp" and is nowhere as sinister as Omarska: it is very grim, something between a civilian prison and transit camp.'[91]

Neither Ed Vulliamy nor the *Guardian* editors had made very much play with the barbed wire scene or Fikret Alic, though Vulliamy's description of starvation in Omarska was especially vivid: 'The internees are horribly thin, raw-boned; some are almost cadaverous, with skin like parchment folded around their arms.'[92] But Vulliamy summarised the impact of the image of Fikret Alic in his book *Seasons in Hell* (1994). He wrote, 'With his rib-cage behind the barbed wire of Trnopolje, Fikret Alic had become the symbolic figure of the war, on every magazine cover and television screen in the world.'[93] In 1993 Mike Jermy, foreign editor of ITN, called the picture 'one of the key

images of the war in former Yugoslavia'.[94] John Major, then Prime Minister, summoned Cabinet colleagues back from holiday for an emergency meeting on 18 August 1992, and shortly after announced that eighteen hundred British troops would be sent into Bosnia. In the United States, where the 1992 presidential election campaign was under way, the Democratic Party candidate, Bill Clinton, used the ITN pictures to demand that President Bush should take military action against the Bosnian Serbs. NATO discussed proposals for armed aid convoys.[95]

In other words, every use of the video of Alic and the others behind barbed wire depended on editors referring to the presumed common knowledge of their audiences. Some chose to make a direct link with the concentration camps of the Holocaust, while Vulliamy refused to make such a comparison. As he wrote in 1997, 'We were and are careful to point out that this was not the Third Reich revisited, but the echoes of another time were loud.'[96] In other words, though neither ITN nor the *Guardian* drew the connection with the Holocaust, Vulliamy openly recognised later that the use of the picture was bound to relate to frameworks of knowledge and expectations that were already in place. The case is a clear example of how the evidential nature of imagery is bestowed upon it by practices and professions, and does not exist within it naturally. The evidential force of photography derives not from some 'magic' quality of the medium but from institutional practices and within particular historical relations: photography as evidence is exercised only within 'conscious and unconscious processes, the practices and institutions through which the photograph can incite a phantasy, take on a meaning and exercise an effect'.[97] This effect may change in time. For instance, the image centring on Alic was often used in the *Guardian* to illustrate stories of 'ethnic cleansing'[98] but its currency altered when Vulliamy discovered that the US State Department in Washington had concealed reports on the camps sent by the International Red Cross, and how a senior government official, Tom Niles, had told the Senate foreign affairs committee that 'there was "no information" of any kind to confirm the existence of the camps or the atrocities'.[99] It altered yet again when the *Observer* used the picture to illustrate a review of Rezak Hukanovic's book on the atrocities in Omarska, *The Tenth Circle of Hell*.[100]

The continuing belief in and reliance on the truth value or authenticity of video or photographic evidence, as well as the ways in which it can be undermined or ignored, have implications for the ways in which people understand the use of computers to alter news images.[101] Digital sampling techniques that allow images (and their negatives) to be generated within computers, so that the tie with objects or what-has-been in the actual world is broken, does not alter the primary importance of authenticity as the basis of press stories: consequently, whenever newspapers present digital sampling and invention as orthodox photojournalism, they endanger their claim to truthful reporting. This eye-witness status has always been hard won, is always under threat and is therefore still closely guarded as a basic tenet of the industry. Despite the reluctance of the press to use altered images as standard photojournalism, the development of digital imaging is without doubt a complication because it increases the already profound uncertainty about the status of photography as eye-witness evidence.[102] In *The Reconfigured Eye* William Mitchell maintains that digital imagery 'deconstruct[s] the very ideas of photographic objectivity and closure, and [resists] what has become an increasingly sclerotic pictorial tradition'.[103] Mitchell's reservations are a continuation of nineteenth- and early twentieth-century doubts about the medium's problematic relation to truth. He sets this 'interlude of false innocence' about photography against the later, increasingly

common, acceptance of multiple, shifting meanings. However, this contrast in periods is too stark. There never was an age of innocence in photography. First, 'the innocent eye' recording absolute fact was always more of a hope than something fully realised. Nineteenth-century photographs were notoriously deficient in information and are constantly disappointing as records.[104] Second, Mitchell forgets that older systems of representation overlap with later ones, and coexist for long periods of time.[105] Looking at photography today presents its semblance of reality, but earlier doubts and confusion about the relation of photography to reality persist. At the same time, and though they are realised in different forms, desires for both illusion and reality remain as strong as ever. Early anxieties about the relation of chemical photography to reality are now joined by contemporary versions of the same problem relating to the digital manipulation of images. Both anxieties need to be understood in the context of professions and practices.

Despite the use of computers in news rooms, the press continues to trade on the indexical bond or one-to-one relation between image and reality which was so distinctive of chemical photography. The press tends to play down the way it uses digital imaging techniques in photojournalism, since it recognises that electronic retouching of imagery destroys the documentary value of witnessing. Eamonn McCabe, picture editor of the *Guardian*, recognises that moving 'the odd football ... has happened for years', but he will not allow footballs to be moved in sports images. He writes that using 'computer wizardry' to alter scenes destroys readers' trust in the paper's authenticity.[106] He states that 'If our readers think we have moved a football, then they'll wonder if we've moved a body'.[107] McCabe is careful to defend the authenticity of photojournalism while acknowledging how easy it is to destroy it. He points out that war photography has had a 'bad name' ever since Mathew Brady moved dead bodies around to make better pictures during the American Civil War. But modern picture editors can 'improve' photographs electronically, so that 'moving bodies is much lighter work now'.[108] Despite the temptations of computers, he suggests, image manipulation is less common in broadsheets than in tabloids because readers of so-called 'quality' papers still expect what they are seeing in photographs to represent what-has-been. Taking a different line, Ken Lennox, picture editor of the *Sun*, contends that changing the image in a computer is not a measure of difference between types of newspaper but marks the difference between news coverage and everything else: to change a photograph is to 'destroy history' and to create 'virtual reality'.[109]

The *Guardian* recently chose the 'virtual' over the 'actual'. Disregarding the danger to its reputation, the newspaper doctored a front-page photograph – but the event was so widely recorded on television and in other press photographs that the newspaper was caught out. Every picture editor wanted the traditional shot of the Chancellor of the Exchequer standing in Downing Street on Budget day and holding up his red ministerial briefcase before going to the House of Commons. But Chancellor Gordon Brown's press officer insisted that a group of training centre apprentices should stand in the background to show Labour's commitment to getting the young back to work. Unfortunately, in the photograph a boy's hair appeared to envelop Brown's raised hand, so the *Guardian* removed it by computer (3 July 1997). This made a better picture but altered the original scene. The *Mirror* was quick to cry foul, and the *Guardian* was forced to admit that it had digitally manipulated a documentary photograph (4 July 1997). The paper had been caught with its 'fingers in the electronic paintbox', as McCabe put it, adding 'it should never have happened' – though he also seemed to be blaming the press officer whose

'good idea' had created a 'bad picture'.[110] The incident reveals that, even though newspapers are wary of undermining the truth-value of documentary pictures, they will excise intrusive detail for the sake of composition and required information.

The *Mirror* itself soon went much further. Instead of merely cropping or enhancing it, the newspaper decided to concoct 'the picture they all wanted' and present the fake as a 'world exclusive' (9 August 1997). The *Mirror* was trying to pre-empt the *Sunday Mirror*, which had bought the rights to intimate shots of Princess Diana and Dodi al-Fayed embracing (10 August 1997). In order to pull off its stunt, the *Mirror* used a photograph of the couple together but reversed the image of al-Fayed by computer so that instead of turning away from the princess he seemed about to kiss her. (The deception was exposed in the *Guardian*, 11 August 1997.) The *Mirror*'s action revealed not only how far the paper would go in the circulation war but also the high price of authentic photographs. (It was, in part, the promise of bounty that led to Diana's and Dodi's death.)

In general, photographers and picture agencies will fight to protect the authentic reality of imagery. For example, Philip Jones Griffiths and Magnum refused the advertising agency Saatchi permission to use one of the photographer's Vietnam War images in a Ministry of Defence army recruitment campaign, but Saatchi went ahead and used a computer to superimpose the face of a model on to the body of a dead soldier in the original image. Griffiths and Magnum objected to the use of this horrific imagery in military propaganda, and, despite Saatchi's success in publishing its version in men's magazines, the photographer and Magnum's lawyers moved quickly to reassert their rights over the original, unaltered image.[111]

The fight for the authenticity of photographs continues, but the fact of digital imaging sets an historical framework around the work discussed in this book. Of course, my concern is not with technology so much as use, and, as Kevin Robins writes, 'The question of technology ... is not at all a technological question.'[112] A system that produces images may best represent the realism of its time, but realism remains a cultural phenomenon.[113] Press photography continues to depend for its effect on establishing the presence of eye-witnesses at an event. The replacement of chemical photography by computer technology, or the application of computers to analogue chemical photography, complicates matters without fundamentally altering them.

The suspension of disbelief which enabled nineteenth-century audiences to accept photographic realism, albeit partially and grudgingly, alters along with a generally declining faith in progress without disappearing altogether. Realism in photography not only trades on the indexical link with the material world but also comes with its own peculiar demands. Photography is a reminder of the passage of time and mortality; images tied to time are accused of bearing the work of death, 'pausing to freeze, mummify, "corpse-ify" whatever body they capture or pose'.[114] Photography becomes a conductor or conduit, allowing death to leap at viewers, or dragging them towards it. If onlookers peruse or gawp at photographs then they are also to blame for what they see as voyeurs and tourists of death. Even worse, they may be to blame for whatever action they take, or refuse to take. Photographs can still connect onlookers with what-has-been. Looking at them deliberately implies some responsibility for viewers, though it is not at all straightforward or likely that viewers will recognise and accept the fact.

Notes

1 Glenda Cooper, 'A helping hand for the abused', *Independent*, 17 December 1996.
2 Zygmunt Bauman, *Postmodern Ethics* (Oxford, Blackwell), 1993, p. 218.
3 James Curran and Jean Seaton, *Power without Responsibility. The Press and Broadcasting in Britain* (London, Routledge), 1991, p. 4.
4 Abigail Solomon-Godeau, *Photography at the Dock. Essays on Photographic History, Institutions, and Practices* (Minneapolis, University of Minnesota), 1991, p. 171.
5 Martha Rosler, 'In, around, and afterthoughts (on documentary photography)', in Richard Bolton (ed.), *The Contest of Meaning. Critical Histories of Photography* (Cambridge, Massachusetts, MIT Press), 1989, p. 306.
6 Andrew Ross, *No Respect. Intellectuals and Popular Culture* (London, Routledge), 1989, p. 60.
7 Andrew Culf, 'Around the clock', *Guardian*, 3 February 1997.
8 Paul Rock, 'News as eternal recurrence', in Stanley Cohen and Jock Young (eds), *The Manufacture of News. Deviance, Social Problems and the Mass Media* (London, Constable), 1981, pp. 64–70.
9 Brian MacArthur, 'The news is not all bad', *British Journalism Review*, 3:3 (1992) 74–6.
10 Roy Greenslade, 'Through Rosie tinted glasses', *Guardian*, 20 January 1997.
11 Brian MacArthur, 'The British keep reading despite the box', *British Journalism Review*, 3:4 (1992) 65–7.
12 Roy Greenslade, 'For whom the bill tolls', *Guardian*, 20 November 1995; John Mullin, 'Easy come, easier go for would-be barons', *Guardian*, 28 December 1995.
13 MacArthur, 'The British keep reading despite the box', p. 66; Roy Greenslade, 'Downhill all the way', *Guardian*, 13 January 1997.
14 Robert Worcester, 'Who buys what—for why?', *British Journalism Review*, 2:4 (1991) 46.
15 Jeremy Tunstall, *Newspaper Power. The New National Press in Britain* (Oxford, Oxford University Press), 1996, p. 340.
16 Alan Doig, 'Retreat of the investigators', *British Journalism Review*, 3:4 (1992) 47.
17 Anthony Sampson, 'The crisis at the heart of our media', *British Journalism Review*, 7:3 (1996) 47.
18 Tunstall, *Newspaper Power*, pp. 35–46.
19 Sampson, 'The crisis at the heart of our media', p. 50.
20 Don McCullin, *Unreasonable Behaviour. An Autobiography* (London, Vintage), 1992, pp. 268ff, 272ff.
21 *Abject Art. Repulsion and Desire in American Art* (New York, Whitney Museum of American Art), 1993; Marjorie Allthorpe-Guyton, *Effluvia—Helen Chadwick* (London, Serpentine Gallery), 1994; James B. Twitchell, *Dreadful Pleasures. An Anatomy of Modern Horror* (Oxford, Oxford University Press), 1985; Martin Tropp, *Images of Fear. How Horror Stories Helped Shape Modern Culture 1818–1918* (Jefferson, North Carolina, McFarland), 1990; Edward Bond, 'A blast at our smug theatre', *Guardian*, 28 January 1995; Mike Ellison and Alex Bellos, '*Blasted*: a deeply moral and compassionate piece of theatre or simply a disgusting feast of filth?', *Guardian*, 20 January 1995.
22 John Fiske, *Television Culture* (London, Methuen), 1987, p. 142.
23 S. Elizabeth Bird and Robert W. Dardenne, 'Myth, chronicle, and story: exploring the narrative qualities of news', in James W. Carey (ed.), *Media, Myths, and Narratives. Television and the Press* (London, Sage), 1988, p. 70.
24 Roberta McGrath, 'Medical police', *Ten.8*, 14 (1984) 13–18.
25 Jonathan Freedland, 'The man with Einstein's eyes', *Guardian*, 17 December 1994.
26 Roland Barthes, 'The brain of Einstein', in the author's *Mythologies* (St Albans, Granada), 1973, pp. 68–70.
27 Martin Jay, *Downcast Eyes. The Denigration of Vision in Twentieth-Century French Thought* (Berkeley, University of California Press), 1993.
28 Leonore Davidoff and Catherine Hall, *Family Fortunes. Men and Women of the English Middle Class 1780–1850* (London, Hutchinson), 1987, pp. 32–4.
29 Don Slater, 'Photography and modern vision: the spectacle of "natural magic" ', in Chris Jenks (ed.), *Visual Culture* (London, Routledge), 1995, p. 222.
30 Cited in W. J. T. Mitchell, *Iconology. Image, Text, Ideology* (Chicago, University of Chicago Press), 1986, pp. 59–60.
31 Susan Sontag, *On Photography* (New York, Farrar Straus and Giroux), 1977, p. 154.
32 *Ibid.*, p. 154.
33 John Tagg, *The Burden of Representation. Essays on Photographies and Histories* (Basingstoke, Macmillan), 1988, p. 3.

34 *Ibid.*, p. 4.
35 Solomon-Godeau, *Photography at the Dock*, p. 169.
36 Tagg, *The Burden of Representation*, p. 63.
37 Solomon-Godeau, *Photography at the Dock*, p. 176; see also Tagg, *The Burden of Representation*, and Allan Sekula, 'Dismantling modernism, reinventing documentary (notes on the politics of representation)', in *Photography against the Grain. Essays and Photoworks 1973–83* (Halifax, Nova Scotia, Press of the Nova Scotia College of Art and Design), 1984, pp. 53–75.
38 Rosler, 'In, around, and afterthoughts (on documentary photography)', p. 334.
39 Solomon-Godeau, *Photography at the Dock*, p. 229.
40 Hugh Cudlipp, 'The camera cannot lie', *British Journalism Review*, 3:3 (1992) 30–5.
41 Ian Katz, 'Kiss and tell ...', *Guardian*, 19 August 1996.
42 Tunstall, *Newspaper Power*, p. 206.
43 Walter Benjamin, *One Way Street and other Writings* (London, Verso), 1985, p. 240.
44 *Ibid.*, p. 251.
45 Roland Barthes, 'The reality effect', in Tzvetan Todorov (ed.), *French Literary Theory Today* (Cambridge, Cambridge University Press), 1982, pp. 11–17.
46 Roland Barthes, *Image/Music/Text* (New York, Hill and Wang), 1977, pp. 30–1.
47 *Ibid.*, p. 31.
48 Roland Barthes, *Camera Lucida. Reflections on Photography* (London, Jonathan Cape), 1982, pp. 90–1.
49 *Ibid.*, pp. 92–6.
50 *Ibid.*, p. 91.
51 Lisa Henderson, 'Access and consent in public photography', in Larry Gross, John Stuart Katz and Jay Ruby (eds), *Image Ethics. The Moral Rights of Subjects in Photographs, Film and Television* (New York, Oxford University Press), 1988, pp. 91–107.
52 Vivian Sobchack, 'Inscribing ethical space: ten propositions on death, representation, and documentary', *Quarterly Review of Film Studies*, 9:4 (1984) 295.
53 See Barbie Zelizer, *Covering the Body. The Kennedy Assassination, the Media, and the Shaping of Collective Memory* (Chicago, University of Chicago Press), 1992.
54 Sontag, *On Photography*, p. 11.
55 *Ibid.*, p. 12.
56 Sobchack, 'Inscribing ethical space', pp. 295–6.
57 Sontag, *On Photography*, pp. 191–2.
58 Sobchack, 'Inscribing ethical space', p. 296; Phillip Knightley, 'Access to death', *British Journalism Review*, 7:1 (1996) 6–11.
59 Sobchack, 'Inscribing ethical space', p. 297.
60 See Angela Kingston, *Freedom* (Edinburgh, Amnesty International Glasgow Groups Exhibition), 1995, pp. 22–3.
61 See Val Williams and Greg Hobson, *The Dead* (Bradford, National Museum of Photography, Film and Television), 1995, pp. 60 1.
62 Sobchack, 'Inscribing ethical space', p. 297.
63 *Ibid.*, p. 297.
64 Allan Sekula, 'The traffic in photographs', in *Photography against the Grain. Essays and Photoworks 1973–83* (Halifax, Nova Scotia, Press of the Nova Scotia College of Art and Design), 1984, p. 99.
65 Nigel Warburton, 'Varieties of photographic representation, documentary, pictorial and quasi-documentary', *History of Photography*, 15:3 (1991) 208.
66 Caroline Brothers, *War and Photography. A Cultural History* (London, Routledge), 1997, p. 179 and pp. 241–2.
67 See Richard Whelan and Cornell Capa, *Robert Capa Photographs* (London, Faber and Faber), 1985, pp. 42–3.
68 Phillip Knightley, *The First Casualty. From the Crimea to Vietnam: the War Correspondent as Hero, Propagandist, and Myth Maker* (New York, Harcourt Brace Jovanovich), 1975, pp. 209–12.
69 Rita Grosvenor and Arnold Kemp, 'Spain's Falling Soldier really did die that day', *Observer*, 1 September 1996.
70 Phillip Knightley, ' "Moment of death": a random snapshot', *Observer*, 8 September 1996.
71 *Ibid.*
72 Brothers, *War and Photography*, p. 180.
73 *Ibid.*, p. 181.
74 *Ibid.*, p. 183.
75 Barthes, *Camera Lucida*, p. 89.

76 Tagg, *The Burden of Representation*, p. 5.
77 *Ibid.*, p. 9.
78 Thomas Deichmann, 'The picture that fooled the world', *Living Marxism*, February (1997) 24–31.
79 Vanessa Thorpe, 'ITN "may sue over article"', *Independent on Sunday*, 26 January 1997.
80 Ed Vulliamy, 'I stand by my story', *Observer*, 2 February 1997.
81 Luke Harding, 'A shot that's still ringing', *Guardian*, 12 March 1997.
82 Andrew Culf, 'ITN wins apology over Bosnia libel', *Guardian*, 18 April 1997.
83 Deichmann, 'The picture that fooled the world', p. 24.
84 Vulliamy, 'I stand by my story'; Ed Vulliamy, *Seasons in Hell. Understanding Bosnia's War* (London, Simon & Schuster), 1994, pp. 102–5.
85 Ian Traynor, 'War crimes trial finds Bosnian Serb guilty', *Guardian*, 8 May 1997; Stephen Bates, 'Serb fury at jail for killer', *Guardian*, 15 July 1997.
86 Harding, 'A shot that's still ringing'.
87 Frederick Baker, 'How the people of former Yugoslavia respond to Western media images of their war', *Independent*, 5 August 1993.
88 Michael Binyon, 'Evidence mounts of executions and beatings in Serb-run camps', *Times*, 7 August 1992; Tim Judah, 'Serbs hasten to hide their horror camps from the world', *Times*, 7 August 1992.
89 Peter Riddell, 'The politics of atrocity', *Times*, 7 August 1992.
90 Ed Vulliamy, 'Shame of camp Omarska', *Guardian*, 7 August 1992.
91 *Ibid.*
92 *Ibid.*
93 Vulliamy, *Seasons in Hell*, p. 202.
94 Baker, 'How the people of former Yugoslavia respond to Western media images of their war'.
95 James Bone, 'NATO to discuss proposal for armed aid convoys', *Times*, 7 August 1992.
96 Vulliamy, 'I stand by my story'.
97 Tagg, *The Burden of Representation*, p. 4.
98 Julian Borger, 'Serbs crowd infamous prison camp', *Guardian*, 17 October 1995; Ed Vulliamy, 'Horror hidden beneath ice and lies', *Guardian*, 19 February 1996.
99 Ed Vulliamy, 'Hard truths swept under red carpet', *Guardian*, 22 June 1996.
100 Rezak Hukanovic, *The Tenth Circle of Hell. A Memoir of the Death Camps of Bosnia* (London, Little Brown), 1997; Ed Vulliamy, 'Diary of the damned', *Observer Review*, 20 April 1997.
101 Fred Ritchin, 'Photojournalism in the age of computers', in Carol Squiers (ed.), *The Critical Image. Essays on Contemporary Photography* (Seattle, Bay Press), 1990, pp. 28–37.
102 Kevin Robins, 'Will image move us still?', in Martin Lister (ed.), *The Photographic Image in Digital Culture* (London, Routledge), 1995, pp. 29–50.
103 William J. Mitchell, *The Reconfigured Eye. Visual Truth in the Post-photographic Era* (Cambridge, Massachusetts, MIT Press), 1992, p. 8.
104 Jonathan Crary, *Techniques of the Observer. On Vision and Modernity in the Nineteenth Century* (Cambridge, Massachusetts, MIT Press), 1990; Susan R. Horton, 'Were they having fun yet? Victorian optical gadgetry, modernist selves', in Carol T. Christ and John O. Jordan (eds), *Victorian Literature and the Victorian Visual Imagination* (Berkeley, University of California Press), 1995, pp. 1–26.
105 David Phillips, 'Modern vision', *Oxford Art Journal*, 16:1 (1993) 137.
106 Eamonn McCabe, 'The electronic lie-machine?', *British Journalism Review*, 2:4 (1991) 26.
107 Martin Wroe, 'Lies, damn lies, and photojournalism', *Observer*, 21 April 1996.
108 Eamonn McCabe, 'Photographers in the front line', *British Journalism Review*, 3:1 (1992) 35.
109 Wroe, 'Lies, damn lies, and photojournalism'.
110 Eamonn McCabe, 'We're framed', *Media Guardian*, 7 July 1997.
111 Vivek Chaudhary, 'Court battle looms over Vietnam War picture', *Guardian*, 30 May 1997.
112 Kevin Robins, 'Into the image: visual technologies and vision cultures', in Paul Wombell (ed.), *Photovideo. Photography in the Age of the Computer* (London, Rivers Oram Press), 1991, p. 55. See also Timothy Druckrey (ed.), *Electronic Culture. Technology and Visual Representation* (New York, Aperture), 1996.
113 Sarah Kember, ' "The shadow of the object": photography and realism', in Lindsay Smith (ed.), 'Photography and cultural representation', *Textual Practice*, 10:1 (1996) 145–63.
114 Lynne Kirby, 'Death and the photographic body', in Patrice Petro (ed.), *Fugitive Images. From Photography to Video* (Bloomington and Indianapolis, Indiana University Press), 1995, pp. 72–84.

5

Press shock

There is no mystery about newspapers, where to buy them, what is in them.[1] The press is a daily, national industry, which deals first and foremost in matters which it judges to be of immediate interest to its readers. Each title decides news value differently, but home stories dominate. Home-grown murders, scandals, accidents and other debacles can outweigh affairs of state and command more space than most international incidents unless they are spectacular 'world news', including assassinations, terrorist attacks or cataclysmic earthquakes and floods.

All this newsmongering takes place within (and sometimes against) the imprecise guidelines on decency, decorum and propriety that relate to public viewing and looking. The aim of this chapter is to examine how the press restrains itself in representing horror, and the next three chapters explore the practice and implications of this governance. Chapter 6 covers heartbreaking stories of suffering that stems from accidents or catastrophes, where dead Britons are close to hand, though their dying is usually kept out of sight. Chapter 7 discusses how murder is pictured in the press. Chapter 8 deals with the way bodies appear as a matter of routine in gruesome stories from overseas.

The daily press uses photojournalism to bolster its engagement with horror. Newspapers publish photographs in massive numbers, and they prize actuality or documentary photographs as evidence or eye-witness proof of what-has-been. At the same time, none of the daily papers represents a single-issue pressure group, and, though each has political preferences, none has a particular programme of reform that it wishes to push through in the manner of campaigning groups with their news sheets, flyers and advertisements. For all their bluster and positioning on matters of state, modern papers are not political broadsides or polemical tracts, though each may take up a cause of public concern from time to time. They do not have overriding moral agendas, and they

are much less focused on issues than engaged in repeating and varying well tried stories in ways that are designed to entertain and inform rather than to teach or inculcate values. They are as likely to stir feelings as thought. Revulsion and sentiment on the front page, or in the headline, always serve their purpose.

Newspapers print more actuality photographs on a regular basis than any other medium does, but they do not necessarily use them to suggest how people may behave. Editors and journalists claim to be responsible in reporting the facts of everyday events, though there is no yardstick of journalistic ethics.[2] Journalists report in the style of their paper, and their choice of news is also shaped by its existing form and voice, and by their sense of who comprise their public. I am not concerned to argue that the papers should be something other than they are, becoming solely or even mostly public records of grisly, preventable events, as if that would force readers to act and encourage those in power to change their policies. There is no evidence that a barrage of repulsive imagery would make any difference. I have no programme for the news industry, and am concerned only to uncover what it does, and ask how photojournalism helps in that endeavour. Photographs in the press carry forward certain ideologies at the expense of others, and photographs are used in displays that reveal and reinforce definite beliefs about the world.

Press, privacy, propriety

Debates within the industry tend not to centre on ethics and morality so much as on taste or propriety. The balance the papers try to strike is between the right to know (which is connected with the right to see) and the right to be shielded from too much reality. This balance, never fixed, sometimes comes unhinged. For example, in 1989 the Sunday *People,* using morbid photographs as a gambit in the never-ending circulation war, published an image of a dead man strapped into his airline seat after the crash of a DC-10 in Sioux City, Iowa, above the caption 'Horror of Flight 232' (23 July 1989). Later that year, the same paper printed a picture of the singer Sammy Davis junior which revealed the shocking scar on his neck after an operation for throat cancer; the front cover of the same issue invaded the privacy of the royal family with a peek-a-boo photograph of Prince William's 'sly pee' in a park under the headline 'The Royal Wee!' (19 November 1989). The proprietor of the paper, Robert Maxwell, sacked the editor for these intrusions on privacy, partly because he had received a complaint from the royal family but mostly because he objected to the picture of the dying film star. The use of distasteful or dreadful pictures in the pursuit of sales was already under attack in 1989. They were considered either counterproductive in the circulation war, or to some extent *passé*.[3]

The daily press sometimes claims to speak for the nation, but generally presumes to speak on behalf of its readers, who are thereby supposed to be the 'general public'. Though my examples are drawn from the national papers, I cannot assume they are evidence of a national consensus.[4] The public, including the readership of newspapers, is too diverse to be described as 'general' and already a fiction that journalists use to describe their audiences. The issue is not so much the truth of the industry's claim to speak for the nation so much as its wish to attract loyal readers, who may feel that a newspaper speaks to them or on their behalf, and who may identify with others who read the same title.

Editors discover what readers expect of their papers when they diverge from normal practice, or break faith by publishing material which a significant number of readers find offensive. Readers' complaints against editors help to define the limits of daily practice. Yet, although readers may feel aggrieved that their paper has broken the rules, most of the time they do not feel responsible for what the paper prints. Lack of evidence of a shared perspective between editors and readers implies that no one should assume that morbidity in the press 'expresses, or even constructs thoughts and sentiments that are popular, that is, widely shared across a given population'.[5]

While stories in the press may not describe a national or consensual idea of what is revolting, I have decided to focus on the stories as they are printed, assuming that editors speak to or on behalf of their imagined audience. The unproved existence of shared points of view between readers and journalists, as well as the varied ways that different titles address their audience, obscures much that the industry holds in common. They all use horror in stories designed to titillate or frighten readers. They may claim that news is often grim, that they restrain themselves and do not exaggerate. This is undoubtedly true of many stories, though the point here is not the way the press approaches or departs from some notion of truth 'out there' but the way it imagines truth 'in here'. Its practice involves the constant redefinition of thresholds of polite and impolite discourse, including the proper use of horror. Redefinition is one part of a wider, continuing debate about what 'press freedom' means.[6] This issue remains unresolved, but most of the debate centres on the times and places when royalty, politicians, celebrities, other powerful individuals and ordinary citizens have the right – or entitlement – to privacy in their everyday lives; less controversial, because apparently self-evident, is the entitlement to privacy in relation to death and disaster.

Since 1989 at least, the press has been under pressure to reform itself or face new legal restrictions. After criticism of the *Sun*'s ill advised and unjustified attack on Liverpool fans for desecrating the bodies of those killed in the Hillsborough football disaster that year, David Mellor, the Home Office Minister responsible for press matters, said the tabloid newspapers were 'drinking in the Last Chance Saloon'. Also that year the government was put under pressure by the Labour MP Tony Worthington, who introduced a Right of Reply Bill, and the backbench Tory MP John Browne, who introduced a Privacy Bill, to 'put water', as he described it, 'in the moat of everyone's castle'.[7] Government diverted the increasing pressure for action by setting up the Calcutt Committee of Inquiry into Privacy and Related Matters, which published its first report in 1990. Calcutt recommended replacing the Press Council with a stronger self-regulatory body, which resulted in the founding of the Press Complaints Commission (PCC) in January 1991.

The PCC drew up a voluntary code of practice which has altered over the years, though the aims remain broadly the same – to encourage the press to 'raise standards' and to protect the industry from direct 'privacy' legislation. Self-regulation has not prevented the press from regularly invading the privacy of individuals, including 'celebrities', and ordinary men, women and children caught up in unusual events if it could justify the stories on the grounds of public interest.[8] Members and former members of the royal family have been subjected to intensive scrutiny. In June 1992 the *Sunday Times* serialised Andrew Morton's book about Diana, Princess of Wales, provoking the chairman of the PCC, Lord MacGregor, to describe reports of the royal marriage as 'an odious exhibition of journalists dabbling their fingers in the stuff of other people's souls'

(though he later discovered that Morton had been directed by the princess).[9] In August 1992 the *Sun* published the so-called 'Squidgy' tapes of conversations between the Princess of Wales and James Gilbey, which revealed her despairing of her life and talking disparagingly of the royal family. In January 1993 the *Daily Sport* and *Kent Today* printed the so-called 'Camillagate' tapes of conversations that had taken place three years earlier between the Prince of Wales and Camilla Parker Bowles. These stories were favoured by the tabloids but the mixture of royal scandal, invasion of privacy and the chance to lambast the tabloids meant there was plenty of copy for the broadsheets.[10]

Also in January 1993 Calcutt published his second report. It called for a statutory Complaints Tribunal with wide-ranging powers to restrain publication, require the printing of apologies, and impose fines and award costs.[11] The recommendations also included the creation of new offences of electronic eavesdropping, the use of telephoto lenses, and intrusion into private property where there was no public interest defence.[12] They did not prevent photographs being taken and published which were an invasion of privacy – notably the *Mirror* Group's payment of as much as £300,000 to an amateur photographer for pictures of the Princess of Wales pulling weights taken without her knowledge or permission (7–8 November 1993).[13] These 'Peeping Tom' pictures brought the PCC close to collapse. Regardless, the government continued to support the PCC, notably after the former Tory Cabinet Minister Lord Wakeham was appointed to head the commission in November 1994. He reviewed the system of appointing its sixteen members and ensured it had a non-press industry majority for the first time. After considering its response to Calcutt's recommendations for two years, in 1995 the government decided not to implement them and chose to continue to support self-regulation.

The PCC has continued to be affronted by tabloid invasions of royal privacy. The *Mirror* in particular continued to attack the Duchess of York in 1996 (see week beginning 30 September), but that year stories about the Princess of Wales proved the biggest draw. Indeed, the *Sun*'s eagerness to 'expose' Diana led it into a trap. It accepted the authenticity of a video claiming to represent the princess with James Hewitt, and it used many stills to illustrate its story 'Di Spy Video Scandal' (8 October). The next day the *Mirror* revealed that the video was a hoax (not of its making). The *Sun* had to publish a fulsome (or 'grovelling') apology and the broadsheets scoffed at the *Sun*'s readiness to see what it wanted to see and its failure to tell fact from fiction (9 October). In a letter to the editor of *The Times* Lord Wakeham made it clear that invasions of privacy 'without any defence of public interest' were unacceptable. He warned the press that the PCC has 'powers to raise its own complaints when it needs to – and will not hesitate to use them' (10 October). In other words, the reluctance of royals to complain to the PCC would not prevent it from pressing charges of its own against newspapers that broke the code of practice, though Lord Wakeham preferred to encourage self-regulation.[14]

Apart from upsetting the PCC with royal-baiting and high-profile stories about sex scandals, the press is well versed in self-censorship. It constantly polices what pictures it will publish, and is quick to denounce those who mistakenly believe that editors will publish any unusual picture without regard to the presumed good taste of their readers. For example, in 1994 an undertaker's assistant tried to sell the *Sun* photographs of the body of Sir Matt Busby, the revered manager of Manchester United football club, as he lay in his coffin. Instead of collecting a small fortune the undertaker's assistant found himself questioned by the police and advised to go into hiding from angry fans.[15]

Editors usually have to make harder decisions about what to publish, and sometimes they have to respond to complaints from the public. The PCC advises them on professional conduct in gathering news, takes up the public's complaints, and publishes its findings; the code also offers the public the chance to reply and invites newspapers to print corrections or adjudications. Editors, guided by the code of practice, advise journalists on accuracy, misrepresentation, harassment and privacy. Editors do not demand that every journalist should sign the code as part of their contract of employment. At present, only editors agree to abide by the code, which remains, nonetheless, a broadly accepted and workable system of self-policing. Essentially, the code is a 'paper tiger', but thus far it has enabled editors to avoid new laws.[16]

The code does not attempt close definitions: clause 10 demands that 'In cases involving personal grief or shock, enquiries should be carried out and approaches made with sympathy and discretion', though the interpretation of these terms is left to everyday 'common sense'.[17] Following the death of Princess Diana, Lord Wakeham proposed that, for the sake of the families involved, the code should 'normally' expect 'due sympathy and discretion' at times of grief or shock not only from journalists but also from the editors who are responsible for the publication of stories – though their judgement still depends on 'common sense'.[18]

Most of the code is a practical guide. Other clauses ask that journalists 'generally' should not name 'innocent relatives and friends', should not intrude upon children without the consent of responsible adults, should not name the victims of crime 'unless, by law, they are free to do so', and should not make 'prejudicial or pejorative reference to a person's race, colour, religion, sex or sexual orientation or to any physical or mental illness or handicap'.

After the death of the princess, Lord Wakeham invited newspaper editors to discuss what to do about photographs of public figures in personal or private moments, and as a result he proposed to tighten the code. He suggested that the press should not publish pictures obtained through 'persistent pursuit' or 'unlawul behaviour' such as trespass or stalking. It was unacceptable to obtain photographs by means of motorbike chases and hounding, and editors who printed such pictures would be subject to 'severe censure' by the PCC. Editors should be obliged to check how photographs had been obtained and picture agencies should be 'encouraged to come within the jurisdiction' of the PCC. Photographers should not harass their subjects and should stay at the scene no longer than necessary for the 'public interest'. In a similar vein, 'children of figures in the public eye' should not be harassed and minors should not be able to sell stories to the press.

To protect privacy, and to raise journalistic standards, Lord Wakeham suggested that the PCC should build on the concept of 'overriding need', an idea already contained in the clause on payments for witnesses. Wakeham wanted to set 'a higher threshold' for 'overriding public interest' than the existing clauses on harassment and children, though he offered no concrete amendments.[19] In fact, while most of the proposals clarified the code, it was equally clear that by upholding self-regulation Wakeham was trying to bind editors to a new measure of restraint. Editors were determined not to be tied more firmly than suited them.

In suggesting those revisions of the code, Lord Wakeham was responding to a rare, possibly unique set of circumstances. His intervention left many areas unexamined. Obviously, it is problematic to link higher standards with stricter self-censorship. If public awareness of horrible events is regarded as a standard, it is possible to argue that

excessive forms of self-censorship, such as deciding not to use grim photographs at all, could lead the press to even lower standards.

Indeed, the code has no comment on the press's role as a sphere of controversy. It seems mainly concerned with containment. The chief moral obligation it lays on journalists is to 'protect confidential sources of information'. There is no assessment of what is appropriate behaviour, beyond the above recommendations. This is not surprising, as there is no fixed or universally agreed understanding on the matter in the media or anywhere else.

Definitions of correct or acceptable news change with time. Consequently, the code has altered since its inception, though the death of Diana concentrated the minds of Lord Wakeham and newspaper editors, spurring them to offer new assurances on privacy and decency. The sense of propriety has shifted recently towards 'protection' and away from 'exposure'. One measure of that change has been the government's decision to incorporate the European Convention on Human Rights into British law. The Human Rights Bill is expected to allow the courts to rule that victims of press intrusion may seek recompense in the British courts for the first time, claiming that a 'public authority' such as the PCC has been unable to provide them with redress.[20] The Bill will obviate the need for special privacy legislation while not aiming to curb the responsible use of the press's freedom to investigate.[21] But the press's code of practice, if it is to survive, must be part of the evolving 'human rights culture'. Crucially, altering the code contributes to the new decorum as well as being evidence of it.

Given the difficulty of defining a universal, public sense of propriety, the code, not surprisingly, concentrates on matters which can be judged according to current taste, or put into practice by editors and journalists. The code's practical slant means that editors are expected to be able to follow it. Doing this is not always straightforward. For example, the nature of 'private' and 'public' sometimes overlaps confusingly, and the 'public interest' is often ill defined, which has allowed editors to interpret the code according to their own interests.

The code of practice allows a wide range of newsworthy photographs. Apart from existing restrictions on obscenity, their publication is limited only by editors' judgement about the market position of their paper and of what readers will stand. Before the proposals to change it following Diana's death, the code did not ban journalists' eyes or camera lenses from peering into what were clearly intended to be private spaces. It drew no clear distinction between 'public' and 'private'. Public figures might be photographed even when they ceased to be 'on duty', when they were on private property and may have thought they were safe from prying eyes. Photographers could take pictures of someone in their garden as long as they were 'within the unaided view of passers-by'. This guideline allowed photographers considerable leeway to invade the privacy of 'celebrities' if cameras were used in the line of sight, though the code stipulated that the use of 'long lenses' is not 'generally acceptable and publication [of photographs] can only be justified when in the public interest'.[22] At the same time, the code ruled that some ambiguous spaces, those which are not entirely private or clearly public, like hotel bedrooms, hospitals and nursing homes, must be treated as private.[23] In his revisions of the code Lord Wakeham redefined a 'private place', for the purposes of the press, as covering the interior of a church, a restaurant and other places 'where individuals might rightly expect to be free from media attention'.[24]

The expanded definition of 'private place', along with the attempt to restrict the

market for intrusive imagery, may alter the way the press treats newsworthy individuals. The climate of opinion regarding certain types of home news and the photography of horrible incidents appears to have changed, and is still changing. Ideas about news, the entitlement to privacy and the right to see mean that contemporary views on decorum and decency are unlikely to be the guiding principles of news production. Fluctuations in guidelines or their interpretation are inevitable and interesting chiefly because of the light they throw on what bad news contributes to present-day knowledge.

The code does not mention good or bad taste, but the issue of taste is constantly under review. Editors are encouraged to limit the publicity given to horror by observing informal guidelines on taste and decency which are related more to a newspaper's own history, its place in the market and the practice of its rivals than to any such measures which exist outside the industry. These self-imposed guidelines centre on restricting the display of dead and badly injured bodies, and reflect audience research indicating that people do not want to see dreadful events in too much detail.[25]

Compared with newspaper editors, media producers have to follow more explicit instructions. The BBC's *Producers' Guidelines* of 1996 propose that:

- The dead should be treated with respect and not shown unless there are compelling reasons for doing so.
- Close-ups should generally be avoided.
- Do not concentrate unduly on the bloody consequences of an accident or terrorist attack.
- Avoid using violent material simply because it is available.
- The same value should be placed on human life and suffering whether it occurs at home or overseas.[26]

The *Guidelines* continue: 'Deaths reported in the news are real. The best way to reflect this reality is by taking obvious care to respect the privacy of those involved. There are almost no circumstances in which it is justified to show executions or other scenes in which people are killed or are dying'.[27] This recommendation extends to people killed in war.[28] In 1993 the *Guidelines* had suggested, 'When these scenes are justified they must not be lingered over,' but by 1996 producers had less leeway, and were being told that 'Editing out the bloodiest scenes need not result in a sanitised version of events' and that the reality of tragedy is conveyed in 'a good script'. This reality may be achieved without blood or natural sounds by using 'still photographs [which] can sometimes convey the horrific reality of a situation, without shocking to the same degree as moving pictures'.[29]

The limits on representing awful sights are clearly drawn, and they cause problems for television reporters, who find themselves unable to record events as they find them. The BBC's former war correspondent Martin Bell, who described himself in 1995 as a 'fierce BBC loyalist', complained that censorship for reasons of 'good taste' (rather than politics) prevented him from reporting the reality of war in Bosnia. He was forbidden to show bodies, or even blood, for fear of breaking the guidelines then in place.[30] Bell wrote, 'in our anxiety not to offend and upset people, we were not only sanitizing war but even *prettifying* it, as if it were an acceptable way of settling disputes, and its victims never bled to death but rather expired gracefully out of sight. How tactful of them I thought. But war is real and war is terrible. War is a bad taste business.'[31]

At 'News World '96', a conference attended by five hundred international news broadcasters in Berlin, Bell called for an end to 'bystander's journalism' based on the

tradition of detached and neutral reporting.[32] Bell insisted that journalists could not remain neutral when faced with genocide. He was arguing for analysis of events by eye-witness reporters and against the practice of 'rolling news', which means that journalists on the spot are able only to recite words fed through an earpiece by a producer in London. His attack on what he called 'puppet journalism' was criticised as misguided by Lucian Hudson, a senior editor on the twenty-four-hour international news channel BBC World, who said that 'the journalism of attachment' was very risky because it left journalists open to accusations of manipulation, persuasion, coercion and propaganda.

Though Bell and Hudson were discussing two different types of broadcast, the row was based on the widespread belief that authenticity in journalism depends on the myth of the neutral witness. From Bell's point of view, the BBC is so concerned with its reputation for neutrality that it will not risk giving offence. Bell conceded that the depiction of gore might be read as a partisan act signifying moral revulsion, but he was ready to countenance the danger. He did not believe that the BBC should show everything the journalists themselves saw or filmed. But, he claimed, 'people have to be left with some sense of what has happened. To do otherwise is to present war as a relatively cost-free enterprise and an acceptable way of settling differences.'[33] He argued that the old 'dispassionate' war reporter could be quite comfortable in carrying out his craft. There was no need to be unflinching in reports because 'nothing is left in the coverage that he has to flinch from. No need to be compassionate, because nothing is left that he has to care about.'[34] There is no evil or suffering or grief, 'just a passing show, an acceptable spectacle'. Bell insists, 'We should flinch less. We should sometimes be willing to shock and to disturb. We should show the world more nearly as we find it, without the anaesthetic of a good taste censorship. And if we do not, then perhaps we should ask ourselves whether we are merely being considerate, or *indifferent*'.[35] Evidently the BBC had always preferred euphemism, which it believed viewers would understand to be equivalent to detached observation.

A similar argument for and against 'involved' reporting was carried forward in the broadsheet press in 1996–97 as a result of doubts concerning the authenticity of footage shot at the detention centre at Trnopolje in Bosnia in 1992, and the debate among journalists seems to have been sharpened by events in the Balkans from 1993. Ed Vulliamy, the *Guardian*'s reporter in Serbia and Bosnia, who publicised the concentration camp in Omarska and the centre at Trnopolje, asserted that journalists are involved whether they like it or not. Their actions have consequences: the Serbs murdered nine prisoners at Trnopolje for speaking to him and to the television broadcasters of ITN.[36]

In 1993 the arguments over propriety surfaced in a disguised form when the BBC television news presenter Martyn Lewis questioned the amount of bad news in the bulletins, and suggested that there might be more room for 'good news' stories.[37] Though Lewis was mocked for his attempt to make people feel better by reporting 'positive' and not 'negative' stories, his intervention forced journalists to justify their determined coverage of bad news in a debate carried largely in the broadsheet press. A leading editorial in the *Independent on Sunday* summarised the case against bloodless reporting, but concluded that 'If we had more of Mr Lewis's good news, we might take more note of the bad': 'Pictures of slaughter in Bosnia or misery in Africa may stir the conscience. But, removed from proper understanding of how and why these things happen, they can easily become an exercise in voyeurism, a luxury for the citizens of more stable and prosperous societies. And, in the end, we become blasé. We see a succession of scandals,

a succession of injustices, a succession of emaciated bodies. One seems much like another. We shrug our shoulders and settle down to the next' (2 May 1993).

This leading article made the 'universal' point that repetition bores people, and must be relieved by variety. It brought together the main reactions to bad news and set them out in descending order of worthiness: conscience, voyeurism, boredom. The article justified current broadsheet practice, which attempted to defray voyeurism with explanation and analysis, and so defended the use of horror pictures as long as they were used within this fuller context. By implication, the editorial attacked the simplicity of the tabloids, which appealed to voyeurism with little explanation, little room for understanding and scarcely any discursive grounds for action. In short, Lewis's intervention became a story about how some papers are more responsible than others, though (unlike the BBC) none is constrained by a parliamentary charter and a Chair of Governors who is a political appointee.

The struggle between broadcasters and their managers is not the subject of this book, but the BBC's policies on what it is proper to show and allow to be seen does inform the general climate on propriety and the public record. Apart from rules governing war reports, the BBC has strict guidelines on covering crime. Crimes must be exceptional, and must raise issues of significance, or new points of law. Gruesome details should be avoided, along with shots of blood, wounds and reconstructions (except those organised by the police).[38] The BBC does not invent these guidelines in a vacuum. It is responding to an agenda on taste and decency which is often set by narrow interests and pressure groups, and centred on sex and violence. For instance, according to the journalist Jaci Stephen, writing in the *Guardian* in 1995, the Broadcasting Standards Council (BSC), which put pressure on broadcasters, was then 'made up of white, middle class, middle-aged individuals' who complained about too much 'sex, violence and bad language' on television – views which were taken up by right-wing tabloids.[39] Stephen ridiculed the *Daily Mail* for attacking what it called the BBC's diet of 'under-age sex, lesbianism and violence' and for calling Channel 4's chief executive Michael Grade its 'Pornographer-in-Chief'. Though the press interacts with television, with each ready to draw from and comment on the other, Stephen highlighted how statements by the conservative BSC were picked up by the *Mail* and used to set the BBC's agenda on 'taste and decency'. Liberal *Guardian* journalists are unlikely to air in public the same views as *Mail* writers, though the broadsheets regularly discuss such views and broadcasting standards.

The regulation of standards is always under review: the BSC merged with the Broadcasting Complaints Commission to become the Broadcasting Standards Commission from 1 April 1997 and continues to represent the interests of consumers of radio and television. It considers complaints about unfairness and unwarranted infringements of privacy from those closely affected, or complaints from anyone about the portrayal of violence, sexual conduct and matters of taste and decency in broadcasts and advertisements. Whatever the press made of the council when it was perceived, by some, as too close to the conservative press and too ready to attack the broadcasting media, it remains one route (in the form of the commission) for the public to take part in the continuing debate among press and television journalists about the content and presentation of news. The nature of news, access, genres and the range of opinions represented suggest that the resulting public record is diverse, argumentative and unofficial, and that contests over professional practice indicate that varied journalism is 'good news for democracy'.[40] However, this assessment fails to notice that the debate

Kabul victors put mercy to flight. Taliban fighters celebrate by the bodies of Mohammed Najibullah, former Afghan leader, and Shahpur Ahmadzai, right, his brother. *Observer*, 29 September 1996. B.K. Bangash/AP

about the public record, as well as the record itself, exists within a circumscribed world of news reporting already limited by a sense of propriety and practices of containment. The uses of photography are as diverse – or as narrow – as the papers themselves. The kaleidoscopic nature of the press, the way it appears to be random but conforms to underlying rules and past practice, means that the bewildering number of photographs published every day may also be organised according to type. The orderly use of photographs is tied to what makes 'news', and so it is possible to discern some fundamental principles which help to define the 'field' of possibilities.

Regular horror

Views about horror, and to what extent it may be put on show, differ according to time and place.[41] In any period there will be public opinions on what is reviled or repugnant, and what should be suppressed.[42] Whatever the public systems of suppressing knowledge, the attempt to disavow dread and disorder is doomed to failure. Horror is reviled, and yet it is compulsive viewing; it is shameful and pleasurable; it is controlled, and available everywhere. Most important, the management of horror by government and by media representatives reveals their fear that realism may frighten or inflame the public: that which is most disgusting and disturbing is exactly that which is most political, most governed by laws against gross indecency and laws or guidelines on

material which is thought to be sexually perverse or violent. Modern societies tighten their hold over subjects, and one means to this end is to enhance both the sense of repugnance and decorum in public spaces. Surprisingly, perhaps, the progress in the press's response to taste and decorum is a measure not so much of its humanity as of its efficiency in measuring both the extent of injury and also the number of images of bodily harm its audiences will withstand.

Displays of the body in the press are a matter of changing custom. At different times the tendency may be towards seeing more of the body or towards restraint. This is almost entirely a matter of editorial judgement, and not something for which legislation exists. The media's guidelines on taste and tone are the signs of civility and fear, describing the tension which exists between the desire to look and its prohibitions. For instance, it is rare to see photographs of corpses which could be recognised by readers such as relatives of the deceased person, or to see close-ups of mutilated bodies, though editors often print photographs of dead or dying foreigners. This is routine if the images satisfy that staple of newsworthiness, the climactic moment of death. For example, in 1988 the *Mirror* published a photograph of three jets colliding at an air show in Germany. The accident killed the three pilots and fifty spectators, but the main interest was in the spectacular photograph of the aircraft beginning to disintegrate: the caption read, 'Split second of death' (2 September). In another example the *Mirror* carried a front-page photograph of two airport workers hanging from the underside of a Zeppelin trying to land in Giessen, Germany, in 1994. The airship had been caught in a gust of wind and took off without warning, with the ground crew still holding on. The men failed to jump clear and hung on for fifty seconds until the airship was 330 ft above the ground. The headline ran, 'Seconds from death' (31 May). These stories were represented within the style of British accidents: the *Mirror* did not use especially gruesome photographs. The horror rested in what was beginning to happen and what came next, which was described rather than pictured.

The desire to get close to the moment of death is satisfied regularly in coverage of foreign murders and political assassinations. In 1991 a front-page photograph in the *Mirror* screamed, 'Five seconds to live – Gandhi face to face with his assassin,' with a helpful arrow pointing to the back of the female killer's head, and inset portraits of her and another victim (the photographer also died in the explosion) (29 May 1991). Though the tabloids specialise in this type of full-colour horror on the front page, often with more details inside the paper, broadsheets are also fond of pictures of foreigners taken near the moment of death. For instance, following the Kurds' uprising at the end of the Gulf War in 1991 the *Independent* printed a photograph of an Iraqi soldier lying among corpses, begging for his life before being killed (11 October 1991). In 1994 the *Observer* published a colour photograph on its front page which showed a paramilitary soldier about to shoot a pro-democracy demonstrator in Port-au-Prince, Haiti (2 October 1994).

In 1996 only the *Sunday Times, Independent* and *Observer* used photographs of the bodies of former leaders shot and strung up in Kabul by the 'fanatical Taliban' soldiers who had captured the city (illustrated opposite). Next to a miniature colour photograph the banner headline in the *Observer* ran, 'Bodies are swinging from poles. Medieval revenge and harsh Islamic justice have arrived in Kabul' (29 September 1996). The newspaper used a much larger and fuller version of the image in black and white on an inside page under the headline 'Kabul victors put mercy to flight'. The paper justified its use of these graphic photographs with the caption 'Eyewitness', but the main effect of the

Serbs turn on second safe haven. 'In a crowd of over 10,000 refugees
sprawled across Tuzla's cornfields, a young woman hanged herself
yesterday. No one knew her name. No one wept for her when her body
was cut down from a tree, and only a single policeman kept vigil over the
corpse as it lay abandoned by the gate of the heaving, sweating camp.'
Guardian, 15 July 1995. Darko Bandic/AP

pictures and the headline was to support the paper's general hostility to Islamic
fundamentalists.

Though photographs similar to these may come a little closer to the climactic moment
than is usual in reports of disasters in Britain, foreign stories still depend on common
industrial practices for their newsworthiness and truth-value. They are presented as
'hard' news or factually correct. In order to boost its authority as purveyor of fact as well
as opinion, the press relies on faith in the authentic nature of documentary photography
to anchor its written accounts in truth. The *Observer* story of executions in Kabul was
substantiated by the photograph, and though the caption reveals the paper's
understanding of the Talibans, neither the image nor the text breaks with established
practice in representing revolution in Islam.

Of course, editors ignore guidelines on good taste if they believe the story warrants

it, but they are quick to respond to readers' criticism of shocking photographs by printing the range of opinion on the letters page. The letters may condemn editors for using pictures which are too upsetting or congratulate them for having the 'courage' to print such images and allow people to see the 'reality' for themselves. An example from 1995 demonstrates the stability of news standards relating to shock photographs: the *Guardian* was the only British newspaper to publish a photograph (in colour) of a woman who had hanged herself as the Bosnian Serbs attacked Muslims in what had been the UN safe haven of Zepa in Bosnia. The photograph (reproduced opposite), by Darko Bandic, did not show the woman's face. Shocking as it was, it remained within the limits of newsworthy photojournalism. There was no caption, but a report by Julian Borger was printed in large type beside the image. It read, 'In a crowd of over 10,000 refugees sprawled across Tuzla's cornfields, a young woman hanged herself yesterday. No one knew her name. No one wept for her when her body was cut down from a tree, and only a single bored policeman kept vigil over the corpse as it lay abandoned by the gate of the heaving, sweating camp' (15 July 1995).[43]

This was 'A picture that attracted a thousand words' from *Guardian* readers. The photograph provoked the normal range of opinions: publishing it showed 'no respect' for the woman, and, more tellingly, it would not have been printed if the suicide had been in Britain; it produced a call for military intervention; it provoked readers into calling for the woman to be named, to prompt the beginnings of a women's movement in the Balkans; it stood for suffering and waste; it was a cynical ploy to sell the paper, which had otherwise failed to take a moral stand when the situation demanded 'a stronger humanitarian editorial line' (18 July 1995).

The *Guardian* was unlikely to be censured by its peers because, though the picture '*fills the sight by force*', it does so within several established types of newsworthiness and story-telling which include topicality, actuality, outrage, impotence and various levels of indifference to suffering and despair.[44] However, the criterion of newsworthiness cannot control, determine or limit absolutely the meaning or use of this or any picture: in August 1995 Amnesty International used the photograph of the suicide in Zepa in its publicity, accompanied by the caption 'Because we do nothing'.

Judgements about stories similar to this suicide are the context of the *politics* of horror pictures, or what pictures are made to say, by whom and for what special purpose. Media images or discourses are not unreal 'shadows in the cave'. On the contrary, images and texts are part of real industries with social force and cultural power. The press uses pictures as clues, causing them to ' "talk" as mute witnesses', coaxing them 'into *telling a story*'.[45] This means that the publication of the pictures in itself constructs the 'public' – the truly shadowy realm which is to be found only as it is imagined in publicity. In contemporary times, in Britain, the actual display or concealment of grisly pictures in the media is significant in itself as a representation of what is public knowledge.

The broadsheets' many scenes of brutal murder are often found in a larger, sometimes political, setting or, at the very least, within the bounds of irony and shame that characterise human interest stories. In 1994 a story in the *Sunday Times* achieved meaning in all these areas. The paper used a sequence of several photographs which showed moments leading up to and moments after the killings of Alwyn Wolfaardt and two of his fellow Boers from the Afrikaner Resistance Movement (AWB). They had gone 'to kill some kaffirs' in the black homeland of Bophuthatswana but they were themselves shot dead by a black policeman 'who said they deserved to die'.[46] The headline read,

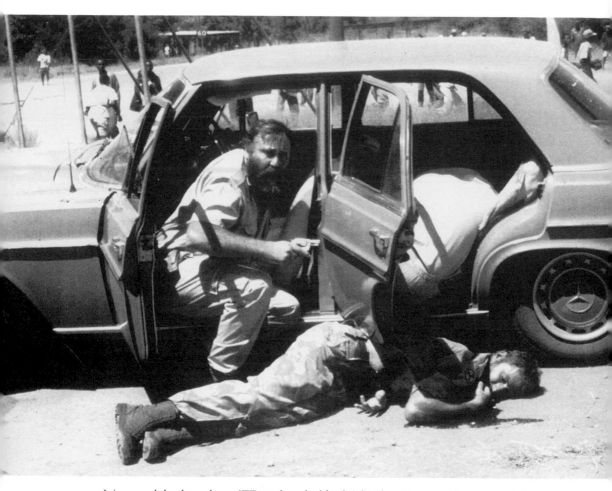

Lying wounded and scared, two AWB members plead for their lives but get no mercy from a Bophuthatswana soldier who said they deserved to die. Rough justice: three escaping AWB members confront Bophuthatswana soldiers on a street in Mmabatho after a gun battle. *Sunday Times*, 13 March 1994. Bradley Arden/AP

'Boers bay for revenge on "kaffirs"', though the four accompanying photographs showed how the tables had been turned and how the men had died (see illustration above). The context of this report in the British press was threefold. First, the Western press and media understand Africa, specifically, to be lawless and unreasonable. Madness, fanaticism and blood lust are clearly on the surface 'out there'. Next, the story was bitterly ironic, even without the headline. Finally, the story was an expression of widespread support for President F. W. de Klerk and Nelson Mandela, then president of the African National Congress, against the AWB, led by the extreme right-wing Eugene Terre Blanche.

The story was followed up several weeks later by the *Independent*, which printed three more photographs under the headline 'Alwyn's Last Trek'.[47] The article, by journalist David Cohen, gave information on Wolfaardt's history of support for the AWB based on interviews with Wolfaardt's family and friends. While the report was factual in tone, the Afrikaners condemned themselves by their racist views. The overriding sense

was one of irony, suggesting that Wolfaardt and his colleagues had played a large part in destroying themselves. The photographs, while not showing the moment of the killing itself, or the men in their death throes, were unusual in that they juxtaposed Wolfaardt alive and pleading moments before his killing with his body then slumped among the spreadeagled corpses of his friends. Shocking without being gratuitous, the pictures seemed to fit the bitter story. The photographs of Wolfaardt and his colleagues are an example of how editors try to limit what they publish to fit the general view of what may appear in public, even though they cannot know exactly how their audiences will receive such pictures.

What the media show in photojournalism must be newsworthy and not too detailed. Consequently, it will differ from police or forensic photographs presented as evidence in court, which lawyers shield from the public gaze. It is tempting, but erroneous, to describe this editing and sifting as a conspiracy of censorship which denies the public what they have a right, or what they want, to see. Censorship does not stand aloof, but is part of the process of establishing consensus among publishers; it too changes over time, and in different publishing and broadcasting arenas. There is nothing about the censorship of the media or about its own self censorship which is fundamentally different from other ways of communicating in public in everyday life. Regulation is the norm, whether it is effective at the micro-level of the individual or, failing that, at the macro-level of civil society. Not everything that can be seen or said is in fact shown or spoken, and authorities of every stripe exact penalties if they think one sector of their industry has published unacceptable sights and sounds.

Restraining body horror

The problem for the press is how to represent the body, specifically the magnitude of hurt, injury and death. Though the press struggles to stay within its own codes on what it is proper to say and show, it aims to prevent new press legislation, chiefly in relation to privacy and the body. With certain localised and predictable exceptions, such as a flurry of interest and indignation arising from a spectacular event, the press is symptomatic of current morality and not a rallying point for intervention. Photographs of past events, especially disgusting pictures of misery and retribution, float in this industry without necessarily provoking any discernible action. Its tendency to 'look on' lays the press open to accusations of voyeurism. At the same time, pressure groups in favour of censoring the media suspect that seeing violence or sex on film and television, especially, but also in words and pictures can provoke illegal acts. They seek to curtail or otherwise manage what is seen in order to stamp out copycat crimes, dampen unwelcome passions, forestall popular movements and deter political agitation.

While the limits of privacy and press freedoms are constantly under review, as well as always being contested by professionals, the guidelines and procedures for complaint are chiefly activated by sex and violence rather than by hard news reportage. This latter type of story seems to be governed by the press's assessment of public squeamishness, which has cultural and political dimensions. Whereas Martin Bell deplored the tendency of his industry to prettify death, in 1995 Germaine Greer felt that both television and newspapers had only lately begun 'the Technicolor portrayal of atrocity in close-up'.[48] She asserted that until recently the tone of newspaper reports of horrors was 'detached rather than ghoulish, [with] grisly detail neither sought nor invented'. The main reason

she gave for the increasing 'search for sensation' was simply that people had become 'jaded'. Bored by a surfeit of images, and bored by peace, the 'population' will always prefer the thrilling spectacle of someone else's hideous death to tempered violence, or to the 'duelling' of peace talks. Unlike Bell, who charged the media with being too restrained, Greer complained that the imagery of death was now more graphic than formerly – though she did not say exactly when the 'tone of newspaper reporting of atrocities was judicious'. Indeed, her brief article is interesting chiefly because it is a lament for some earlier, ideal time in reportage when editors were supposedly careful and discreet, and also because she adopted a familiar position about how standards had slipped, with more horror available than before.

This debate on standards usually centres on good and bad taste. Those who want to see representations of dreadful events are stigmatised as ghoulish or jaded, and censorship is encouraged because prurience is ugly, unrestrained and possibly immoral. The debate rarely centres on the political and historical consequences of seeing images of appalling crimes or of being prevented from seeing them.

Others argue from different positions. At times journalists are seen as 'watchdogs', warning the world and politicians of the consequences of their actions, though this role may be regarded as futile or self-deluding. ITN's reporter Nik Gowing asked whether horrible pictures from Bosnia had any impact on state policy or merely elicited personal distaste among politicians. He concluded that television might help to highlight problems, but 'when governments are determined to keep to minimalist, low-risk, low-cost strategies, television reporting does not force them to become more engaged'.[49] This assessment echoes and complements Susan Sontag's views on the 'analgesic' effect of photography.[50]

From a completely different perspective, in 1995 Madeleine Bunting maintained that the press itself has no real sense of duty to truth or history, let alone a sense of fair play to individuals. She wrote that the press's 'cry of freedom' was 'phoney', and its effect had been to reduce the industry to the status of a 'harlot', without morals or scruples. Bunting claimed that the press would flout the law and any sense of good taste to publish a story. She blamed the tabloid press chiefly for allowing 'free market forces' to justify its 'contempt for privacy and propriety', and challenged 'liberal critics' to counter the press's lack of morals. The press decides what it will print, and often invades privacy, shows no respect, and does not observe what is proper and seemly.[51] The arguments of Bunting, Bell and Greer, and their lack of resolution, express the current high anxiety about the human body, especially the contemporary squeamishness about showing it as diseased or injured.[52] These points of view are the context of the politics of looking at revolting pictures, regulating them or hiding them away.

Notes

1 Jeremy Tunstall, *Newspaper Power. The New National Press in Britain* (Oxford, Oxford University Press), 1996.

2 A. David Gordon, John M. Kittross, Carol Reuss and John C. Merrill, *Controversies in Media Ethics* (White Plains, New York, Longman), 1996; see also Andrew Belsey and Ruth Chadwick, *Ethical Issues in Journalism and the Media* (London, Routledge), 1992.

3 Stanley Reynolds, 'Curtains for a freak show', *Guardian*, 21 November 1989.

4 Guy Cumberbatch and Dennis Howitt, *A Measure of Uncertainty. The Effects of the Mass Media* (London, John Libbey), 1989.

5 Ian Connell, 'Personalities in the popular media', in Peter Dahlgren and Colin Sparks (eds), *Journalism and Popular Culture* (London, Sage), 1992, p. 66.

6 John Keane, ' "Liberty of the press" in the 1990s', *New Formations*, 8 (1989) 35–53; John Keane, *The Media and Democracy* (Cambridge, Polity), 1991; Alan Rusbridger, *The Freedom of the Press, and other Platitudes*, James Cameron Memorial Lecture 1997, *Guardian*, 1997; Alan Rusbridger, 'The freedom of the press ... and other platitudes', *Guardian*, 24 May 1997; Piers Morgan, 'Cry press freedom', *Media Guardian*, 9 June 1997; Alan Rusbridger, 'Why are we the libel capital of the world?', *British Journalism Review*, 8:3 (1997) 25–30.

7 Raymond Snoddy, *The Good, the Bad and the Unacceptable* (London, Faber and Faber), 1992, p. 95.

8 Bill Hagerty, 'Showdown at the Last Chance saloon', *British Journalism Review*, 3:3 (1992) 26–9.

9 Jane Thynne, 'Threat of legislation used to curb excesses', *Daily Telegraph*, 9 April 1994.

10 Roy Greenslade, 'How MI5 tried to sink Prince Charles', *Guardian*, 9 October 1996.

11 National Heritage Committee, *Privacy and Media Intrusion* (London, HMSO), 1993; Andrew Culf, 'Editors scorn new press safeguards', *Guardian*, 25 March 1993.

12 National Heritage Committee, *Privacy and Media Intrusion. The Government's Response* (London, HMSO), 1995; Andrew Culf and Rebecca Smithers, 'Government retreat on press privacy', *Guardian*, 18 July 1995.

13 Cassandra Jardine, 'A case of indecent exposure', *Daily Telegraph*, 19 July 1995.

14 Roy Greenslade, 'A total eclipse of the *Sun*', *Observer*, 13 October 1996.

15 Martin Whitfield, 'Pallbearer in hiding after anger over Busby pictures', *Independent*, 3 February 1994.

16 'Paper tiger leaves editors purring', *Guardian*, 26 September 1997.

17 *Code of Practice, Press Complaints Commission Briefing* (London, Press Complaints Commission), 1990.

18 'Lord Wakeham unveils radical proposals on privacy and the paparazzi. New code will be "toughest in Europe" ', press release (London, Press Complaints Commission), 25 September 1997.

19 *Ibid.*

20 Alan Travis, 'Judges win power in historic bill', *Guardian*, 25 October 1997.

21 Alison Daniels, 'Press has nothing to fear from privacy law, QC argues', *Guardian*, 28 October 1997.

22 *Code of Practice*, item 4.

23 See Andrew Culf, 'Press privacy code revised to permit garden photos', *Guardian*, 25 March 1995.

24 'Lord Wakeham unveils radical proposals on privacy and the paparazzi', *ibid.*

25 Ann Shearer, *Survivors and the Media* (London, John Libbey), 1991, pp. 33–36.

26 *Producers' Guidelines* (London, BBC), 1996, p. 63.

27 *Ibid.*, p. 63.

28 Sally Hillier, 'The grim reality: editors' dilemma when handling news pictures', *Ariel*, 6 June 1995.

29 *Producers' Guidelines*, p. 63.

30 Martin Bell, *In Harm's Way. Reflections of a War Zone Thug* (London, Hamish Hamilton), 1995, pp. 211–12.

31 *Ibid.*, p. 215.

32 Andrew Culf, 'BBC man attacks neutral war reports', *Guardian*, 23 November 1996.

33 Martin Bell, 'Here is the war – live by satellite', *Guardian*, 8 March 1997.

34 Martin Bell, 'TV news: how far should we go?', *British Journalism Review*, 8:1 (1997) 15.

35 *Ibid.*

36 Ed Vulliamy, ' "This war has changed my life" ', *British Journalism Review*, 4:2 (1993) 5.

37 Geraldine Bedell, 'Sweetie among the cynics', *Independent on Sunday*, 2 May 1993.

38 Polly Toynbee, 'The channels of fear', *Guardian*, 3 June 1994.

39 Jaci Stephen, 'Little taste, no decency', *Media Guardian*, 31 July 1995.

40 John Eldridge, ' "Ill news comes often on the back of worse" ', in John Eldridge (ed.), *Glasgow Media Group Reader*, vol. 1, *News Content, Language and Visuals* (London, Routledge), 1995, p. 38.

41 T. W. Laqueur, 'Crowds, carnivals and the English state in English executions, 1604–1868', in A. L. Beier *et al.* (eds), *The First Modern Society. Essays in Honour of Lawrence Stone* (Cambridge, Cambridge University Press), 1989, pp. 305–55; V. A. C. Gatrell, *The Hanging Tree. Execution and the English People 1770–1868* (Oxford, Oxford University Press), 1994.

42 Steven C. Dubin, *Arresting Images. Impolitic Art and Uncivil Actions* (London, Routledge), 1992; Tom Crone, *Law and the Media* (London, Focal Press), 1995.

43 Julian Borger, 'Lonely death in a crowded cornfield', *Guardian*, 15 July 1995.
44 Roland Barthes, *Camera Lucida. Reflections on Photography* (London, Jonathan Cape), 1982, p. 91.
45 John Hartley, *The Politics of Pictures. The Creation of the Public in the Age of Popular Media* (London, Routledge), 1992, p. 30.
46 Richard Ellis, 'Boers bay for revenge on "kaffirs"', *Sunday Times*, 13 March 1994.
47 David Cohen, 'Alwyn's last trek', *Independent*, 30 March 1994.
48 Germaine Greer, 'War is hell. We can't get enough of it', *Independent*, 1 September 1995.
49 Nik Gowing, 'Instant pictures, instant policies?', *Independent on Sunday*, 3 July 1994.
50 Susan Sontag, *On Photography* (New York, Farrar Straus and Giroux), 1977, p. 110.
51 Madeleine Bunting, 'A phoney cry of freedom', *Guardian*, 4 January 1995.
52 Geoffrey Goodman, 'Brutality sells, OK ...', *British Journalism Review*, 4:2 (1993) 3–4.

6

Disaster tragedy

Horror in the press

Despite their differences in voice, content and audiences, broadsheets and tabloids are dedicated to the value of horror. It is the normal, everyday practice of the press to lay before its readers somewhat restrained pictures taken in public places of bodies in misery, frightened, and grieving, and sometimes at the point of dying or already dead. Photographs of dead bodies in the press always have a mundane purpose. They are usually tied to a simple morality tale based in the unfathomable play of chance and fate, though historical circumstance and culpability are not forgotten by the press as 'public spheres of controversy'.

The press often reveals more details of misery and viscera in its written accounts than in its pictorial record of the same events. The industry agrees on how to limit the representation of bodies without much guidance from the professional code of practice, which proscribes very little. The thrill of disaster reports does not derive from close-up photography of corpses or body parts but from restrained imagery tied to stories about fatally bad luck.[1] The press governs itself according to estimates of what readers will prefer to look at day after day, erring on the side of the squeamish rather than the ghoulish. The shape of disaster stories derives from much wider social rules than those which loosely guide news production. In fact the industry gives expression to and confirms ordinary, polite ways of looking – in which readiness to avert the gaze or give no more than a quick glance is considered most acceptable.

In the visual depiction of catastrophe, newspapers are more concerned with having authentic, eye-witness photography which editors judge to be within the bounds of decency than with detail that proves too gruesome. The press often settles on similar discreet photographs of wreckage. In picturing disasters, bodies are generally absent or signified by spatters of blood, as in the *Guardian*'s front-page picture of the scene after

The foiling of the IRA. The trail of blood left after a
man was killed during the police raid in Hammersmith,
west London. *Guardian*, 24 September 1996. Louise
Buller/PA News

Israeli troops had killed three Palestinians in Jerusalem (28 September 1996). The gory
aftermath is not at all an unusual subject for press photography, and the *Guardian* had
used an image of a bloodstain only a few days before when the police shot an IRA
suspect, Diarmuid O'Neill, in London: the photograph by Louise Buller (reproduced
above) depicted the trail of blood left on the steps and path as the man's body was
dragged away (24 September 1996). Though the photograph was a sign of sudden death
without showing the body itself, many readers complained that the image was intrusive
and unacceptable in a daily newspaper. It is not clear whether people were offended by
the picture because it involved British police and an unarmed Irishman or because it took
place in London, whereas readers care less about dead Palestinians. What is clear,
however, is that picture editors, duty editors and designers face real difficulty in judging
what their varied readers will find disgusting. Signs of death, as in these cases, are usually
less disquieting than views of corpses. For all that, the dead are frequently represented
and may appear in the foreground or centre of pictures if they are unidentifiable or
covered, or they may be seen uncovered in the distance. Most people in photographs
taken at the scene are very much alive: they tend to be ambulance crews and firemen
saving people or beginning to remove wreckage strewn across a site.

This convergence around certain types of euphemistic imagery is especially noticeable
when stories break overseas, and editors rely on what they receive by wire from the
international agencies. Newspapers which would not write in the manner of other titles
will then use the same or similar photographs as their competitors. For instance, when
TWA flight 800 exploded near Long Island on the night of 17 July 1996, killing 230
people, all the national dailies which led with the story used an image of a large piece of

wreckage floating in the calm sea (19 July 1996). This photograph was taken early in the morning of 18 July by Jon Levy of Agence France Presse, whom the coastguard asked to form a pool comprising photographic, video, print and radio journalists. He described his photograph as a 'metaphor' for the whole plane; Seth Jones, picture editor of the *New York Post*, called the image an 'impromptu memorial'; Michele Stephenson, director of photography at *Time* magazine, chose the image for the cover because it was like a poster – clean and direct, telegraphing the whole story.[2] Levy's image was used so much because it was metaphoric, elegaic and elegant. Its tone suited the mood better than the more explicit image taken by freelance Tony Fioranelli, who had joined the flotilla of small boats at the scene on the night of the crash and had taken a picture of a dead woman held by her limbs face down as her body was transferred from a pleasure craft to a coastguard vessel. The photograph was used by the *New York Post*, *Time* and *Newsweek* but on their inside pages so that it was not staring out from the news-stands. Fioranelli was displeased, because he had been at the scene during the night at moments of high drama and danger, and had witnessed raw news. Regardless of that, editors judged that the metaphorical value of Levy's picture was more suited to the front page than Fioranelli's revelation of dead flesh. They were concerned not to display a corpse that was probably American, certainly a woman and possibly recognisable to her relatives. By curtailing or more strictly farming its pictures of horrible scenes, the US and British press managed to be topical and newsworthy without becoming a dedicated show of morbid horrors. It anticipated ways in which explicit photographs can be subject to prolonged staring or gawping – which are stigmatised ways of viewing that are regularly used to describe long looks at pornographic material. However, it did not deny that impulse altogether.

Home horror

For all the newspapers' historical claims to be 'observers', 'chronicles', 'clarions', and 'recorders', it is an error to imagine that the press is mainly a system of political communication. The press is also the historic repository of gossip and tall stories. The newspapers are not so much almanacs of the times as arrays of passing shows and 'human interest'. But it is equally an error to imagine that the trivial, entertaining elements of the press are mere diversion or relief from political content. This false division ignores the significance of what most people read in newspapers. Since the 1930s, when leading publishers began to commission market research into reading habits, human-interest stories have proved to be the most popular reports in the tabloid papers and those sections of the broadsheets which appeal to voyeurism and titillation.[3] Human interest favours the random forces of luck, fate and chance worked out on the bodies of isolated, discrete individuals in a naturalised, taken-for-granted world. This given world is understood to be stable in its deeper structures but prone to local, surface turbulance and fragmentation.[4]

Stories about disasters may touch on public issues like airport security; they may allow survivors to feel incredibly lucky to have escaped; they may be diverting and entertaining; but they are not simply windows on a multifaceted and diverse world. The existence of fate and mischance as news follows and supports a particular set of beliefs about the world. On the one hand, they tend to skirt around intractable historical and social antagonisms and mask deep-rooted structural inequalities. On the

other, they symbolically unite individuals by inviting them to identify with the supposedly shared experiences of accident, sickness and death. Other news stories and advertisements in the papers encourage readers to comfort themselves with the pleasures of consumption. The ideological significance of what most people read is that the presentation of disorder becomes the restoration of order: 'As bad news enters our heads openly through the front door, so order and normality re-enter largely unnoticed through the back.'[5]

Human-interest stories arise from the sudden collapse of generally reliable systems. The resulting sudden deaths do not make sense, and the concept of pure 'accident' is hard to fathom. In this regard, fate is an important explanation. Though it weighs more heavily in the tabloids than in the broadsheets, fate sweeps through all the papers. It is presented as a universal condition – a mark of unreason and carelessness in nature that tests human frailty and destroys aspiration, hope and progress.

At the same time, journalists and investigators look for rational, material causes for the catastrophic failure of machines and the culpable acts of mismanagement; they seek explanations for breakdowns in diffuse ideas about conduct, civility and social responsiblity. The deep structures are matters for public inquiries, litigation and possibly new legislation. Disasters which were controversial and took up a great deal of space in the press as well as resulting in new regulations include the fire at the football ground in Bradford (1985), the sinking of the Townsend Thorenson ferry *Herald of Free Enterprise* outside Zeebrugge harbour (1987), the fire at King's Cross Underground station in London and the explosion on the Piper Alpha oil platform in the North Sea (1988). All these stories are British, and that is important. The press weighs the value of a disaster as news by the nationality of its victims, which guarantees home sales. In this country a dead Briton is more newsworthy than a greater number of foreigners, and dead 'friendly' foreigners in larger numbers are more newsworthy than vast numbers of dead in far-off, 'unfriendly' places.

Of course, there are exceptions. A dead foreign celebrity, for example, can have more news value than an unknown Briton. At the same time, reporting the deaths of famous individuals can indicate the hierarchy which exists in news. For example, when the fashion designer Gianni Versace was murdered outside his house in Miami Beach, it was a front-page story in all the press (16 July 1997). But only the *Daily Telegraph* carried the story of the brutal loyalist murder of the Catholic Bernadette Martin in Aghalee, Northern Ireland, on its front page. The difference in treatment uncovered what Roy Greenslade called a 'hierarchy of death' in reporting the 'Troubles': 'in the first rank – getting the most prominent coverage – are British people killed in Britain; in the second, the security forces, whether army or RUC; in the third, civilian victims of republicans; and, in the fourth, garnering very little coverage indeed, the victims of loyalists'.[6] The extensive reports of Versace's murder highlighted not only the elevation of celebrity over anonymity but the relative newsworthiness of different types of Britons.

The hierarchy of death has its parallel in photographs. In general, dead bodies in Britain are treated with more respect or restraint than the corpses of foreigners. The simple explanation for this may be that editors choose pictures on the basis of good taste and decency, or at least they realise it may be counterproductive to upset readers with horrifying pictures of identifiable British people. They also seem to assume that the audience's stomach for pictures of dead foreigners is stronger, and guess that such images

are unlikely to provoke complaints from relatives. A rider to the general rule would be that the dead are accorded more respect if they are white, or if they are from Western liberal democracies. As I discuss in chapter 8, the press affords least restraint in depicting the bodies of Arabs, Asians and Africans.

This simple division between the treatment of British and foreign dead bodies can break down. Now and then American, British and European deaths are represented graphically. Consider the case of the woman hanging from a tree in Bosnia (see p. 80) and the detailed imagery shown when two Signals corporals were killed in Belfast in 1988 (see *Sunday Telegraph*, 20 March). Editors always claim these breaches in decorum are for the public good, since, according to the editor of the *Sunday Telegraph*, they transcend 'the merely horrific' (27 March 1988).[7]

Nonetheless, it is unusual to see new corpses, notably murder victims, if they lived and died in predominantly white (and nominally Christian) societies where ideas about death, squeamishness and decency seem to be similar to – or not too dissimilar from – British attitudes. On the rare occasions when a dead, white body appears in full colour in the press it is always accompanied by wide comment, opposition and debate about propriety. But it would be easy (and correct) to assume that when newspapers break with the normal practice in pictorial restraint they are usually trying to steal a march on their rivals in an age of telecommunications which makes old-style news scoops much less common.

Newspapers may achieve this advantage by accident, or because their rivals misjudge the climate and overlook a brutal but iconic picture. For example, Charles Porter, an amateur photographer, took a picture of one-year-old Baylee Almon dying in the arms of a fireman following the terrorist bombing at the Alfred Murrah building in Oklahoma City which killed 168 people in April 1995. (An almost identical image was taken by another amateur, Lester LaRue, and both images were distributed by Sygma.) Porter's cropped picture (illustrated overleaf) became the most enduring image of the bomb. All the British daily newspapers used it except the *Sun* and the *Guardian*. Ken Lennox of the *Sun* said that he chose not to print the picture because two hours after receiving it he had learned that the child had died, and to use a photograph of a dead baby on the cover was 'seldom something we do'.[8] Eamonn McCabe of the *Guardian* chose not to publish the picture because it was 'too shocking', and used instead a photograph of the wrecked building. He later regretted the decision, because the picture of the baby did summarise the event, and was printed by other broadsheet papers including the *Independent*, which toned down the horror of the bloody scene by reproducing it in black-and-white.[9] Though the *Guardian* missed its opportunity when the hard news broke, it eventually published the image in colour on the first anniversary of the bombing on the front page of its weekly 'Review' section under the standard guise of revisiting a major news event (18 April 1996). Presumably, picture editors at the *Guardian* felt the need to 'correct' their earlier oversight, as far as possible, because they agreed with the majority of their competitors that it was the 'best picture'. Bob Bodman of the *Daily Telegraph* said the caption with the photograph when the story originally broke had described an 'injured child', but he would have used the picture even if he had known the baby was dead, because it 'summed up the situation'.[10] The picture has continued to stand for the crime, and was used again when Timothy McVeigh was convicted (3 June 1997).[11]

Disquiet about this photograph is couched both in terms of losing out to the opposition on the news-stands and in terms of what is too shocking. Perhaps most editors

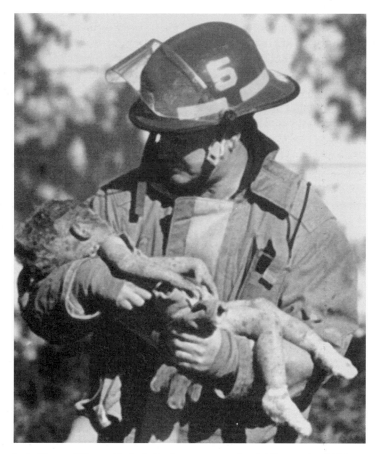

In the Name of Islam ... Plucked alive from carnage as bomb kills 80. [The child later died, and Timothy McVeigh was convicted for the bombing in 1997.] *Today*, 20 April 1995. Charles Porter/Sygma

felt comfortable with the picture in the end because the fireman appears to be cradling and rescuing a living child, and because (though no one said it) the image of a babe in arms is so fundamental to the Christian iconography of love, while the similar Pietà figure is the sign of grief and sacrifice. In other words, what makes this picture 'the best' is its unconscious reflection or reproduction of such a stereotypical and familiar form. Cradling doubles for experiences in life and death: the Virgin Mary cradles the infant Jesus, but that foreshadows her grief over his body in the Pietà. Porter's image strikes this chord, which is so resonant that it silences objections on the grounds of good taste. As Aren Almon feared, the photograph of her baby would linger for years as the key picture of the bombing. The picture will remain a permanent and unwelcome reminder for her personally, but its success and longevity derive from references to (and alterations of) familiar, somewhat generalised, scenes in Western iconography.

The photograph of Baylee Almon did not breach press guidelines and did not create a new benchmark for the press photography of grim sights. The photograph was acceptable because a sign of public service joined with a sign of the death of innocence, and the two signs together stood as a silent, emotive rebuttal of the 'twisted logic' of

terrorists who do not baulk at killing children. Editors look for a combination of signs in a picture which more than doubles their appeal, and publish those which place duty and sacrifice in the forefront of readers' minds.

Photographs of mothers cradling injured babies are standard – even if they have to be 'grabbed' from television. As well as sacrifice, they can signify waste or murder for doubtful political ends, as in the *Daily Mail*'s front-page picture of a mother and child in Sarajevo after 'Slaughter at the Market' (29 August 1995). Indeed, the press frequently uses photographs of babies in the arms of men – notably firemen, policemen or paramedics – if politics is involved. For example, about a month after the Dunblane massacre in March 1996, when the death of children was in the news but unsupported by pictures of the murder scene (see p. 105) the Israelis bombed a UN camp in the town of Nabatiyeh and a refugee centre at Qana in Lebanon. The broadsheets used colour pictures of the dead and injured on their front pages and the *Guardian* chose a rescue worker carrying the bloody 'body of a child' under the comment by Ehud Barak, Israel's Foreign Minister, 'An unfortunate mistake' (19 April 1996).

Similarly, a photograph of a police officer cradling a baby was widely used after the IRA bomb in Manchester in 1996 (16 June). Despite its differences from the simple, bas-relief arrangement of figures in Porter's image, this photograph struck home with British readers. It was near enough in time to the Oklahoma incident to have some resonance, though in this case a live baby proved the destruction of 'innocence' by guilty men. It is a moot point, but the press in Britain would probably not have used a similar photograph of a badly injured or dead baby. Instead, it used a picture which was in good taste, condemned the IRA for trying to kill babies and incidentally praised the police for ensuring no one died.

The search for scoops has led the press to intrude into private affairs, including grief and misery, which in turn has seen the government threaten the press with new legislation. The press has not moved smoothly towards respect for privacy or self-regulation in photographing the victims of accidents. Demands for new laws reached a crescendo in 1990 after the hurricane of 25 January which hit much of Britain and killed thirty-seven people. The most newsworthy individual to be injured was Gordon Kaye, the lead actor in *'Allo, 'allo*, a popular television sit-com. On 13 February 1990 the *Sunday Sport*, which specialises in freaks, pin-ups and sexual advertising, took unauthorised photographs of Kaye in hospital where he was recovering from a serious head wound. (The mainstream industry does not regard the daily and Sunday versions of the *Sport* as rivals in the business of news, so their high sales are not included in newspaper circulation figures.) The comedy actor's agent, Peter Froggart, obtained a High Court injunction preventing publication of the photographs, but on 23 February the *Sunday Sport* successfully appealed against the ban. The judges said there was no right of privacy in English law and so no right of action for breach of a person's privacy, suggesting that Parliament should consider whether the law should be changed to protect individuals from such intrusions. The judges ruled that the paper could print pictures of Gordon Kaye in hospital, but only if it was made clear that they had been obtained without consent. The paper printed a small box next to the front-page picture in which it boasted that 'The snap was taken when *Sunday Sport* newsmen SNEAKED to the actor's bed for the showbiz scoop of the year'.[12] Just as the judges were calling for a new law of privacy, the Calcutt Committee let the press know that it was inclined to offer the newspaper industry one

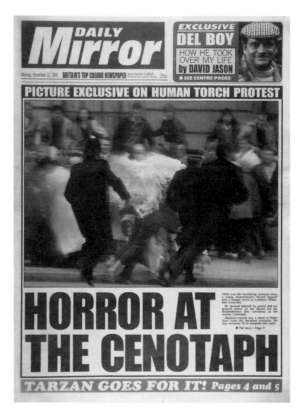

Daily Mirror, 12 November 1990. MSI

more chance to set its house in order. Most of the dailies responded to the first warnings to 'clean up their act' or face the possibility of legislation by introducing stricter self-governance, and eventually by accepting the main practical outcome of Calcutt's inquiry – the Press Complaints Commission's code of practice, instigated in 1991.

Despite occasional aberrations like the Kaye story, since 1989 the press has continued to defend itself against new laws, and has left itself plenty of room to publish gruesome pictures and stories if it feels able to justify them on the grounds of newsworthiness. The *Mirror*'s coverage of the 1990 hurricane stayed within the normal guidelines on privacy and grief, while satisfying the demands of human interest. The *Mirror* chose the photographs of two girls for its front-page story. One portrait was of Emily McDonald, who died in the storm, and the other was of Ellie Tramonte, who narrowly avoided being crushed by an uprooted tree and was pictured later leaning against it with her hand bandaged. The headline was 'Tears of Heartbreak and of Joy' (27 January 1990). The *Mirror* had captured in one page the twin elements of news – good luck and ill fate – without invading privacy in unusual ways and without showing gruesome details. The inside story on the 'victims' also used family portraits and the standard photograph of wreckage.

The *Mirror* is not always so restrained in what detail of death it chooses to show in photographs, especially if the story is hard news. A demonstrator at the Remembrance

Day ceremony in Whitehall set himself alight in what the paper called 'Horror at the Cenotaph' (12 November 1990). The 'picture exclusive' (illustrated opposite) showed the 'human torch', with policemen rushing towards him. The *Mirror* could justify this front-page story because there was a breach of security near politicians and members of the royal family attending the ceremony, because the picture was spectacular but not too close or gruesome, and because the police appeared to be dealing with the problem. In other words the 'Horror' was easily contained.

History and fate

As well as recognising that fate is crucial in deciding whether people live or die, the press is equally interested in the power of humans to make or unmake futures. Human agency allows into newsworthiness a sense of the historical, a sense that people make critical decisions that determine what will happen next, or in the end. The press's first 'reasoned' cries after a catastrophe are to blame culprits and call for compensation. The main culprit is 'human error', which newspapers find easy to accommodate within their expectations that 'hot' news stories concern unexpected crises happening apparently at random and not resulting from the slow burn of systemic faults which are hard or tedious to explain.

A second immediate and therefore 'hot' reason for catastrophe is corporate negligence, which may be owned immediately, as in the failure of the BR signals at Clapham Junction which resulted in the deaths of thirty-five passengers in 1988 (see press for 13 December). This happens only if there is undeniable proof of error. The benefit of immediate acceptance of fault is that it does less harm to the relevant industry than denials or the search for other scapegoats: it immediately foreshortens comment and speculation in the media, and that seems to be a matter of policy. Nevertheless, it does not mean that industries rush to accept their negligence. After the Clapham crash, two BR signalmen went on television to expose many of the safety lapses which preceded the accident and, as a consequence of breaking the policy of silence, were sacked. The code of silence about management errors in British Rail was already in force on the day of the crash, and that very morning BR employees were distributing leaflets about poor safety standards. To avoid being victimised the employees had disguised themselves in fancy dress.

The errors of big business that arise from its interest in profits, and which enable catastrophes to happen, will most likely take months or years to unravel. This time scale does not match that of the press, which is committed to a daily routine of news gathering. Consequently, stereotypical photographs of crash sites and so forth appear in the press immediately, long before the real causes are known or officially announced. The only unusual element in the case of the Clapham crash was that the *Independent* printed a photograph of the site over its whole broadsheet front page. The story also pushed the running story of that November's earthquake in Armenia out of the headlines, which is not surprising, because death on a commuter train in London has more value for newspaper sales than greater numbers of people killed abroad.

A third cause of sudden failure in reliable machines is sabotage, which does not absolve corporations of blame. It involves them and their insurers in enormous financial losses and can destroy major businesses. The terrorist sabotage of Pan Am flight 103 mixed fate and history together from the outset, and the airline itself was one casualty of the disaster. The plane was blown up by a bomb over Lockerbie in the

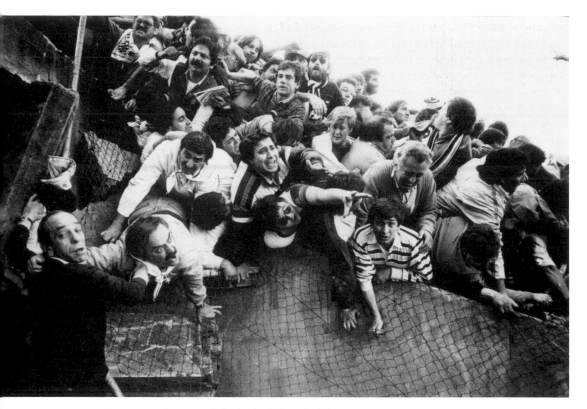

Ten years on from Heysel, the day football nearly died. Panic in the Heysel stadium in Brussels as spectators are trapped against a wall which moments later collapsed, causing the deaths of 39 people in the summer of 1985. *Guardian*, 29 May 1995. Eamonn McCabe

Scottish borders at 7.19 p.m. on 21 December 1988, killing a total of 270 people on board and on the ground. The catastrophe still resonates in Britain and in the United States, where President Clinton dedicated a memorial to the victims in Arlington National Cemetery in 1995.[13]

What was for some the worst thing in the world could be read and seen in differing degrees of detail in the press of 23 December. The papers reproduced their usual gap between the written and pictorial records: bodies reduced to 'scraps' were described more fully than they were shown in restrained pictures. Published photographs of corpses were either taken from a distance or seen covered by the police. Photographic realism is popularly understood to be sudden and potent in its shock effect, but the British press did not publish images of dreadful detail. For the most part, photographers restricted their efforts to picturing the debris, and concentrated in particular on the cockpit and nose of the aircraft, which had not disintegrated. Both the *Mirror* and *Today* chose symbolic pictures of the cockpit seen from a graveyard. Another popular shot was the burned houses and crater where the fuselage had crashed and exploded. Only the *Sunday Telegraph* published a picture in its colour supplement of a different type of crater – the impression made by a body (already removed) that had fallen thousands of feet before it landed, spreadeagled, in a field. Other bodies, not yet removed, were still visible in the background, and one of them lay on its back in a similar dent, so the pit in the

foreground left little to the imagination (1 January 1989).

The shame of it all, what made it seem so ironic, or (as the papers like to call it) so 'tragic', was that none of the travellers on flight 103 deserved to die. Their deaths made sense only in terms of fate or if they had been killed by an unknown enemy, which allows for grief. They did not make sense when blame was laid at the doors of the British and American governments and aviation authorities responsible for the flight. Hence the unforgettable, bitter tears of the father who was 'all right' in his grief until he discovered that on 9 December the US Federal Aviation Administration had issued a warning (discounted by the British authorities) that a Pan Am flight from Frankfurt might be bombed within the next two weeks.[14] As a result of this, embassy staff who knew of it had changed their flight plans. This man's child had fallen victim not to fate or terrorists alone but to the airline's fear of boycott and loss of profit. This knowledge led relatives to fight the 'power and greed and political vested interests' of government in Britain and in the United States.[15]

After any disaster there may be strong suspicions that the authorities did not do all in their power to prevent it. Though there were earlier rumblings of muddle at the Department of Transport, it was not until 16 March 1989 that the depth of government 'cover-up' began to emerge. An exclusive story in the *Mirror* printed the 'restricted' Department of Transport memorandum of 19 December 1988, which contained even more detailed information about the likelihood of a terrorist bomb hidden in a radio or cassette player. The memo was leaked to the press by the department's own principal aviation security adviser (*Guardian*, 17 March 1989). But when the failings of politicians came to light, they appealed to the pandemic of terror. If terror is so widepread, how can politicians be held responsible?

The appeal to the 'eternal presence' of terror was supposed to prevent the press's search for culprits from touching on the misjudgement of Ministers. The government tried to deflect the heat through the system of unattributable but authoritative briefings, which led a number of newspapers on 17 March 1989 to reveal a police breakthrough in the hunt for the terrorists. The story was immediately rubbished, and the government accused of creating yet more disinformation. None of the government's tactics prevented the press from discovering that the authorities had withheld information that had led directly to those horrible deaths – information available to others in the political cadre who had changed flights and survived. The way this story unfolded, from fatalism to blaming individuals who had the authority to change events, is characteristic of news coverage of major disasters. The sudden failure of systems is inherent and statistically predictable. What is unknown, and what makes disaster news, is that the random but constant eruptions of chaos provide human faces and personal dramas.

The depiction of chaos is permissible as long as the theme is fear and not an excuse for staring at people as they die, or for staring at broken bodies. Hence Eamonn McCabe's photograph (illustrated opposite) of panic in the Heysel stadium in Brussels in 1985 shortly before a wall gave way, killing thirty-nine people, is 'hard news' (made more acceptable because probably none of the people in this picture died, though readers would not necessarily know it). The photograph has come to represent this catastrophe: it combines the incidental detail of an eye-witness record with elemental signs of terror such as shrieking faces and, most critically, a man grasping at the air. Not surprisingly, the image has been widely published, including on the tenth anniversary of the disaster (*Guardian*, 29 May 1995).

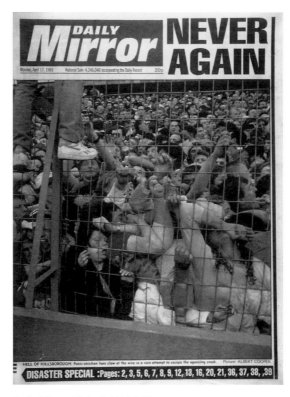

Daily Mirror, 17 April 1989. MSI

In contrast, hard news photographs of football supporters dying in the crush at the Hillsborough stadium on 15 April 1989, which killed ninety-six people, were roundly condemned for being intrusive and undignified.[16] The immediate cause of the disaster was the decision of the police to open a gate into the ground to relieve pressure in the crowd outside which was already dangerous. The inrush of people pushed forward those crammed inside until they were pressed against wire fences designed to keep spectators off the pitch. There was nowhere for fans to go. Many of them suffocated in front of television cameras and sports photographers. The issue for editors was how much detail would they dare to show, given that it would it be possible to identify victims? Though such questions are usually answered by avoiding close-up photographs, in this case the disaster was represented in horrific detail in all the papers. This provoked a general outcry against press coverage and attacks on photojournalists (see all press for 16 and 17 April 1989). Some shots of the fans suffocating were judged too graphic and too ghoulish by the Press Council, which received more than three hundred complaints. The *Mirror* in particular was criticised for its shocking images (as illustrated above) of people crushed and dying against the fence (17 April 1989). The widespread attack on the press led the *Mirror* to trace some of the young women from the scene who had appeared to have no chance of survival and declare, 'Alive! Miracle every one of us prayed for ...' (21 April 1989).

But the shocking photographs may have helped to ensure that the Hillsborough disaster was not left at the level of personal 'tragedy'. Fate alone is a poor explanation

for what happened compared with the police authority's negligence. The press set out to apportion blame among the police, the football authorities and the Liverpool fans (though this backfired on the *Sun*, which lost sales in the city). The disaster assumed national importance, and the deaths were catalysts of changes in football grounds already contemplated by the richer clubs or desired by politicians. Terraces were replaced with seats, and price increases were intended to shift the profile of supporters away from hooligans and towards a 'sober' or genteel family entertainment.[17] Practical developments to prevent a repetition of this disaster made some sense of the deaths in the end.

Bad luck

Though the press mixes analysis of what went wrong with the fate of unlucky individuals, the emphasis is usually upon the latter.[18] The press supposes that readers are interested in the underlying causes of disasters but attract attention by concentrating on those people who somehow failed to thread their way through it all, and did not survive. The bodies of strangers *in extremis* also offer readers solace because it is '*their* bodies and not *my own*' which have suffered or died.

Yet not every stranger's agony or death gives pause or pleasure to survivors. Strangers become newsworthy through the force of peculiar circumstance. Fatal accidents are not newsworthy unless they can add the value of bitterness or shame. Accidents do not need to be seen in photographs, spelled out in bold headlines, or given much space on the page, but can increase in intensity if stated as a 'flat fact': for instance, a brief news story stated that a Golden Wedding celebration began with the husband reversing his car over his wife and killing her (*Guardian*, 30 August 1995).

News value rests conventionally in the pity and irony of coincidence: *The Times* reported that a cyclist was knocked down and killed in the same manner that his son had been – a death that 'echoed' his 'son's fate' (8 June 1995). The *Express and Star*, a local paper based in Wolverhampton, noted that a mother was accidentally killed where her daughter had been raped and murdered (10 June 1995). A journalist sent to cover a crash discovered that its victims were his parents. This story was sufficiently cruel to be widely reported but not illustrated (*Daily Telegraph*, 14 July 1995). However, the *Mirror* chose to accompany the story with a photograph of the whole family and it highlighted the smiling faces of the dead couple (14 July 1995). Viewers learned what these smiling, identifiable victims themselves never knew – the outcome. This experience of knowing the end of the story is so ordinary among survivors that it is easy to overlook its significance: viewers discover that what happened to these families is more savage than they would wish for themselves. The stories end in ways which are hopelessly sad, and people die in ways more unusual than the majority of deaths, which are, for the most part, mourned but thankfully mundane.

At the same time, irony is intriguing. The dead may have been on the ill-fated ship, train or aircraft because their family had persuaded them to return home immediately for a long-awaited reunion. This was a common reason for people to board Pan Am flight 103 just before Christmas in 1988. Some turns of fate can be more unlikely, which makes them even more dreadful. For instance, a married couple who lived in Centre Moriches on Long Island, New York, drove to JFK airport to fly to Paris, and died close to their own home town two hours later when TWA flight 800 exploded and fell into the ocean

near Moriches Bay (see all press for 19 July 1996).[19] These stories show how the random passage of life, with all its chances and changes, may come together in a peculiar twist which pits hope against a delirium of error and unavoidable fate. The outcome may be cruel and pitiable; it may invoke a shudder of horror; but it is so symmetrical and perverse that even as it saddens the heart it electrifies the soul. Each stranger who reads the miserable experiences of others may wish to escape a newsworthy end – but who can be sure?

The unexpected success of the National Lottery is symptomatic of the interrelationship of fate, good and bad luck and catastrophe. The catch-phrase 'It could be you' is intended to encourage individuals to buy tickets by thinking of themselves as lucky. It is a gamble with the hope of big rewards and little risk to life, but even that is uncertain. In the early days of the lottery in 1994 the tabloid press especially went into a frenzy over winners of jackpots of millions of pounds (see press, 13 December 1994). Both tabloids and broadsheets are interested in big losers. For example, a father killed himself because he believed that by failing to complete his ticket in the usual manner he had forfeited £1 million (*Mirror*, 11 April 1995). It transpired that he had misread his choices against the winning numbers: they did not in fact match and he would have won nothing, which made his suicide even more poignant or pointless. The only public issue here was in the coroner's call for a reduction in the size of jackpot prizes, which was reported by the press but ignored by the lottery authorities (*Guardian*, 16 June 1995).

The lottery is news if it not only makes people rich but also wrecks lives. Then lottery stories derive some of their venom from being bitter, ironic and cruel. These dreadful qualities are understood to arise incidentally and by chance as intense examples of bad luck, and are not regarded as fundamental to the purpose of the given world. On the contrary, press practice centres on recording the fates of individuals in a world which has no specific goal of its own. The press rarely offers any consolation for misery and heartbreak, though it never ceases to suggest how those not directly affected may enjoy themselves while they can. At the same time it notes that riches, or the desire for them, can lead to disaster – rather like supernatural horror stories in which wishes are granted but turn into deadly perversions of desire.

Lucky escapes

Fate can also be 'kind,' allowing people to miss flights and so avoid crashes by a quirk. Domenico Consales from White Oak in Pennsylvania unknowingly boarded a flight to Italy instead of TWA flight 800 to Paris – ground staff at JFK airport had noticed that there was a seat free on a plane going direct to Rome, which had been Mr Consales's preferred route. He knew nothing of the switch until five hours into the flight. Later, at Fiumicino airport, he was found by reporters and photographers wandering about in a state of shock after learning how he had escaped death by boarding the wrong plane.[20] Stories of charmed lives can appear in the press years afterwards on the anniversaries of what should have been their death-day but by a fluke turned into the moment of their 'rebirth'.[21]

Luck can run counter to common sense. In January 1996, above the caption 'And he Lived', the *Mirror* carried a front-page 'picture exclusive' of a man who had been stabbed and was photographed with the knife still sticking through the back of his

skull (5 January). The implication was, of course, that he should not have lived. The newsworthiness of stories often hangs on the surprising turn of events that allows someone to live when in most cases they would have died. This type of story is so commonplace that it merits space only if it is extraordinary, or if it happened in Britain – similar twists of fate from abroad usually occupy a few lines in a miscellany of news fragments. Characteristic tales of good luck are as follows: a man falls over 200 ft from a tower block, lands on a car and walks away uninjured (*Mirror*, 3 April 1993); a blazing plane lands in the sea and the crew escape unhurt (*The Times*, 17 May 1995); an undertaker spots 'miraculous' signs of life in a woman certified dead whom he was about to seal in the mortuary (*Guardian*, 8 January 1996). This last story was all the more poignant and therefore newsworthy because the undertaker knew the woman. Even better from the viewpoint of news value, the 'miracle' turned bitter-sweet a few days later when it was revealed that the 'Wife who "came back from the dead" had tried to end it all' with a drug overdose (*Independent*, 11 January 1996).

Escapes are even more fascinating if they involve bravery and resourcefulness: Tony Bullimore, a British round-the-world yachtsman, was lucky to survive when his craft capsized in the Southern Ocean nine hundred miles from Antarctica and fourteen hundred miles from Australia. He rigged up a hammock in an air pocket and survived several days suspended above the sea in the upturned hull before the Australian navy rescued him (see all press, 10 January 1997). The *Guardian* headline was 'Alive – after four days in a watery tomb', and the photograph showed Bullimore's grizzled face peering out from a protective body suit. The sailor's ordeal was 'worthy of [the explorers] Scott or Shackleton [and] if he had never existed, *Boy's Own* would have had to invent him'.[22] The Queen sent a message praising his 'extraordinary feat of survival'. Part of Bullimore's appeal was his life of rags-to-riches and constant daring as an ex-Royal Marine and self-made millionaire: companies began to bid for the right to film his story.

Close encounters with death are a staple of the industry, though they are more likely to figure as front-page news in the tabloids than in the broadsheets. This is partly because the space for spectacular photographs in the tabloids is limited to the front and back pages, and to the centre fold (except in the case of major disasters). One example from *Today* will suffice. Under the headline 'Luckiest man alive', the front page was split between two pictures illustrating a plane crashing at an air show: the smaller image depicted a MiG jet 'plunging out of control', while the larger one, taken a fraction of a second later, showed the fireball and the ejector seat as it 'slams into the ground'. The test pilot escaped, and so a portrait of the 'luckiest man' was inset in the top left corner (9 June 1989). Of course, the front page might have been designed the same way had the pilot died – with only the headline altered. It is unlikely that the editor would have decided to put this 'good news' story on the front page if there had been no spectacular, sequential photographs.

Lucky escapes, while a standard of the press, serve as a counterpoint to stories that end in misery. Newspapers may run the two contrasting types of story on the same page. This device is favoured in the tabloid press, partly because it has much less space to attract readers and frequently relies for effect on bold headlines and pictures which bring life and death together. To take another example from *Today* (illustrated overleaf), the headline 'Death Wind traps Brits', referring to the potential of a hurricane approaching Bermuda, had no accompanying photograph – and indeed no actual news of anything

Today, 7 August 1989. News International

having happened. The purpose of the bold text was to 'bleed' into the other story on the front page, which featured a large photograph of two airborne balloons – one fully inflated and floating but the other collapsed and plummeting to the ground (7 August 1989). According to the story, the 'Doomed Chariot of the Sky' fell 2000 ft, while the pilot, Robert Mock, gave up trying to inflate the balloon and turned off his hot air burner before he hit the ground at speed, thus preventing a gas explosion which would have killed many more people. The accident happened in Louisiana, which is sufficiently far away from the British readers of *Today* to make the story less compelling to someone buying a paper on impulse. The design of the front page overcame the disadvantage of distance by not revealing that the event happened in the United States. The headline 'Death Wind traps Brits' implies at first glance that the 'Brits' trapped by the 'Death Wind' may be in that falling balloon.

If editors can drag a foreign horror story into the home context, then so much the better for sales. A week later thirteen people died in another ballooning accident – this time in Australia. *Today* fell back on its normal practice of scaremongering and hinting at home-grown fears by printing a photograph of the wrecked gondola above the headline 'Royal escape'. A casual glance at the news-stand would mislead readers into thinking that the 'Royal escape' had been from the balloon accident, whereas it actually referred to the low-grade news story of a tower collapsing near Princess Anne's children at a horse trial in Gloucestershire (14 August

1989). Once again, the conjunction of two different stories gave the front page its unusual impact. The paper slyly, but conventionally, tied a non-event involving royals to an event that killed only unknown foreigners.

Grief

While lucky escapes are newsworthy, they are not commonly presented on the front page unless they can be combined with heartbreaking stories for maximum effect. Through good fortune some people may survive a catastrophe and so become either a 'witness' or a 'grieving relative'. By their very nature as eye witnesses, these survivors are questioned by journalists when they are most vulnerable, or relatives of the deceased are asked how they 'feel'.[23] The camera is often on hand to capture grief – though not always intentionally, and usually there is a limit to the use of footage or photographs that show people grieving. For example, the thirty-second footage of the space shuttle *Challenger* exploding in 1986 has been repeated many times, but not the initial live footage of astronaut Christa MacAuliffe's parents as they watch the launch, see the catastrophe and *know* their daughter is dead (or soon will be). Photographs of the haunting moment when the MacAuliffe family recognise their daughter's fate were published in the *Observer*'s colour supplement at the end of that week, but then the story was still hot news (9 February 1986).

The subsequent restraint shown by broadcast media and press in showing these shocking moments for MacAuliffe's parents derived from there being no public good in repeating the footage or photographs. In contemporary times, the *Challenger* disaster is a 'stereotype' (according to the BBC's *Producers' Guidelines*[24]) and its routine use as 'wallpaper' must be avoided. The *Guidelines* state that the 'Use of material depicting pain, suffering, violence, or grief becomes less defensible as the original event passes into history,' and so producers should avoid needless or repeated use of traumatic library material, especially if it features identifiable people.[25] Nevertheless, images of some events are continually repeated. Film and photographs of the explosion of the airship *Hindenburg* in 1937 are included on CD encyclopaedias and seen on television. The press and television industries make occasional use of the film and photographs of Jack Ruby's killing of Lee Harvey Oswald in 1963 and the assassination of US President John Kennedy after Abraham Zapruder's film of the shooting was shown on national television in the United States in 1975. These events have increasingly become public property and are repeated without shame as straightforward events which, though old, remain newsworthy because they just happened to be captured on film and are examples of eye-witness records of extraordinary moments.[26] The repetition in such cases is the exception rather than the rule; in general the guide to taste and tone in British broadcasting is lack of repetition.

When the guide is broken, individuals have recourse to the Broadcasting Complaints Commission. On 11 February 1991 Granada's *World in Action* examined the anxieties aroused in society by the violent dangers threatening its children. The programme included film shots, originally shown on news bulletins, of a child murdered in 1989. The child's father was not warned of the transmission and he complained that the programme had 'unwarrantably infringed his privacy'. The commission agreed with him because the story was not current news and (after some delay because of litigation) Granada broadcast a summary of the adjudication on 13 March 1995 and published it in the

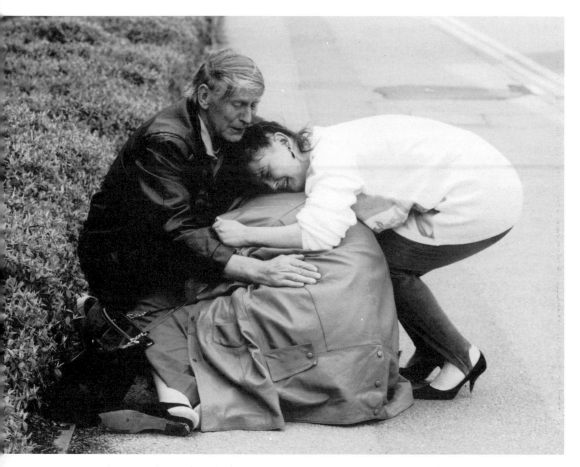

Victim's mother comforted by friends as she collapses outside court after murder charge hearing. The mother of Marina Turvey, shot dead at the weekend, being helped by friends in Luton yesterday. She was among relatives of the dead woman who had been at the town's magistrates' court when David Edwards, 21, was charged with murdering both Mrs Turvey and her seven-month-old daughter, Charlene. *Independent*, 4 May 1993. Louis Hollingsbee/PA News

edition of the *TV Times* for the week 11–17 March.[27]

Papers are less likely to show horror except when the news is 'hot'. There seems little need to repeat specific images of grief when new examples occur every day to fill the expectations of editors and audiences. Grief is alarming in its immediacy and veracity, and the press is permitted to represent it. At times newspapers print memorable and frightening photographs of grieving relatives or loved ones: the woman at Kennedy airport who collapsed at the news of her daughter's death aboard Pan Am flight 103 (*Sun*, 23 December 1988); the boxer James Murray's girlfriend 'grief-stricken' beside the ring where he lay dying (*Observer*, 15 October 1995); the mother of the murdered Marina Turvey 'comforted by friends as she collapses outside court' in Luton (*Independent*, 4 May 1993). This latter photograph (illustrated above) is remarkable for capturing the accidental composition of the fallen group in a form reminiscent of sombre, classical sculpture or bas-relief. The aesthetically pleasing form of the figures in the photograph is suggestive: its unintentional reference to a convention in art highlights the

fact that in some cases the photograph is not a sign of grief, but the sign of a sign, or the photographic trace of an artistic archetype.

The depiction of grief is a matter of judgement. When Thomas Hamilton killed sixteen children and a teacher in the primary school massacre at Dunblane in 1996, it was only after several days' independent coverage that the press and other media agreed to pool their reports of the funerals (see all press for 14 March and after). This decision followed the initial television broadcasts of a mother breaking down as she heard that her child had died, and the *Sun*'s and the *Daily Mail*'s close-up shots of the same woman as she waited in fear, then learned the worst (14 March). As the television news presenter Jon Snow remarked, 'The news event perhaps demands explicit evidence of the truth of bereavement [while] the human response shies away from so close an intrusion'.[28]

The murders in Dunblane were extraordinary, and the response was unusual in its intensity, in the rapidity of movement from private to public grieving: politicians were shown to be visibly moved, and the Queen cried in public (*Daily Express*, 18 March). The nation observed a minute's silence the following Sunday (which happened to be Mothers' Day). The response was also marked by a new, rare respect for privacy: the media voluntarily stopped invading the privacy of vulnerable people whose loved ones had died in the massacre. The anniversary of the massacre was marked by the continuing conspicuous absence of invasive 'doorstep' journalism from Dunblane, which in this case was regarded as unfitting or outlandish. Instead, lighted candles became the leading sign of death and mourning, and were depicted in photographs printed on the front pages of the national newspapers (13 March 1997).

Heartbreak by accident

If there is a 'human angle' a story comes alive, even in relation to death. This is no paradox, because the liveliness of the story is measured in the heartbeat of readers. It is by chance and mischance, primarily, that 'ordinary' people may become newsworthy. Not every fatal incident nor everyone who dies is caught in the news net. Inclusion depends on how sad the death makes other people feel, which is measured, characteristically, by youth, prospects and beauty. When a dredger struck a pleasure cruiser in the Thames, drowning fifty-one young partygoers, the headline in the *Daily Mail* was 'Death toll of the beautiful people' (21 August 1989). This headline spelt out a common theme in fate – that it is ironic, that death strikes unexpectedly, and (worst of all) those who die bring it upon themselves. In this case, beauty seeking pleasure found death – a horrible fate but one, it is implied, that the 'beautiful people' themselves contributed to by being there, and one which may bring some bitter and gruesome satisfaction to less privileged individuals who at least remain alive.

Favourite types caught in the news net include children, young women, young wives and young lovers whose 'dreams' end in nightmare and oblivion. Children killed at the seaside, at funfairs, in rivers or lakes are the familiar subjects of lengthy reports and photographs. The strength of such stories stems from the convergence of elements which are irresistible in combination: the waste of 'innocent' life, the moment when fun turns to tragedy, the trivial error that led to the accident, the peculiar drive which makes people die for others. In *Today*'s 'Ice Game of Death' – 'Sister sacrifices herself in lake tragedy' – the front-page photograph showed policemen hacking at a frozen lake, trying to reach the bodies of Julie Moles, a girl aged thirteen, and her five-year-old

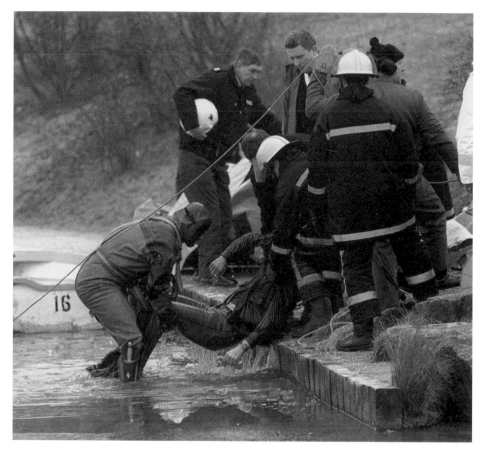

The Ice Hero. After two hours trapped under ice, a hero is pulled alive from a West Yorkshire lake. He was one of two men who plunged in to rescue a girl. But the battle to save all three ended in tragedy. *Daily Mirror*, 29 December 1995. Ross Parry

brother Stephen, whom she tried in vain to save when the ice broke beneath them (18 February 1991). She had already saved her other brother. The newspaper called Julie Moles's death a 'sacrifice', which is a rare description always reserved for special, selfless acts that end in death.

Despite the widespread observance of decency and taste in the display of British bodies, all the press will show them if they are not obviously for the sake of ghouls and gawpers. The usual justification of pictures showing the bodies of British dead is that there are some redeeming features in the scene, such as heroes or rescuers. Two examples will suffice. A front-page 'picture exclusive' in the *Daily Star* showed a doctor and other medics performing open-chest surgery on a policeman stabbed to death in the street as he fought off thieves: the caption framing the picture read, 'In the line of duty', and referred to both the dying policeman and the medical team (10 February 1994).

Another example is a photograph of one of two men who drowned after a vain attempt to rescue a girl who had fallen through ice trying to save her dog (see *Guardian*, *Telegraph* and *Mirror*, 29 December 1995). The photograph (illustrated above) was used on the front covers of broadsheets and tabloids, though the cropping was tightest in the

Mirror, which also had a typical pithy headline – 'The Ice Hero'. Crucially, the drowned man could not be identified from the picture, or at least his head was invisible. The body was otherwise whole, and the divers held it so that it fell into a shape similar to the familiar – or half remembered – religious composition of Christ's 'Deposition from the Cross', and was even reminiscent of the way the dead are sometimes represented on war monuments. In the case of the 'ice hero' his body becomes a sign evoking not so much pity as the acknowledgement of the aesthetic representation of pity. The photograph is permissible and effective because it is not the sign of drowning but the sign of a sign, removing itself from the reality of drowning as it becomes iconic. This is one way in which the press keeps within its professional code of practice, and within wider bounds of acceptable taste. Moreover, similar iconic representations of such incidents pull them away from meaning no more than the waste of life towards more uplifting explanations, including selflessness and sacrifice.

A famous reference to the Pietà is W. Eugene Smith's documentary image of a Minamata mother bathing her daughter, who is dying of mercury poisoning.[29] Referring to Smith's picture, Susan Sontag writes, 'Even those photographs which speak so laceratingly of a specific historical moment also give us vicarious possession of their subjects under the aspect of a kind of eternity: the beautiful ... In a consumer society, even the most well-intentioned and properly captioned work of photographers issues in the discovery of beauty.'[30] Sontag suggests that the discovery of 'beauty' is the final response and intends this to be a criticism of photography, in line with Benjamin and as often remarked on by others. But the 'beauty' viewers may see in these pictures may be regarded less harshly. After all, both human beings in Smith's photograph are alive, and one cares for the helpless other; in the press photograph the policeman's death is seen in the elevated form of self-sacrifice. Sadness and bitterness are not the only or even the dominant emotions associated with the figurations of Christ's deposition or the Pietà; nor are the emotions relating to care or sacrifice worthless or disabling. There is nothing viewers can do about these dead or dying individuals, but responding to the 'beauty' of the photographs, or recognising the aesthetic tradition, is not bound to block the misery of the scenes, which is forcefully represented in the photographs' contexts.

Waste

Lacking the causal connection with rescues or caring, other incidents are presented as a pure waste of life. In those cases the heartbreak is complete if something trivial, not even fatal, sparks a chain of events that leads one and then another to their death. For instance, a woman walking with her three children beside a canal is horrified to see her young daughters fall into the water, and in her failed attempt to rescue them also loses her baby. *Today* pictured the police divers at the scene, and headlined the story 'Nightmare in Lock 103', which is reminiscent of Pan Am flight 103 and a reminder of the awful magic of numbers (28 December 1990).

News stories tell of people who die for a small error, or for no good reason at all. For example, after a long day driving a van full of children from the Midlands to London a teacher falls asleep at the wheel on the return journey, crashes into a parked maintenance lorry and kills herself and eleven pupils (all press, 19 November 1993); a boy dies because a gale blows a hoop of metal into the carriage he is riding in at a seaside funfair (*Telegraph*, 2 April 1994); a man jumps out of a train on fire and is killed by an engine

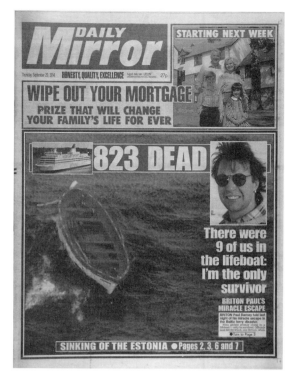

Daily Mirror, 29 September 1994. MSI

on the other track (*Guardian*, 9 September 1995). Each of these stories was illustrated with photographs – of crying children from the school of those who died, of the deadly metal hoop, of the burned-out carriage. None of the reports showed the bodies of the dead, which would have been in bad taste, intrusive and gratuitous.

Normal practice is to show the aftermath of the scene once the bodies have been removed or are out of sight. It is the wreckage which denotes the violence, matched by headlines such as 'Scrapheap of Death', which the *Sun* used to describe a huge 'pile-up' on a motorway which killed ten people (14 March 1991). In 1991 the *Sun*'s front-page picture was an aerial photograph of mangled and burned-out cars and lorries; in 1997, after a similar crash, the *Guardian*'s photograph was in the same style (11 March 1997). Aerial shots of such wreckage are commonplace on the front pages of all the national dailies. The main variation on this type of picture is the inclusion of rescue services, mostly firemen, police and ambulance crews. A typical headline in the *Guardian* was '10 die in coach horror', with an aerial shot of the scene taken long after the event had happened. In this example the sub-heading spelled out what the photograph could not show: 'Impact, fire and drowning take toll after M4 plunge' (24 May 1995). Coaches and cars crash, ships sink and planes 'plunge' in disorderly but predictable procession. Accidents are repeated, though each is different, and machines never cease to fail – three related facts which grab the headlines. Repeats are crucial to horror, and are retold with gusto.

This means that some terrible incidents never really go away. The demands of coroners' courts and courts of inquiry keep them alive. New technology revives them.

The press feeds on the various moments of fascination, from the story breaking to attaching blame, exacting retribution or winning redress. Not only does the horror story have a long life of its own, but it is never the last in the line. Stories of disasters pile up. The Townsend Thorenson ferry *Herald of Free Enterprise* sank with the loss of 193 lives in 1987, and when the ferry *Estonia* sank in the Baltic in 1994 according to the first reports over 850 people died. It was an example of the same-but-worse, and it meant that no one could rest – not ship designers, nor ferry owners, nor passengers. Readers can also take little comfort from the scene, because the same-but-worse waits to catch them in their turn.

The press prints only the aftermath, when much of the horror lies in imagining it. There are endless permutations of the same-but-worse. If an aircraft hits a mountain, that is bad enough. If in mid-air a panel rips off the side of the plane – as happened over the 'paradise' island of Hawaii in March 1989 – and people are sucked out at 22,000 ft, then that is worse (25 February). Even worse, though not generally applicable because it involved a parachutist who was anyway 'dicing with death', was an incident that took place at an air club near Maidstone in Kent in 1989. Tatiana Pond, a free-fall parachutist, jumped from the plane as normal but unexpectedly met up with it again on the ground: she landed on a propellor of the plane which had just dropped her. The horror of her death was compounded by the immense, reverberating ironies (*Guardian*, 13 March 1989). Even a terrible incident such as this can have unexpected, heartless repercussions: in 1994 the air club sued Ms Pond's parents as executors of her estate, claiming £129,000, because her feet went through the cockpit window before she fell on to the rotor blades of the port engine, 'causing substantial damage' (*Guardian*, 6 December 1994).

Events can have a special quality when reported in the tabloids. The stories are grim, and made sadder and more frightening because of the savagery and suddenness of death. But the odd juxtapositions of image and text carry a trace of unintended grim humour – something that can only be enjoyed by survivors who are not in any way involved. For example, the day after the *Estonia* sank the front page of the *Mirror* had a peculiar, resonant design. The headline estimated '823 Dead', printed boldly over the main picture, frame-grabbed from television, of an empty life raft drifting on the sea, with two small photographs set around it depicting the ferry afloat and a portrait of Paul Barney, the only Briton to survive (illustrated opposite). It was a usual combination of 'before and after' shots, along with a portrait of a lucky passenger, but in this case it contrasted markedly with the advertisement which ran next to the newspaper's title banner: a photograph showed a family standing in front of a house, with the strap line 'Wipe out your mortgage' (29 September 1994). The advertisement intended 'wipe out' to be associated with mortgage debts, but the words took on a different meaning when linked with the main story of hundreds of people dying. Though no one intended the meaning of the advertisement to be altered by its association with the cover story, no one can prevent such slippage taking place. Another example, even more grotesque, occurred in *Today*'s coverage of the damaged jumbo jet and the death of passengers 'Sucked into Space' mentioned above. Beside *Today*'s title banner the newspaper ran an advertisement for cheap holidays: it was illustrated by a drawing of a 'smiling' jet with the caption 'It's miles better' (25 February 1989).

The transference between these worlds of consumption and death was also seen in the *Sun*'s report of the rail crash at Clapham Junction (13 December 1988).

An advertisement for Dansk low-alcohol lager was placed on the left-hand page of a spread. It depicted the cricketer Ian Botham (who had been involved in various brawls) walking away from a pub which had been reduced to a shambles or a wreck. He appeared to speak in a cartoon 'bubble', saying 'Nothing to do with me.' Looking at the opposite page, the *Sun*'s viewers found a photograph of a smashed railway carriage. Under the headline 'I saw office girls with their feet torn off ...' the *Sun* printed a photograph of a dead woman, her body apparently whole but her face turned away from the camera. The caption read 'Carnage – the body of a woman victim sprawls among the shambles of a wrecked carriage'. The chance conjunction of wreckage and shrugging off blame in the Dansk advertisement with the picture of the corpse in the crash site was an unintentional irony. Many pubs have been destroyed by bombs and so this advertisement, as well as being a 'joke', was also a reminder of terror. Bringing together the advert and the 'hard' news story reveals the several sources of terror, sharpens the desire to escape and promises that some consumers may be fortunate in their choices while others will unwittingly choose death. In addition, the conjunction emphasises the return of the 'victim', after her death, to the steady world of newspaper consumption. This was one example of what the newspapers generally represent: a world of three entangled possibilities, including the dangers of everday choice, the possibility of sudden death and, if only for the moment, the promise of reprieve.

Notes

1 See Anthony Giddens, *Modernity and Self-identity. Self and Society in the Late Modern Age* (London, Polity), 1991, pp. 109–43.
2 Paul Tilzey, *Decisive Moments*, BBC Television, 1996.
3 James Curran, Angus Douglas and Garry Whannel, 'The political economy of the human-interest story', in Anthony Smith (ed.), *Newspapers and Democracy. International Essays on a Changing Medium* (Cambridge, Massachusetts, MIT Press), 1980, pp. 293–305.
4 Curran *et al.*, 'The political economy of the human-interest story', p. 306.
5 Graham Knight and Tony Dean, 'Myth and structure of news', *Journal of Communication*, spring (1982) 145.
6 Roy Greenslade, 'How the cult of celebrity leads to a hierarchy of death', *Media Guardian*, 21 July 1997.
7 John Taylor, *War Photography. Realism in the British Press* (London, Routledge), 1991, pp. 142–3.
8 Elaine Shepherd, *Decisive Moments*, BBC Television, 1995.
9 *Ibid.*
10 *Ibid.*
11 Alex Duval Smith, '"Patriot" who hated US', *Guardian*, 3 June 1997.
12 Raymond Snoddy, *The Good, the Bad and the Unacceptable* (London, Faber and Faber), 1992, pp. 92–5.
13 Joan Deppa, *The Media and Disasters. Pan Am 103* (London, David Fulton), 1993; Ed Vulliamy, 'Lockerbie dead live on in US heroes' cemetery', *Guardian*, 4 November 1995.
14 Nick Cohen, 'Delay and disbelief surrounded warnings of bomb attack on jet', *Independent*, 20 March 1989.
15 Nick Davies, 'Breaking the silence in America', *Guardian Weekend*, 15–16 April 1989.
16 Eamonn McCabe, 'When sport turns to Hillsborough', *Guardian*, 24 April 1989.
17 Ian Taylor, 'Hillsborough, 15 April 1989: some personal contemplations', *New Left Review*, 177 (1989) 89–110.
18 Martin Woollacott, 'Pride goes before a fall', *Guardian*, 24 February 1996.
19 Ian Katz, 'The scene: those who saw the crash are trying to come to terms with it', *Guardian*, 19 July 1996.
20 *Ibid.*
21 Julia Llewellyn Smith, 'The day of the crash is like my birthday – the day I was reborn', *Times*, 22 December 1993; Rupert Cornwell, Mary Dejevsky and Andrew Gumbel, 'Tragic mix of luck and despair', *Independent*, 19 July 1996.

22 Luke Harding and Christopher Zinn, 'Alive – after four days in a watery tomb', *Guardian*, 10 January 1997.

23 Ann Shearer, *Survivors and the Media* (London, John Libbey), 1991.

24 *Producers' Guidelines* (London, BBC), 1996, p. 64.

25 *Ibid.*, p. 45.

26 See Harold Evans, *Pictures on a Page. Photo-journalism, Graphics and Picture Editing* (London, Heinemann), 1978, p. 6 and pp. 89–90; Barbie Zelizer, *Covering the Body. The Kennedy Assassination, the Media, and the Shaping of Collective Memory* (Chicago, University of Chicago Press), 1992.

27 R. M. Hargreaves, *World in Action, Granada Television. Complaint from Mr. B. A. Wade* (London, Broadcasting Complaints Commission), 25 July 1991.

28 Jon Snow, 'What should the message be?', *Guardian*, 18 March 1996.

29 W. Eugene Smith and Aileen M. Smith, *Minamata* (New York, Holt Rinehart and Winston), 1975, pp. 138–9.

30 Susan Sontag, *On Photography* (New York, Farrar Straus and Giroux), 1977, p. 109.

7

Murder

Killer plots

In reporting murders the press satisfies both curiosity and concern. In a public sphere of controversy it discusses right and wrong, remarks the nature or existence of evil independent of individual actions and comments on social policy, legal judgement and political responsibilities. These discursive practices are found in relatively explicit descriptions of corpses and murderers combined with euphemistic and stereotypical photography.

Murder stories and their plots sometimes unfold as conventional 'tragedies', in which blood is up, faith is lost, fate is cruel and disaster strikes. Such plots are most common in family killings, or among people who know each other, and are driven by jealousy or revenge. Another convention emphasises the randomness of murder. In these cases the tragedy has nothing to do with personal entanglements and everything to do with bad luck or fate. What fate does is to compound victims' miscalculation, progressing from bad to worse, from misfortune to a dreadful end incommensurate with the life as lived. Victims of random killing are desperately unlucky to have been chosen to die through no known error of their own. Sometimes they have not helped themselves, or they have unwittingly put themselves in danger, but have suffered beyond imagination for what seems in hindsight to have been a small fault. The inclination to find most victims 'innocent' is one of the standard forms in press accounts. It matches the industry's pattern of reporting the cruellest and most ironic twists in heartbreaking tales of those who never chose or deserved to die.

In a similar vein, murder plots echo forms of human-interest stories with regard to history, or attempts to manage human affairs. Actions, decisions and oversights by the professions of sobriety, like medical authorities and social workers, can have alarming, unforeseen results. These cases include random murders and parricide by paranoid

schizophrenics released into the community;[1] revenge murders by men against women and children whom the police have promised to protect;[2] deliberate mass murders planned by individuals such as Thomas Hamilton, who killed sixteen children and a teacher in Dunblane (see all press for 14 March 1996). In every corresponding example and numerous similar cases the press adopts the familiar guise of 'watchdog', allowing it to investigate the policies which led to murder or to follow the progress of enquiries.

'Murder' is an emotive term used to describe certain types of homicide or illegal killing. There are several categories of murder in British law, although whether any particular incident is placed in one or another depends not on the nature of the incident itself but on the outcome of the judicial process. Shooting or stabbing someone to death could be normal murder, insane murder or manslaughter. 'Normal' murder is 'any homicide committed with malice aforethought by a person not subsequently found to have been mentally abnormal by reason of insanity, diminished responsibility or suicide'.[3] 'Insane murder' is homicide committed by someone who does not know the nature of their act, or that they are morally wrong. 'Manslaughter' is homicide committed either by someone who claims diminished responsibility or who kills by accident or negligence. Other categories of murder include infanticide and homicide followed by successful suicide. Besides these various definitions of types of homicide, 'murder' may be used to describe any killing depending on the point of view of victims' families and their supporters.

Not every murder is reported or receives much attention. In 1994 there were 727 homicides, but few of them became prolonged news stories. Murder and the grief of bereaved families are not by themselves enough to interest editors. The most newsworthy murders leave the reader asking, why was this life ended? Stabbings outside pubs are frequently short on mystery, whereas the 'perfect media murder' keeps readers guessing and eager to buy the next instalment. In addition, victims should be upper-middle-class and palpably innocent of any crime. For maximum coverage, the victim should be 'a woman or child, white, blonde, and, despite their innocence, there should be a hint of sex'.[4] More often than not, sex is at the heart of the murder mystery: paedophiles, rapists, sadists, fetishists, jealous or rejected lovers.[5]

Sex, brutality and corruption are not enough to ensure sympathetic media coverage of someone's murder and their grieving family. Media attention was withheld from Mercy Zani-Merriman, for example, whose fifteen-year-old daughter Nobantu was found strangled on the moors near Bradford in September 1995 (*Independent*, 3 October). The girl was 'a regular face' in Bradford's red-light district and the local authorities suspected that she was involved in the city's child prostitution trade. The media were uninterested in the story, and local papers began 'to point a nasty finger at her "neglectful" mother, a poor, black widowed immigrant from Africa'.[6] If editors find that victims' families are relatively inarticulate, or that victims themselves do not fit the style of heartbreaking stories because they are not respectable, black, criminal or on the fringes of the law, their stories are unlikely to become news at all, are not followed for long or are not presented in a favourable light. For example, when three drug dealers were killed near the village of Rettendon in Essex the *Guardian* headline used the term 'finished off' in its initial story (2 January 1996); two months later the paper featured the story on the front page of its review section but began it with the dismissive caption 'Sorted' (7 March 1996).

My interest is in how editors report those few homicides in Britain which are considered to be newsworthy, how they present them in photojournalism and how they encourage types of writing and looking. Murders and heartbreaking human-interest stories share more than the common forms of fate and history. They share the standard gap between their relative detail in writing and restraint in what they show. There is always a disparity between the way a murder is reported in detail and how it is seen, as if from afar, and in characteristic signs of distance, usually with no body in sight.

Photographs of the bodies of British murder victims rarely appear in the press, while reports may be quite explicit. In describing the style of murder the text may reveal that the dead person's throat was cut, or that individuals died from strangulation or massive gunshot wounds to the head. Corpses are often identified from dental records, suggesting how badly deformed and unrecognisable they have become as people. In contrast, photographs accompanying these graphic accounts show that murder endures in standard, euphemistic forms of press photography. The crimes are usually illustrated by portraits of victims when they were alive, seen in family snaps, or in the poses, lighting and backdrops adopted by professional High Street photographers. Other shots typically taken by press photographers include pictures of their home and neighbourhood; their haunts; the place where they died; the common practice of 'shrining', or laying flowers of condolence at the scene; weapons, or other material objects which killed them; relatives at press conferences; signs of detection; mug shots of suspects, identi-kit portraits, computer-generated imagery known as e-fits, or artists' impressions; photographs of captive suspects, and convicted killers; images of the exterior of courts and prisons. Examples from this range of pictures appear and reappear until the trial ends and the story more or less slowly loses news value and slips from sight. Any of the pictures may be resurrected should the story become news again through appeals, memorials or controversy. No matter how often murder recurs, or how horrible the crime, the pictorial record is invariably limited by decorum in the face of grief and by squeamishness in the face of gruesome detail. (For an exception which proves the general rule see the explicit photographs of Michael Ryan's victims, 19 and 20 August 1987.)

The news industry's treatment of killers and their victims in Britain and overseas relates to the practice and ideology of the 'art of mismeeting', in which people deliberately fail to meet the eyes of others and so escape feeling any obligations towards them. This should come as no surprise. The relative absence of horrific murder pictures in British newspapers, or the propriety which governs the limitation of shocking pictures that *'fill the sight by force'*, is neither a matter of privacy nor of respect for the dead and injured which touches exclusively on the news industry. On the contrary, restraint in the news is part of the wider understanding and practice of decorum in everyday discourse and social interaction in public places.

Murderer

The press takes the stance of its readers, whom it supposes to be sickened but curious about how killers commit their crimes. To say that they 'do' their victims to death is a relatively colourless description. Apart from intent, it offers no clue about its agents, methods and objects. The term is not much used in the press, which prefers more emotive words, including 'massacre', or 'slaughter'. Now and again the tabloids resurrect the old-fashioned, rhetorical verb 'to slay', which is scarcely used to mean murder

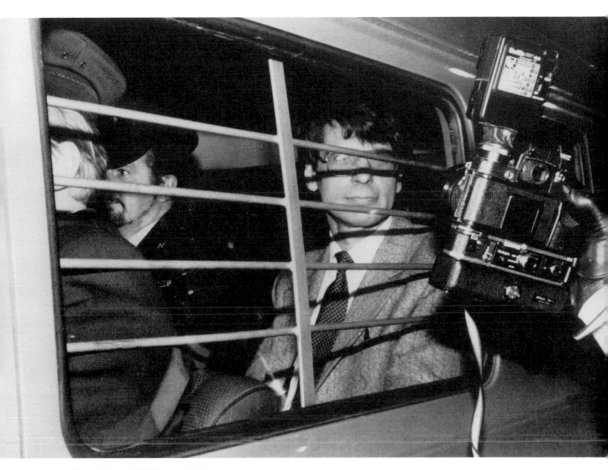

Say Cheese! The serial killer as celebrity.
Dennis Nilsen. *Guardian*, 26 January 1993. Frank Martin/*Guardian*

anywhere else. The word 'murder' is colourful and, though it obscures methods, it certainly identifies a crime.

To 'do to death' is so taboo in civil society that it arouses curiosity. It opens on to such forbidden territories as extreme but murderous passion and killing in cold blood: who would do it, and how? This mystery puts killers in the frame. 'Say cheese!' is the *Guardian*'s caption to a photograph (illustrated above) of Dennis Nilsen, who murdered fifteen young men and boys over four years until his arrest in 1983 (26 January 1993). He kept the bodies, masturbated over them, shoved them under floorboards, cut them up, and tried to flush bits down the drains.

The photograph and its context invite viewers to think of Nilsen as both calculating and trapped. The murderer is fascinating in his suit and tie. He appears so unmoved, so unlikely to say 'cheese'. He is not alone in the rear of the car, but only he stares across the bars at the camera thrust towards him. After all, the lens is aimed at him, since it is he who is 'the serial killer' and the 'celebrity'.[7] He looks impassive, just like a killer. He has that flashlit, narrowed eye, while the other is hidden by one of the bars that cross his face and neck. Nilsen is captured, and captivating, a killer who is the same-but-worse:

throttler, butcher, necrophiliac; a man literally at home with dismembered corpses, or what he called 'my tragic products'.[8]

Such products are one thing, rarely seen in the press, but murderers are another, and stare out of the papers in happy snaps, police mug shots or photographs snatched in transit during the trial.[9] Readers of contemporary newspapers are often invited to read evil written on the face of a killer, in a throwback to the early uses of photography, which set out to demonstrate that the intention of the mind appeared on the surface of the face.[10] These old attempts to define and identify the appearance of criminal types survive in the ways the press uses mug shots of killers who have been caught and whose faces are to be scrutinised for their 'evil'. The notion that evil is written on the face itself, or that mental faculties are betrayed by the shape of the head and its features, grew in the nineteenth-century 'sciences' of physiognomy and phrenology which artists used to picture criminal 'types'.[11] Criminal anthropologists, such as Francis Galton and Alphonse Bertillon, used photography to chart the surfaces of bodies which by themselves revealed the propensity to thieve or murder.[12] Killers' faces still stand for 'evil', as if killing is foretold in the shape or tilt of the head, or leaves its mark on brows or eyes. But these photographic revelations appear only after the events of murder, detection and conviction. Other killers are unknown, and remain so after the discovery of their victims' corpses. Then the press is in the dark, listening to police reports, looking for witnesses, and joining in a hue-and-cry by printing fuzzy images from surveillance cameras as in the hunts for the killers of two-year-old James Bulger and the murderer of Emanuel Spiteri and four other men in 1993 (*Today*, 16 February, and *Guardian*, 17 February; *Observer*, 4 July).[13]

Murder is first a mystery, and becomes horrible once details are brought to light. Fear surrounds what murderers do to bodies. They kill them brutally, as the papers report. They may try to hide the crime. They bury corpses, throw them weighted into water, hide them, or eat them. No matter how battered and fragmented they become, most of the bodies are somehow unearthed, float to the surface, or block the drains so that neighbours complain of the smell.

Murder stories in the press allows readers into the world that binds criminals, police and dead bodies into atrocity entertainment, which is both bizarre and common enough to provide the press and book publishers with endless, captivating material.[14] The most repulsive and chilling tales are front-page news in all the newspapers. They include serial killers,[15] random murders for the sake of excitement,[16] child killings by paedophiles,[17] sudden 'killing sprees' by a 'lone gunman' such as Michael Ryan in Hungerford (19 August 1987), Thomas Hamilton in Dunblane (14 March 1996) and Martin Bryant in Port Arthur, Tasmania (29 April 1996). In his essay on the 'Decline of the English Murder' (1946), George Orwell complained that murders then had become 'casual', 'wanton', 'callous', and were therefore less English than 'Americanized'. Truly English murders had 'depth of feeling' and were typically 'the old domestic poisoning dramas, product of a stable society where the all-prevailing hypocrisy did at least ensure that crimes as serious as murder should have strong emotions behind them'.[18] Unlike murder 'American style', English versions would have plots, motives, mistakes, downfall and justice.

This does not describe murder so much as the values of stories favoured by the press. These values, summarised by Steve Chibnall, stress the relevance of 'The Present, The Unusual. The Dramatic, Simplicity, Actions, Personalities and Results'.[19] However, in contemporary times the press is equally captivated by apparently motiveless, random

murders 'American'-style. This may be because audiences are drawn to murder mysteries, or perhaps audiences have a taste for extremely cruel murders inflicted by 'lethal strangers' without apparent cause.[20] Murders resulting from dreadful but nevertheless mundane domestic turmoil are usually less sensational and disgusting than those carried out for money, jealousy or unfathomable sexual desires.

Modern murders in the news move back and forth between two poles. There are moments of distillation centred on the body of the victim when the crime seems to be a pointless, gruesome act, and there are the stops and starts of the unfolding detective plot. The story begins with a sudden interruption of normal life which is so shocking that its full import cannot be understood. As the story develops readers learn more of what happened, who did it and why. Though these stories tend towards resolution, they never do so evenly, and can recoil on themselves, returning to those early moments of shock and horror associated with the corpse or other human remains. In this way, news reports of murder bring together an historical awareness of crime and a feeling of revulsion which alters but never entirely fades away.

In the beginning the news reports concentrate on the spectacle, the criminal's 'tragic products'. After all, murderers plot or execute their crime in secret, or out of sight, and the plot stirs only when the corpse is discovered. This frequently happens by accident, which is a horrible thought in itself. Strollers enjoying a walk in a forest, or beside a river, may find a body. The first moments are unlikely to be photographed, and once police arrive to photograph the scene and begin the task of making corpses speak of their killers they tend to screen bodies from prying eyes or interference.

The moment of corpse discovery is the recognition of mayhem and the site of most clues. Consequently, its mysteries are closely guarded. News reports of murder respect this mystery, and depend upon it to draw readers with them day by day. Fulsome reports are printed at the moment of discovery and promise to take readers close to what they otherwise cannot see. But police keep photojournalists away, who (probably gratefully) fall back on picturing police searches, cordons and the outward signs of intense detective work in forensic tents.

The recalcitrant nature of dead bodies – their greater capacity to resist destruction than to hold on to life – leaves them and consequently whoever killed them open to discovery. The plot thickens when the body is forced to 'speak' by science. Pathologists dissect the remains of flesh, hair and bone to identify the dead person, find the cause of death and reveal intimate, individual details that may eventually be proof of guilt. This 'painstaking' detection points to the killer. The plot then moves more or less quickly from the corpse to another recognition scene – the sudden apprehension or revelation of the murderer. Accounts of trials are everyday fare, allowing gruesome details into print. For instance, a man accused by his stepdaughter of sexual abuse slowly electrocuted her to death (*Guardian*, 19 February 1992); a jealous husband at first tried to strangle his wife, and put her in a vat of acid when she had passed out but was still alive (*Guardian*, 22 February 1992). In some crimes the circle is closed with the conviction of the suspect – though conviction does not necessarily end a case. Plots and narratives can twist and turn beyond that moment, depending on the notoriety and cruelty of the killers.

Some murders remain for ever open. The narrative affords no pleasing resolution in the case of Myra Hindley and Ian Brady, who tortured and killed five children in 1964 and were convicted of the 'Moors murders' in 1966.[21] The body of one of their victims, Keith Bennett, has never been found; Hindley and Ann West, mother of the murdered

Lesley Ann Downey, are constantly fighting one another in the tabloids; and there remains the question of whether Hindley should be released on parole or whether, as the tabloids demanded, her life sentence must mean life with no hope of release.[22]

The Moors murders have been before the public since 1966. In 1994, the thirtieth anniversary of the murders, several television programmes and newspaper stories were devoted to Hindley (*Sun*, 17 December; *Sunday Times*, 18 December). In 1995, when Hindley had been in prison for twenty-eight years, the *Daily Telegraph* still used its main front-page headline to splash the fact that she was to undergo hypnotism to help locate the missing body of Keith Bennett (25 January). Later that year the *Guardian* published an article by Hindley in which she admitted she was 'more culpable' than Brady for the killings.[23] This led to a further spate of letters concerning Hindley's sentence and new revelations from Trevor Smith, who claimed that in 1963, when he was ten years old, he narrowly escaped being abducted by the two murderers (20–1 December).[24] In similar cases which never end, press stories continue to move from the unfathomable 'evil' of killing to the recognisable misery of families, looking closely at victims apparently picked at random.[25]

Evil

The fascinating murderer is matched by the story of the murderee. To be done to death – to be a victim – reveals an abyss of horror. Fatal accidents, famines and floods fill the press with reports of bodies enough, but murders are especially cruel. They invite survivors to imagine the victim's last frenzy and torment. Newspapers are usually as interested in the victim as in the killer, and in the chaos of murder as much as in detection, apprehension and the particular order of the courts. At times, pity for the victims, or the shamefulness of the murder, is so overwhelming that capturing and convicting killers never seem enough.

A recent case which promises never to end is the killing of James Bulger by two ten-year-old boys, Robert Thompson and Jon Venables, in February 1993. The older boys enticed the infant away from his mother in a shopping precinct in Bootle, Liverpool, and killed him beside railway lines in Walton, Merseyside. The photographs accompanying the newspaper stories ran the familiar gamut: a family snapshot of James, police hunting for clues along the rail track, worried and protective mothers in the shopping mall and placing flowers near the murder scene, probably as a memorial, though possibly for some (it must be said) providing an excuse to visit. One unusual element, but not unique in publicising killers in the press, was the reproduction of blurred images taken from security cameras. The shots of James Bulger and his abductors were taken from machines inside the shopping centre and from a video-tape taken at a construction firm, both of which indicated two boys leading James away (*Today*, 16 February 1993; *Guardian*, 17 February 1993).

This murder was especially chilling because its showed not only how vulnerable children can be but also how cruel they can be. Generally, press reports in the tabloids subscribe to and promote belief in essential evil, whereas reports in the broadsheets are more circumspect. The Bulger case was one in which the existence of absolute evil governed most accounts.

During the trial the law always hides children's identities, and they remain anonymous if convicted. In this case, unusually, once the boys were pronounced guilty

the court presented them whole to the papers. They were not only named and their portraits published, but the judicial and police framework for understanding them was revealed to be exclusively as 'others', and that line was continued in the press. Detectives who interviewed Thompson and Venables called them 'Freaks of Nature'. After their conviction the *Mirror* used this phrase as its headline under school photographs of two ordinary-looking boys (25 November 1993). The *Independent* ran the school portrait of Robert Thompson alone, who had been represented in court as the leader. Its headline was a remark by the judge, who described the killing as 'An act of unparalleled evil' (25 November). The *Sunday Times* used both portrait and surveillance photographs and called the convicted boys 'Little Devils' (28 November). Tabloids and broadsheets were at one.

When the press uses school portraits of victims they appear to be open and honest, whereas police mug shots of killers usually satisfy the need to see a face which is at least troubled or guilty if not exactly evil. Portraits of young victims like James Bulger seem to reveal only their innocence, but the happy school portraits of Thompson and Venables seemed to reveal their innocence too: after all, they were no more than boys. This was confusing, and helped to underscore the incomprehension of children engaged in child murder. Given that newspaper readers knew the boys killed James Bulger, the pictures clearly hid more than they revealed. The usual supposed transparency of school portraits had to be turned inside out. Instead of revealing the boys' openness, they concealed the boys' natures. Rather than standing for innocence or evil, the unrevealing portraits become signs of the boys' secret identities. It was, of course, impossible to see freakishness or evil on the faces of the boys. This lack of a clear sign actually preserved the mystery of evil and the inexplicable nature of their crime. The pictures hinted that evil lurks behind the most ordinary faces, and suddenly leaps out. Once this is seen to have happened, and is repeated, it calls into question every assumption about childhood and innocence, about the responsibilities of parents, and about living in a pleasant land.[26]

Child abduction and murder are common in myth and legend.[27] The main attempts to discover the source of evil in the Bulger case centred on the contemporary media. Parents were blamed for allowing children to watch horror films, and the press echoed the call for censorship of violent films such as *Child's Play 3*, *Braindead*, and *Body Melt* (*Today*, 13 April 1993). The trial judge repeated the belief that these or similar videos might have encouraged the killers to act out some scenes, 'including possibly' some from *Child's Play 3*, which 'has some striking similarities to the manner of the attack on James Bulger' (*Today*, 27 November 1993). The judge's remarks renewed the press debate on media effects and censorship.[28] This 'explanation' for the eruption of 'evil' in ordinary homes is commonplace, and is constantly revisited, notably in the rows over Oliver Stone's film *Natural Born Killers*,[29] violence on television, 'video nasties' and copycat crime.[30]

Polite looking and propriety may guide the press in how to represent murder stories but it is more restrained in what it shows than in what it writes. If a murder is caught in the news net and is illustrated, the press uses visual and rhetorical devices of distance, innuendo, or oblique reference. For instance, in December 1992 a sixteen-year-old girl named Suzanne Capper was tied to a bed and tormented and tortured for six days in north Manchester before she was taken to a nearby wood at night, doused in petrol and set alight, suffering burns to 75 per cent of her body. Still alive, she escaped from the wood to the main road, where she was found at dawn by three workmen. She was taken to hospital, where she died, but not before naming her killers. The *Guardian*'s report

following their trial in December 1993 was accompanied by diagrams of the area, portraits of the five killers and their victim, photographs of the room and the bed where they had chained her, and photographs of the streets where they lived. The story was also illustrated, in typical fashion, with photographs of the place where Suzanne Capper was found alive but with hands 'like ash' and legs 'like raw meat'.[31] A year after the murder, and after the convictions of the killers, readers might review the injuries resulting in a 'sadistic death [that] went beyond belief' but they would never see any of it in photographs.

Language in the daily press always exceeds the photographs in the details it records. Consider the depiction of the crimes of the serial killers Frederick and Rosemary West, who, over twenty-five years, abducted, raped, sexually tortured and murdered at least twelve girls and young women, including their daughter Heather. They mutilated the corpses and buried nine of them in the cellar and garden of their home in Gloucester.[32] Whereas the trial reports recounted many of the gruesome details of these murders, the accompanying photographs were standard in the distance they kept from corpses and from police evidence.

Nevertheless, the story of the Wests' murders varied from the more typical and limited coverage of Suzanne Capper's death because of the time it took the police to recover the bodies, because of the suspense surrounding the number and identity of the victims, and because of the extreme depravity of Frederick and Rosemary West. The press had to sustain its limited repertoire of euphemistic pictures over a much longer period than is usual, but even so it always found something to photograph. There were pictures of police digging the 'Garden of Horror' (*Today*, 2 March 1994); many photographs of rooms inside the 'House of Horror' (*Daily Mirror*, 7 March 1994); many photographs of the West family and of Frederick West at work as a handyman (*Sun*, 9 March 1994); photographs of Professor Bernard Knight, the pathologist and part-time crime writer (*Guardian*, 11 and 12 March 1994); photographs of the broadcasters' satellite dishes near a field excavated by police looking for more human remains (*Independent*, 30 March 1994); old police mug shots and family portraits of West following his suicide (all press, 2 and 3 January 1995); extensive use of family snapshots – including pin-ups of Rosemary West in the *Sun* – once the trial had ended (23 November 1995).

The tabloids and broadsheets never came close to photographing any remains of the Wests' victims, but on 9 March 1994 they published images of a policeman with a box which was supposed to hold pieces of a skeleton. Alongside the caption 'The Last Rites', the *Daily Mirror* pictured 'A grim-faced officer in overalls' carrying 'a box of human remains' from the Wests' house and passing a constable with 'his head bowed in tribute'. In contrast, the *Guardian* was more interested in the 'growing crowd of journalists and onlookers, who also appeared in the photograph above the caption 'Neighbours cash in on city's grim notoriety'. Later that month the *Independent on Sunday* revealed that the police had 'laid on' this so-called box of human remains 'to placate the frustrated snappers who hadn't had anything to photograph for a while' (27 March 1994). The story was so long in unfolding, so titillating, and yet so barren in detail, that the press was forced to search for new angles: the *Daily Mirror* preferred to thrill its readers with the sign of a box of bones, whereas the *Guardian* photographer captured both police and crowds of onlookers in his image (illustrated opposite), appealing to the newspaper's more media-conscious readers with a sign of plain and professional gawping.

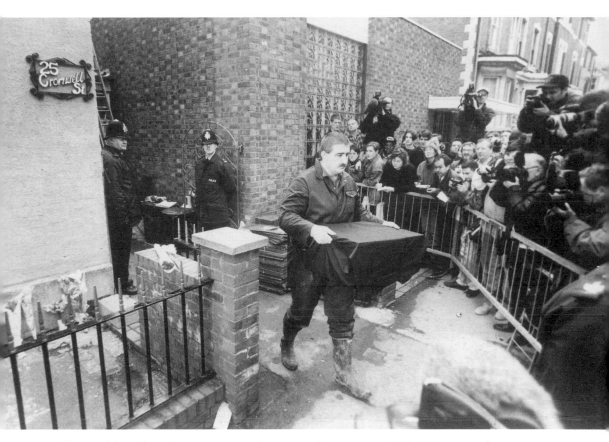

Neighbours cash in on city's grim notoriety. Focus of attention ... the remains of another body being removed from 25 Cromwell Street yesterday, watched by a growing crowd of journalists and onlookers.
Guardian, 9 March 1994. Sean Smith/*Guardian*

The tabloids tended not to comment on the media circus, though this remained a subject in the broadsheets throughout the police investigation and is one of the favourite devices of broadsheet photojournalism. However, being self-reflexive is not the same as being restrained, and the media were criticised for their enthusiastic reports of the case. After the conviction of Rosemary West in November 1995 the journalist and broadcaster Jeremy Paxman complained that the trial 'licensed' obscenity and 'salaciousness'.[33] Yet what jurors hear and what is reported as news are not the same. Trials cannot be said to 'license' pornography, though its production may be one of the unintended effects of reporting evidence. The 'obscene' nature of the Wests' murders given in evidence was not fully reported in the press because (as Paxman knows) editors censor themselves according to what they guess their readers expect. After all, the newspaper is written over the copy of the previous day, and press titles rarely depart from their standard practice. Consequently, editors did not carry the full transcript of the trial nor every detail of the murders because they always report within what they estimate are readers' expectations on the coverage of extremes. Given the difference between trial evidence and news reports, Paxman overstates the case when he claims that trials license obscenity, because editors are more likely than not to omit the worst excesses. Nonetheless, Paxman is

correct in asserting that editors will report material in terms which are titillating. Editors do allow the quality of 'salaciousness' into written details of sexual torture. Although an improper, voyeuristic response to these details is inappropriate among jurors, it is a response that journalists often seek among readers.

In other words, Paxman's attack on the pornography in the papers is part of his larger complaint against book publishers who paid 'professional ghouls' to sit through the whole case, and against cheque-book journalism, including the *Daily Mirror*'s payment of £100,000 to a witness. Paxman is not suggesting that the broadsheets are morally superior in this matter – far from it. He writes that, following Rosemary West's conviction, the *Sun* gave its report thirty-three pages out of thirty-seven, and 'The *Daily Telegraph*, which long ago learned the tricks of titillation under the guise of news reporting, devoted nearly half of its domestic news pages to the House of Horror.' According to Paxman, all editors make these 'investments' because they know what their readers want. Though Paxman was also a journalist who reported the Wests' case and its reception, he placed himself among ordinary readers, reflecting that 'It says something about all of us that they believe we want to share Fred and Rosemary's fantasies'.[34]

All the daily newspapers are steeped in murder stories.[35] They allow drama, sensationalism and prurience, indulging in tales of extreme cruelty and perverse sexuality. But murder poses problems other than crime, grief and punishment. It may also bring 'upright consciences' together and concentrate their views and responses in 'public spheres of controversy': moral outrage promotes an explicit sense of community.[36]

Murders are a daily reminder of 'evil in our midst'. Some murders take place in broad daylight, but most are private affairs, something they share with family life. Murders and families converge when killings are carried out within families. Murder in the family is an expression of the nature of familial relationships, which can be dangerous or positively 'toxic'.[37] In extreme cases, parents murder children, and vice versa (though less commonly); husbands kill wives, and vice versa (also less commonly). The family is not always safe for children, who are sometimes sexually abused, tortured and murdered (generally but not solely) by male relatives. Even when the killer is a member of the same family as the victim, the press adopts the commonsense position on healthy family life, confirming its normality in contrast to the world of killers.

Even though every section of the press reports that murder is a domestic crime, the industry fastens on unusual killings by strangers who suddenly appear from nowhere.[38] Killers destroy families which, in their stereotypical forms, are supposed to be safe. The press sets photographs of murderous 'loners' against the 'lost' members of victims' families. Images of the victim are often published along with pictures of the rest of the family, some of whom speak at press conferences, so that the impact of the murder and the destruction of the family are made apparent. There is no remedy for grief; newspapers do not dwell on it, since it is both indecent to intrude and by itself so ordinary that it is not considered newsworthy.

To become newsworthy, bereaved families should also be poised and articulate. For example, Jonathan Zito was murdered by Christopher Clunis, a psychiatric patient released into the community in 1992 (*The Times*, 19 December). This prompted his wife, Jayne Zito, to start a public campaign against the government's policy of pressing health workers to discharge mentally disturbed individuals from hospital when they were unable to cope. Mrs Zito said that 'the fact that Jonathan was good-looking, that we'd been married just three months, that the personalities were attractive and sympathetic,

made the press interested in me'.[39] Casting victims as innocents, as beautiful or personally attractive, while casting their killers as morally or physically repulsive is an old convention in murder plots. It is found in the 'revenge tragedies' of the Elizabethan stage and in nineteenth-century melodramas. It is not surprising that such a powerful motor of narrative should be found in contemporary newspaper stories.

From the perspective of the press, the massacre at Dunblane Primary School matched one of the definitions of the horror story – the tale of lost innocence and the deviant, deranged killer (see all press for 14 March 1996). Though an extreme incident, the massacre fitted the normal pattern of extensive coverage of dreadful, sudden events. Apart from the *Daily Star*'s unusually intrusive publication of images which appear to have been taken of a mother before and after she learned of her child's death, this mass murder was reported and pictured in the normal fashion, though journalists did not badger grieving parents as much as usual.[40] No photographs of dead bodies were seen in the press, and instead the signs of youth, innocence and unity were reproduced by publishing the official school photograph of the class. Stuart Nicol, picture editor of the *Daily Record* (the Scottish version of the *Mirror*), traced the school photograph to one of a number taken by a local firm, Whyler Photos. Nicol negotiated exclusive rights by playing on local connections, despite competition from the *Sun*, and both parties agreed that all profits should go to the Dunblane Fund which was later set up to help bereaved families. Lack of information from the police meant that Nicol could not be sure which of the three first-year primary classes had been attacked and so he withheld publication. Later that day, Sky television broadcast a slightly different picture of the same school group which it had obtained from another local agency, Newsflash. Nicol had lost his exclusivity, but at least he knew which was the correct image.[41] At 10.00 p.m., when all the children had been identified, the police issued the school photograph for free use world-wide in the hope that it would prevent the press from intruding on grieving families in the search for images.

The class photograph was appropriate because it included everyone and because it was so symbolic of hope. The broadsheet press spoiled this pure message (for some grieving parents) by using a large reproduction of the class image and a small portrait of the killer, Thomas Hamilton, on their front pages, while the *Mirror* and *Daily Star* used different portraits of Hamilton on their covers and reproduced the group picture on their inside pages. The parents were distressed by seeing photographs of the smiling children and their teacher with their smiling killer. Of course, this type of placement is standard practice and its value as information overrides any element of bad taste. The broadsheet and tabloid picture stories were similar in many other respects: images of the school, the town, police, worried parents. The themes were the same across the titles, though expressed in different 'trade-mark' voices: the story encompassed the death of innocence, a disturbed and thwarted 'loner', the terrifying scene, the responsibility of the authorities, the power of the gun lobby, school security, and reminders of recent, similar massacres.

The story quickly moved in several standard directions. The press rejects murderers as insane and as not responsible for their actions: they are more newsworthy if they appear to fit into the community before destroying it, as in the *Independent*'s description of Hamilton as 'The man of whom nightmares are made' (15 March 1996). The press always searches for someone at fault, and so asked, 'Who licensed him to kill?' (*Guardian*, 15 March). It immediately gives voice to national sorrow, and the *Observer* emphasised a mixture of emotions in its front-page story 'Anger, grief, silence

and renewal' (17 March).

The massacre took place on Wednesday, and the following Sunday was Mothers' Day. In preparation for the unusual sadness or bitterness of that year's annual celebration, on Saturday the *Daily Mirror* printed the school photograph of the class behind a clock face with hands showing 9.30 a.m.: the moment when 'Nation Backs One Minute's Silence for the Mothers' (16 March). The photograph was shaded at the edges, and had a purplish tone, recalling photographs from the past. This apparently faded, old-style picture was designed to keep the memory of the children and their teacher alive. It corresponded in mood if not in appearance with the sign of official, national grief in the minute's silence of Remembrance Sunday, which had been restored only the previous November. The sense of national loss was achieved mostly by the Queen's visit to Dunblane on Sunday, 'The Day the Queen Wept' (*Daily Express*, 18 March).

As in this case, the photographic display is usually extensive if the story offers more opportunities than reproducing stereotypical studio portraits of schoolchildren or amateur snapshots of family members. The wide reverberation of the story for gun control in Britain was prefigured in pictures of concerned politicians, the Queen and the sympathetic public. Images of these three groups united in grief and determination to ensure that similar crimes never happened again in this country signified political will as well as sentiment. They supplanted shocking and unwanted photographs of the bodies of children and rendered them unnecessary.

Consider an earlier example which continued in the news for months and eventually converged with the Dunblane incident: Philip Lawrence, a headmaster who had appeared on television describing the safety and surveillance devices he had installed in his school to protect his pupils, was stabbed to death defending one of them against a gang outside the school gates shortly before Christmas in 1995. This story was heroic, pitiful and ironic, though it had a longer life than the usual run of similar tales because it was part of wider fears about the growth of a 'knife culture' in schools (see all press from 9 December 1995). It was easy, and normal, to illustrate the continuing story with pictures of the dead man in happier times, but there was the opportunity to include pictures of the floral tributes placed where he died, pictures of his family and even a reproduction of his son's letter to Santa, asking for his daddy back (*Guardian*, 11 December 1995).

The story opened on to more events which could be pictured, including an amnesty for handing in knives, a memorial service, and the look and presence of young gangs – a sequence of stories that ran into the new year. More portrait photographs were published when a sixteen-year-old youth, Learco Chindamo, was convicted of the murder (18 October 1996). The story had much greater resonance than most murders, bringing together morality, religion and politics: the headmaster's widow, Frances Lawrence, called for a nationwide movement to ban the sale of combat knives, banish violence and encourage civic values, teach citizenship in primary schools and strengthen family ties. The Conservative, Labour and Liberal Democrat parties all claimed they were the closest to Mrs Lawrence's agenda for the regeneration of Britain (22 October 1996). Though Frances Lawrence won support for what the newspapers called her 'moral crusade', the press also reported the deep cynicism of children and parents at how this story about schooling, youth crime and moral leadership was suddenly so important to politicians: a general election was no more than six months away. The press was quick to deride the Conservative, Labour and Liberal Democrat parties for beginning a stampede towards the moral bandwagon for the regeneration of Britain at a time when schools were being

closed by union action and government officials for complete breakdowns in discipline, or what is known officially as 'failing'. The *Guardian* reported that 'the class of '96 [had] switched off at moralistic lectures and double talk' (23 October).

The massacre in Dunblane and the murder of Philip Lawrence were particularly resonant, touching anxieties about the state of carelessness in Britain and the lack of a modern morality. They created publicity for the feeling that times were now more lawless than they had been in the past. Philip Lawrence's death led the government (with all-party support) to propose that for the first time police officers should be allowed to enter school property without invitation in order to search pupils for knives and other weapons (*Guardian*, 5 March 1996); that police should have wider powers to stop and search for knives or drugs anyone suspected of being a member of a street gang (*Guardian*, 7 November 1996); that 'marketing' knives 'suitable for combat' should become illegal (*Guardian*, 12 December 1996). The Dunblane massacre led bereaved parents to band together to defeat the powerful gun lobby, forcing the Conservative government to go further than the recommendations of the Cullen inquiry on gun controls.[42] As a result of this pressure, the government (shortly before it fell in May 1997) introduced the controversial Firearms Act banning all hand guns except 40,000 target pistols of 0.22 in. calibre which were to be held in licensed, secure gun clubs; owners of 160,000 larger-calibre hand guns were expected to surrender their weapons to the police in April 1997.[43] The incoming Labour government went further, and set about introducing the Firearms (Amendment) (No. 2) Bill, which would close loopholes left by the Conservative administration and outlaw smaller-calibre weapons still in private hands from 1 October 1997.[44]

These murders provoked rare action from politicians but not from journalists, who, according to professional practice, write stories that place crime in context.[45] Part of the journalists' work requires them to judge their paper's response correctly. Recounting murder in images, narratives and language may be emotive, or it may centre on reason and detection. These processes introduce the tragedy of those involved, call for revenge and retribution, demand action and allow the public expression of abhorrence and disgust. One of the principles governing murder reports is that the normal is supposed to be entirely separated from the deviant. This principle is always in tension with another factor of murder stories: the interweaving of panic and fascination. Murder stories open on to the horrors endured by others and also on to the desires of distant strangers who want to be thrilled by chaos and indulge morbidity. The public issues and reforms that may ensue from murders are only part of their cultural significance; they also permit feelings to run high, and are consequently always dangerous. But in the newspapers, in the end, awkward and unpleasant feelings associated with prying or pleasure are deflected away from 'normal' readers on to the deviant nature of criminals.

In 'The story of otherness', Bill Nichols argues that the 'other' is that which cannot be admitted to exist within – let alone be central to – the culture which creates it.[46] To the extent that the press reinforces cultural stereotypes, it places the blame for murder firmly on the 'other'. It proposes a 'gallery of the forbidden' which puts killing and murder beyond the norm. At the same time, actual, historical murders are a normal subject of news, along with murder in art, popular fiction, and reconstructions on film and television.[47] Sometimes any one of these systems of recounting murder invites readers to admit that a bond exists between themselves and monsters, aliens and killers. But no sooner is the bond proposed than it is rejected, because the 'other' is truly alien and

incomprehensible. Whereas the monstrous gallery of the forbidden may include horrors which are accepted as everyday risks, killing is never accepted in that way. Murder is essentially uncivil and, despite the evidence to the contrary, even un-British. The press almost never carries the process of identifying with the forbidden to the point where it becomes clear that 'the monster is fully and entirely a creature of the system that represents it'.[48] The opposite is more likely: the press insists that murder is out of the ordinary, and that murderers are outsiders.

Restraint in press reports and photographs of home-grown horrors is not driven simply by decency in looking. Criminal murders are not at all rare in Britain, but they serve as a complete and chilling contrast to the overwhelming sense of personal safety and family peace which newspapers hold out to their readers as the most normal of experiences. Murder is a dangerous area because it satisfies as well as repels; it is a dangerous area because it becomes the focal point of so much investigation – legal, medical, moral and inquisitive. Press reports indulge all this, and incidentally reveal not only how murder unleashes power but also how power permits murder – though these deaths signify as killings or executions. The press represents those killings which are sanctioned by the police or army as attempts to restore normality against an outside threat. For instance, when the *Observer* reported on one of Amnesty International's publications on torture, called 'A Glimpse of Hell', it failed to mention the British government's involvement in killing and torture, except to say, 'Ill-treatment of terrorist suspects in Northern Ireland has been well documented.'[49] It is unusual for the press to concede that forbidden and monstrous acts are supported by those who claim to oppose them. Exceptionally, the *Guardian* did not hide from the issue of 'Britain's "trade in terror" ', and reported Amnesty's conclusion that Britain is one of only six countries, including China and Russia, which organise 'the export of military and security equipment to regimes that kill and torture their victims'.[50] Such coverage as this, based on Amnesty reports, is unusual in the broadsheet press, and appears rarely, if ever, in the tabloids.

Notes

1 See Wendy Holden, 'Mental hospital freed patient who killed father and couple', *Daily Telegraph*, 8 July 1995.
2 See Alex Bellos, 'Mother who died in multiple killing was living at refuge', *Guardian*, 22 January 1996.
3 Deborah Cameron and Elizabeth Frazer, *The Lust to Kill. A Feminist Investigation of Sexual Murder* (London, Polity) 1987, p. 6.
4 Tim King, 'Bodies that lie uncovered', *Guardian*, 15 April 1995.
5 Keith Soothill and Sylvia Walby, *Sex Crime in the News* (London, Routledge), 1991.
6 Decca Aitkenhead, 'Bereavement power', *Independent on Sunday*, 27 October 1996.
7 Catherine Bennett, 'Journey into iniquity', *Guardian*, 26 January 1993.
8 Brian Masters, *Killing for Company* (London, Coronet), 1986, p. 149.
9 Charles R. Acland, *Youth, Murder, Spectacle. The Cultural Politics of 'Youth in Crisis'* (Boulder, Colorado, Westview Press), 1995, pp. 45–59.
10 David Green, 'Veins of resemblance: photography and eugenics', *Oxford Art Journal*, 7:2 (1984) 3–16.
11 Mary Cowling, *The Artist as Anthropologist. The Representation of Type and Character in Victorian Art* (Cambridge, Cambridge University Press), 1989.
12 Allan Sekula, 'The body and the archive', *October*, 39 (1986) 3–64.
13 See Sarah Kember, 'Surveillance, technology and crime: the James Bulger case', in Martin Lister (ed.), *The Photographic Image in Digital Culture* (London, Routledge), 1995, pp. 115–26.
14 Duncan Campbell, 'How murder is putting new life into publishing', *Media Guardian*, 22

March 1993; Sebastian Faulks, 'Making a killing?', *Guardian*, 10 June 1994; Nicci Gerrard, 'Delivering ourselves from evil', *Observer Review*, 1 October 1995.

15 See Terry Kirby, 'Serial killer locked up for life', *Independent*, 21 December 1993.

16 See John Steele, 'Students in dare killing jailed for life', *Daily Telegraph*, 9 November 1994.

17 See Duncan Campbell, 'Daniel Handley's killers told they must die in prison', *Guardian*, 17 May 1996.

18 George Orwell, 'Decline of the English Murder', *Decline of the English Murder and other Essays* (Harmondsworth, Penguin Books), 1965, p. 13.

19 Steve Chibnall, 'The production of knowledge by crime reporters', in Stanley Cohen and Jock Young (eds), *The Manufacture of News. Deviance, Social Problems and the Mass Media* (London, Constable), 1981, p. 87.

20 Anne Spackman, 'Spark that fires a random killer', *Independent*, 28 September 1988; David Rose, 'Lethal strangers reflect violent society', *Guardian*, 1 January 1990.

21 Jonathan Goodman, *The Moors Murders. The Trial of Myra Hindley and Ian Brady* (Newton Abbot, David & Charles), 1986.

22 Helen Birch, 'If looks could kill: Myra Hindley and the iconography of evil', in Helen Birch (ed.), *Moving Targets. Women, Murder and Representation* (London, Virago), 1993, pp. 32–61; Duncan Campbell, 'Hindley to fight no-release ruling', *Guardian*, 24 January 1997.

23 Myra Hindley, 'Myra Hindley: my story', *Guardian*, 18 December 1995.

24 David Ward, 'Hindley letter prompts man to break 32–year silence over his escape from Moors murderers', *Guardian*, 23 December 1995.

25 Henry Porter, 'Reason eclipsed by evil', *Guardian*, 16 March 1996.

26 Cal McCrystal, 'Murders scar this grieving pleasant land', *Observer*, 6 August 1995; Blake Morrison, *As If* (London, Granta Books), 1997.

27 Brian McConnell, 'James Bulger – victim of a legend?', *British Journalism Review*, 5:4 (1994) 60–2.

28 Michael Medved, 'The seeds of evil sown on our screens', *Sunday Times*, 28 November 1993; Patricia Highsmith, 'Child's Play 4?', *Times Literary Supplement*, 22 April 1994.

29 John Hiscock, 'Oliver Stone sued for £20m by victim of copycat film violence', *Daily Telegraph*, 1 July 1996.

30 Julian Petley, 'In defence of "video nasties" ', *British Journalism Review*, 5:3 (1994) 52–7; Annette Hill, *Shocking Entertainment. Viewer Response to Violent Movies* (London, John Libbey), 1997; David Gauntlett, *Video Critical. Children, the Environment and Media Power* (London, John Libbey), 1997.

31 David Ward, 'Sadistic death went beyond belief', *Guardian*, 18 December 1993.

32 Howard Sounes, *Fred & Rose. The full Story of Fred and Rose West and the Gloucester House of Horrors* (London, Warner Books), 1995; Brian Masters, *'She Must Have Known'. The Trial of Rosemary West* (London, Doubleday), 1996.

33 Jeremy Paxman, 'Wallowing in the house of horror', *Sunday Telegraph*, 26 November 1995.

34 *Ibid.*

35 Jeremy Tunstall, *Newspaper Power. The New National Press in Britain* (Oxford, Oxford University Press), 1996, p. 209.

36 Graham Knight and Tony Dean, 'Myth and structure of news', *Journal of Communication*, spring (1982) 144.

37 Roddey Reid, ' "Death of the family," or, keeping human beings human', in Judith Halberstam and Ira Livingston (eds), *Posthuman Bodies* (Bloomington and Indianapolis, Indiana University Press), 1995, pp. 177–99.

38 Terry Kirby, John Arlidge and Rachel Borrill, 'A year of killing', *Independent*, 12 January 1992.

39 Aitkenhead, 'Bereavement power'.

40 Magnus Linklater, 'Why Dunblane *was* different', *British Journalism Review*, 7:2 (1996) 15–19.

41 Paul Tilzey, *Decisive Moments*, BBC Television, 1996.

42 Nick Cohen, John Arlidge and Patrick Wintour, 'An accomplished mission', *Observer*, 20 October 1996.

43 Alan Travis, 'Law to ban all but .22 handguns', *Guardian*, 2 November 1996.

44 Alan Travis, 'Lords clash likely over gun ban', *Guardian*, 15 May 1997; Rebecca Smithers, 'Free vote leads to ban on all handguns', *Guardian*, 12 June 1997; Vivek Chaudhary, 'Gun law deadline looms. Let's shoot across the Channel', *Guardian*, 29 September 1997.

45 Stuart Hall, Chas Critcher, Tony Jefferson, John Clarke, and Brian Roberts, *Policing the Crisis. Mugging, the State and Law and Order* (London, Macmillan), 1978.

46 Bill Nichols, *Representing Reality. Issues and Concepts in Documentary* (Bloomington and Indianapolis, Indiana University Press), 1991, pp. 204–7.

47 Joel Black, *The Aesthetics of Murder. A Study in Romantic Literature and Contemporary Culture* (Baltimore, Johns Hopkins University Press), 1991; Cynthia A. Freeland, 'Realist horror', in Cynthia A. Freeland and Thomas E. Wartenberg (eds), *Philosophy and Film* (London, Routledge), 1995, pp. 126–42.
48 Nichols, *Representing Reality*, p. 205.
49 Leonard Doyle, 'Agony of the global torture chamber', *Observer*, 26 May 1996.
50 Maggie O'Kane, 'Britain's "trade in terror"', *Guardian*, 19 June 1996.

8

Foreign bodies

Death is rarely seen in ragged human remains unless they are foreign. Reports of horrors overseas concentrate on the essential strangeness of victims, whether they invoke revulsion or invite compassion. Even in those stories which spark moral debate, the press uses stereotypes of alien life: they include refugees, corpses and even skeletons in the streets. These pictures contrast with idealised British systems of value, care and order. They imply that outside Britain chaos is the norm, and life is cheap. They strengthen prejudices that the 'nature' of very different cultures is, at worst, primitive and barbaric. If it is not impolite to stare at strangers, what are the assumptions that underpin this permission and what does such staring imply? Certainly, greater coverage is not bound to produce new knowledge or compassion. After all, the point about foreigners is that they are strange, and that death abroad appears to be different and worse than is normal in British culture.

Dead foreigners are essential signs of the 'other' to dead Britons. Bill Nichols argues that the 'other' is 'evil or chaos, excess greed or indolence, horror or monstrosity, the nefarious and the destructive'.[1] In representing death and disaster abroad, journalism emphasises disorder and even the impossibility of civil society in foreign countries. The dead in foreign stories confirm that famine, epidemics of disease, war or natural disasters such as typhoons and earthquakes are un-British. Consequently, these 'others' who cannot represent themselves serve principally to accelerate or discourage the actions of Western or British heroes. In other words, the press uses foreign stories to contrast with or invoke British values and does not use them to reflect the values of different countries. The interests of the 'other' are to a large extent subordinate to the interests of the figures who make use of the images and stories. Nichols writes, 'The death of anyone represented as Other is never of inherent significance ... Its importance comes from what

The killers of Kigali. In this picture an RPF soldier stands guard over prisoners held in a church. The prisoners are members of a government-sponsored militia responsible for mass killings in the Gikoro district. The woman clasping her neck is said to have murdered many people. *Observer*, *Life* magazine, 22 May 1994.
Jack Picone/Network

it allows the narrative to reveal of the protagonists.'[2]

This does not mean that foreign stories are entirely separate from home news. In fact they share some preoccupations: fate, bad luck and mismanagement are at the root of all catastrophes. The way story-telling methods overlap reveals how newsworthiness is regarded as having an absolute quality, self-evidently emerging from the seriatim of experience. News is supposed to present itself to editors, who simply report what-has-been as a matter of public record. This convention allows the press to demonstrate that as a matter of fact foreigners live and die in extreme circumstances. Following the Hutu massacres of Tutsis in Rwanda in 1994 a report in the *Independent on Sunday* charted the progress of the killings and explained why they occurred; it also described combatants and their victims.[3] Accompanying the story was a picture of numerous bloated bodies jammed into a pool beside the river Akagera at Rusumo. The caption was 'Flow of death: ... the river has carried thousands of corpses since the massacres began last month.' The bodies appeared *en masse*, lacking distinction as a mess of corpses. Even when living people are represented as being on the move or living in refugee camps they often appear to be trapped, doomed or as good as dead. A week after the report on the pool at Rusumo the *Observer* gave seven pages of its weekend 'Life' magazine to a report on 'The killers of Kigali' by Mark Huband, and photographs by Jack Picone of casualties, refugees and captives (as illustrated above) as well as corpses. Hideous wars and famines roll across Africa, Asia or the ill-defined 'East'. In these places the dead or dying body becomes a sign of excessive reality in nightmarish worlds.[4]

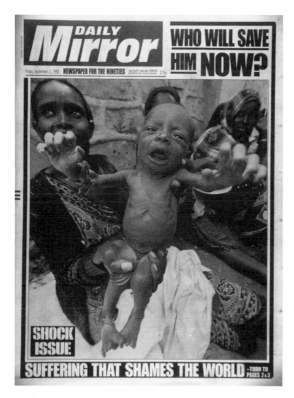

Daily Mirror, 11 Sept 1992. MSI/Ken Lennox

This emphasis is particularly noticeable in the broadsheets, which cover foreign stories at greater length and more frequently than the tabloids. Photographs of injured foreign bodies, specifically if they are black, may seem to exemplify repulsive cultures. These foreigners are cyphers in the press, standing for the elemental. Commenting on the way the French picture magazine *Paris Match* supports 'petit-bourgeois myths' about Africa, Roland Barthes wrote, 'Ultimately the Black has no complete and autonomous life: he is a bizarre object, reduced to a parasitical function, that of diverting the white man by his vaguely threatening *baroque*; Africa is a more or less dangerous *guignol*.'[5]

'Hard' news photography of Africa appears occasionally in the tabloids. In 1992 the *Mirror* printed Ken Lennox's campaigning picture-story of starvation in Somalia. It placed a hard-hitting image of a dying baby on its front cover (illustrated above), and asked, 'Who will save him now?' (11 September – two days after taking the picture, Lennox found the baby and its mother dead in the road). In 1996 the *Mirror* used a photograph of a four-year-old boy wounded (by a grenade made in Britain) when Rwandan refugees returned home from exile in Zaire (renamed in 1997 the Democratic Republic of Congo). The boy was 'Saved by [*Mirror*] readers', who had given more than £150,000 by telephone to Médecins sans Frontières and the Red Cross (18 November). While such stories have sometimes appeared in the *Mirror*, the widespread absence of foreign horror pictures from the tabloids does not mean they avoid the stereotyping which is common in the broadsheets. On the contrary, their rare stories use the standard forms of victims and refugees. But the tabloid press's indifference to foreign stories is

shameful, since it erases the plight of Africans from an industry which is a daily platform for airing controversies. According to Zygmunt Bauman, writing on how some Germans separated themselves from the Holocaust, the distance between the act and its consequences means that 'moral dilemmas recede from sight'.[6] This seems to be a condition of all reporting. But it is less harmful to public knowledge than rendering the victims invisible by keeping them out of sight, or by hinting that they are not worth looking at. In contrast, the broadsheet press is more committed to its role as witness to foreign affairs even if they are inevitably seen from a distance and are of no immediate concern to readers. This is the broadsheet press as national 'watchdog', another of its normal functions in promoting controversy.

In this chapter I shall discuss the conditions for viewing dead foreigners in Britain, but I intend to broaden my examples beyond refugees, corpses and skeletons to include state executions in Saudi Arabia. In addition, I shall examine how the British press reports American executions. Whereas execution in Arabia is regarded as messy, the American way of killing convicts is obsessed with the publicity of cleanliness. Depending on their markets, British newspapers look at the unbelievable, neurotic claims of cleanliness in state killings in the United States with a mixture of alarm, admiration and disdain. When torture and executions are publicised in British newspapers or videos they are more likely to provoke attacks on the unwarranted depiction of horror than awaken consciences.

Accusations of prurience and editors' wariness in depicting violence are important factors governing newspaper practice, but they do not mean that moral choices are redundant or that ethical codes are irrelevant. Human rights and social justice are current issues. Present generations are not separated at all from mental universes which carry out systematic murders, 'ethnic cleansing' or even genocide. The end of chemical photography, which signals the end of traditional documentary, does not mean that photojournalism has no place in representing the enormity of past terrors or contemporary atrocities. The broadsheet press is also home to the campaigning advertisements of Amnesty International, which I shall discuss. Finally, I shall consider how the press treats foreign bodies in its use of photojournalism. Despite its ambiguities, eye-witness photography harvests the unintelligible. Who reads it and to what effect is another matter.

Documentary compassion and disgust

Not all foreign stories are designed to make readers turn away in disgust. Newspapers often appeal to readers' compassion, and show that distant sufferers are brave and dignified in the face of adversity. The broadsheets are more likely to use aesthetic references. This urge can sometimes lead editors to break with the expectation that documentary photographs relate to the same incident as reports. For example, in 1993 the *Independent on Sunday* used a photograph, taken in 1971 by Mark Edwards, of Bangladeshi refugees dying of cholera in Calcutta (illustrated opposite). The *Independent* chose Edwards's image of a man carrying 'his dying wife, who is stricken by cholera, through the streets of Calcutta' to illustrate the story that a new strain of the disease had recently claimed more than twenty-two thousand victims there (30 May 1993). Though strictly inaccurate as an image of a current disaster, the appeal of Edwards's image proved irresistible. His photograph of the dying woman is remarkable for her nakedness and

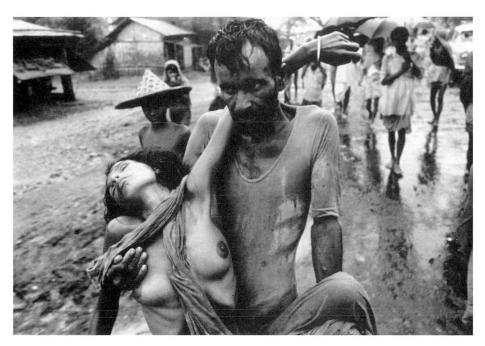

Hopelessness in the time of cholera. Burden of sorrow ... a man carries his dying wife, stricken by cholera, through the streets of Calcutta. A new strain of the disease has claimed more than 22,000 victims there over the past month. *Independent on Sunday*, 30 May, 1993. Mark Edwards/Still Pictures

beauty, the grim face of the husband and incidentally for the children in the background, who seem to be either indifferent or more intrigued by the photographer than by his subjects. The powerful appeal of this picture, again, derives in part from its accidental similarity to the Pietà figure. The editor's headline 'Hopelessness in the time of cholera', referring to Gabriel García Márquez's famous novel *Love in the Time of Cholera*, indicates not only the fashion for allusive captions but also the peculiar way that suffering is frequently made aesthetic. If a photograph has this appeal then it can quite easily move from a picture editor's desk to a national art collection: an archivally processed copy of Edwards's image is held in the Victoria and Albert Museum in London. There is nothing unusual about this, and many similar record photographs are lodged at the V & A, including work by the war photographer, Don McCullin. However, he has said, 'I've never considered my work art, I have watched too many people die,' which provokes outrage in him, not an aesthetic response (*Independent*, 15 February 1997).

Nonetheless, documentary photographs often become art. Commenting on the interest in contemporary photojournalism in America in the 1980s, Andy Grundberg noted that it could be a sign not of vitality but of the medium's status as an artefact: 'Taken off the page and folded into the museum, the New Photojournalism becomes simply another genre in the realm of art, dysfunctional but beautiful.'[7] Nothing can prevent this movement of pictures and their meanings, and being in a museum does not mean that the images are bound to lose their moral impact. In any case, this line of thought raises the question whether the images had a moral impact to lose. The meaning of a photograph depends on its location but also on the location's politics, or the purpose of display. Museums are not inherently sterile in moral terms any more than

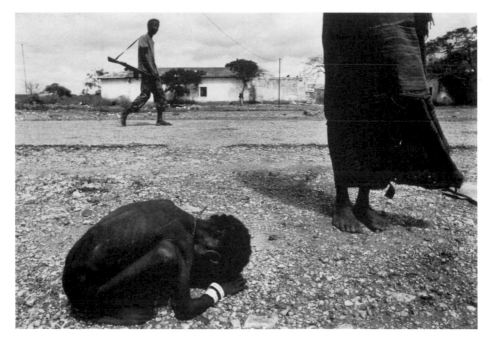

A Year without Pity. *Independent on Sunday* review, 27 December 1992. James Nachtwey/Magnum

newspapers are inherently active in this regard. In the current climate, however, museums are more likely to offer their audiences pleasure in aesthetic form and not use photographs deliberately to stir political consciences. Broadsheet newspapers are more likely to combine the formal pleasures of documentary photography with some kind of political point of view, though it may not be a radical one.

Shocking pictures may be formally pleasing and match conventional story lines. For instance, the press reports on 'courage in the face of adversity'. This style of report is popular in home stories of both disaster and murder, and when applied to foreign stories it may increase readers' empathy because people are seen to help themselves. This type of coverage usually accompanies stories about death by famine or other so-called natural disasters instead of murders or killings arising directly from waging war. Consider James Nachtwey's photographs of famine in the town of Baidoa in Somalia, reproduced in the *Independent on Sunday*'s review magazine shortly after Christmas in 1992 (27 December). This review of 'A Year without Pity' used one of Nachtwey's pictures (illustrated above) on the cover: it depicted a starving child crouched in the earth, with its head sunk to the ground, and wearing an identification tag around its wrist; an adult stands near, and a young man with a rifle ambles past, glancing at the photographer at work. There were nine photographs in all, in black-and-white and without captions. They indicated what it looks like to starve to death in a pitiless, unforgiving wasteland. The pictures are grim, but they are relieved by many signs of humanity. A women bathes a starving child; men wash a dead child; men and women shroud a corpse; a child covers a crouching man; one skeletal figure caresses another.

Nachtwey's picture story followed an article called 'How fares the human spirit?' which declared, 'Mammoths are emerging from the ice: ethnicity, religious sectarianism, nationalism.' The author, Ian Jack, writes, 'there have been many impulses and plans to

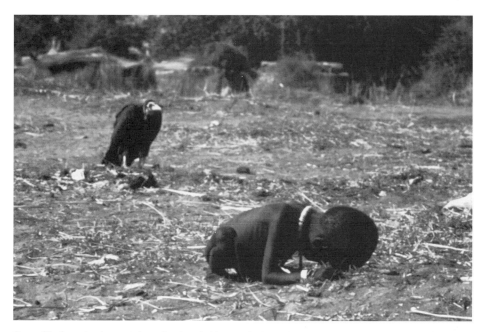

Dogged by haunting images. Through a lens darkly ... nobody can know the effect on Kevin Carter of taking this award-winning photograph of a starving child in [Sudan]. *Guardian*, 22 August 1994. Kevin Carter/Sygma

help [beleaguered people], from many individuals and governments with no direct involvement and with no real self-interest to be satisfied. Somalia may be saved in this way – 28,000 US troops and shiploads of foodgrains are on their way.'[8] This humanitarian impulse, then, is the setting for the pictures, which show these distant people to be among the 'deserving poor' in the season of goodwill. This is not a cynical or reprehensible pitch by the *Independent on Sunday*, though it must be seen in the context of the newspaper's annual review in which it comments on current affairs instead of reporting hard news, and as part of its everyday practice of appealing to a concerned readership. Of course, readers may still find these pictures incongruous and grotesque, blame the Africans and turn the page in disgust.

Nachtwey's image did not offer much hope that the child would survive, but it is quite different in tone from Kevin Carter's photograph (illustrated above) in Sudan in 1993. This depicts a starving, abandoned girl who crouches, head to the ground, with a vulture perched near by, hinting that the child will become carrion. Carter's image was used in the *New York Times* (26 March 1993) and won him a Pulitzer Prize in 1994. But the picture was so brutal that the editor of *The Times*, mindful of readers' sensitivities, published a note on the fate of the girl: 'Mr Carter said she resumed her trek to the feeding center [and] he chased away the vulture'.[9] This seems like wishful thinking and indeed, a piece in the *Guardian* reported no such intervention. Carter did not help the child because, he said, 'there were thousands of them'.[10] The *Guardian* story was reflecting on Carter's suicide, observing that, 'Bringing home the first-hand evidence of mass suffering can have a destructive effect on the messenger'. The various editorial uses of Carter's and Nachtwey's images suggest some of the ambiguities and compromises of humanitarian reporting.

These stories and pictures together encapsulate several themes in reports from Africa,

which are repeated so frequently in style and content that they have become the standard form. First, they are about refugees. It is traditional for documentary to concentrate on such people, who, according to Barthes, appear to be produced by 'nature'.[11] The picture and story intimate that other natural or so-called 'native' African products include disease, misery and atrocity. Refugees are lumped together with these other 'native' products and all are presented as natural, endemic and unfathomable. This treatment of refugees (as well as of the other products) may overlook the way they are produced by international wars, fed by the international arms trade, or serve other forces, including the Western need to perceive relative order in liberal democracies and chaos everywhere else.

In contrast to the idea that the press photograph carries no moral weight, some newspapers occasionally invite readers to respond to gruesome pictures. Proximity to the deaths of strangers, even in the form of images, can provoke action. An example of the effect of one horrific sight comes from the California Senator Diane Feinstein, who claimed that Darko Bandic's image of the woman hanging from a tree following the attack on Srebrenica 'punched through' to her so that she reversed her original vote in favour of lifting the weapons embargo in Bosnia (see illustration on p. 80).[12] A second instance comes from Zaire in 1994: the flight of a million people across the border from Rwanda after the Tutsi-led Rwandan Patriotic Front's victory over the extremist Hutu government, which had launched genocide of Tutsis and Hutu moderates, led to huge refugee camps and the spread of disease. The *Observer* reported the spread of cholera in Munigi camp: 'In a desert of brittle black stones the dying lie barely stirring among the dead. Relatives pick their way through the corpses, stumbling across the shards, listlessly begging for help.'[13] The report noted that 'US President Bill Clinton called [the plight of refugees from Rwanda] "the world's worst humanitarian crisis for a generation"'. The photograph (illustrated opposite) which accompanied this story showed corpses wrapped in blankets, men in masks gathering the dead, a lorry, and onlookers. But it focused on a woman trying to comfort a 'a dying cholera victim, one of thousands now perishing in and around the Goma refugee camps'.

Reports may underline that the survival of Africans depends on Western aid agencies, supported at times by armies. Whether or not people believe it is worth while helping others may depend on how they perceive physical suffering. They may consider that the agony of others stems from their own moral and intellectual degradation. The disease, famine, superstition and barbarous customs of chaotic foreigners all exist as the imaginary other to the desired Western order. The rhetoric of humanitarian aid to some degree requires the constant reproduction of abject images both as a justification for intervention and as the necessary restatement of a basic difference between donors and recipients. The story and picture of the man dying of cholera in the Munigi camp in 1994 may have been intended to provoke action, but it may also have hardened the belief that there is a necessary gulf between those who are civilised enough to have aid to distribute and those who are merely civilised enough to receive it. Such a view of this centuries-old (and exploitative) humanitarian narrative informs many of the accusations levelled at photography: it is able to show in detail the suffering of fellow humans but it conspicuously fails to oblige viewers to act on the knowledge.

This account of the Munigi camp is conventional in overseas stories in representing the extreme wretchedness of the scene. Moreover the dying man's plight is altered by the woman's tenderness towards him. The photograph's revelation of human kindness is

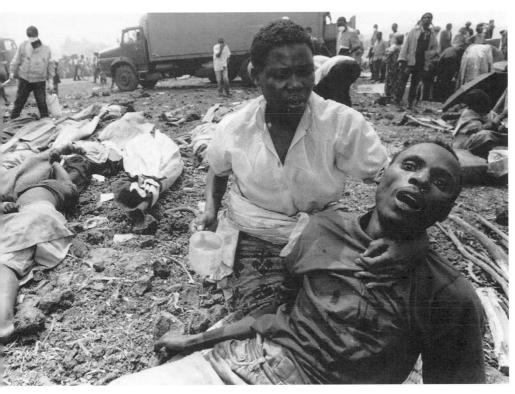

Silent killer follows the massacres. Death in the desert: a Rwandan refugee tries to comfort a dying cholera victim, one of thousands now perishing in and around the Goma refugee camps. *Observer*, 24 July 1994. Corinne Dufka/Popperfoto (Reuters)

altered again by the unself-conscious reference, in Western eyes, to the Pietà and imagery of sorrow and loss. This means that the picture, once again conventionally, appeals to individual emotional response and not to a fundamental structure of injustice that lies beyond the frame. The story uses devices which are familiar in all reporting, but the dying man appears to look at the camera, and so for once viewers are invited to look death in the eye. This meeting of eyes is a direct appeal to the individual onlooker, changing the 'I–it' relation to a possible 'I–thou' relation, inviting some reaction. Eye contact threatens to overpower the aesthetic and other conventional forms of representing foreigners, which usually allow viewers to adopt a conditional response to matters which they may feel do not concern them.

The meaning of the story remains unstable. It invites a range of responses including pity, anguish and repudiation. The image of this dying man may contribute to humanitarian feelings and actions, but it *'fills the sight by force'* and may produce revulsion. As Alphonso Lingis writes, 'The faces and surfaces of others afflict me, cleave to me, sear me. They solicit me, press their needs on me; they direct me; order me. [But] the face of a stranger in the crowd turned to me is an imposition. The face of a Somalian [or a Rwandan] looking at me from the newspaper page intrudes into my zone of implantation; I am relieved that the opaqueness of the paper screens me from him.'[14]

Relief at the opaque nature of the screen is not the only reaction. Others may include

anger directed against Rwandans or Somalis for failing to save themselves; disgust at their wretchedness; indifference at their plight and boredom with its familiarity, because such miseries are usually presented as the natural product of the continent and often seen in photographs. Clear sight of the dying bodies of Africa indicates their suffering, but the opaqueness of reproduction in newspapers affirms that the bodies are distant, defined and localised in another culture. The distance of audiences from sufferers encourages non-identification, and even allows audiences to draw some satisfaction from the image of suffering as it belongs to others and not to themselves. In addition, these images appear unbidden in the act of turning the page, and so can be made to disappear just as quickly.

Nonetheless, the fact that photojournalism confirms Western beliefs about the brutality of these foreign worlds does not mean that viewers are bound to be numbed by the suffering of others. The media – notably the broadcast media, with the press following on – can appeal on behalf of refugees or victims of famine, and bring forward practical responses. Moreover the opaqueness of the newspaper has a beneficial as well as a harmful effect: because readers are unable to identify totally with the suffering of others, their ability to act is not paralysed by pain or terror. Consequently, though suffering is represented and always belongs to someone else distant in time and place, it may work on the imagination or sensibility of viewers until it cannot be ignored. If photographs and picture stories of misery enlarge the space for reflection and action, they justify the opaque screen of the newspaper, which at least invites viewers to engage in controversy.

Execution

Executions happen only overseas; they are almost as newsworthy as murder in Britain because they are an exotic death that the British state has not inflicted on convicted criminals since 1964. (The death penalty was abolished in 1973.) They allow the press to highlight the strangeness of foreigners; they permit and guarantee spectatorship and eye-witnessing. Above all, they enable the press to deepen or indulge its absorption in the debate on capital punishment, deterrence and revenge.

Executions give rise to the problem of degree: they measure as well as perform the degree of punishment the state brings to bear on the bodies of miscreants.[15] The press assumes its readers to be at least intrigued if not outraged when states 'put' criminals to death. The phrase 'to put to death' is relatively neutral, since it gives nothing away about methods or objects, though it is clear about the exercise of power. In contrast, the term 'executions' is as colourful as 'murder' but more ambiguous. The term denotes a higher level of ceremony and efficiency than murder, as well as carrying the weight of law. 'Execution' describes a deliberate, methodical act carried out in cold blood, as if state killings and the courtroom somehow insulated themselves from the heat of unreason. This illusion is often called into question, not least when prisoners condemned to death in the United States demand their right to be executed as the law requires.[16] These demands stir up action at every level of the law and also among those groups who support or oppose execution in general or fight over specific cases. As a result, the frenzied activity around some executions means that the United States is not entirely at ease with itself in this matter. The legal status of executions, and the fact that some prisoners willingly participate in them, does not mean that the country's sense of itself or its reputation overseas is enhanced by its addiction to the letter of the law. Executions

can reflect badly on those who carry them out, hinting somewhat paradoxically at an act which is both brutal and clinical. For many people execution smacks too much of revenge and torture to belong in contemporary democracies: it is relegated to foreign powers and is a sign of their difference and inferiority. For many other people – perhaps even the majority among the population in Britain – execution is felt to be a just punishment for what are known as 'heinous' crimes, primarily those ending in the murder of children.

In another aspect the term 'execution' can describe brutal, summary and illegal acts carried out in antipathetic religious cultures, or by dubious political 'regimes' regarded in Britain as deeply suspect forms of government. The British government bases its acceptance or rejection of those seeking political asylum on its assessment of quasi-legal 'regimes' led by so called 'fundamentalists' or military leaders, though it rarely intervenes in their internal affairs. For example, in 1995 the Nigerian authorities charged nine Ogoni leaders with murder, tried them before a kangaroo court and hanged them (10 November). The Ogoni nine, including the playwright Ken Saro-Wiwa, had been campaigning against the exploitation and degradation of their homeland by their government and the Shell oil company. This story of opposition was not such big news as the convictions. There was some belated agitation for clemency among Commonwealth leaders, though most of the international outcry arose after the condemned had been hanged. The British government did not recognise the killings as legal executions: Prime Minister John Major called them 'judicial murder', which suggests they had only the veneer of law and were more akin to killings by gangsters and terrorists.[17] In either of its aspects, whether legal or not, whether carried out in Nigeria or the United States, execution is tainted by its excessiveness.

State killings

In contrast to the death of innocents in acts of murder, legal executions kill those who have been judged and found guilty. Instead of death dealt at random by lone killers or bombers, executions are brought down precisely on the body of the tried and condemned. Apart from Japan and the United States, which has the death penalty in twenty-seven states (some of which offer a choice of method), no advanced industrial country executes convicted criminals. But government killings are routine elsewhere, and the seven most common methods are shooting (eighty-six countries), hanging (seventy-eight), stoning (seven) and beheading (six); the United States is the only country which uses electrocution (twelve states), gassing (four), or lethal injection (nineteen).[18]

The British broadsheet press appears to be uncomfortable with all state killings of convicted prisoners, no matter where they take place. Beheading and stoning in Arab, Asian and African states are notably bloody, while hanging, electrocution and shooting in the United States are supposed to be clean and free of blood. In all cases the politics of East and West are focused on doing the condemned body to death. Neither the supposedly clean killings carried out by American technicians from a distance and like clockwork, nor the bloodier scenes in Arab, Asian and African states carried out by identified state executioners and sometimes in front of crowds, are free of exotic cruelty in the context of British newspaper reports. The 'clinical', so-called civilised, approach pretends that the procedures are painless; that the pain lasts such a short time that the condemned person does not suffer for long; that prisoners deserve to feel some high level of pain to match their crime if not the suffering of their victim.[19] This pretence is always

being contradicted and state killings shown to be painful and cruel torture.[20] The knowledge about execution in the United States makes that country appear strange in Britain, stranger than expected, given the cultural and linguistic ties between the two nations. At the same time, the press also regards state killings in Arab countries, Asia and Africa as a sign of strangeness, though it is not so unexpected, given the cultural and linguistic distance between the various nations in these regions and continents.

Executions are supposed not to torture criminals to death but to kill within principles of moderation in applying the power of punishment. Those giving evidence to the Royal Commission on Capital Punishment (1953) rejected shooting on the grounds that 'it does not possess even the first requisite of an efficient method, the certainty of causing immediate death'.[21] Expert witnesses frequently emphasised that death should be rapid, clean and dignified. The most perfect expression of this wish for 'humane' execution is in the United States, where instruments of death have been designed to give the impression that death is clean as well as quick. When John Taylor was executed by firing squad in January 1996 the warden said it went 'like clockwork … just like we rehearsed'.[22] Four bullets entered the heart and made a single hole 'the size of a dime' in the wooden backing of the execution chair, and hinged panels on the steel chair prevented blood from spattering the chamber. The *Independent* printed three photographs with its report: a prison portrait of Taylor; a snapshot of his victim; an image of a warden pointing to the small hole in the plywood.[23] The Director of Corrections said there was 'nothing to clean up on the floor'.

This avoidance of 'mess' perfected the process begun in 1792 with the introduction in France of the guillotine: 'Contact between the law, or those who carry it out, and the body of the criminal, is reduced to a split second. There is no physical confrontation; the executioner need be no more than a meticulous watchmaker.'[24] The absence of mess did not mean the state showed moderation in Taylor's execution. On the contrary, the exercise of power demanded that the execution should be designed so that nothing would spill or spatter. What the state contrived was the excessive use of power on the body of the condemned to the point where it succumbed utterly to the state's will: no blood and gore, nothing to indicate that state killing is similar to immoderate, criminal murder in which blood is everywhere.

Rehearsing and designing a means of 'clean death' are supposed to demonstrate the civility of the state authorities, but they are part of a pro-death advertising campaign. The opposing view is aired in the British broadsheet press, in particular, which highlights the barbarism of executions in the United States. Following the release in Britain of the issue-based film *Dead Man Walking*, Amnesty International ran an advertisement which attacked electrocution as a cruel method of killing, the mental torment of suffering one or more stays of execution, and the attempt by some US broadcasters to screen executions on live television 'for your viewing pleasure' (*Independent*, 21 April 1996).

The press generally notes high-profile US executions, but the story was brought home when a British-born murderer was due to die in the electric chair in Georgia on 6 April 1995. This story also received greater pictorial coverage, because Clive Stafford Smith, the lawyer who tries to save convicted killers from a 'barbarous' death in the United States, won Nicky Ingram a twenty-four-hour reprieve. The story had more time to run, and continued after Ingram was eventually killed late the following day. The *Independent* placed the story on its front page, with a portrait of Ingram and a larger photograph of

the electric chair inside the 'Georgia Diagnostic and Classification Center' in Jackson.[25] Smith asked why, if death was instantaneous, as the prison's glossy hand-out insisted, did the authorities electrocute the man for two minutes? He wrote, 'When Jimmy Gray [was electrocuted] in Mississippi in 1983, his head thrashed around and graphically illustrated his pain. Witnesses vomited... So before they killed my client, Edward Johnson, in 1987 they strapped his head tightly to a pole ... so nobody could see the pain.'[26] Ingram was tied down tightly to prevent him moving, his mouth was bound firmly shut, his nose was blocked to prevent the spread of blood, and his head was covered with a leather flap, probably to prevent witnesses from seeing too much of what took place. Once again, the state had moved deliberately towards advertising executions as clean, and separating them from murder.

Despite the American publicity, the British broadsheets do not accept this view of execution as a clean kill. There is very little they can do visually to disprove it, so they rely on descriptions. Two days after Ingram's death, the *Independent on Sunday* published an article drawn from Harold Hillman's account of the pain experienced during execution by different methods. Hillman's description of how people die in the electric chair was especially graphic: 'The prisoner's hands grip the chair and there is violent movement of the limbs which may result in dislocations or fractures. The tissues swell. Micturition and defaecation occur. Steam or smoke rises and there is a smell of burning.'[27] The detailed account of what happens to the body as it is killed disturbed the *Independent*'s readers, and the newspaper published a few letters either complaining about the details because they were 'not suitable for family reading', or supporting the exposure of 'cruel and revolting' ceremonial murders (16 and 23 April 1995).

The press was drawn to Ingram's case because he was born in England, but the broadsheets report steadily on executions in the United States. It helps a story if executions show anomalies in US society, such as when rugged individualists campaign for state intervention to kill convicts.[28] It helps a story if the execution is bizarre. For instance, the 'clean' execution ritual was ruined when a terrified prisoner, Charles Campbell, fought with warders as he was about to be hanged in May 1994. A pepper spray was used to subdue him, but as he was then too weak to stand at the gallows the only way to keep him upright was to strap him to a board.[29] The barbarity of execution in the United States is always exposed when machines fail. For instance, the botched electrocution of the convicted killer Pedro Medina in Florida in 1997 'caused a foot-long flame to burst from the side of [his] head', with smoke and the smell of burnt flesh spilling through air vents into the witness room.[30] While many states still have the option of electrocution, most have already changed or are changing to the demonstrably 'cleaner' system of lethal injection.

Messy execution

The 'clockwork' executions in the United States are designed to separate the state and its watchmakers from 'dirty deaths', which are common in executions in foreign countries, thus enhancing the United States' reputation for 'clinical' kills at home as well as in warfare (notably in the Gulf War of 1991). In contrast to the Americans, other nations use ancient, pre-modern methods of execution which are decidedly bloody. Stoning is used in Iran, Mauritania, Pakistan, Saudi Arabia, Sudan, the United Arab Emirates and Yemen. It requires the condemned to be buried up to their necks in sand, their heads

covered by sheets, and pelted with stones which are not 'too large, so that a person dies on being hit by one or two of them'; nor should they be too small to be defined as stones.[31] According to Hillman, this form of execution is likely to result in a slower death than any of the other six methods.

Another method of execution is beheading, which is practised in Congo, Mauritania, Qatar, Saudi Arabia, the United Arab Emirates and Yemen. The broadsheet press frequently attacks executions in those countries. In April 1995 the *Guardian* printed five undated photographs (one of which is illustrated opposite), taken secretly, of an official executioner beheading a drug dealer in Saudi Arabia. The caption ran under four of the photographs, in bold across the full width of the page: 'I feel numb. I have seen Islamic justice firsthand.' It was taken from the journalist Kathy Evans's account of a killing she had witnessed, and appeared to describe what she had seen.[32] The original photographs were in colour, but the *Guardian* reproduced them in black-and-white: they depicted a swordsman who advances on his kneeling victim and strikes him from behind, the victim toppling to the ground. The pictures were supplemented by graphic – though stereotypical – descriptions of sensory impressions: 'The heavy sword whirls in an arc. There is a wet, chopping sound. The head falls with a thud.'[33] This treatment of a beheading contrasts markedly with the way US executions are reported, despite the *Independent*'s coverage of Ingram's death. In the case of the Saudi execution the journalists supplied a soundtrack to the imagery which expressed their revulsion.

Readers did not criticise the *Guardian* for voyeurism in its account of the beheading. After all, the *Guardian*'s report was an unusual piece of campaigning news opposing state killings, and used emotive language and unusually explicit, secret photography to support the witness's visceral account of what happens at a public beheading. The story compared Saudi Arabia with Britain, and claimed that if the kingdom's population were taken into account the equivalent of ninety state killings so far in 1995 'would be 18 executions a week' in Britain.[34] Though Evans herself does not elaborate, this large number would make a total of well over nine hundred a year and therefore greatly exceed the average of 750 people executed by noose and axe in Britain every year in the century 1530–1630, which was Britain's bloodiest period for state executions.[35] Even if this point is not made, Evans's report together with the photographs demonstrates that Islamic justice in Saudi Arabia is decidedly 'other' than the judicial system in Britain. This journalistic story fits easily into the Western framework of 'orientalism', in which Islam in general and Arabs in particular are assumed to be relatively uncivilised and cruel by comparison with Christian liberal democracies.[36] Readers' uncritical reception of this story, and the *Guardian*'s uncritical editing, was very different from the heavy criticism of state killings in a video produced later in 1995 when the British Board of Film Classification granted an adult-viewing, age '18' certificate to the video *Executions* made by EduVision Films. The video shows twenty-one actual violent deaths by (among other means) shooting, stoning, hanging and beheading. This video caused a brief public debate because the historical or moral resonance of horrible films or photographs is inevitably shadowed by their power to arouse unpleasant, murky emotions.

The row over the release of the video *Executions* is an example not only of how other forms relate to journalism but also of how the arguments about the right to see and the prurience of looking inform public knowledge. *Executions* was widely reported in the press. The video showed mostly state killings recorded on film and originally housed in archives. The video caused such a stir because motion and the possibility of sound on film

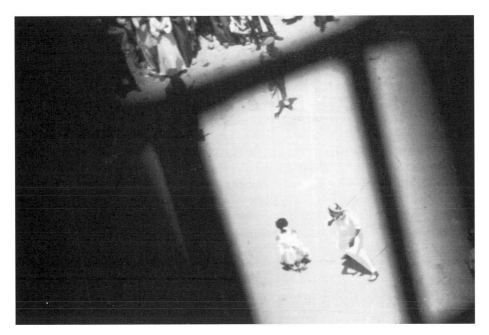

'I feel numb. I have seen Islamic justice firsthand'. A public execution ... A Saudi executioner wields his sword as he ... advances to behead a drug dealer in Jeddah. *Guardian*, 27 April 1995. Rex Features

are especially gruesome. Film shows bodies falling and folding away, the sudden severance of bodies from life. Photography can be gruesome, though it offers different visual information. It lingers on the fall, the appearance of body parts, freezing the frame for maximum scrutiny. But the ability to stop film, and run it again in slow motion, halting its movement at climactic moments, is a central device in viewing and reviewing television and video (and it is not alien to motion pictures). Consequently, because video can be seen in both modes of quick succession and slow motion, frame by frame, I would stress its similarities to photography in terms of the viewing experience. I have chosen to refer to this video because it raises several issues relating to sadism and sensibility which are central to the public debate, such as it exists, on the propriety of releasing images of dreadful acts of violence to close and prolonged scrutiny.

The sudden appearance of *Executions* raised arguments for and against easy access to horror in High Street shops. It also provoked the guardians of a few photographic archives who were concerned that the video would misuse their images of executions or corpses for cheap publicity or voyeurism; they certainly did not believe that the video would increase measured hostility to state executions. EduVision, an 'infotainment' video company, approached Amnesty International for the respectability of its name and access to its archival material. Staff at Amnesty first thought the film would be useful in educating the public about the issue of so-called painless deaths in state executions. However, EduVision's vigorous promotion, which included plans to get stories about executions into the British tabloid press, alerted Amnesty, the Imperial War Museum and Reuters to the production company's 'sensationalist' approach. Consequently, they all refused to allow EduVision to use their material.[37] Regardless, EduVision obtained film and still photographs from twenty-seven reputable national

archives and commercial agencies, mostly in Germany, France and the United States. It declared that it was making public images of death 'to educate the living', as 'a legacy of those executed'. The company charged that 'To suppress such images on the grounds of taste is the ultimate indecency'.

Shortly after the film's '18' certification and release in mid-June 1995, Woolworth and Blockbuster Videos refused to stock it, and the newsagents W. H. Smith and John Menzies banned it when stocks sold out; Virgin and HMV continued to sell it, the latter saying that it was not its policy to censor films which had been given classification. James Ferman, director of the British Board of Film Classification, did not believe the film would 'attract' children, since its 'documentary style ... is not only serious but dauntingly fact-laden', and he defended the Board's decision. Ferman claimed that 'the video was felt to be within the range of discourse, polemical or otherwise, which adults in a free society should be entitled to view'.[38]

When the row became public in June, the *Guardian* printed two photographs from *Executions*: one was a still from a film depicting a firing squad shooting three people accused of desertion in battle in the First World War, and the other was a picture of a man strapped into a chair in a gas chamber in the US state of Nevada in 1924, when cyanide pellets were used to kill a convicted prisoner. Not surprisingly, perhaps, the *Guardian*'s report made no reference to its earlier coverage of the beheading in Saudi Arabia, even though the same still pictures appeared in the video: the treatment of the beheading in the video was very different from the newspaper story. In contrast to the journalists' emphasis on feeling, judgement and sensation, the editors of *Executions*, who used colour photographs, placed beheading in a historical context, and stated that Saudi Arabia, the United Arab Emirates and Yemen use it as part of Islamic law. It also named Saudi Arabia's chief executioner. *Executions* said this killing had taken place in 1985, whereas the same pictures were used to illustrate Kathy Evans's story in the *Guardian* in 1995. The film editors were not witnesses to the event, but even so the film did not relate subjective impressions of the event, which (apart from the difference in dates) is one crucial difference between the observational, documentary style of the film and the testimony of shock and nausea chosen on this occasion by the *Guardian*'s reporters. The different ways of presenting the story in *Executions* and in the *Guardian* are a difference between the objective or at least matter-of-fact manner of documentary and the more heated, personal viewpoint of eye-witnessing. Each requires its characteristic type of voice to have authority, but each is a form of documentary polemic. *Guardian* readers were treated to a more salacious and voyeuristic report than viewers of *Executions*, and although both seemed to declare their opposition to beheading nothing could guarantee that either would be understood in those terms.

Such stories and coverage are not at all rare in the *Guardian*. The newspaper has continually criticised Taliban leaders for imposing an extreme version of Islam in Afghanistan after their victory in Kabul in September 1996. They were attacked for their 'rigid interpretation' of the Sharia legal code disowned by Islamist governments such as Iran's. A report by Suzanne Goldenberg in December described how a man who had murdered a pregnant woman and her three children during a robbery was himself killed: he was shot dead by the victim's husband in the state's first public execution. Goldenberg's graphic account of the whole process was headed 'A current of horror ran through the crowd ... as the Taliban took revenge'; the accompanying photograph by

Zhiruddin Abdullah was a restrained image of the prostrate corpse lying in the foreground while the crowd of two thousand began to disperse (19 December 1996). Dr Mohammed Alam, a spokesman for the Taliban government, said it was 'wrong to see this as a medieval punishment. "There is no law of retribution in America or Europe and a lot of theft takes place and a lot of women are raped." '[39] These reports and photographs demonstrate the brutality of retribution. They also indicate the gulfs between cultures. After all, in Britain no one is legally shot in front of a crowd and the press censors even photographs of sudden or macabre deaths.

The discussion of self-censorship is tied to the exposure of foreign bodies. Both together indicate the high level of anxiety about representations of violence in public places, a theme which is regularly found in the broadsheets. The *Guardian* reported the row taking place over *Executions* and the book *Death Scenes*. In the case of the book, the manager of the shop insisted that 'if people want to buy this sort of thing, it's up to them' and a spokesman for the Anglican general synod declared that 'This [book] has no place in a civilised society.'[40] The paper did not follow the story and discover why the manager of a 'pop culture shop' had suspended sales of this so-called '"Snuff" book of real corpses'. It was probably clear enough that a report in the press about children and their access to images of violence would touch British nerves made raw by the Dunblane massacre. Three days later this minor spat was superseded by the furore over the Duke of Edinburgh's remark that guns are no more dangerous than cricket bats (see all press, 19 December 1996). Though it was not the duke's intention to cause offence, his comments seemed to support the pro-shooting lobby against its 'scapegoating' for Dunblane. The duke apologised for giving offence but did not withdraw his support for guns, revealing that politics is always exposed in talking about violence.

Photojournalism and morality

The press relies on photojournalism despite the widespread academic criticism that the medium is generally ineffective and morally insignificant.[41] For example, photographs of Russian violence in Chechnya continued to appear in the British press in 1994 even though they had no discernible effect on politicians and did not ignite popular British opposition to Russia. In December that year the *Guardian* published a front-page 'Eyewitness' report of the bombardment of villages near Grozny, along with a photograph (illustrated overleaf) of 'a Chechen body' lying near a burning military vehicle (14 December). The fact that the appearance of the body in a British newspaper made no difference to the situation in Chechnya accords with Sontag's doubt whether realistic photography or film has any discernible or useful moral effect on distant civilian populations. The number of occasions when photography makes little or no difference to what happens seems to support the view that photography fails to stir the consciences of audiences and helps to numb them.

The news industry does not recognise itself in these condemnations, and some sectors continue to provide evidence of atrocities for national consideration. For example, the press reported at length an incident which took place in Chechnya in April 1995 because it touched on Western values. In anticipation of celebrations of the end of the Second World War in Moscow in May, the Russian military killed as many as three hundred Chechen civilians. Russian troops invaded the village of Shamaski and carried out what the *Independent on Sunday* called a 'brutal massacre'. Villagers who witnessed

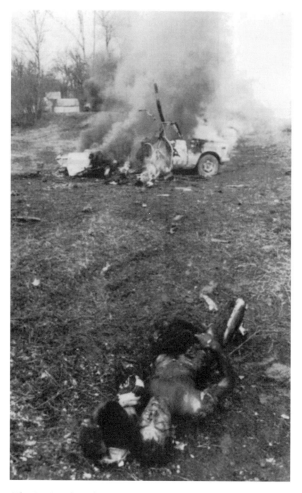

'The Russians have forgotten what they learned in the siege of
Leningrad. The city didn't give in. Now they are surrounding a peo-
ple, and we won't give in either'. Near Grozny as the invasion gath-
ers pace, a Chechen body lies near a burning military vehicle.
Guardian, 14 December 1994. Ivan Shlamov/Popperfoto

the incident spoke of 'Russian troops armed with flame-throwers roasting civilians
alive "like shish-kebabs", throwing people under moving tank-treads and lobbing
grenades into cellars where civilians had taken shelter from a preliminary bombardment'
(16 April 1995).

The *Independent on Sunday*'s leader column, headlined 'A massacre to mark
VE Day', alleged that 'drugged and drunk Russian soldiers' undertook 'this particular
piece of barbarism … as part of a strategy to terrorise the Chechens' and end resistance
in the republic before President Boris Yeltsin welcomed Western leaders in Moscow on
9 May. The article stated that the European Union couched Western protests at the
violations of human rights 'in the strongest terms', while France formally denounced
'brutal attacks on civilians' and in the United States 'voices were raised' against President
Clinton's visit to Moscow. The protests amounted to very little, in that they had no effect

on politicians, or the military authorities, or roused civilians to mass protest.

To the *Guardian* Russia and its surrounding problems were 'a moral maze … in which Bill Clinton and John Major have got hopelessly lost'. Committed with others to attend the celebrations, 'they can do little but whimper at Russian barbarity'.[42] The Western response would have been more forceful, so the *Independent on Sunday* claimed, if the ferocity of the action had been witnessed in the West. Unfortunately, 'No film crews or photographers seem to have been present last weekend … Had they been, Shamaski would by now have been infamous as a place of terrible slaughter and governments in the West would have been forced to make loud protests' (16 April 1995). Presumably government, lost in the moral maze, would have been shown the way out by a clear-sighted populace driven to act by film footage and photographic evidence. The newspaper implies that the moral conviction of civilian populations is so weak that verbal accounts and eye-witness reports alone are insufficient to stir opinion beyond 'strong protest'. It suggests that conviction or beliefs can be strengthened by pictures, which may alter politicians' views to the point where they intervene and make a difference.

Despite this plea, Sontag's view of photography as a tranquilliser remains dominant among media critics. The sociologist Keith Tester makes a related case against television. He knows that it spreads 'harrowing' pictures but believes that such coverage 'denudes' moral significance. He contends that the image of the other which should be so compelling becomes commonplace and incapable of attracting a thoughtful second glance: 'Media significance means moral insignificance.'[43]

Both Sontag and Tester see the image glut of contemporary capitalism as one of the main reasons why people are indifferent to strangers whom they only ever meet in photographs. But there is nothing inherent in capitalism that ensures indifference. In discussing capitalism, Thomas Haskell offers an explanation for the large number of occasions when photographs of suffering make no difference and also those occasions when they do have a positive effect. According to Haskell, the main route by which a 'humanitarian sensibility' developed in the eighteenth century was not through innate human nature or high culture but through the development of capitalism.[44] He identifies four conditions for humanitarian action. In the first place, people must recognise the Golden Rule – 'do unto all men, as we would they should do unto us'.[45] There can be no basis whatever for the emergence of humanitarian activities unless people believe that helping strangers is the right thing to do. But the Golden Rule alone is not enough to make them act. A second condition is that they must perceive themselves to be responsible (if only indirectly) for the evils befalling others. Thirdly, there must be a technique, recipe or remedy within their grasp. Finally, the recipes for intervention must be ordinary, familiar and certain; they must be so easy to operate that 'our failure to use them would constitute a suspension of routine, an out-of-the-ordinary event, possibly even an intentional act in itself. Only then will we begin to feel that our inaction is not merely one among many conditions necessary for the occurrence or continuation of the evil event but instead a significant contributory *cause*.'[46]

What happens if photography is taken to be one avenue for the humanitarian narrative? While it is true that what is literally represented in the photograph is not fully seen, the resemblance of the object and its sign in documentary photography presents viewers with a challenge. Do they recognise and acknowledge that they are linked with this scene, or do they feel that their contribution to the final effect is too minute or remote

to be part of its cause? Photography is useless as a humanitarian tool if outsiders fall beyond the reach of the Golden Rule. Photography may have some bearing on humanitarian sensibility if viewers recognise that they themselves bear some responsibility for what they see in the evidence of pictures, if they have an easy remedy to hand, if the intervention is sufficiently ordinary, and if they feel that not to act will contribute to more suffering. This is the paradox of photographic realism in the press: on the one hand, its very nature and opaqueness distance viewers from everything they see; on the other hand, it represents a certain, considerable kind of knowledge and an invitation to act.

If photographs fail to induce action, the fault lies not with photography but with the larger system which provides viewers with victims and then presents them as 'under', 'outer', or otherwise marginal to 'normal', centred society, while punishing them either directly or through moral inaction and indifference. Those who blame photography for its weakness as a magic wand and its feebleness in awakening conscience fail to account for what W. J. T. Mitchell calls a 'complex interplay' of 'visuality, apparatus, institutions, discourse, bodies, and figurality', which altogether produces knowledge.[47] Consequently, if photography fails, it does so within a failing system, or at least a system which makes failure seem less than it is, laying the blame elsewhere. The indifference of people to the suffering of others is not an effect of photography but a condition of viewing it in modern industrialised societies.[48] Indifference has a long history in Europe. People have never been easily persuaded that the fate of others is their concern, and that it may be their business to intervene.[49]

In contrast to the view that film exacerbates indifference, the authority of eye-witness photography and film – especially television – is widely assumed by governments, military authorities and international aid agencies to stir up public opinion.[50] In 1993 the then Foreign Secretary, Douglas Hurd, indicated that policy was not driven by media coverage, but suddenly war-wounded Sarajevans, once they were seen on television, were being flown to previously unavailable hospital beds.[51] The potential of television to change minds is feared by some groups and nurtured by others. In the autumn of 1996 Rwandan-backed Zairean rebels drove the Zairean army and Rwandan Hutu extremists from huge tracts of land in Zaire, creating more than a million refugees who were beyond the reach of aid. In November Médecins sans Frontières said thirteen thousand people had died, though it had pulled out of eastern Zaire two years before and there were no aid workers in the region. Some feared that MSF's charge may have been an attempt to exaggerate the death toll so that it could be the charity that appeared first on television and so benefit from donations. The rebels deliberately kept television cameras away, and the lack of pictures was said to have undermined French and other aid agency attempts to 'pressure the world into action' through pictures.[52]

Aid agencies, Western governments and the United Nations rarely act together. Their aims are often quite disparate, and can no longer be said to support a common humanitarian narrative which is disinterested or even beneficial to others. Humanitarianism has fallen foul of the eclipse of rational explanations for action in the world, the fragmentation of experience, and uncertainty in economics as well as in cultural forms. Global communications, however they are applied, weaken the universe of obligation which assumes geographical proximity. At the same time, charities and pressure groups try to make the global network a source of remedy, because donations are only a phone-call away.

Consider the use of actuality photography by Amnesty International, which has a humanitarian and political programme, and tries to encourage its British readers to see that they have a responsibility for what happens, no matter how far away, and that, despite the distance, they can take positive action. Amnesty sometimes but not always uses shocking photographs of dying people or of corpses, though it is careful to choose images that sit within mainstream photojournalism. It uses photographs which may have already appeared in the press, or whose horror is exceeded by media images. Amnesty recognises the value of shock, but knows that endless gruesome photographs may deter people from helping strangers rather than persuade them that they are able to act positively to alleviate suffering.

One of Amnesty International's advertisements, which aimed to raise money for the refugees from mass murder in Rwanda in 1994, used a picture of numerous victims of a massacre framed in a television screen. The caption was an appeal – 'Oh for God's sake turn it off' (*Guardian*, 17 September 1994). The call, according to the advertisement's copy, evoked the sentiment of one of half a dozen regulars who were enjoying a drink and talking about cricket in their local pub. Then the early evening news came on, 'bringing nightmares from Rwanda'. 'Conversation faltered. No one objected when a man at the bar made his comment. The channel was changed ... Faced, night after night, by the sheer scale of suffering, we become paralysed and hopeless. So many tragedies, so many victims. We can't possibly help them all.' But, the Amnesty advertisement insists, while onlookers cannot expect to help everyone, individual action can help someone. The advertisement appeals to the sympathy of individuals stalled at the threshold of action by disgust or indifference, but who pause long enough, perhaps held by the photograph, to feel ashamed by the cry 'turn it off'. The advertisement exposes, and plays upon, squeamishness and denial of another's reality. By placing the photograph of the dead inside the ordinary means of receiving film in the home or public place, it confronts viewers not so much with the horror of Rwanda as with the choices they themselves make. Its appeal hinges on exposing the fastidious, morally inadequate attempt to block out the sight of corpses, and proposes that viewers might accept personal liability for other people's deaths. In so doing, Amnesty International battles against a systemic indifference to the fate of others, running much deeper in the culture than boredom with images.

Nevertheless, perhaps those who act on Amnesty's appeals are deluding themselves in trusting to charitable donations or activity in political movements to improve the lot of suffering strangers. As Thomas Haskell writes, 'neither of these routes can seem anything but arbitrary and "selective" from the standpoint of the stranger who starves next week'.[53] Yet, Haskell continues, these are 'the best choices available to us'. He argues that it is better to send an annual cheque to a charity or to adopt a political rhetoric that condemns maldistribution of wealth than to do nothing at all, though he adds, 'How much better remains far more open to question than any of us like to think.'[54]

Amnesty International

In many respects the broadsheet newspapers are the ideal setting for campaigns by Amnesty International which use photographs and text to encourage action, and which challenge newspaper readers to concern themselves with the distant and the foreign. Newspapers are an opaque screen, and so do not endanger the viewer, but they are the

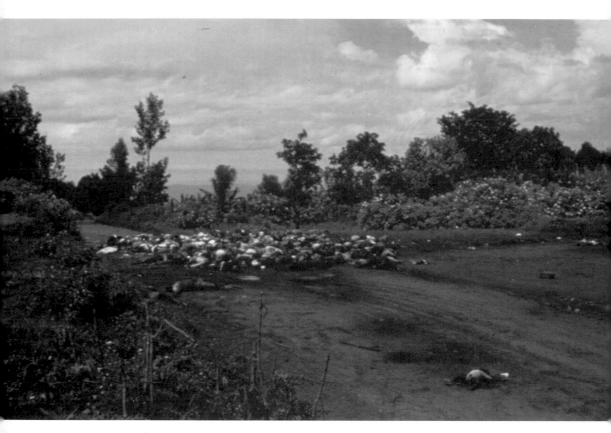

UN sets face against Rwanda operation as new massacres come to light. Assassinated: Government forces killed these Rwandan refugees near Kigali using grenades, machine guns and machetes. *Observer*, 1 May 1994. Luc Delahaye/Rex Features. [This photograph was also used in an Amnesty International advertisement with the caption, 'Listen. Can you hear the silence?' *Guardian*, 28 May 1994]

place where viewers sometimes risk looking at difficult imagery, without being always and for ever affected by what they see. Broadsheet readers are judged to be alive to foreign issues, and to have money to spare for political and humanitarian causes.

Newspapers often represent foreign bodies in extreme distress, and Amnesty International is careful to go no further in its reproduction of horror than is customary in the press. Indeed, Amnesty uses portraits, drawings, images 'grabbed' from television and photographs which have already been published. The *Observer* printed a photograph (illustrated above) by Luc Delahaye of a heap of refugees slaughtered near Kigali, the capital of Rwanda, under the headline 'UN sets face against Rwanda operation as new massacres come to light' (1 May 1994). The caption described who killed the refugees and how they had died: Hutu government troops killed these Tutsis with 'grenades, machine guns and machetes'. The accompanying report described the sights, textures and smell of the scene inside the garden and church of the Rukara Catholic Mission, where fifty corpses had been rotting for a fortnight.[55] Amnesty used the same picture a few weeks later, though in its own distinctive style of writing, which is not so much a report or an evocation as a plea to the awakening conscience. Delahaye's photograph appeared above the caption 'Listen. Can you hear the silence?' (*Guardian*,

28 May 1994). The advertisement first mentions 'The silence of the dead', but the killing now silences 'the world's governments', the United Nations and 'good people' – a silence which Amnesty appeals to 'you' to break. Amnesty's agenda is different from that of news reports, and its identity is made clear in typography, in layout, in its logo and in the standard form which readers can use to donate money or join the organisation. Even so, the advertisement is built on press practice, and is close enough to it for its veracity and the authenticity of its reportage to go unchallenged.

Amnesty has used photographs and accounts by well-known and respected war correspondents. For instance, it used images and a report by Don McCullin over two pages in the *Independent* in 1997 (15 February). Even though the account was brutal and startling, it remained within the bounds of usual practice: in this case, one image depicted a scene in the Congo in 1964 of a young man surrounded by soldiers pointing rifles at his head. The caption informed readers that 'minutes before this picture was taken, this man and others had been dragged behind trucks by ropes tied to their penises' and that the youth tormented by soldiers was then 'shot and his body thrown into the river'. A different pair of photographs was taken in Beirut in 1973: the first depicted a Palestinian family being hustled out of their home by Christian Phalangists, while the two men of the family were held at gunpoint in the stairwell. The second picture was taken moments later, and showed the men lying dead, shot at point-blank range. McCullin had heard one of them crying for 'Allah' with his dying breath. McCullin acknowledges that 'the tragedy of my work, of thirty years photographing wars and human rights disasters, is that I could never save the people I photographed'. But he was a witness; he saw it all and brought back the images, the evidence. 'When someone doubts my word I sometimes think I've been living in a fantasy or a nightmare world. But I've got the pictures.' He himself never saved a life through photography, and is surrounded by ghosts and 'headless people' who demand to be remembered. If they could speak, they would probably say, 'You didn't do your job properly [and] our numbers are growing.' The silent and ever-present ghosts haunt McCullin, and the only way to lower the 'mounds of corpses', he suggests, is concerted action. 'You have a means to protect, help, and shield the people who are at this moment being hurt, killed, or flung in blood-soaked cells. It is your voice, your pen. Pick it up and use it'.

This advertisement was particularly shocking because McCullin's testimony carries weight. But Amnesty often chooses photographs that are not in themselves gruesome: it is only a headline similar to 'Shock horror' that alludes to what the text reveals – that the objects on show are electric batons, ordinarily used as cattle prods but in this case used to torture prisoners in China (*Guardian*, 21 October 1994). This layout complements exactly the press's normal practice of representing horrors in more detail in writing than is conventional in photographs.

Amnesty's emphasis on representing individuals in pain and on depicting ordinary objects which become instruments of torture stems from its human rights project. It asks individuals to act against the politics of other countries, many of which, like Turkey or Cyprus, are relatively close to Britain and provide resorts for British holidaymakers. Other countries, though far away, are nevertheless visited by people from Britain. If it cannot politicise viewers, Amnesty sets out to shame them into some level of direct action, such as writing letters to politicians, ambassadors and heads of state.

Amnesty's decision to mimic the press allows it to make judicious use of pictures which are shocking in content, and which may not otherwise be published because the

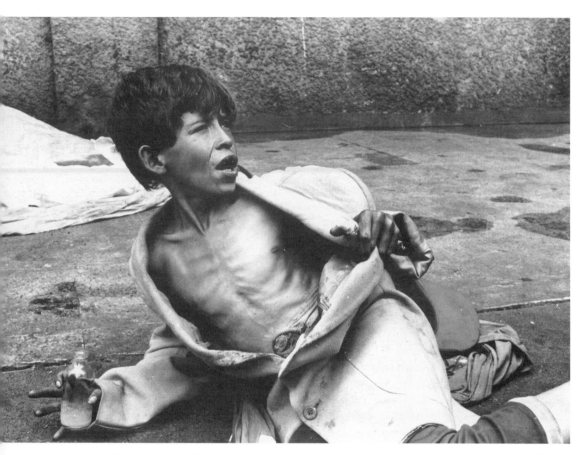

'When you look at this picture, what do you see?' [Street youth wounded in his stomach, Bogotá, Colombia.] Amnesty International advertisement, *Guardian*, 14 May 1994. Julio Etchart/Reportage

story is insufficiently newsworthy. For example, newspapers have carried stories on the plight of 'disposables' in Bogotá, the capital of Colombia, though the 'social cleansing' or murder of street children is not a burning issue of the day to the British press. To drag the murders, and that situation, into the press, Amnesty's advertisement used a photograph (illustrated above) by Julio Etchart of 'A child in pain, begging help from passers by, his stomach torn by a suppurating knife wound'. The caption read, 'When you look at this picture, what do you see?' (14 May 1994). The text described the child, and explained that the bottle he is holding contains not milk but footwear glue. The child is a glue-sniffer, was probably wounded by another child addict, and 'more than likely ekes out his existence on the street by peddling "crack" cocaine for drug lords'. Amnesty then asks whether 'your' sympathy may now be tempered by distaste; traders and police in Colombia have intensified their distaste so much that they hate these children enough to kill them, at times selling their organs to medical students as specimens. Obviously, the photograph does not tell the whole story. Amnesty describes who else is 'disposable' in Bogotá and who are murdered as a matter of course or 'just vanish and are never heard of again'. 'Disposables' include paper collectors, prostitutes, the mentally ill and two human rights workers who tried to help them. Reading the text

allows 'you' to see more than the picture can show, yet the question remains, 'If you could do something [then] would you?' Amnesty replies by saying that 'you' really can help to save children and human rights workers from 'death squads' by donating money or joining the organisation.

The advertisement was published in the *Guardian*, the *Independent*, *The Times*, the *Sunday Telegraph*, the *Observer* and the *Financial Times* between 14 and 21 May 1994, and immediately created a major row between the papers and the British government, because of complaints from the Colombian government, which felt the advertisement impugned its reputation and so harmed relations betwen the two countries. The story dominated Colombian national newspapers and television for several weeks; Etchart's life was threatened. The anger even spread to the House of Commons, where a Conservative MP and former Minister of State at the Foreign Office, Tristan Garel-Jones, wrote to several newspapers complaining that 'The nauseating thing about the advertisement is that the picture of the small boy smacks more of an effort to raise money for Amnesty International than of a serious attempt to work in partnership with a friendly democratic state whose aims and objectives are ours but whose resources are [fewer].'[56]

This row reveals that Amnesty International is not simply a humanitarian agency but is more recognisably political than aid agencies. It opposes what it takes to be injustices meted out by government agents. Consequently, its use of photography in advertisements is usually quite distinct from that of aid charities, which also advertise in the broadsheet press. Unlike aid charities, Amnesty uses hard-hitting documentary reportage of dead or dying people. The victims are always named and always described (rather than pictured) as suffering at the hands of particular groups or in particular places sometimes misleadingly called 'correction' units. Amnesty also represents objects like the electric chair, electro-shock batons and kitchen knives which are used for torture. The accompanying text always makes some sardonic reference to the site of torture and to the life style of broadsheet readers. The caption 'Chinese cracker' was used over an image of an electro-shock baton that Chinese prison guards used on Tang Yuanjuan, an organiser of peaceful demonstration, in 1991 (*Guardian*, 1 October 1996); 'Steak tartare' was used over an image of a kitchen knife used to torture, mutilate and murder so-called 'criminals' in an unnamed 'central Asian republic' (*Guardian*, 3 October 1996).

In contrast to Amnesty International, aid agencies invite viewers to support action from within their own country that translates directly into the alleviation of short- and long-term suffering, mostly in developing countries or places hit by natural disaster, including floods and earthquakes. They certainly do not blame groups within the country for creating the wretched conditions; neither do they represent the misery of those they are trying to help, or represent themselves as rescuers. These last two developments are relatively recent. Until the 1980s most appeals for charity used stereotypical disaster imagery of helpless, passive victims and heroic saviours. As Jonathan Benthall writes, 'Virtually all imagery of disaster in "distant lands" was (by present-day standards) patronizing to the victims.'[57] In the mid-1980s Oxfam, Christian Aid and War on Want set up working parties to develop new guidelines on visual communications. Oxfam's report *Images of Africa* showed that negative images of Africa as a doomed continent date back to the colonial era, but that positive images led viewers to assume that help had in fact arrived.[58] In 1989 the General Assembly of European non-governmental organisations (NGOs) adopted its Code of Conduct on Images and Messages relating to

the Third World. It aimed to ban the extremes of fatalistic images of hopeless victims and also idyllic images which 'lead to a clear conscience rather than a consideration of the root problems'.[59] For all that, the guidelines (which applied only to development education and not to the whole work of the NGOs) were naive in supposing that the meanings of imagery could be fixed. One guideline recommended that 'A message should be formulated in such a way that generalisations are avoided in the minds of the public'.[60] As Benthall points out, it is impossible to convey any message with a guarantee that it will not lead to generalisations in the 'minds of the public' (entities which are themselves so amorphous as to be almost meaningless). In 1991 Save the Children UK published *Focus on Images*, which set mandatory guidelines for all its promotional workers, including fund-raisers, volunteers, illustrators and commissioned freelances. The guidelines put an end to pictures of dominant relief workers dispensing aid to passive villagers and instead promoted positive imagery.[61] This trend in aid advertising away from hard-hitting documentary photography has led to bland pictures which carry latent messages of reassurance. In other words, while recognising that extremely negative imagery can lead to so-called 'compassion fatigue',[62] the current preference for bland imagery continues to say more about our own culture than about Africa: it suggests that Britain has become 'too squeamish to include the truth about African famine in the domestic rituals of Christmas'.[63]

Amnesty's use of photography is quite different from the way editors use it to cover hard news. Everyday news does not set out to make a moral claim on readers, though it may have that unintended effect. Everyday news is a tale, and the lessons to be learned relate to the dangers of indulgence, and the risks run by even ordinary consumers as they shop or go to work. Fate, mismanagement and murder kill 'innocent' people. The press's depiction of death overseas, by contrast, permits greater detail and tends to feed the suspicion that foreign cultures are debased, so that physical suffering is tied to moral and intellectual degradation. The danger of this type of imagery is that it may encourage 'compassion fatigue' or, just as likely, moral complacency among readers. As the case of Amnesty International indicates, photographs by themselves may arrest the eye, but no photograph can carry the story which Amnesty provides.

The greatest brake on improper and disgusting imagery is provided by the industry; it does not picture awful events in any great detail and Amnesty remains well within its conventions. The advertisements operate within larger systems that may limit their ability 'to disrupt the textual, epistemological, and ideological systems that inscribe and contain them'.[64] Despite this restriction, Amnesty's advertisements are carefully designed to survive in this climate and the press does not 'ultimately neutralize them'.[65] The broadsheet habit of revealing foreign bodies, even in stereotypical form, supports Amnesty's work. Amnesty's self-control matches that of the press, which serves as a host. Each lends authority to the other. The greater danger to the press in publicising controversial matters is not squeamishness or self-restraint but direct censorship, advance news management, and the weight of conventions which demand that bodies are redescribed as inanimate objects or disappear altogether. This danger was given full expression in the press's coverage of the Gulf War.

Notes

1 Bill Nichols, *Representing Reality. Issues and Concepts in Documentary* (Bloomington and Indianapolis, Indiana University Press), 1991, p. 204.
2 *Ibid.*, pp. 205–7.
3 David Orr, 'Rwanda reduced to a ghost land', *Independent on Sunday*, 15 May 1994.
4 Mark Huband, 'The killers of Kigali', *Observer*, 22 May 1994.
5 Roland Barthes, *The Eiffel Tower and other Mythologies* (New York, Hill and Wang), 1979, p. 37.
6 Zygmunt Bauman, *Modernity and the Holocaust* (Cambridge, Polity), 1991, p. 25.
7 Andy Grundberg, *Crisis of the Real. Writings on Photography 1974–89* (New York, Aperture), 1990, p. 190.
8 Ian Jack, 'How fares the human spirit?', *Independent on Sunday Review*, 27 December 1992.
9 Bill Keller, 'Kevin Carter, a Pulitzer winner for Sudan photo, is dead at 33', *New York Times*, 29 July 1994.
10 David Beresford, 'Dogged by haunting images', *Media Guardian*, 22 August 1994.
11 See Roland Barthes, *Mythologies* (St Albans, Granada), 1973, p. 96.
12 Robert I. Rotberg and Thomas G. Weiss (eds), *From Massacres to Genocide. The Media, Public Policy, and Humanitarian Crises* (Cambridge, Massachusetts, World Peace Foundation), 1996, p. 1.
13 Lindsey Hilsum, 'Silent killer follows the massacres', *Observer*, 24 July 1994.
14 Alphonso Lingis, *Foreign Bodies* (London, Routledge), 1994, p. 217.
15 Michel Foucault, *Discipline and Punish. The Birth of the Prison* (Harmondsworth, Penguin Books), 1979, p. 90.
16 Christopher Hitchens, 'The American play of death', *Guardian*, 30 March 1995.
17 Simon Beavis and Paul Brown, 'Shell has human rights rethink', *Guardian*, 8 November 1996.
18 Phil Reeves and David Usborne, 'Plop plop, fizz fizz', *Independent on Sunday*, 26 April 1992; Harold Hillman, 'The possible pain experienced during execution by different methods', *Perception*, 22 (1993) 745–53.
19 Hillman, 'The possible pain experienced during execution by different methods', p. 750.
20 Amnesty International, *When the State Kills* (London, Amnesty International), 1989; Amnesty International Medical Commission and V. Marange, *Doctors and Torture* (London, Bellew Press), 1989.
21 Hillman, 'The possible pain experienced during execution by different methods', p. 745.
22 Ian Katz, 'Execution "went like clockwork" ', *Guardian*, 27 January 1996.
23 David Usborne, 'Remember me, but let me go – that's it', *Independent*, 27 January 1996.
24 Foucault, *Discipline and Punish*, p. 13.
25 Rupert Cornwell, 'Briton gets 11th-hour reprieve', *Independent*, 7 April 1995.
26 Clive Stafford Smith, 'My private view of a ritual death', *Guardian*, 12 April 1995.
27 Hillman, 'The possible pain experienced during execution by different methods', p. 747; Harold Hillman, 'The cruel myth of "humane" execution', *Independent on Sunday*, 9 April 1995.
28 Hitchens, 'The American play of death'.
29 Hugh Davies, 'Fight before prisoner hangs', *Daily Telegraph*, 28 May 1994.
30 Richard Thomas, 'Execution witnesses see killer "burn alive" ', *Guardian*, 26 March 1997.
31 Article 119 of the Islamic Codes of Iran 1980, cited in Hillman, 'The possible pain experienced during execution by different methods', p. 746.
32 Kathy Evans, ' "I feel numb. I have seen Islamic justice firsthand" ', *Guardian*, 27 April 1995.
33 James McCredie, 'Eyewitness in Riyadh', *Guardian*, 27 April 1995.
34 Evans, ' "I feel numb. I have seen Islamic justice firsthand" '.
35 V. A. C. Gatrell, *The Hanging Tree. Execution and the English People 1770–1868* (Oxford, Oxford University Press), 1994, p. 7.
36 Edward Said, *Orientalism* (Harmondsworth, Penguin Books), 1978.
37 Richard Brooks, 'Video nasty or sick marketing?', *Observer Review*, 25 June 1995.

38 Andrew Culf, 'Chief film censor defends "disturbing" video of real-life executions', *Guardian*, 20 June 1995.

39 Suzanne Goldenberg, 'A current of horror ran through the crowd ... as the Taliban took revenge', *Guardian*, 19 December 1996.

40 John Ezard, ' "Snuff" book of real corpses on sale in pop culture shop', *Guardian*, 16 December 1996.

41 Bill Nichols, *Blurred Boundaries. Questions of Meaning in Contemporary Culture* (Bloomington and Indianapolis, Indiana University Press), 1994, pp. 17–42.

42 'Losing the way in Moscow', anonymous leading article, *Guardian*, 15 April 1995.

43 Keith Tester, *Media, Culture and Morality* (London, Routledge), 1994, p. 130.

44 Thomas L. Haskell, 'Capitalism and the origins of the humanitarian sensibility', Part 1, *American Historical Review*, 90:2 (1985) 339–61; Thomas L. Haskell, 'Capitalism and the origins of the humanitarian sensibility', Part 2, *American Historical Review*, 90:3 (1985) 547–66.

45 Haskell, 'Capitalism and the origins of the humanitarian sensibility', p. 564.

46 *Ibid.*, p. 358.

47 W. J. T. Mitchell, *Picture Theory. Essays on Verbal and Visual Representation* (Chicago, University of Chicago Press), 1994, p. 16.

48 Michael Ignatieff, 'Is nothing sacred? The ethics of television', *Daedalus*, 114:4 (fall 1985) 57–78.

49 Thomas W. Laqueur, 'Bodies, details, and the humanitarian narrative', in Lynn Hunt (ed.), *The New Cultural History* (Berkeley, University of California Press), 1989, pp. 176–204.

50 Greg Philo, 'From Buerk to Band Aid: the media and the 1984 Ethiopian famine', in John Eldridge (ed.), *Getting the Message. News, Truth and Power* (London, Routledge), 1993, pp. 104–25.

51 Robin Gedye, 'Hurd hits out again at media', *Daily Telegraph*, 11 September 1993; Michael Leapman, 'Do we let our hearts rule?', *Independent*, 15 September 1993.

52 Chris McGreal, 'Catastrophe looms over Rwandans' unseen flight', *Observer*, 10 November 1996.

53 Haskell, 'Capitalism and the origins of the humanitarian sensibility', p. 356.

54 *Ibid.*, p. 356.

55 Mark Huband, 'Church of stinking slaughter', *Observer*, 1 May 1994.

56 Anon, 'Colombians angered by Amnesty advert picture', *British Journal of Photography*, 6978 (15 June 1994) 5.

57 Jonathan Benthall, *Disasters, Relief and the Media* (London, I. B. Tauris), 1993, p. 177.

58 Benthall, *Disasters, Relief and the Media*, p. 180; Nikki van der Gaag and Cathy Nash, *Images of Africa. The UK Report* (Oxford, Oxfam), 1987.

59 Benthall, *Disasters, Relief and the Media*, p. 182.

60 *Ibid.*, p. 183.

61 *Ibid.*, p. 184.

62 John C. Hammock and Joel R. Charny, 'Emergency response as morality play: the media, the relief agencies, and the need for capacity building', in Robert I. Rotberg and Thomas G. Weiss (eds), *From Massacres to Genocide. The Media, Public Policy, and Humanitarian Crises* (Cambridge, Massachusetts, World Peace Foundation), 1996, pp. 115–35.

63 Benthall, *Disasters, Relief and the Media*, p. 186.

64 Abigail Solomon-Godeau, *Photography at the Dock. Essays on Photographic History, Institutions, and Practices* (Minneapolis, University of Minnesota), 1991, p. 171.

65 *Ibid.*, p. 171.

9

The body vanishes in the Gulf War

Though the bodies of allies and enemies are central to warfare, their appearances in war publicity are limited and images presented that obscure bodies as much as possible. A war apparently without bodies is an imaginative and bureaucratic feat achieved by direct omission (as in censorship), by metonymic transfer on to objects such as machines, and by the media's adherence to polite discourse when reporting state killing on an unknown scale.

The Gulf War of 1991 took place in the modern era of 'derealisation', the era when the objects of violence in warfare are grouped together in fields that are rendered abstract and map-like. The objects of violence are unknown and distant, or they are lumped together in masses and lack individuality. In military and press language the act of killing is so impersonal that it scarcely signifies as murder at all. In fact it is more likely to be understood as 'attrition', and presented in verbs and similes which glide into sport, such as 'strike' or 'turkey shoot'. Killing is done at a distance, and if the victims are optically separated from their killers the insulation of combatants and viewers from the action is likely to be enhanced.

The absence of a visible enemy was matched by the absence of personal responsibility inside the military unit, and by the lack of political power of civilian populations. According to Elaine Scarry, civilians in the United States have lost the authority to take responsibility for the injury that US military forces may inflict on other populations.[1] Presidents have decided how to use what is effectively a standing army, and gone to war (in Korea, Vietnam and Central America) without congressional approval. Civilians no longer take part in meaningful or effective deliberations over grave military matters. Instead, they are encouraged to take part in a 'mimesis of deliberation', taking part in debate in ways that succeed in making them 'inattentive to military events' or 'attentive

in a way that still deprives us of any authorization over them': in effect, they have been 'infantilized and marginalized'.[2] Though Scarry refers to specific developments in the United States, her remarks also apply to relations between civilians and the state in Britain, where wartime allows people to perform only a similar mimicry and denies them the opportunity to intervene in decisions about whether or not to enter a war, how to execute it, what its aims may be and under what conditions it should end.

Governments, the military and the media always make the objects of violence seem less than real, and take away responsibility for the personal actions in wars that involve home forces, as was the case with British civilians in the war in the Gulf. A great deal of propaganda derived from the need to pretend that enemy civilians were not the intended targets of home forces and their allies. When such killings occurred they were described as incidental, marginal or 'collateral'.

The decision to show or withhold photographs of bodies which have been wounded or destroyed is always tied to a political programme designed to make the war more human in scale than it actually is. Photographs taken on the ground produced what Bernd Hüppauf, in his essay on modernism and the photographic representation of war, calls 'predominantly archaic images' of either enthusiasm or despair. These feelings have as their 'central object the fighting, running, resting, eating, laughing, dying soldier'. Looking at these images in the newspapers or on television, viewers never discovered how soldiers had become subservient to mass armies, 'appendages of anonymous huge structures' which remained 'largely invisible to the documentary lens and were subsequently "forgotten"'.[3] Instead, photography reproduced imagery of faces that readers of newspapers were already used to seeing. Photographs allowed eye contact with optimistic (or sometimes despondent) soldiers, appealing to viewers at a sensuous level, encouraging empathy and creating considerable moral impact. Ground-level photography of men preparing to fight, or returning from the battle, was tightly controlled and humanistic. Men were usually pictured upright. Viewers saw no mutilated bodies of British casualties.

Elaine Scarry argues that the tendency to hide bodily injury in military representations of war is effected through an 'exchange of idioms between weapons and bodies' in which the 'central inner activity of war comes to be identified as (or described as though it were) "disarming" rather than "injuring"'.[4] The 'wounding' language of weapons and arms is applied to hardware 'at precisely the same moment that it is being lifted away from the sentient source of these projections'.[5] Scarry is writing about language and speech, but the existence, content and dissemination of pictures also depend on the tendency to hide injury to soldiers, to deny the fact of injuries to civilians except as unfortunate accidents, and as much as possible to redescribe and show killing to be damage to insentient objects. This systemic displacement 'ceases to be morally resonant', but it is not perceived to be 'morally disastrous': on the contrary, 'it may be perceived as inevitable and perhaps even "necessary"'.[6]

The aesthetics of disappearance

The bodies of Gulf War troops were made to disappear in the British newspapers, which entered fully into expressing the era of 'derealisation'. The papers were committed to representing warfare as something acted out by machines rather than on the bodies of people. Their absorption in this ideological work was the civilian equivalent of the long

military history of protecting civilians and fighters from emotional disturbance, and possible moral qualms, by separating warfare from individuals. Hiding the body is not a new turn in military rhetoric. Humans have long been subjected to distancing modes of symbolic representation until they disappeared. Warfare has long since been tied to a basically empty, amoral space for the use of an army conceived as a colossal body that operates like a machine. Considering the army to be mechanised or (better still) cybernetic lessens the impact of losing friendly soldiers. Considering the enemy to be a robot changes the status of its soldiers. Most commonly, military language which is then used in press coverage translates violence on to machines such as 'cannon' or on to other non-sentient material like 'fodder'. In other words, the absence of bodies from the media is not simply a matter of censorship or self-censorship on the grounds of taste and tone, though as always these remain factors in news production. On the contrary, it is conventional for individual bodies to be unimportant to the sense and purpose of the army. Apparently, enemy bodies are not the target. Their deaths are the excess, the incidental product of destroying the real targets, which are communication links, airfields, ammunition dumps or major weapons. Material is more important than bodies; bomb damage assessments outweigh body counts; technology replaces necrology.[7]

The aerial bombardment of Baghdad and front-line trenches along the Iraqi borders with Kuwait and Saudi Arabia lasted forty-four days, from 16 January to 1 March 1991, while the ground attack lasted about one hundred hours. This was long enough to bring war reporting to the fore, but not long enough to put it to the test. Despite innovations in the management of war and news, the British press reported the conflict in accordance with past practice, and in line with guidelines on good taste and tone. As usual in wars involving British forces, reports were shaped largely by military censorship and media self-censorship.[8] As usual, they promoted sanitised views of the 'theatre of operations', empathetic imagery of heroic fighters, a subhuman enemy leader, an impersonal or depersonalised enemy, atrocity propaganda, very few gruesome pictures – and nothing that might shake home-front morale.

At a conference on nationalism in a post-Marxist world Anthony Giddens described the Gulf War as 'the most heavily mediated, reflexively organised war in human history'.[9] War publicity was not limited to extolling the power of military force as if that alone would be enough: it also managed to guide perceptions of this force by 'pre-censoring' or regulating information from the battlefield. News management consisted quite simply of not allowing journalists to report or represent in photographs the details of gruesome deaths. If pictures are some kind of evidence of what-has-been, then the absence of pictures will throw a shroud over the details of events and even obscure them altogether. Images were weapons in the actual waging of war. Direct vision was a thing of the past, and vision technologies took over.[10] The target area became 'a cinema "location", the battlefield a film set out of bounds to civilians'.[11] Information about the battle site, available in aerial and satellite photography, turned the objects of violence and even discernible bodies into symbols. Enemy bodies were always clumped together as 'Iraqis'; they were always turned into abstractions, marks on emulsion, or 'data'. In all cases, they were easy to wipe away. Seeing the enemy meant that it could be hit, since *what is perceived is already lost*.[12] But perception meant more than spotting and targeting the enemy: it also helped to shape what civilians believed to be really happening. What Virilio calls 'the aesthetics of disappearance' included not only hiding the allied forces but concealing the extent of injury to enemy bodies. The key terms in war publicity were

psychological impact, perception and a strong sense of moral virtue, and these replaced attempts in earlier wars to quantify loss or victory by counting the numbers of dead enemies.[13]

From the perspective of the coalition forces, led by the United States and backed by UN resolutions against Iraq, not only was the Gulf War of 1991 brief, but no armies were lost, and very few allied combatants died. The numbers were small enough to publicise, though they vary a little, depending on whether the counting begins with the arrival of troops in Saudi Arabia in August 1990 and so includes accidental deaths or is limited to the period of fighting in 1991. According to the historian Philip Taylor, writing in 1992, and the journalist David Fairhall, writing in 1996, there were 266 American dead (105 before the war began); forty-seven British dead (the single largest group being killed by US 'friendly' fire); two French dead; one Italian dead; twenty-nine Saudis dead; nine Egyptians dead; six UAE dead.[14] Some Israeli civilians were killed by Iraqi missile attacks, though the total number of coalition dead was small compared with estimates of enemy dead, which remain high but vague. The coalition never attempted to count the number of Iraqis killed, as war propaganda determined that they were not the main target. When General Schwarzkopf, leader of the UN alliance, was asked about Iraqi casualties, he replied, 'we are not in the business of killing'.[15] General Colin Powell, chairman of the joint chiefs of staff, said that he was not 'terribly interested in' the number of Iraqi soldiers and civilians killed.[16] When the US National Resource Defense Council used the Freedom of Information Act to wring an estimate of the number of Iraqi casualties from the Defence Intelligence Agency, it estimated the Iraqi dead to be 'in the range of one hundred thousand'.[17] But that number had a grotesque statistical margin of error of 50 per cent or higher, which implies a 'low' estimate of fifty thousand.[18] Official US government estimates have ranged even lower: ten to thirty thousand; the French guessed that the death toll was two hundred thousand; in early March 1991, before he realised that silence on the matter was more important than disclosure, General Schwarzkopf said, 'We must have killed 100,000.'[19] Such moments of candour turned out to be rare, and the increasing refusal to be clear about military deaths implies that the number of Iraqi soldiers to be killed had ceased to be central and had become beside the point or even theoretical.

The US government took the opportunity of the Gulf War to wipe away more than theoretical Iraqis. It had a clear and publicly stated motive for concealing the harm done to bodies, namely to displace the memory of defeat in Vietnam. In Vietnam the US military authorities had foregrounded the dead bodies of enemies, counting them as a measure of success. They did not prevent journalists from photographing the bodies or picture magazines from publicising dead and injured Americans. Some examples of famous photographs include Larry Burrows's image, taken in a helicopter with a shouting crew chief and a dying pilot, published in *Life* in 1965 (16 April); Burrows's photographs of wounded men, medics and other marines on a hilltop awash with mud during 'Operation Prairie' which appeared in *Life* in 1966 (28 October); Burrows's photograph of a wounded GI reaching out to a 'stricken comrade' taken during the same action and published in *Life* in February 1971 in memory of Burrows, who died earlier that month (26 February); Don McCullin's picture spread and cover story 'Vietnam: old glory, young blood', published by the *Sunday Times Magazine* in 1968 (24 March). Wounded bodies and 'dirty' death were the professed, normal and visible products of that war.[20] The disorderly, blundering army and even its atrocities were all too evident in photographs:

Eddie Adams pictured Brigadier General Loan shooting a Vietcong suspect in the street (*New York Times*, 2 February 1968); 'Nick' Ut photographed children fleeing from an 'Accidental Napalm Attack' (*New York Times*, 9 June 1972); Ron Haeberle photographed the My Lai massacre in 1968 (*Life*, 5 December 1969). Attempting to head off similar bad publicity, at a press conference on 1 December 1990 President Bush assured the country, 'If there must be war, I promise there will not be any murky endings,' as in the conveniently unnamed 'unhappy conflict in Asia'.[21] On 16 January 1991 the President repeated his assurance that 'this [war] will not be another Vietnam', and General Norman Schwarzkopf, in an initial address to troops stationed in the Middle East, made the same pact: 'This is not going to be another Vietnam. We're going to wrap this thing up and get you all home as soon as possible.'[22]

The term 'wrapping up' has many connotations and uses, from improving or embellishing to ending a film or recording session. Here Schwarzkopf meant 'finishing', but his means were to keep a wrap on the representation of the war by keeping control over the imagery of violent death. The military wrapped the war in a supposedly 'clean' technology of death. The most perfect impression of 'clean' death was conveyed by the simple device of fixing video cameras to missiles: 'images of buildings, bridges, and military targets (but never civilians) being destroyed by laser-guided bombs were photographed by cameras on the planes and on the bombs themselves'.[23] The planes and bombs relayed the images to satellites where they were 'downloaded' and recorded on video-cassettes. The 'Nintendo' video war came into the home mainly via television and was shown to audiences already familiar with video and computer games, the special effects of Hollywood, cyberspace and cyberpunk fiction. Viewers had only to tune in to see the war unfolding in front of their eyes. Following the familiar method of 'public opinion' survey, the sociologist David Morrison carried out research into the responses of British audiences to the television coverage of the war. He found that 86 per cent of viewers were 'satisfied' with the television coverage and so were 84 per cent of those reading a newspaper regularly.[24] Morrison is a leading member of the Institute of Communications Studies, based at the University of Leeds, and his book *Television and the Gulf War* was commissioned by the BBC, the Independent Television Commission (ITC), the Broadcasting Standards Council and the Economic and Social Research Council. Morrison's methodology is largely concerned with numbers or statistics. He is not particularly interested in what it meant for home audiences to see videotapes replayed day after day that projected the illusion that only machines and not people were involved in this new 'techno-war'.[25] But this so-called audience satisfaction may arise from ignorance, all the more profound and impenetrable for being so well managed by the military and the media.

Philip Taylor made a more critical point in his book on propaganda and persuasion in the Gulf War. He argued that the Gulf War brought into question 'the role of journalists as custodians of the public's right to know'.[26] It appeared that the public wanted to know next to nothing beyond 'the sketchiest details' of an action and seemed 'more than willing' to wait until the military could report that a mission had been accomplished before finding out about it.[27] However, Taylor's assessment was based on Morrison's preliminary findings from the audience survey.[28] Taylor is more interested than Morrison in the ways in which a controlled information environment overwhelmed knowledge, but he shares the opinion that a picture of how people die 'does not make for good television in most people's minds'.[29] There are many assumptions here about

decorum and good taste which remain unexplored or taken for granted, and which the public are supposed to welcome in place of knowledge of what is happening in their names. Taylor acknowledges that war seems to be exceptional: the British (and North American) publics are 'prepared to suspend their right to know, provided they believe the war to be just and the anticipated gains worth the price of the deaths of a certain number of professional soldiers'.[30] Public opinion surveys based on media coverage suggested that the British were willing to be mesmerised for the duration of the war. Furthermore, these surveys suggested that this behaviour was unusual, or 'only a temporary aberration of the basically rational, knowledge-seeking model citizen'.[31] There is no sense in Morrison's survey of the public, or in Taylor's assessment of it, that media management serves anything but its best interests and, besides, it is bound to be the normal, low state of information in liberal democracies from now on. This work confirms how successful the military were in controlling the media, and suggests that people wanted it to be controlled in that fashion. Neither sociologists nor empirical historians seem concerned to enquire about the consequences for knowledge when the media allow themselves to foster indifference or to circulate largely unchallenged a mass of false, persuasive or satisfying information.

War publicity was never intended to reveal to the watching public the war as combatants experienced it, even within the limits of photography or film. The authorities approved of war publicity as long as it promoted the war effort and kept up morale. Sustaining the gap between what violence civilians guessed must be happening and what they wanted to believe about 'surgical strikes' made it easier to sustain the war. Morrison's work suggests that most people did not want to reason about the war; they wanted to be numbed, and have responsibility taken from them. Giving up on reason and embracing generalised national hopes and desires is central to patriotism: it helps war leaders to stir up enthusiasm in the population and disguises or dismisses the dangers. Elaine Scarry writes, '*it is when a country has become to its population a fiction that wars begin*, however intensely beloved by its people that fiction is'.[32] The management of war opinion cannot stop civilians from feeling that they are not being told the 'truth', but such management promises to quieten fears; the management of news does not prevent individuals from having uncomfortable, reasonable suspicions about the horror of war but it separates those fears from patriotism, in which fear of failure is overcome by belief in the fiction or 'imagined community' of the country.[33]

Consequently, the immediacy of news about weapons did not mean more information about their effects. The purpose of the missile and gunship videos was not to reveal death but to hide it altogether. They aimed to show how 'surgical' and precise the alliance was in hitting military targets. The videos showed bunkers, command centres, radar stations and so forth getting closer, and larger – and then the screen went blank. There was no sound, no explosion, no body parts or wreckage. There was nothing of the dead and wounded familiar in photographs of other wars, which had been harrowing for US audiences chiefly in the case of film and photography from Vietnam. Instead, there was nothing at all.

Video-tapes that showed Iraqis dying were withheld from television until after the war. Gun cameras on Apache helicopters filmed close-up the killing of individual soldiers, though viewing them was restricted to the military. As Margot Norris writes, 'The army was not ashamed of killing but only of *being seen* killing.' By 'squelching' knowledge of what the guns 'saw', the Pentagon removed the potential for citizens to 'take

responsibility for individual killings in warfare'.[34] Video clips of targets which were released to the media were chosen to avoid these close-ups as they were considered to be obscene and taboo, like 'snuff' movies in which people are reputedly murdered for the benefit of film. Instead, US and British television showed a tape taken by a US Air Force jet bomber of a fortunate escape – a distant, miniature 'Pac-man' safely crossing a bridge seconds before it exploded. Frames from the video captioned 'target' and 'getaway' were printed in *Today* and described as representing, in Schwarzkopf's words, the 'luckiest man in Iraq' (31 January 1991). The US and British media did not show the camera-eye view of a man's screaming face as a missile flew into his truck before destroying it. General Colin Powell had been told this video showed 'the unluckiest Iraqi of the war', and he decided not to screen it at a media briefing in Saudi Arabia since its immediacy spoiled the impersonality of the idea of 'surgical strikes'.[35]

The video images that were made public failed to represent the enemy being wiped away, but that was the effect of an erasing technology in which the reputed 'screaming face' image was anomalous. The aim of technology was the comprehensive destruction of the enemy *en masse* without revealing the details of what this might mean to the watching public. For example, Schwarzkopf's troops used tank ploughs and combat earthmovers to pummel through defensive fortifications, but these actions were admitted only after the war was over. Drawing on eye-witness accounts (and possibly a Pentagon informant), the American journalist Patrick Sloyan reported in *Newsday* of 12 September 1991 that 'the US division "The Big Red One" destroyed trenches and bunkers being defended by more than 8,000 Iraqi soldiers with a combination of airpower, artillery, tanks, and vehicles with plows that buried alive hundreds, perhaps thousands, of hapless Iraqi conscripts'.[36] This happened along seventy miles of front-line trenches, according to US Army officials, and was so successful that 'No Iraqi body count was possible after the assault'.[37] The decision not even to attempt to count the dead Iraqis meant that they had no significance, and that they were literally discounted. Those killed in other actions were shovelled into mass unmarked graves, in violation of the Geneva convention on the burial of war dead.[38]

Press collusion

The central record is dominated by the military's own description of their work. In what is a standard shifting of agency in military language, the leaders of the alliance proposed that technology simply wore itself away. Intelligence gathered from satellites in space guided 'smart bombs' to 'legitimate' military targets. Sometimes the war was seen in photographs and film to be machine-on-machine, with high-sounding Patriot missiles 'killing' low-sounding Scud missiles. Publicity spun war away from soldiers and on to armour. Enemy soldiers were referred to as 'units' and 'assets' and represented by green rectangles. General Schwarzkopf stood in front of maps on which these abstract signs for armies were first placed and then removed once they had been sufficiently 'pounded' or 'attrited'. Schwarzkopf was able to believe he killed armies and not individuals 'largely because of the power of a system of representations which marginalizes the presence of the body in war, fetishizes machines, and personalizes international conflicts while depersonalizing the people who die in them'.[39]

Press coverage mimicked the military language which replaces men with armies and force. It also showed that armies were a collection of machines and positions, and were

somewhat abstract. Schwarzkopf dealt in rectangles, maps, forces, targets and armies, and the press followed suit. Maps are useful in this process of depersonalisation, specifically those drawn for newspapers in simplified, comic-book style and colouring. The 'theatre of war' becomes an abstract space overlaid with drawings of tanks or planes, and of armies represented by geometric shapes, with aggressive arrows indicating the speed and intent of their inward movement. The war did not look awful or even difficult on these maps, since graphic explosions occurred among computerised machines in a space which was both abstract and already empty (see *Mirror*, 18 January 1991).

The unknown Iraqi army occupying this empty space was damned several times over in press representations of the imagined enemy. It was the 'arm' of a cruel tyrant who had slaughtered his own Kurdish citizens with poisonous gas at Halabja in March 1988: photographs and film footage of the corpses were shown repeatedly in the preparations for war that began to isolate Iraq as soon as the Iran–Iraq War ended in August 1988.[40] The Arab League council complained in 1990 about the 'unjust, hostile and tendentious media campaign against Iraq'.[41] But Western political attacks and media reports hostile to Iraq ensured that by 1991 it was relatively easy to declare that its army had taken part in an illegal invasion; it would not retreat, and its leader would not listen to reason. Consequently the Iraqis were to blame for their own losses. Fighting at night, coalition tank commanders looked through their technologically superior heat-seeking sights and clearly saw Iraq's hot, blind tanks. Catching them in the line of sight linked with the line of fire meant that enemy tanks were no sooner seen than as good as destroyed. In effect, poverty in arms meant that Iraq's army contributed to its own destruction. It had only itself to blame for losing armour – and the press's photographs and headlines often contributed to this interpretation of events as well as in turning its readers' attention towards the destruction of material instead of men.

Sometimes the choice of headline was crucial in limiting the sense of the photograph. For example, after one Iraqi loss the *Mirror*'s front-page story carried a photograph (illustrated opposite) of a dead enemy soldier, but the presence of his body did not encourage the newspaper's audience to perceive the reality of his suffering. Instead, the headline 'Cannon Fodder' turned the body into non-sentient material, partly metal, partly vegetable (2 February 1991). Cannon fodder was a by-product of the battle of machines; the soldier's death was his own fault for being an extension of artillery. Or it was Saddam Hussein's fault for failing to hide his artillery and its operatives: according to the *Mirror*, Saddam 'signed death warrants' for his troops, and forced them into 'suicide' (*Mirror*, 22 February 1991). In this version the allies were blameless: they did not produce cannon fodder, never signed death warrants themselves and were not at fault if the Iraqis committed suicide.

Indeed, it seemed that the allies did everything in their power to prevent the Iraqis from killing themselves. Most enemy soldiers were seen standing up, able bodied, coming forward in surrender (*Sun*, 25 February 1991), or they were seen rounded up and marched into captivity (*Independent*, 2 March 1991). Taking prisoners of war is always presented as a humane and proper action, and this publicity on the war shows the allies saving the enemy from themselves.

Military rhetoric, and the compliance of most of the press, ensured that dead bodies scarcely figured in the record. The stated military and political decision to destroy armies (and not kill people) had its parallel in the press's choices in what to write into the record, what to tell and show its readers. Of course, the press did not have a free hand in

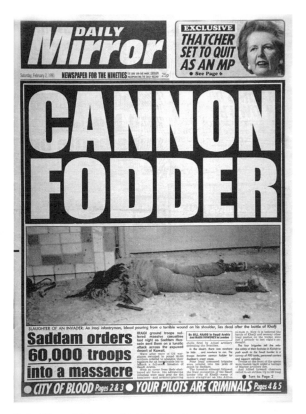

Daily Mirror, 2 February 1991. MSI/Ken Lennox

gathering information, since it was subject to strict military control and censorship. Nonetheless, the press continued the work of the military by concentrating on hardware and not bodies. The public record, as seen in newspapers, was revealing for what it showed, but also for what it hid. The record's hidden face perverts the public memory so that, in one of Benjamin's most famous phrases, '*even the dead* will not be safe from the enemy if he wins'.[42] When the international alliance won, the Iraqi dead were buried twice – both in the desert and in the memory. The Iraqi dead were buried through two kinds of deliberate effacement: the military decimated bodies or bulldozed them into the sand, and this literal erasure was matched by the lack of publicity about what had happened to them.[43]

After the bombing of the bunker or shelter in Amiriya in February 1991, which killed hundreds of civilians, the BBC and ITV news broadcasters announced that they were about to withhold uncensored images beamed from Baghdad because they were too 'grim' or 'distressing'.[44] Accordingly, it seemed as if British decency explained the lack of bodies. The pictures were released by Saddam Hussein's government. There were almost no equivalent pictures taken by coalition photojournalists, who were either nowhere near the scenes of destruction or whose movements and freedom to photograph were heavily controlled.

The work of official censorship was obscured by the apparently helpful system of pooling. The fifteen hundred or so journalists were put in Media Reporting Teams, which

had only two hundred places in the field and were strictly controlled.[45] Journalists in MRTs shared information and gathered news from official sources. This system ensured that reporters would have sufficient copy to write stories every day in their own paper's style, but it also prevented them from roaming, competing with one another and looking for 'scoops'.[46] Pool reporters were unable to interview medical teams. Bringing journalists together, and strictly controlling their movements as well as what they were allowed to photograph, ensured that the war appeared in the form preferred by the authorities.

When the war had ended television crews and photographers were allowed to take pictures of the wrecked convoy on the Basra road which were not subject to military censorship. Nevertheless, only one picture of a corpse from that action was printed (in the *Observer* on 3 March 1991 – illustrated opposite). Until this point the omission of horror pictures concealed what happened in the name of civilisation and democracy. The *Observer* was out of step in choosing to print the picture, which may suggest that the other Sunday papers never received it or that they were fixated by their sense of propriety.

War made simple

The main source of national news about the Gulf War for the majority of people 'across all age, sex, social grade and political groups' was television: 76 per cent claimed it provided the 'best coverage, compared with 10 per cent naming radio, and only 7 per cent opting for the press'.[47] In contrast to broadcasting, press stories were thought to be unreliable. Readers of mass-circulation dailies were doubtful about the truth-value of news. Over a third of the readers of the *Sun* and *Daily Star*, and nearly a third of the readers of *Today* and the *Daily Mirror* said they had 'no trust at all' in their own paper's war reporting.[48]

The long-term decline in the use of papers as the main source of news remains a problem for the industry. Yet the appearance of the Gulf War in the press remains relevant because, like television news, the press claims to speak on behalf of the public. It provides a sense of community which is not directly experienced and is joined together by images held in the minds of its fellow members.[49] What distinguishes a sense of community among like-minded people is not whether the shared images are true or false but the style in which they are imagined.[50] In other words, the truth-value of news reports is less significant in establishing a community than what its members accept as 'knowledge'.

Individual titles in the industry derive their authority from custom and practice, by speaking to their imagined readers in characteristic, 'trade-mark' voices which readers recognise, in some sense, as their own. Tabloid editors tapped in to the community knowledge of warfare by referring to famous films centring on 'showdowns' and heroic struggles. For instance, the *Sun* called the ultimatum to Iraq 'High Noon' (23 February 1991), and the *Mirror*'s map of the plan of attack termed it 'The Killing Fields' (1 February 1991).

Another fixed point in the story was the personalisation of history into a grudge match between political leaders, a stand-off between the good and the evil. This simple 'knowledge' began with George Bush and Saddam Hussein themselves. Each leader claimed the conflict was black-and-white, a contest between 'good and evil'.[51] The 'good' Presidents Bush and Gorbachev were seen to agree that they must begin to establish a

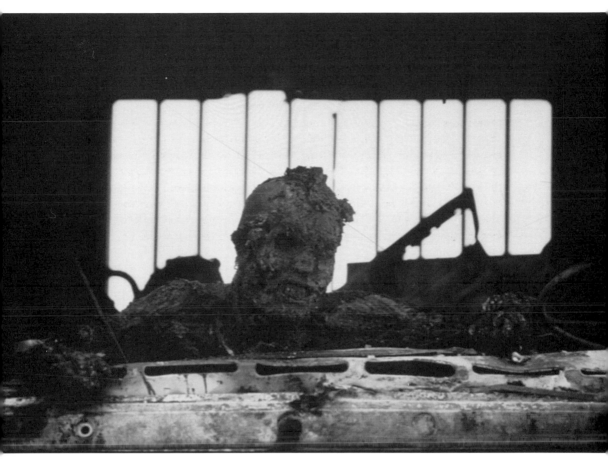

The real face of war. Price of victory: The charred head of an Iraqi soldier leans through the windscreen of his burnt-out vehicle, attacked during the retreat from Kuwait. *Observer*, 3 March 1991. Kenneth Jarecke/Colorific

so-called 'New World Order', whose first test was to confront the 'evil' of Saddam Hussein. This theme was readily picked up in the tabloids. In September 1990 the *Mirror* used a photograph of Bush and Gorbachev together, appearing to point at the camera. The headline made the two men speak with one voice, declaring, 'We're after you Saddam'. (The use of the name 'Saddam' by itself is suggestive and sounds ugly in English but is more insulting in Arabic.) The photograph of two leaders gesticulating at Hussein, apparently, and accompanied by that particular headline seemed to underline their resolve to attack (10 September 1990). In the British press Hussein never moved from his designation as the embodiment of evil, while the home force was always seen to be empathetic and heroic. As the ultimatum expired in January, and war came closer, the *Mirror* opposed photographs of Saddam 'The Villain' with those of 'The Heroes,' in the shape of individual British fighters (15 January 1991).

One advantage the allies gained from the simple opposition of good and evil was that it bypassed the historical and immediate economic reasons for the invasion of Kuwait, making war seem inevitable.[52] More advantages were gained from two further refinements. Firstly, Hussein was revealed to be none other than Hitler – a common

theme in the US media too.[53] *Today* declared him to be the 'New Hitler of the Middle East' who annexes 'world oil' at the point of a gun (3 August 1990). A few weeks later *Today* 'proved' that Hussein was Hitler by placing side by side two photographs – one depicting the Iraqi leader with seven-year-old Stuart Lockwood, an English boy he had taken hostage, and the other showing Hitler with a boy of similar age in a corresponding pose: the headline ran, 'Hitler also used children' (25 August 1990). In keeping with standard propaganda about enemies, numerous stories circulated about rape, torture, summary executions and the murder of babies, which reinforced the early view of Hussein as 'Hitler II' (*Daily Star*, 3 August 1990). But the references to Hitler were complicated by an 'Orientalist' vision of the Middle East in which the sight of Arabs touching boys suggests pederasty, in keeping with the 'Orientalist' view that Arabs for all their strict religious laws enjoy lascivious and promiscuous pleasures. When Saddam Hussein was seen stroking Stuart Lockwood's hair, the British Foreign Secretary Douglas Hurd said it was the 'most sickening thing I have seen for some time'.[54]

In keeping with this need to pander to ingrained Western prejudice, the media were ready to accept brutal atrocity stories if they came from a sufficiently authoritative source. Many such stories about murder were designed by the American public relations firm Hill and Knowlton, which planted them in government agencies, where they became available to the media. Hill and Knowlton were engaged by a Kuwaiti government group to help demonise the Iraqis. This firm concocted one of the most notorious pieces of black propaganda of the war: in October 1990 a teenage girl, whose identity was not revealed, supposedly to protect her family from reprisals, testified to the House of Representatives Human Rights Caucus that she had seen Iraqi soldiers remove fifteen babies from incubators and leave them to die on the floor of the hospital. George Bush, Vice-President Dan Quayle, General Schwarzkopf and other military leaders often referred to the story, and seven US senators mentioned it in speeches supporting the January resolution authorising war.[55] It was not until January 1992 that John MacArthur, the publisher of *Harper's* magazine, revealed in the *New York Times* that the girl was the daughter of the Kuwaiti ambassador to the United States. Hill and Knowlton coached her in what to say to the congressional human rights hearings, which it also helped to organise. Furthermore, the company's president was Craig Fuller, a Bush loyalist.[56] The *Daily Telegraph* reported various atrocity stories as told to the Congressional Human Rights Committee in 1990, including tales of rape, torture and the bayoneting of pregnant women.[57] Even though on 17 January 1991 US television's ABC '20/20' exposed the lies of a fake 'doctor' who claimed to have buried dead babies taken from their incubators, there was no clear-cut division between authoritative and false stories.[58] In February 1991 the *Guardian* reported that the Physicians for Human Rights in the United States and Denmark claimed that premature babies had indeed been removed from hospital incubators and left to die.[59] Some atrocity stories appeared to have more authority than others, and though difficult to verify they were given 'considerable credence – and widespread publicity'.[60] The eventual exposure of the part played by Hill and Knowlton in concocting stories does not mean that no atrocities were committed by Iraqis in Kuwait; it only means that they were also invented by an American public relations firm with personal links with the US presidency and repeated by powerful Americans leaders trying to smooth the path to war. In other words, the idea of Saddam-as-demon suited US foreign policy, and any available means might be used to represent him as the embodiment of evil.

Immediately after the cease-fire, the press offered plenty of evidence of murder, torture, rape and mutilation. The *Independent on Sunday* published a report and posed photograph re-enacting a torture technique in Kuwait,[61] and the *Independent* printed a report and picture of a 'chamber of horrors' in the Kurdish town of Arbil, where Iraq's State Internal Security forces tortured its victims, 'and now, no doubt, is doing so again'.[62] When the United Nations abandoned the cause of the Kurds in April 1991, Hussein went on murdering minorities in Iraq. These actions carried little weight as atrocity propaganda once the war had ended for the coalition. Murder might subdue the occupied people, or render them leaderless, but atrocity stories are for home consumption, and are a product of war publicity, exactly like the ideal soldier.

Atrocity stories are crucial in the build-up to war or in its continuation. Because enough people believed Saddam Hussein was the same as Hitler, the coalition felt morally justified in bombing the Iraqis and spreading lies about his activities. Hill and Knowlton's secret campaign succeeded in persuading leading Americans that Iraqi soldiers had killed Kuwaiti infants. Faced with this outrage, Americans did not baulk when their government bombed Iraq and destroyed the entire urban sanitation network. This action, combined with economic sanctions preventing repair of the infrastructure and lack of medicine led directly (according to post-war UN figures) to the death of some 170,000 Iraqi infants within a year,[63] and of 567,000 by 1995.[64] The moral, financial and political motivations of the international community were uninterested in Iraqi children or infants yet to be born. Instead, the authorities either used or were driven by such atrocity stories. Consequently, public opinion was so incensed by news that described the murder of innocent babies, women, and other civilians that it allowed the authorities to kill and frighten enemy civilians in disproportion and for long periods of time, without any sense of irony or shame.

In order to be certain of public support for Desert Storm, the Western allies had to portray Saddam Hussein as something more than just Hitler. Representations of Hussein drew heavily on reserves of prejudice and racism endemic among Westerners, who, according to Edward Said, see Arabs as 'essentially sadistic, treacherous, low'.[65] Hussein was an Iraqi, after all, so the *Daily Star* named him the 'Butcher of Baghdad' (3 and 23 August 1990). Publicity drew on stereotypes of Arabs as duplicitous or slippery; for example, the *Mirror* called him 'The Great Pretender' (24 August 1990). Of course, this term has older meanings in the West, where religious people believed that Christ was the one true son of God and Mohammed an unworthy pretender. Hence Saddam Hussein was a pretender in religious terms as well as a deceiver in politics and leadership. On the eve of war Hussein was reported as saying Iraq would withdraw, but readers, primed to expect him to be shifty, were not surprised by the US declaration that 'the war goes on' (Birmingham *Evening Mail*, 15 February 1990). It seemed obvious that the war must be fought, since Hussein was both Hitler and the embodiment of the Western stereotype of the profoundly untrustworthy Arab.

In contrast, the shared knowledge of broadsheet readers, not so firmly rooted in popular entertainments, did not include readiness to imagine Saddam Hussein as Hitler. The broadsheets were more likely to become excited over new business opportunities, as in the *Independent on Sunday*'s 'British Aerospace flies into the front line' (27 January 1991) and 'The oilman's war – how the West can win the battle for black gold' (3 February 1991). They recognised not only that oil was at the root of the war but that considerable financial benefits would flow from winning it.

The gap between broadsheets and tabloids was not absolute: broadsheets too drew on military clichés and were triumphalist in tone. For instance, the headline in the *Independent* at the start of the 'aerial offensive' was 'Iraqi defences crumble as allied bombers pound on' (18 January 1991). But real differences of 'voice' can be seen by comparing how a broadsheet and a tabloid dealt with the same picture. On 26 February 1991 both the *Guardian* and the *Daily Mirror* ran a photograph of mines wrecking an Iraqi bunker. In speaking for its readers the *Mirror* used the headline 'Rats Get Stuck In', which implies that British troops (descendants of the 'Desert Rats' of the Second World War) carried out the attack. The headline was factually misleading, as the caption printed under the picture revealed that the Americans had blown up this position. The purpose of the headline, however, was to provide yet another of many references to the Second World War and to emphasise nationalism. In contrast, the *Guardian* caption was more explicit in detailing which US unit had destroyed the bunker and it made no attempt to claim the attack for British 'Rats'. It chose instead to share collective responsibility in its headline, 'Allies race to snap pincer on Guards'. While the *Mirror* used vernacular speech and emphasised the role of home troops, the *Guardian* chose a military phrase and placed the British contribution in smaller type – 'British armour in spearhead which could end war in days'.

Otherwise, in both cases there was undisguised glee at the success of the attack seen in the photograph of the destroyed enemy position. Both newspapers contrived to make the enemy disappear altogether. The *Mirror* assumed that the 'casualty of war' was in fact the 'enemy bunker', not enemy soldiers. In the same vein, the *Guardian* spoke of 'pincers', 'spearheads' and 'armour'. Both reports turned the attention of their readers away from injury done to the bodies of soldiers and towards the mechanistic, distant war fought by machines against other machines. The horror that attaches so readily to frail bodies recedes as machines take their place, and armour spears and pinches other armour.[66]

This example reveals that the national broadsheets and tabloids were excited by the same news, even if they expressed it differently. Military rhetoric and censorship always preceded story-telling in the press. The military sought to control or heavily steer press reports into following the official line by controlling the information that came from the front. The national press generally consented to this state of affairs. It was already self-primed to adopt suitable militaristic language, promote suitable imagery and adopt a warlike frame of mind.

The unbelievable cleanliness of war

The *Guardian*, despite its reputation as 'liberal conscience', was unable to be sceptical all the time, as is evident in its use of militaristic terms like 'spearhead' and so on. Nevertheless, it carried critical commentaries from independent writers including Edward Said,[67] John Pilger,[68] Noam Chomsky[69] and Phillip Knightley.[70] The *Independent* ran stories by the journalist Robert Fisk, who stayed outside the pool system and was one of the first to 'express scepticism' concerning the official coalition line.[71] There was indeed a difference between the *Guardian*'s and the *Independent*'s cautious style of imagining the war, the fuller support of the *Daily* and *Sunday Telegraph*, and the jingoism of some of the tabloids. The greatest gap lay between the *Guardian* and the populist *Sun* and *Daily Star*. Each newspaper imagined its readers to have quite different beliefs, and each

supplied its readers with different types of information.[72]

The destruction of the bunker or shelter and its inhabitants at Amiriya was imagined quite differently among the various newspapers. The struggle over the meaning of the event began long before the press coverage. Something like it had been anticipated by Saddam Hussein. He had reversed his early decision to exclude foreign networks from Baghdad because he believed that reports of dead civilians would disprove US boasts about the accuracy of strikes against military targets. Consequently, Hussein allowed the television news agency WTN to record what had happened at Amiriya and send uncensored footage of badly burned bodies via satellite link to its parent companies ITN in Britain and ABC in America. Hussein released pictures, but he could neither guarantee their distribution nor control their reception. ITN refused to broadcast the raw footage of burned corpses because it was considered to be 'too harrowing'.[73] As Philip Taylor writes, 'In Britain and the United States [broadcasting WTN's video] revolved around questions of taste and decency. The pictures were so horrific, and the filming of corpses so graphic, that they would need skilful editing if audiences were not to be offended or alienated – not necessarily from a propaganda point of view, but from a broadcasting point of view.'[74] This argument is supported by the work carried out by David Morrison based on group discussions and content analysis of seen and unseen footage. It transpired that in the case of the Amiriya shelter 'practically everyone' thought that the BBC and ITN were right to show the less graphic footage they did show, and 'hardly anyone considered that it would have been correct for ITN to have shown the WTN footage'.[75] The companies may have censored the worst shots on grounds of 'taste and tone', but terrible images and gruesome descriptions were widely reported. Audiences saw shocking images from inside the shelter, men carrying burned corpses wrapped in blankets, as well as grieving and angry Iraqis. Nothing like these pictures had been seen so far: they wrecked the dream of 'smart bombs' aimed at 'units'.

All the newspapers 'frame-grabbed' some of the images, though each explained what happened in completely different ways. The broadsheets placed the blame for the bodily destruction on faulty US 'intelligence'. However, the front-page story in the *Express* attacked the BBC for its outrageous 'war bias' in showing the footage of the aftermath of the bomb. Along with the *Sun* and the *Daily Star*, the *Express* complained that the BBC was hostile to the war effort and all too ready to use 'propaganda scripts written by Saddam Hussein' (14 February 1991).[76] The tabloid press, with one voice, condemned Hussein for the civilians' deaths. The Americans always maintained that the shelter was a bunker and a military 'command and control centre'; the Iraqis always said it was a shelter for civilians.[77] Whether or not the site was a military bunker at the time it was hit or was always a refuge for civilians may never be resolved. The importance of the shelter from the point of view of propaganda or persuasion is not the 'falsity' or 'genuineness' of claims and counter-claims about its use but the style in which it was imagined. The day after its destruction, the press had decided on the degree of distance they were willing to put between themselves and the allies' official line. The *Independent* printed a photograph of the outside of the smouldering building. It placed the words 'Shelter "a military target"' in quotation marks, and reported the 'Myth of pinpoint bombing', implying criticism of the US position (14 February 1991). The *Guardian* headline ran, 'US insists it hit army bunker,' but the paper created a much greater visceral impact by headlining 'bodies shrunk by heat of fire', with a picture of 'rescue workers' carrying out the remains of a body wrapped in a blanket. Again, this story revealed that pinpoint

bombing of military targets was a myth and that it was civilians who were dying horrible deaths (14 February 1991). In complete contrast, *Today* blamed Saddam Hussein. Its pictures of grieving relatives and covered bodies were fixed by a headline declaring, 'Entombed by Saddam.' Similarly, the *Star* used a picture of an injured child whom, it declared in its headline, Saddam had 'Sacrificed' (14 February 1991).

The incident of the bombed bunker/shelter at Amiriya produced a strong sense that something was being hidden. The dispute in Britain centred on how much people needed or wanted to know. Three influential journalists expressed their different views in the *UK Press Gazette*. Peter Preston, then editor of the *Guardian*, believed readers wanted to know everything and expected to 'argue' about the war. Ron Spark, chief leader writer for the *Sun*, described the readership of the *Guardian* as 'bizarre' for having doubts about the aims and conduct of the war and declared that any newspaper should 'support the cause'. He wrote in the *Sun*, 'A newspaper that tells only part of the truth is a million times preferable to one that tells the truth to harm its country.'[78] Sir Peregrine Worsthorne, a well-known conservative, was also critical of papers that were 'adversarial', writing in the *Sunday Telegraph* that the 'public reacts [to revelations] with more hostility than gratitude'. Worsthorne believed 'the public wants less, not more'.[79] He asserted that the media were getting more and more out of step with public opinion, which was moving away from supporting 'a right to know' towards greater support for the 'right to privacy'.[80]

The views of Spark and Worsthorne represent a wider movement in the press away from disconcerting knowledge towards comforting knowledge, away from harsh realities towards a squeamish denial of reality. They underly the overall tone of story-telling in the press during the Gulf War. This tendency has a long history, and substantial support from within government. After the Falklands campaign in 1982 the press and broadcasting media were invited to give their views to the Ministry of Defence, which brought out a report on 'handling the media'.[81] The report, which was firmly on the side of views similar to those later expressed by Spark and Worsthorne, emphasised several factors which had a bearing upon news accounts of the Gulf War. First, news management was acceptable, since the national interest lay in winning the war. Next, the 'harsh realities of war', especially television pictures, must be censored because they would lower morale on the home front. Finally, the press should continue to exercise good 'taste and tone', avoiding unpleasant scenes that might cause offence to the families of serving men and women.

Following the American adventure in Grenada in 1983, the US press complained about its total exclusion from coverage, and so the Pentagon set up a commission of mainly military and government officials. The commission recommended that future wars should be covered by pools of news representatives – selected, controlled and censored by the military. This 'pre-censorship' of events 'allows the Pentagon to determine in advance what will be seen and not seen, known and not known, shown and not shown, of the war'.[82] 'Handling the media' in the Falklands campaign, and the similar experiences of the United States in Grenada in 1983 and in Panama in 1989, ensured that the bureaucracy for representing war was in place by 1991. Governments and military organisations had learned how to incorporate news professionals into the armed forces, thus setting up a high measure of control without the need to invoke legislation.[83] By 1991 it was clear that press freedom was not in danger as long as the industry complied with the pool system and also policed itself.

The press acted in response to existing legislation, the fear of more legislation, and the established skill of the government and military in handling the media. At the 'What the Papers Say' Awards in February 1991 the Home Secretary, Kenneth Baker, reminded journalists about the possibility of creating a new criminal offence of intrusive journalism – and at the same time he congratulated them on their coverage of the war, chiefly for exercising their judgement 'correctly'.[84] This meant the war was being fought with civilians in mind and with commitment to the lives of allied troops. Home support depended on this confidence, which was reinforced in 'thumbs-up' images and texts.

Despite this apparent unity of press managers and readers, a war without bodies went against normal press practice. After all, the public were quite used to seeing dead people – primarily foreigners – in newspapers, and did not often baulk or complain. Photojournalists usually arrived at the scene of violent deaths soon enough to take shocking, visceral pictures. The question whether or not editors might use them was generally decided on the grounds of 'taste and tone'. No newspaper publishes photographs which show the dead as police or fire services find them, or which might be produced as evidence in coroner's courts. In civil disasters, for all the press's obsession with sudden and macabre deaths, the overwhelming practice of the industry is to avoid intrusive photographs of corpses. Editors continue to self-censor in wartime.[85] Given its ability to police itself, the press is suspicious of government motives if it has no dreadful photographs to edit out in the first place: then it criticises official news management for presenting an unrealistically 'deodorised' war, as happened following the heavily censored coverage of the Falklands campaign.[86] During the Gulf War the censorship of pictures began in the field with the constant replaying of video displays of supposedly high-precision bombing in which the 'missing element' in any realistic representation of war was 'blood'.[87] Journalists complain if military censorship makes the war appear to be unbelievably clean because they would prefer to exercise their own judgement about what constitutes news.

Although editors would prefer to make these choices for themselves, they are aware that pressure for restraint comes not only from military and government news 'handlers' but from their own readers or viewers. As Philip Taylor argues, no one 'except the most ghoulish would want to witness a real motorway or train crash, and the same is probably true for war'. The military feared realistic imagery of the dead and the public 'did not want to see it': on this issue they 'were at one'.[88] Philip Taylor is referring here to David Morrison's research into television audiences, which revealed that 'very few people really wish for the full horror of war to be shown on their screens'.[89] The reason for this was not that they did not want to know what went on in war but that they did not need to see very explicit images of death and injury to believe that a hideous incident had taken place.[90] Nor did they believe that it would be acceptable for broadcasters to show horrific footage if the point was to make anti-war statements.[91] Even when confronted with blunders and the deaths of civilians, the groups decided '[n]o one was morally culpable, apart from Saddam Hussein who, as far as the viewers were concerned, was responsible for the war, and therefore for all the suffering that followed'.[92] In this respect the research shows viewers to be not so much complacent as conservative and compliant in their unacknowledged politics. It also takes at face value the groups' declarations of no interest in gruesome imagery – in which they did no more than publicly reinforce the general abhorrence of voyeurism. The interviewees seemed to support the overriding use of good taste and tone in the media, but the study did not discover whether or not the individuals

in these groups were likely to own up to the fascination of horror. The way the groups quickly reinforced the standard line on censorship meant that, for whatever reasons, the possible impact of grim pictures on the perception of war remained unexplored.

Virtual war

Various groups on the side of the allies collaborated in pretending that Iraqis were not dying, or that they deserved to die: military rhetoric disregarded bodies; media coverage depended on military leads and was caught in its own professional web of self-restraint. The convergence of these interests meant that the press fell back on traditional ways of viewing warfare. The press found itself bound by its own everyday interests in the fate of individuals. It modified the novelty of the war (its new weapons and its appearance on television) by basing its narratives on selected, older ideas of infantry, artillery and flying. It often fell back on the device familiar from previous wars of the image of the heroic, individual soldier-going-forward. These ideas were given their fullest (but not exclusive) expression in the tabloid newspapers, especially in the more enthusiastic tabloids. For example, a soldier going forward would show 'No Mercy' (*Star*, 18 January 1991), and soldiers were constantly on the 'Attack!' and 'In the Heat of Battle' (*Today*, 28 February 1991). At the same time, the press was caught in the abstractions of the military, with their preference for basing the story of the war on maps and diagrams, and for representing the armed forces in terms of weapons or units. The *Independent*'s account of a thousand bombing missions in the first fourteen hours of the conflict used two maps of the area with arrows curving into Iraq and drawings of aircraft and missiles (18 January 1991); the *Mirror*'s story on the 'amazing first twelve hours of [ground] onslaught' used bold red and purple arrows punching into Kuwait and Iraq (25 February 1991); the *Star*'s story 'We kicked his arsenal' used photographs of 'Allies' sci-fi weapons' alongside pictures of Iraq's wrecked weapons and captured soldiers (1 March 1991); the *Independent on Sunday*'s business section applauded 'Weapons that Work' (3 March 1991). Great increases in the speed of movement and in the power of surveilling and destroying did not wreck the older, heroic image of soldiering, though it certainly modified it. The *Sunday Times* declared that 'The Gulf war proved that old-style soldiery is no match against sophisticated high-technology'.[93] The soldier and his weapons were sometimes brought together in the publicity on allied armies. Professional soldiers who knew how to go on the attack with new weapons only increased confidence in the coalition forces.

Viewers on the home front learned about military superiority in the most general terms, with plenty of images of aircraft taking off and action replays of missiles hitting their targets.[94] Safeguarded by hardware, the soft bodies of allied soldiers appeared in a kind of exoskeleton, a technological shield far surpassing the limitations of flesh. Allied soldiers wore night-vision goggles to see tanks in the dark, and mirrored driving goggles for protection from the sun. They looked like cyborgs in their amazing machines, or kitted out to survive early-modern weapons like gas or chemicals. Even civilians 'Under fire' in Israel appeared to be well protected from gas attacks in their protective suits and masks (*Guardian*, 26 January 1991). What the cyborg myth obscured was the faultiness of the masks, even leading to some deaths through misuse: the instructions were in Arabic. They had been manufactured in Israel, and some had been sold to Germany with the aim that they would be resold to unknown Arab countries, but once the Gulf War

began they were rapidly bought back from Germany and distributed to Israeli citizens (but not to Palestinians in the 'Occupied Territories').[95]

The myth of the hero-cyborg soldier had its counterpart in the overlap between the first aviators and contemporary airmen. The purpose of flying over enemy-held territory was the same: to measure it and so prepare the bigger picture for the strategists, and then to bomb and 'degrade' the enemy's army. The *Daily Mirror* mixed old and modern ideas of flying and bombing in its headline 'The Biggest Blitz Mankind Has Ever Seen', which combined (an unironic) reference to German bombardments of civilians in the Second World War with the bombastic headlines of the Great War (18 January 1991). Extravagant claims were not confined to the press: the *Mirror*'s headline 'We'll Bomb Them Till They're Not There Anymore', was the boast of an American colonel (19 January 1991).

Advertising changes in air power also enhanced confidence in the forces. The increased 'envelope' of the planes altered the element of air itself. The variety of missiles and systems to deflect them made the air explosive and fiery, with photographs of missiles exploding over Baghdad and Dhahran in Saudi Arabia (*Today*, 19 and 24 January 1991). At the same time, advances in aircraft capacity and design made it easier for airmen to hide by 'Stealth', disappearing into thin air.

The publicity about super-added hero fighters kept up morale on the home front, suggesting that troops-going-forward would soon be troops-coming-home. Most publicity avoided humans and showed how superior machines would overcome inferior ones. By 'wasting' the enemy's weapons, radar sites and computerised control centres with 'clean' technology the coalition intended to use its own well honed rhetoric to convince its publics that war was no longer horrible. 'History is what hurts', writes Fredric Jameson, but the techno-war in the Gulf didn't appear to hurt very many people, and they were mostly people no one knew who were considered not to matter.[96] The imagery of the techno-war emerged as unpeopled, as functional 'instruments without accountability [in] a contrivance of information – abstract, quantitative, unassailable, and completely alterable'.[97]

Removing horror from the popular, historical understanding of killing (or dying) for one's country is one effect of recent war management, made easier by the 'virtual' nature of warfare practised by highly developed nations organised and led by the United States. In his critique of 'virtual' war Baudrillard does not maintain, as Christopher Norris suggests, that there is no 'operative difference between truth and falsehood'.[98] However, Baudrillard's three essays of 1991 clearly give the impression that he thinks the war will not take place, that it really was not taking place, and finally that it 'did not take place'.[99] He is insisting not that nothing happened but that the coalition so carefully planned the war as a mediated event that its editing preceded its happening. Planning the mediation of the war went hand in hand with laying out the military strategy needed to retake the territory.

The military scripted the progress of the war in models, maps and simulations before its events occured. They surveyed the territory thoroughly beforehand and designed tactics to ensure few opportunities for armies to engage. Their superior weapons enabled their forces to see and destroy the enemy before they even knew they were in the line of fire. The British realised after the Falklands conflict and the Pentagon decided after Grenada and Panama that future wars would have to be edited in advance. The Gulf War would be covered by journalists so tightly controlled that they would in effect be

pre-censored.

Faced with this planning of the war and editing of its representation, Baudrillard contends that, rather than seeing a war, '[w]e have seen what an ultra-modern process of electrocution is like, a process of paralysis or lobotomy of an experimental enemy away from the field of battle with no possiblity of reaction'.[100] One side destroyed the other without significant loss, so the engagement was not so much war as massacre, or 'a "turkey shoot," as some US forces described it, adopting the term used by US troops slaughtering Filipinos at the turn of the century'.[101] The perception of this 'shoot' is altered in 'virtual' war: troops focus on the enemy by means of 'intelligent machines'.[102] 'Virtual' war against an army that has few or inferior modern weapons results in the enemy's disappearance in a process which is not necessarily visible. Baudrillard writes, 'The isolation of the enemy by all kinds of electronic interference creates a sort of barricade behind which he becomes invisible. He also becomes "stealthy," and his capacity for resistance becomes indeterminable. In annihilating him at a distance and as it were by transparency, it becomes impossible to discern whether or not he is dead.'[103] Decisions about inflicting and announcing the death of enemies are a matter of choice, and in the Gulf the allies decided to promote the style of 'virtual' war, to kill and keep silent.

The war also became 'virtual' on the home front, with the precise actions of the alliance invisible behind a barricade of electronic interference. War on television and in the newspapers, whether censored at the front or at home, met the pre-condition that the war be seen as technological, distant, 'clean', and morally correct. All these conditions were war aims, and the product of war management. The cultural critic John Berger wrote in the *Guardian*, 'Four or five times a day the public received a TV lesson about how to become deaf to the voice of their memory, of their conscience or of their imagination.'[104] He might have added the press to the teachers of numbness. Information was broadcast and published not to meet the public's right to know but because it matched the main criterion of war news, which is to obscure experience and satisfy expectation.

The contest of bodies

Horror normally has a central place in news reports. The appearance of bodies is constrained by taste and tone, though dead foreigners are shown in greater detail. However, in wartime the press routinely makes the bodies of both British and enemy dead disappear. According to the photojournalist Martin Cleaver, the Press Association received plenty of 'red meat' photographs during the Falklands campaign, but editors decided not to publish them.[105] In recent wars involving British troops the press hides more bodies than it exposes, engaging in its own non-violent 'disappearance' of the enemy. This shift away from peacetime practice in relation to dead foreigners is only partly explained by the physical difficulties of taking the pictures, and the ways of military censorship and press self-censorship. These practices of making bodies disappear are symptomatic of another aim of war publicity: war on the home front becomes a special type of knowledge, different from the knowledge of foreign wars, disasters and so on. The knowledge of war which is widely advertised in the civilian community pretends that contemporary wars produce 'clean', heroic or invisible deaths and not 'dirty', banal death. This imaginative leap into safety and invisibility requires that wars are *redescribed*

as the collision of technological forces and unfeeling materials.

The work of eliding dirty death is characteristic of official reports, and becomes so in war reporting, chiefly in its visual forms. When the news industry adopts polite language and euphemisms it comes close to the language which is commonplace among military leaders, historians, strategists and defence analysts. This language and the way it removes bodies from the text has a long history. Leaders in the Second World War developed a special language which denoted their fantasy of bombing the enemy and deliberately not hitting those who just happened to be in the area. They talked of 'strategic bombing', which misleadingly implied that bombs were aimed: everything destroyed wide of the mark was 'unintentional'. From the 1940s defence analysts were eager to develop language which surpassed the failings of their weapons, speaking of 'clean' weapons and 'collateral damage' to describe the effects of nuclear arms and fall-out.[106] The military and the press found many synonyms for 'to kill' or 'to destroy', including 'to degrade', 'to take out', 'to impact', 'to interdict', 'to down' and 'to cleanse'.[107] In 1991, when General Schwarzkopf said that the Iraqi 'front lines had been attrited to 25 per cent' he was speaking in the tradition of what Hugh Gusterson calls 'reframing mass murder as the completion of a bureaucratic task'.[108] As Zygmunt Bauman has argued, 'inhumanity [becomes] a function of social distance'; distance technologies separate people from the consequences of their actions, which *reach far beyond the "vanishing point" of moral visibility*'.[109] In the longer historical perspective of wars this century, the American decision to foreground bodies in the war in Vietnam is an aberration. In the Falklands campaign, and the invasions of Grenada and Panama, US and British governments rediscovered the importance of making heroic bodies appear while emphasising the clash of machines; at the same time they made enemy armies disappear, and left dead bodies out of their accounts.

In contrast, the Iraqis emphasised bodies. Saddam Hussein promised great loss of life among the coalition forces. Iraqis used Scud missiles to kill a few Israeli civilians and US soldiers asleep in their barracks, but when his own people were killed by allied missiles Hussein appealed to foreign news crews with evidence of civilian corpses. This exposure of bodies does not mean that Hussein was willing to reveal the truth which the allies were trying to conceal. It is more likely that he wanted to emphasise the body count because he guessed the allies were afraid of large numbers of casualties. He promised the 'Mother and Father of all Battles', ending with US soldiers 'swimming in their own blood' and sent back to their families as 'lifeless corpses'. As Hugh Gusterson points out, Hussein 'spoke explicitly about his intention to kill as many Americans as possible, and there was no pretense that the Scud attacks on Israel and Saudi Arabia were intended to do anything but terrorize and kill civilians'.[110]

Saddam Hussein could release pictures of bodies, but he could not determine their use. He could not prevent the press from using them in its customary ways, supporting the official policy on 'surgical strikes' against a cruel tyrant. If anything, Hussein's decision to place bodies at the centre of his discourse made Iraqi warfare seemed violent and random, 'proving' that Hussein was an international terrorist. His attempt to use the English boy Stuart Lockwood to demonstrate his compassion backfired because he was seen as cynical and manipulative, if not worse. Oblivious to how this propaganda was received in the West, Hussein used other 'guests' and prisoners of war as 'human shields'.[111] In January he placed captured airmen in front of television cameras, where they 'confessed' their opposition to the war. As the Iraqis hoped, these pictures were

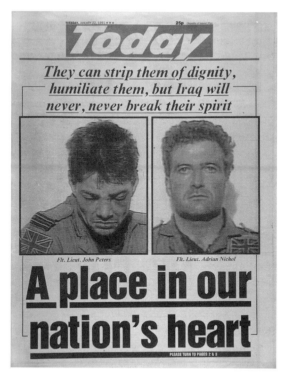

Today, 22 January 1991. News International

broadcast or 'frame-grabbed' and printed in the press (see press for 22 January 1991). But these so-called confessions counted for nothing in Britain, and the injuries were redescribed as a misguided attempt to harm Britons merely by hurting their flesh. *Today* wrote above photographs (illustrated above) of the captured Flight Lieutenants John Peters and Adrian Nichol, 'They can strip them of dignity, humiliate them, but Iraq will never, never break their spirit' (22 January 1991). Not only were the airmen saved by the misdirected actions of the Iraqis, but the harm done to their bodies was superseded, as the headline declared, by the airmen's removal to 'A place in our nation's heart'. The lieutenants were safe because the Iraqis knew nothing of their spirit, could not break it anyhow, and could never reach them now they had become national heroes. The press never endorsed Saddam Hussein's attempt to spin the war towards the harm done to individual bodies. Hussein, Iraq, captives and dead bodies fell into a system of skilfully omitting and redescribing bodies in warfare, a system skilfully practised at representing tyrants, Arabs, heroes and horror which was reinforced rather than altered by events in the Gulf.

Nevertheless, even before the incident at Amiriya, British newspapers did not fully concur with US attempts to spin the war away from bodies. Chris Buckland, a journalist writing in the *Daily Express* on 21 January, warned readers of the gap between video of 'smart bombs' and actual war. He charged that 'computer images [were] hiding the real horror of conflict'.[112] He emphasised that, despite the unprecedented bombing campaign, 'not a single body has yet been photographed, and not a single injured soldier seen on TV'. The absence of pictures of bodies is explained partly because almost all the dead

were Iraqis who had been killed at night and in bombardments, and no coalition photographers saw any of this action. More important, the military had arranged that journalists were controlled in the pooling system. Even if photographs of dead soldiers could have been taken, they were unlikely to pass the military censors. But the absence of such pictures did not seem realistic. To underscore Buckland's point about missing bodies, the story was illustrated with a photographic montage: it combined a portrait of General Schwarzkopf with a still image from the video taken by a laser-guided missile 'bombing an Iraqi ammunition dump'. The video image, placed next to the General's head, appeared to be a perfect 'thought bubble', an idea of precision bombing which was supposed to exist in the General's mind and yet an idea which *Express* readers were unlikely to accept was taking place in the real world.

Buckland was concerned about the unbelievable nature of a war with no evidence of casualties in film or photographs. This absence shrouded the war in mystery, and encouraged suspicions that the public were being misled. The absence of bodies was unrealistic, and the newspaper industry, as it is generally understood, is supposed to anchor its news stories in reality with eye-witness accounts and photographs. This need to appear to derive news from actuality is at the root of Buckland's complaint. It does not come from a desire to present awful pictures for the sake of it, but because news must appear to be connected with actuality, and because photojournalism, for all its problems, is widely understood to be evidence of 'what-has-been'. Recognising this, the military contrived to omit or redescribe death; they disguised war aims as simple choices between good and evil, democracy and tyranny. Omitting bodies, or any sign of death, in favour of technological euphoria affected home audiences: knowledge was separated from feeling. As Robert Lifton wrote in the *Guardian*, 'We know that our weapons are murderous, but we cannot afford to feel the pain of death at the other side of them.'[113] The tabloid press in particular condoned this series of omissions and choices, though Buckland's article reveals that there was room for some limited resistance.

The massacre at Mutlah Gap

Dead bodies which have literally disappeared, or were never counted as part of an official audit, or which were scarcely seen in the press, become less than real. As Margot Norris writes, 'When censorship reduces the dead to phantoms of speculation,' they stop being ' "evidence" (in empirical language) capable of serving as the locus of ethical debate,' and are merely 'figures impossible to verify and locate and therefore incapable of serving in any intellectual operation other than that of the impossibility of determining their reality'.[114] Certainly, individual bodies were systematically overlooked in favour of large forces. When US leaders were asked about dead Iraqis, they preferred to talk about the undifferentiated mass of armies. President Bush's National Security Adviser, Brent Scowcroft, said, 'our goal was not to kill people. Our goal was to destroy the Iraqi army.'[115] This remark suggests that the presence of individual Iraqis is hypothetical and that only armies are known to exist.

Consider what happened during the Iraqi retreat from Kuwait on the last Tuesday in February 1991. A convoy of a thousand vehicles left Kuwait City and was moving north towards Basra in southern Iraq when it was caught near the Mutlah Gap by a US division and aircraft. The one-sided firefight killed an unknown number of Iraqis (and possibly Kurds, Turks and Kuwaitis).[116] Unofficial estimates of the number of dead range from

four hundred to two thousand.[117] The wide discrepancy in the numbers indicates that journalists based the body count on two measures: corpses and the number of vehicles at the site. Calculating the dead from body parts rather than from trucks would give a low figure, because 'the fact is that modern weapons, such as fuel-air bombs or soft-tipped uranium shells, leave little evidence of human remains'.[118] This may explain in part why ten days after the war one reporter saw 'only 37 bodies in a 50–60 mile stretch of carnage' on the coastal route running north to the Iraqi border city of Umm Quasr.[119] Most of the dead throughout the 'theatre' of war had simply disappeared in huge blasts from fuel-air explosives and 'Daisycutter' bombs, or were cut to pieces by multiple launch rocket systems carrying six missiles that delivered cluster bombs of nearly eight thousand bomblets generating millions of high-velocity shrapnel fragments over sixty acres in one salvo.[120]

It was only on Friday 1 March that the first film and photographs of the massacre on the Basra road were released in Britain. Even so, the massacre received little media attention. It is one example of how incidents of mass killing in the Gulf War either disappeared from – or, more strictly, never fully entered – the mainstream media. Even when massacre stories did appear in the press they were massaged so much that they became the fault of Saddam Hussein. The *Sun*, *Daily Star* and *Today* made no attempt to shame their readers in reports of the final massacres. On the contrary, these papers protected readers from knowledge of British responsibility. They never mentioned the Mutlah Gap battle.

The remaining lower-market tabloid, the *Daily Mirror*, made only slightly more effort to report events. Its report on the Mutlah Gap incident concentrated on Iraqi hostages 'Snatched by the Brutes', but it did give some idea of the slaughter, quoting a pilot who said the enemy 'were like sitting ducks' (27 February 1991). The *Daily Express* and *Daily Mail* blamed Iraq for the incident. The *Express* said, 'the Allies took revenge on the Iraqi killers' (1 March 1991); the *Mail* blamed the ferocity of the killing at the Mutlah Gap on Iraqi looters, and its pictures spun away from 'carnage' and on to the imagery and language of motorway crashes, with wrecked vehicles caught in a 'bottleneck' on 'the highway to horror' (2 March 1991).

The *Times* and *Daily Telegraph*, along with the *Guardian*, used pool reports on the Mutlah Gap incident, and photographs of wreckage (2 March 1991). The *Telegraph* placed the story on its inside pages and made no comment; *The Times* remarked that 'Allied cluster bombing' created a 'grim slaughterhouse' (2 March 1991).

The *Independent* was also restrained in its pictorial coverage of this massacre, using a photograph of the 'scorched remains' of hundreds of vehicles on an inside page, and a photograph of a column of captured Iraqi soldiers under guard in the Kuwaiti desert on the front page (2 March 1991). Robert Fisk was the main eye-witness. His story 'Horror, destruction and shame along Saddam's road to ruin' appeared on the front page of the *Independent* of 2 March under the photograph of the captured soldiers.[121] He described the 'horror' of 'mutilated bodies', the 'destruction' of burned tanks and armoured vehicles, and the 'shame' of a retreating army of looters, who had stolen carpets, jewellery, video sets, vacuum cleaners and children's toys. His story spared few details of 'the ghoulish traffic jam', which no film could 'do credit to', and which was 'both surreal and pathetic'. He wrote, 'In a lorry which had received a direct hit from the air, two carbonised soldiers still sat in the cab, their skulls staring forward up the road towards the country they never reached. Kuwaiti civilians stood over the bodies laughing, taking

pictures of the Iraqis' last mortal remains.' Fisk made no judgement on what he saw, except in one significant case: he blamed the Iraqis for looting, surmising that the crime revealed a lack of morals steming from Saddam Hussein himself: 'No wonder he lost.' The paper later absolved the allies for their action. Three days after Fisk's report, an editorial claimed that a 'natural sense of horror did not invalidate the operation. War is always an ugly business' (5 March 1991).

Characteristic of war publicity, gruesome photographs did not appear until after censorship had been lifted, and even then the newpapers did not rush to show how horrible the war had been. After all, now was the time to celebrate. But on the day of the cease-fire, and two days after the first restrained pictures and television film of the aftermath of the massacre, the Sunday *Observer* published a photograph (illustrated on p. 167) taken by Kenneth Jarecke, who was travelling with a CBS television crew and two military escort officers. This picture arrived in London on Saturday morning and so it was available only to Sunday papers. The image was a horrifying, raw picture of a burned corpse, which the paper captioned 'The real face of war' (3 March 1991). The photograph dispelled the air of unreality about a war with almost no pictorial evidence of death. In contrast, and in line with the conventions of wartime photography, other Sunday papers illustrated their accounts with pictures of wrecked lorries. No other British broadsheet or tabloid used Jarecke's picture that Sunday or in the next few days – possibly because they never received it on Saturday or because by Monday its moment as news had passed. The image was not published in mainstream newspapers in the United States at the time.[122] Jarecke said, 'I figured it would never get published in this country [the United States]. In fact when the Associated Press in Dhahran transmitted the picture, some editor in New York took it off the wire.' One American group, *Refuse and Resist*, projected the image on to the side of the UN headquarters in New York, and on to the walls of CBS, ABC and NBC, in an action funded by Kurt Vonnegut and others.[123] Its later, retrospective use was less spectacular but just as limited, though definitely for reasons of taste: the managing editor of *Life* magazine, Jim Gaines, decided against its publication before going to press in March. *Life* is normally a monthly, but it ran a weekly special during the Gulf conflict and originally planned to run Jarecke's picture across two pages. At the last minute Gaines decided to pull the picture because it was 'the stuff of nightmares', stating that his action was 'in deference to children'.[124] The photograph appeared in mainstream US publications only well after the war.[125]

On the Monday after the *Observer*'s coup, the *Guardian*'s Eamonn McCabe wrote an article called the 'Dilemma of the grisly and the gratuitous', in which he considered whether or not the press should print similar pictures.[126] Since Jarecke's picture was unavailable on Saturday, the *Guardian* had covered the attack in the usual way by illustrating its report with a photograph of burned-out cars and trucks seen from a distance, and redescribed the killing of people as 'charred civilian and military vehicles' on the 'Road to destruction'. On Monday, however, the *Guardian* decided to respond to the *Observer*'s use of this picture, though it would have been unacceptable to use it as if it were still hot news. McCabe revealed that he was pulled in several directions. He suggested that the *Observer* might have been wrong to publish the picture, since it is 'gratuitous' to use horror when the story 'has moved on'; after all, the Iraqi had died several days before. At the same time, McCabe gave the photographer credit for making a picture which symbolised the horror of the war, though he did not square this with his belief that the *Observer*'s editors had been mistaken in printing the picture some time

after the event. McCabe points to a real, continuous problem for editors, who have to decide what is fit to print from many disgusting images of death, guided by no more than press practice and personal taste.[127] In this case the *Guardian* did no more than publish a detail of what McCabe conceded would become the key image of the war, and yet his reasons for restraint are entirely consistent with his own paper's practice and his judgement on news value in photographs. McCabe felt that the *Guardian* in fact had published images of captured soldiers that represented its horror (though taking prisoners is a sign of the end of a battle and therefore represents a humane action). Finally, he claimed that the *Guardian* had never shrunk from printing photographs of dead people when they were immediate news, when the pictures would not be seen by relatives of the dead, and when they symbolised an event (overlooking for the moment the symbolic significance of Jarecke's picure). As McCabe wrote, the *Guardian* had shown the bodies of people starved to death in Eritrea across eight columns, and 'no one complained'.[128] In his view, this silence did not mean that readers were indifferent, since they are generally quick to complain if they find images instrusive, but he guessed that the image had reminded people of events in Eritrea without offending them.

As I suggested in the previous chapters, photographs of dead foreigners, specifically those who die in a famine or disaster, have at least three different effects: they may evoke pity and outrage; they may lead to action; they may evoke nothing more than revulsion and indifference. But there is an important difference between photographs of starving Africans and that of an Iraqi killed by Western gunners. Whatever the responsibility of the West, Africans appear to starve as a result of the immediate actions of their own governments or from natural disasters, and so pictures of them may invoke pity and redress. In the case of photographs depicting war with British troops or their American allies it is easier to see how these governmental, military and social systems are responsible for the way enemies die, and what their deaths are supposed to mean.

At the same time, and despite the headline 'The real face of war', the meaning of the *Observer*'s intervention was uncertain. The newspaper pushed an accusatory photograph of a burned man in its readers' faces. Yet forcing viewers to look at such a horrific picture, closing the gap between a distant action and its effect, is not enough to ensure its moral meaning.

The lack of moral certainty about Jarecke's picture began with the editor's decision to couple it with the report by Julie Flint published on the same page, which was written independently of Jarecke. Her argument undermined the picture's ability to stand unambiguously for a Western atrocity, allied soldiers shooting people like 'fish in a barrel'.[129] Flint could not condemn the massacre because she had witnessed Iraqi atrocities in Kuwait. She stated that after the recapture of Kuwait City and first-hand evidence from Western journalists of Iraqi murders, tortures and rapes, it became impossible to pretend that Saddam Hussein alone was bad and that the army was made up of unwilling and basically decent people.[130] The tone of the story moved from pity at the massacre to outrage that the Iraqis now dead had earlier looted the city. In the end, Flint's story came close to implying the Iraqis deserved to die because they had broken what Margot Norris calls the 'capitalistic compact' – 'Western consumer products … must be bought and not stolen by Third World countries' – and that the carnage 'signified the justice of a criminal execution'.[131] Blaming Hussein was extended to blaming his looters, as if theft is properly followed by burning, crushing and so forth.

Flint's report goes further. She points out that the dead looters might have (who

knows?) perpetrated rapes and vile murders. At that moment Flint removed blame from Saddam Hussein and extended it to the 'regime', which included more people than the military elite: 'The Nazis killed the people, but not like this. It is not just Saddam. The whole regime is a monster' (3 March 1991). This reading shifts the meaning of Jarecke's photograph and brings the *Observer* closer than usual to the opinion of most of the tabloid press, which never ceased to blame Saddam Hussein alone for everything that happened.

If the picture signalled an end to the war, it struck a note of ambivalence, and allowed into the British press a discussion of what had been done in the name of Western values. In combining Jarecke's photograph with Flint's report the *Observer* summed up much of the unease about the war found in some sections of the broadsheet press, notably the *Guardian* and *Independent*. At the same time, the report gave expression to deep-rooted Western beliefs about Hussein and his soldiers. Despite the clarity of the headline, the story was unable to settle upon a simple ending, and therefore was unable to make sense of the event. The confusion of tone is a perfect analogue of the confusions engendered by the whole war – fought most obviously for oil, but also for a free Kuwait, for the New World Order, for US self-esteem, for the United Nations, for Western imperialism, for stability in the region, for the end of tyranny in Iraq – all at the same time. Multiple, competing, unresolved and unrealised war aims have kept the story open-ended, with narrative closures of the most tentative kind.

Nonetheless, the *Observer* did publish Jarecke's picture, and did begin a debate on the moral implications of this war which has never ceased. The questions raised by horror pictures do not rest with methods of killing or gruesome deaths, but return to media management and the way government and military authorities hid blunders or brushed aside their consequences. Revisions of the war, or attacks on allied methods, propaganda and news management exist in evidence gathered by the former US Attorney General Ramsey Clark, who conducted a fact-finding mission to Iraq in the middle of the allied bombardment, took videos of the destruction of civilian buildings and published books on US war crimes against Iraq.[132] Politicised editors and groups, including those working for *Index on Censorship*,[133] Article 19,[134] and Human Rights Watch,[135] have published similar attacks on allied war aims and methods. Photographs of the aftermath of the Mutlah Gap incident and other massacres in Kuwait do exist in the files of press agencies, along with vivid eye-witness descriptions of bodies blown apart, squashed flat or 'cooked to the point of carbonization'.[136] Such visceral images and accounts are not central to the public record of a 'clean' and necessary war contained in the British press. Revisions of this record are limited to occasional stories in broadsheet newspapers. Shocking photographs similar to Abbas's image of a charred corpse in front of a tank (reproduced on the cover of this book) began to appear only when the war was long over, in investigative reports which attempted to revise the official history of the war.[137] Terrible images and accounts belong to the war's peripheral history.

Friendly fire

The debate surrounding the sudden appearance of an Iraqi corpse on 3 March 1991 was quickly superseded, and even surpassed in news value, by two more stories involving the appearance and disappearance of bodies. Critically, both stories enabled the press to re-establish its standard outraged, 'watchdog' roles.

The first story concerned the deaths of nine British soldiers in a fatal blunder or so-called 'friendly fire' incident carried out by US pilots. The soldiers' bodies continued to haunt the papers from the day they died on 26 February 1991 until May 1992. This long-running story began with 'heartbreak' stories in all the newspapers. The *Sun* declared, 'British heroes [killed] in bomb blunder,' and displayed photographs of two of them in dress uniform, with the banner headline 'So Young So Sad'; the *Guardian* carried a full report, including photographs of four of the soldiers, on an inside page under the headline 'Families count cost of "friendly" fire' (28 February 1991). As we already know from General Schwarzkopf's testimony, 'accidental' or 'unintentional' deaths are considered to be unforeseen interruptions on the road to victory. In other words, killing armies remains the aim, even if an army kills its own soldiers. Accepting the 'fog of war' explanation for these deaths, the earliest reports were accompanied by fatalistic cries such as the *Daily Star*'s 'What a bloody shame they all had to die so young' (28 February 1991). The headline accompanied a portrait of the youngest victim, seventeen-year-old Conrad Cole, crouching in combat uniform and holding a gun.

In the case of the 'friendly fire' deaths the press overcame its own inertia and standard dependence on fate and chance as insuperable forces. According to the first information from the Ministry of Defence the deaths had taken place 'in very bad weather and visibility,' but the story of an unfortunate accident in the confusion of battle was increasingly discredited by tales emerging from official sources and investigative journalists of American blunders and lies supported by the MoD.[138] The official board of inquiry in July 1991 cleared the British troops of any blame, but failed to establish whether the US pilots were at fault. The *Telegraph* headline was 'Families decry Gulf deaths report', and the story was accompanied by a dignified picture of Susan Cole, mother of Conrad, holding a framed print of her son in uniform and hoping 'someone would stand up and say they did it'.[139] The *Mirror* also used the same portrait of Conrad Cole but alongside the headline 'Now we know what death by "friendly" fire means … Never Having to Say you're Sorry' (*Mirror*, 25 July 1991). Journalists kept this story alive by interviewing members of the soldiers' families and eye-witnesses who reported that the attack took place in good weather and visibility, and the American pilots had mistaken stationary allied personnel carriers for Iraqi tanks even though the carriers bore American imposed identification marks and were situated exactly where they were meant to be according to the plan of attack.[140]

The story was picked up again the following May when the inquest declared the deaths had been 'unlawful' killing by USAF forces. The *Guardian* carried the verdict on the front page, with a large photograph of distraught and determined relatives outside Oxford County Hall under the headline 'Gulf killings "unlawful"' (19 May 1992). In its different voice, the *Mirror*'s headline the same day carried the same message: 'Dishonour and Disgrace – US Top Gun pilots guilty of unlawful killing, says jury' (19 May 1992). This unexpected verdict promised further revelations of British government weakness in the face of American intransigence and unconcern, but nothing came of it.

Kurds

The second story which superseded the dead Iraqi in the *Observer* of 3 March was the uprising of Kurds in northern Iraq, their defeat and their flight from Hussein's army. Early in April thousands of Kurds moved north towards Turkey through 'The valleys of

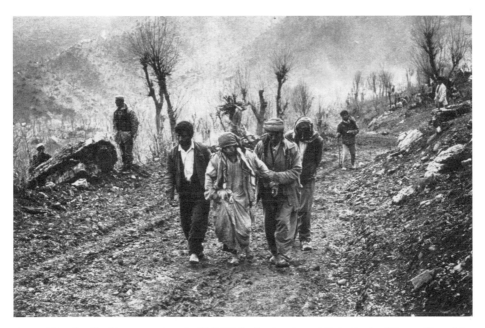

Over 1,000 a day die. *Observer* readers give £160,000 for Kurds as huge airlift begins. Iraqi Somme: Up to 1.5 million starving Kurdish refugees have trekked across the mountains towards Turkey to escape Saddam. *Observer*, 14 April 1991. Dod Miller/Network

death' (*Guardian*, 3 April 1991) in what the *Daily Mail* called an 'Avalanche of Despair' (6 April 1991). This became front-page news in most of the papers – especially in the tabloids – for two main reasons: firstly, John Major suddenly looked like an international statesman with his imaginative call for support which resulted in the UN resolution to create so-called 'safe havens' for the Kurds in northern Iraq; secondly, the story was accompanied by photographs of large numbers of refugees so afraid of Hussein's revenge that they would rather run into the mountains or die in the attempt. The plight of the Kurds, and a shrewd assessment of its audience, led the *Observer* to organise an appeal fund, raising £160,000 from readers as 'Over 1,000 a day die' and 'huge airlift begins' (14 April 1991). This story, illustrated with large photographs (one is reproduced above) of hordes of people on mountain-sides, continued to interest the broadsheet press sporadically at least until December that year (*Guardian*, 7 December 1991), though save in the exceptional cases mentioned above the tabloid press was largely indifferent to the Gulf region once the war had ended.

The *Sun*, *Daily Star* and *Today* protected readers from knowledge of allied responsibility for encouraging the post-cease-fire uprisings among Shias and Kurds in Iraq in 1991. They failed to cover the Shi'ite revolt in Basra, and scarcely mentioned the Kurds apart from publicising Margaret Thatcher's plea for them (4 April 1991) and John Major's sudden reversal of policy to back 'safe havens' for the Kurds in northern Iraq with military support (10 April 1991).

The *Daily Mail* attacked the West for not intervening to save the Shias (18 and 19 March 1991) and, over a photograph of Kurdish refugees, praised Margaret Thatcher, now 'The Voice of Conscience', for speaking out against genocide (2 and 4 April 1991). When Major and Bush proposed 'safe havens', the *Mail* condemned the 'Shame of the

West' for betraying the rebels and for 'sending so little so late' (11 April 1991).

The *Daily Mirror* mentioned the Basra revolt, but not the allied refusal to intervene (4 March 1991), and was largely silent about the Shias and Kurds. Its only full front-page coverage of any of these events was in response to Thatcher's demand that 'YOU MEN [Bush and Major] Do something for these doomed people' (4 April 1991). Photographs represented President Bush fishing and Prime Minister Major watching football in contrast to a photograph of Kurdish refugees, who were made to say, 'Help, please, we're dying.' The editorial declared 'And STILL we stand by,' while comparing Hussein's massacre of the Kurds to the Nazi Holocaust.

The *Daily Express* reported the civil wars only occasionally and backed Major's early 'keep out' policy, while remarking at the same time on 'The shame of our silence' (2 April 1991). It supported Major's later proposals for 'safe havens', but the Kurds quickly faded from view once the allies had decided to intervene.

The *Times* and *Daily Telegraph* had only a little more to say about the morality of leaving the Shias and Kurds to their fate. The *Telegraph* recognised the moral problem raised by President Bush himself urging the Iraqis to rise against their leadership, but the newspaper did not support the rebels. The *Telegraph* admitted that it was 'not an edifying spectacle' to see the Americans sit by and allow Hussein's forces to destroy their own people (16 March 1991). But this newspaper directed that the allies must disengage from the region, and made no moral case for Western involvement – other than to support crippling sanctions (4 April 1991). In one respect *The Times* reacted quite differently: it called for an end to sanctions, but was even more cautious about helping the Kurds and Shias in 'safe havens' (10 April 1991).

The *Guardian* and *Independent* treated their readers to the fullest analysis of all aspects of the war and its aftermath of any media audience. They published more information than any other papers on the death toll, carpet bombing, life in Baghdad, the British media, the attitudes of Muslim organisations and anti-war opinion in Britain.

Despite its extensive coverage, the *Guardian* had no clear line on what to do about the post-war uprisings. It acknowledged no responsibility to help the Shias and Kurds, and only called for intervention once the allies had decided on 'safe havens'. Furthermore, it diluted its editorial message by calling for 'a much greater international effort which targets *all* the refugees, and *all* the civilian victims of the war' (18 April 1991).

The *Independent* alone focused on allied responsibility for the uprisings and their outcome (25 March 1991). Its editorials spoke of 'outraged incomprehension bordering on shame' for 'our' capacity to 'tolerate unspeakable horror in far away places', especially this 'man-made human tragedy in which we are deeply involved and for which we bear much responsibility' (4 and 5 April 1991). The paper kept the Kurdish crisis on its front pages until the end of April, and if the stories were illustrated the photographs tended to be of rebel soldiers with weapons (23 March 1991). It also harked back to Hussein's use of chemicals to kill five thousand Kurdish civilians in the border town of Halabja in March 1988, illustrating the story with a large photograph of a poisoned infant.[141]

The *Independent*'s line was unusual. Most of the press either ignored the 'turkey shoot' battles in February and the later uprisings, or covered them with great caution. This timidity reflects the press's own sense of where readers' interest lies – namely, with national interests and an end to foreign adventures. Given that the military and political

leaders were enthusiastic about the conduct of the war, and had largely washed their hands of the Kurds and Shias, none of the press except the *Independent* saw any reason to campaign for intervention. Similarly, most of the industry was unwilling to attack decisions made by the military and by government, which seemed to cause them no moral qualms.

The pictures accompanying the reports might represent split seconds in the lives of far-away Kurds, but they met the long-established needs of home audiences. They encouraged staring and excused it by stirring a degree of conscience. They represented subjects in exotic dress taking part in an exodus through extravagant scenery. They allowed several ideas and feelings to intermingle: the reveries of tourism; recognition of fear; intimations of hardship and death among refugees.

Such photographs are never useless, but they are always impure in their effect. They provide the chance to look on without shame, perhaps feel a prick of conscience, or be stirred by the danger and pity of it all. They are surrounded by impure texts which try to persuade readers that, among other things, they should mourn the loss of Margaret Thatcher, be thankful for the presence of John Major and contribute towards the cost of aid. Even if they try, the surrounding words cannot guarantee to save the pictures, moralise them, or turn them into springboards for action. Texts and pictures together do not suit any one reading. Altogether, they may induce viewers to do no more than take aesthetic pleasure in the wild scene or to recollect extremes in their own lives. In the end they can do no more than invite readers to accept or reject, with varying degrees of warmth and severity, the invitation to feel obliged, indignant or ashamed.

Once the military had ceased to intervene in the region so catastrophically, the news industry returned to its everyday practice. The presence in the daily press of images of Kurdish refugees and stories about secrecy and whitewash inquiries concerning the deaths of British soldiers signified, above all else, the resumption of normal duties in the news room. The forty-four days of the Gulf War clarified for the military and the newspapers exactly what 'handling' the media means in conflicts where home-front morale has to be kept high and quietly confident. Good civilian morale requires that people are diverted by the spectacle of war, and that they do not feel personal responsibility. Civilians will acquiesce in intervention as long as the warring forces are sufficiently distant to mean that civilians are not at personal or psychic risk, and as long as the morality of the war appears to be straightforward.

High morale requires a certain type of knowledge to be sustained and never seriously challenged: it depends on officially approved photographs in which (for instance) soldiers prepare, go forward and capture the enemy. Such scenes produce what Malek Alloula (in his work on French postcards of women in Algeria) called 'pseudo-knowledge' or 'stereotypes in the manner of great seabirds producing guano', the 'fertiliser' of the nationalist vision.[142] What really took place in the idealisation of soldiering was the reinscription of older ways of thinking about war work, specifically the right to guard the figure of the patriotic native, thus ensuring that he remained 'the bearer of multiple violence': the mass production of excitement about soldiering went under the guise of protecting actual men, but it prevented them from giving their own evidence. Viewers of published photographs might mistake them for knowledge about fighting the war, when they were really looking at messages sent to support civilian beliefs or hopes. Borrowing further from Alloula's insight, I propose that images of the so-called glories of war did not simply reveal a higher, righteous civilisation, as intended, but also

demonstrated that the management of war was firmly established. These mundane procedures were designed to produce pseudo-knowledge and encourage viewers to be sanguine about mass murder.

There is little point in accusing photography of failing to represent the reality of war as if its publication were unmediated. It is worth remembering that the sparing use of photographs is part of the management of war news. At the same time, photography is not simple propaganda, with censors hiding the 'truth' from an unsuspecting public and replacing the visceral horrors of war with diverting, positive stories. The censors did not simply dupe the home front and betray the soldiers. Instead, photography, along with language, was used to support what Mary Douglas called 'cherished classifications' or beliefs that were widely held by civilians and soldiers alike.[143] The press scarcely departed from repeating the classifications which separate 'clean' from 'dirty', or wholesome from defiled. The war as the press represented it hardly ever forced readers to focus on dirt, since 'our strongest mental habit' rejects discordant or abject materials.[144] Far from overthrowing 'cherished classifications,' the function of photography was to establish them against whatever actual conditions prevailed.

The history of news management in war means that Alloulla's strictures about photography and the production of knowledge have to be taken seriously. His idea that photography may be the 'fertiliser' of the nationalist vision is more useful in revealing the politics of pictures than Sontag's belief in the analgesic effect of shock photographs. Official reluctance to show such pictures during the Gulf War separated language and imagery from experience, and demonstrated how easy it is to manipulate both. The terms 'propaganda' and even 'information' no longer stood for the explication of war aims but meant the cynical organisation of public opinion, the official creation of 'misinformation', subterfuge and lies. Besides negative information, the 'fertiliser' of the nationalist vision always made the enemy out to be inhuman, used empathetic imagery of soldiers, overlooked their experience, and did not neglect the aesthetic appeal of an abstract war zone. Publicists were able to use photography in this work because it has no independent authority whatsoever. The coverage of the Gulf War revealed the conservative role of photojournalism within the press when it almost ceases to function as a public sphere of controversy.

Notes

1 Elaine Scarry, 'Watching and authorizing the Gulf War', in Marjorie Garber, Jann Matlock and Rebecca L. Walkowitz (eds), *Media Spectacles* (London, Routledge), 1993, p. 59.
2 *Ibid.*, pp. 59–61.
3 Bernd Hüppauf, 'Modernism and the photographic representation of war and destruction', in Leslie Devereaux and Roger Hillman (eds), *Fields of Vision. Essays in Film Studies, Visual Anthropology, and Photography* (Berkeley, University of California Press), 1995, p. 101.
4 Elaine Scarry, *The Body in Pain. The Making and Unmaking of the World* (Oxford, Oxford University Press), 1985, p. 67.
5 *Ibid.*, p. 67.
6 *Ibid.*, p. 67.
7 Margot Norris, 'Only the guns have eyes: military censorship and the body count', in Susan Jeffords and Lauren Rabinovitz (eds), *Seeing through the Media. The Persian Gulf War* (New Brunswick, New Jersey, Rutgers University Press), 1994, p. 292.
8 Phillip Knightley, 'Here is the patriotically censored news', in 'Warspeak: Media Management in the Gulf War', *Index on Censorship*, 20:4–5 (1991) 4–5; Caspar Henderson, 'The filtered war', *Banned* (London, Channel 4, *New Statesman*, BFI) (April 1991) 16–17.
9 Anthony Giddens, *Modernity and Self-identity. Self and Society in the Late Modern Age* (London, Polity), 1991, cited in Martin Shaw and Roy Carr-Hill, *Public Opinion, Media and*

Violence. Attitudes to the Gulf War in a Local Population, Gulf War Report Project, Report No. 1 (Hull, University of Hull), 1991, p. 2.

10 Kevin Robins and Les Levidow, 'Socializing the cyborg self: the Gulf War and beyond', in Chris Hables Gray, Heidi J. Figueroa-Sarriera and Steven Mentor (eds), *The Cyborg Handbook* (London, Routledge), 1995, pp. 119–25.

11 Paul Virilio, *War and Cinema. The Logistics of Perception* (London, Verso), 1989, p. 11.

12 *Ibid.*, p. 4.

13 Michael J. Shapiro, 'That obscure object of violence: logistics and desire in the Gulf War', in David Campbell and Michael Dillon (eds), *The Political Subject of Violence* (Manchester, Manchester University Press), 1993, pp. 114–36.

14 Philip M. Taylor, *War and the Media. Propaganda and Persuasion in the Gulf War* (Manchester, Manchester University Press), 1992, p. 318; David Fairhall, 'Archbishop's cathedral salute to Gulf fighters who died in "just war of liberation"', *Guardian*, 29 February 1996.

15 Hugh Gusterson, 'Nuclear war, the Gulf War, and the disappearing body', *Journal of Urban and Cultural Studies*, 2:1 (1991) 51.

16 Ramsey Clark, *The Fire this Time. US War Crimes in the Gulf* (New York, Thunder's Mouth Press), 1992, p. 42.

17 Noam Chomsky, 'The media and the war: what war?' in Hamid Mowlana, George Gerbner and Herbert L. Schiller (eds), *Triumph of the Image. The Media's War in the Persian Gulf. A Global Perspective* (Boulder, Colorado, Westview Press), 1992, p. 52; Taylor, *War and the Media*, p. 318.

18 Dilip Hiro, *Desert Shield to Desert Storm. The Second Gulf War* (London, Paladin), 1992, p. 396.

19 Clark, *The Fire this Time*, p. 43.

20 For 'dirty' death see Philippe Ariès, *The Hour of our Death* (Harmondsworth, Penguin Books), 1981, pp. 568–70.

21 Michelle Kendrick, 'Kicking the Vietnam syndrome: CNN's and CBS's video narratives of the Persian Gulf War', in Susan Jeffords and Lauren Rabinovitz (eds), *Seeing through the Media. The Persian Gulf War* (New Brunswick, New Jersey, Rutgers University Press), 1994, p. 59.

22 Kendrick, 'Kicking the Vietnam syndrome', p. 59.

23 Douglas Kellner, *The Persian Gulf TV War* (Boulder, Colorado, Westview), 1992, p. 157.

24 David E. Morrison, *Television and the Gulf War* (London, John Libbey), 1992, p. 4.

25 Kellner, *The Persian Gulf TV War*, p. 160.

26 Taylor, *War and the Media*, p. 274.

27 *Ibid.*, p. 274.

28 *Ibid.*, p. 319.

29 *Ibid.*, p. 29.

30 *Ibid.*, pp. 274–5.

31 Kevin Robins, *Into the Image. Culture and Politics in the Field of Vision* (London, Routledge), 1996, p. 68.

32 Scarry, *The Body in Pain*, p. 131.

33 Benedict Anderson, *Imagined Communities: Reflections on the Origin and Spread of Nationalism* (London, Verso), 1989, pp. 5–7.

34 Norris, 'Only the guns have eyes', p. 288.

35 James Adams, 'Pentagon bans video of doomed Iraqi driver', *Sunday Times*, 10 February 1991.

36 Patrick J. Sloyan, 'Buried alive', Newsday, 12 September 1991, cited in Clark, *The Fire this Time*, p. 52; Kellner, *The Persian Gulf TV War*, p. 378.

37 Patrick J. Sloyan, 'US tank-plows said to bury thousands of Iraqis', *Los Angeles Times*, 12 September 1991, cited in Norris, 'Only the guns have eyes', p. 296.

38 Holly Burkhalter, 'Some bodies don't count', *Los Angeles Times*, 12 March 1991, cited in Norris, 'Only the guns have eyes', p. 296.

39 Gusterson, 'Nuclear war, the Gulf War, and the disappearing body', p. 51; Allan Sekula, 'War without bodies', *Artforum*, 30:3 (1991) 107–10.

40 Clark, *The Fire this Time*, pp. 19–20.

41 *Ibid.*, p. 21.

42 Walter Benjamin, *Illuminations* (London, Collins/Fontana), 1973, p. 257.

43 Kellner, *The Persian Gulf TV War*, pp. 404–10.

44 Morrison, *Television and the Gulf War*, p. 93.

45 Taylor, *War and the Media*, pp. 51–9.

46 Stig A. Nohrstedt, 'Ruling by pooling', in Hamid Mowlana, George Gerbner and Herbert L.

Schiller (eds), *Triumph of the Image. The Media's War in the Persian Gulf. A Global Perspective* (Boulder, Colorado, Westview Press), 1992, pp. 118–27; Robert Hamilton, 'Pools, minders, unilaterals and Scud studs: war reporters in the news', in Jeffrey Walsh (ed.), *The Gulf War did not Happen. Politics, Culture and Warfare Post-Vietnam* (Aldershot, Arena), 1995, pp. 159–69.

47 Morrison, *Television and the Gulf War*, p. 4.

48 Robert Worcester, 'Who buys what—for why?', *British Journalism Review*, 2:4 (1991) 48; Martin Shaw and Roy Carr-Hill, 'Public opinion and media war coverage in Britain', in Hamid Mowlana, George Gerbner and Herbert L. Schiller (eds), *Triumph of the Image. The Media's War in the Persian Gulf. A Global Perspective* (Boulder, Colorado, Westview Press), 1992, pp. 144–57.

49 Jean Morgan, 'Iraq pack may be made Saddam's pawns … but eyewitness accounts are vital', *UK Press Gazette*, 11 February 1991.

50 Benedict Anderson, *Imagined Communities. Reflections on the Origin and Spread of Nationalism* (London, Verso), 1989, p. 15.

51 Asu Aksoy and Kevin Robins, 'Exterminating angels: morality, violence and technology in the Gulf War', *Science as Culture*, 2:3 (1991) 322–36.

52 Greg Philo and Greg McLaughlin, 'The British media and the Gulf War', in Greg Philo (ed.), *Glasgow Media Group Reader*, vol. 2, *Industry, Economics, War and Politics* (London, Routledge), 1995, pp. 146–56.

53 Ella Shohat, 'The media's war', in Susan Jeffords and Lauren Rabinovitz (eds), *Seeing through the Media. The Persian Gulf War* (New Brunswick, New Jersey, Rutgers University Press), 1994, pp. 147–54.

54 McKenzie Wark, *Virtual Geography. Living with Global Media Events* (Bloomington and Indianapolis, Indiana University Press), 1994, pp. 3–5.

55 Kellner, *The Persian Gulf TV War*, pp. 68–9; Douglas Kellner, *Media Culture, Cultural Studies. Identity and Politics between the Modern and the Postmodern* (London, Routledge), 1995, pp. 206–10.

56 *Ibid.*, p. 207.

57 Stephen Robinson, 'Fugitives tell of Kuwait atrocities by soldiers', *Daily Telegraph*, 11 October 1990.

58 Kellner, *Media Culture*, p. 68.

59 Simon Tisdall, 'Kuwaitis bear army terror', *Guardian*, 2 February 1991.

60 Taylor, *War and the Media*, p. 162.

61 Tim Kelsey, 'Kuwait on the bloody trail of the torturers', *Independent on Sunday*, 17 March 1991.

62 Harvey Morris, 'Inside Saddam's chamber of horrors', *Independent*, 4 April 1991.

63 Lynda E. Boose, 'Techno-muscularity and the "boy eternal": from the quagmire to the Gulf', in Miriam Cooke and Angela Woollacott (eds), *Gendering War Talk* (Princeton, New Jersey, Princeton University Press), 1993, p. 78.

64 Sarah Zaidi and Mary C. Smith Fawzi, 'Health of Baghdad's children', *Lancet*, 346:8988 (1995) 1485; Ramsey Clark, UN Food and Agriculture Organisation and others, *The Impact of Sanctions on Iraq. The Children are Dying* (New York, World View Forum), 1996.

65 Edward Said, *Orientalism* (Harmondsworth, Penguin Books), 1978, p. 287.

66 See Scarry, *The Body in Pain*, pp. 63–81.

67 Edward Said, 'Empire of sand', *Guardian Weekend*, 12 January 1991.

68 John Pilger, 'Myth-makers of the Gulf War', *Guardian*, 7 January 1991.

69 Noam Chomsky, 'A stand on low moral ground', *Guardian*, 10 January 1991.

70 Phillip Knightley, 'A new weapon in the news war', *Guardian*, 4 March 1991.

71 Robert Fisk, 'Free to report what we're told', *Independent*, 6 February 1991; Taylor, *War and the Media*, p. 66.

72 Martin Shaw, *Civil Society and Media in Global Crises. Representing Distant Violence* (London, Pinter), 1996, pp. 97–118.

73 Morrison, *Television and the Gulf War*, p. 1.

74 Taylor, *War and the Media*, p. 188.

75 Morrison, *Television and the Gulf War*, p. 33 and p. 35.

76 Jack Lee, Michael Atcherson and Ted Daly, 'Outrage over BBC war bias', *Daily Express*, 14 February 1991; see Steve Platt, 'Casualties of war', *New Statesman*, 4:139 (22 February 1991) 12–13.

77 Taylor, *War and the Media*, pp. 187–98.

78 See Platt, 'Casualties of war'.

79 Anon, 'The role of the press at war', *UK Press Gazette*, 18 February 1991.

80 Sir Peregrine Worsthorne, 'The press *v.* the people', *Sunday Telegraph*, 10 February 1991.

81 House of Commons Defence Committee, *The Handling of Press and Public Information during the Falklands Conflict*, HC 17–I and HC 17–II (London, HMSO), 1982.

82 Norris, 'Only the guns have eyes', p. 286.

83 Martin McNamara, 'Muffled response teams', *UK Press Gazette*, 25 March 1991.

84 'Baker praises Gulf War coverage', *UK Press Gazette*, 25 February 1991.

85 David Morrison and Howard Tumber, *Journalists at War. The Dynamics of News Reporting during the Falklands Conflict* (London, Sage), 1988, p. 182.

86 John Taylor, *War Photography. Realism in the British Press* (London, Routledge), 1991, p. 111.

87 Chris Buckland, 'Bloodless video games', *Daily Express*, 21 January 1991.

88 Taylor, *War and the Media*, p. 29.

89 Morrison, *Television and the Gulf War*, p. 33.

90 *Ibid.*, pp. 30–1.

91 *Ibid.*, p. 38.

92 *Ibid.*, p. 21.

93 Richard Caseby, 'Victory was the stuff of strategists' dreams', *Sunday Times*, 3 March 1991.

94 Timothy Druckrey, 'Deadly representations, or apocalypse now', *Ten.8*, 2:2 (1991) 16–27.

95 Israel Shahak, *Open Secrets. Israeli Foreign Policy and Nuclear Policies* (London, Pluto Press), 1997, p. 103.

96 Fredric Jameson, *The Political Unconscious* (London, Methuen), 1981, p. 102.

97 Druckrey, 'Deadly representations, or apocalypse now', p. 18.

98 Christopher Norris, *Uncritical Theory. Postmodernism, Intellectuals and the Gulf War* (London, Lawrence and Wishart), 1992, p. 12.

99 Jean Baudrillard, *The Gulf War did not Take Place* (Sydney, Power Publications), 1995.

100 *Ibid.*, p. 61.

101 Chomsky, 'The media and the war: what war?', p. 52.

102 Manuel De Landa, *War in the Age of Intelligent Machines* (New York, Zone Books), 1991.

103 Baudrillard, *The Gulf War did not Take Place*, p. 43.

104 John Berger, 'In the land of the deaf', *Guardian*, 2 March 1991.

105 Morrison and Tumber, *Journalists at War*, p. 182.

106 Carol Cohn, 'Sex and death in the rational world of defense intellectuals', *Signs: Journal of Women in Culture and Society*, 12:4 (1987) 687–718.

107 Matthew d'Ancona, 'Low warspeak', *Index on Censorship*, 20:4–5 (1991) 9.

108 Gusterson, 'Nuclear war, the Gulf War, and the disappearing body', p. 50.

109 Zygmunt Bauman, *Modernity and the Holocaust* (Cambridge, Polity), 1991, p. 155 and p. 193.

110 Gusterson, 'Nuclear war, the Gulf War, and the disappearing body', p. 51.

111 Tim Lewis and Josie Brookes, *The Human Shield. British Hostages in the Gulf and the Work of the Gulf Support Group* (Lichfield, Staffordshire, Leomansley Press), 1991.

112 Buckland, 'Bloodless video games'.

113 Robert J. Lifton, 'Techno-bloodshed', *Guardian*, 14 February 1991.

114 Norris, 'Only the guns have eyes', p. 290.

115 Gusterson, 'Nuclear war, the Gulf War, and the disappearing body', p. 51.

116 See Caroline Ellis, Saeeda Khanum and Steve Platt, 'Highway to hell', *New Statesman*, 4:156 (21 June 1991) 21–7.

117 John Simpson, *From the House of War* (London, Hutchinson), 1991, p. 350; Taylor, *War and the Media*, p. 261.

118 Taylor, *War and the Media*, p. 262.

119 *Ibid.*, p. 262.

120 Kellner, *The Persian Gulf TV War*, pp. 378–9; Michael T. Klare, 'Weapons of mass destruction in Operation Desert Storm, the non-nuclear equivalent of Hiroshima and Nagasaki', in Cynthia Peters (ed.), *Collateral Damage. The New World Order at Home and Abroad* (Boston, Massachusetts, South End Press), 1992, pp. 222–7.

121 Robert Fisk, 'Horror, destruction and shame along Saddam's road to ruin', *Independent*, 2 March 1991.

122 Lynne Jones, *File on 4*, Programme No. 91VY3015LHO (London, BBC Radio), 9 and 10 April 1991.

123 Mordecai Briemberg (ed.), *It Was, It Was Not. Essays and Art on the War against Iraq* (Vancouver, New Star Books), 1992, pp. 349–50.

124 Eamonn McCabe, ' "The stuff of nightmares" ', *British Journalism Review*, 2:3 (1991) 24; Ian Buchanan, 'Controversial Gulf War image withdrawn by *Life*', *British Journal of Photography*, 6812 (21 March 1991) 4.

125 John R. MacArthur, *Second Front. Censorship and Propaganda in the Gulf War* (Berkeley,

University of California Press), 1993, p. 155.

126 Eamonn McCabe, 'Dilemma of the grisly and the gratuitous', *Guardian*, 4 March 1991.
127 Jon Tarrant, 'The real face of war', *Professional Photographer*, 32:4 (1992) 23.
128 McCabe, 'Dilemma of the grisly and the gratuitous'.
129 Aksoy and Robins, 'Exterminating angels: morality, violence and technology in the Gulf War', p. 333.
130 Julie Flint, 'Arabs suffer the agony of military humiliation', *Observer*, 3 March 1991.
131 Norris, 'Only the guns have eyes', p. 293.
132 Ramsey Clark *et al.*, *War Crimes. A Report on United States War Crimes against Iraq* (Washington, D.C., Maisonneuve Press), 1992; Clark, *The Fire this Time*.
133 'Warspeak: the Gulf and the news media', *Index on Censorship* (1991) 20, 4–5.
134 Article 19, 'Stop press: the Gulf War and censorship', *Censorship News*, 1:15 (February 1991).
135 Human Rights Watch, *Needless Deaths in the Gulf War. Civilian Casualties during the Air Campaign and Violations of the Laws of War* (Middle East Watch, New York), 1991.
136 Michael Kelly, *Martyrs' Day. Chronicle of a Small War* (Basingstoke, Macmillan), 1993, p. 240.
137 Maggie O'Kane, 'Bloodless words, bloody war', *Guardian Weekend*, 16 December 1995.
138 Christian Wolmar, Alex Renton and Edward Lucas, 'Duke of Kent "furious over MoD version"', *Independent*, 10 May 1991.
139 George Jones, 'Families decry Gulf deaths report', *Daily Telegraph*, 25 July 1991.
140 Denis MacShane, 'There was a soldier', *Guardian Weekend*, 18 January 1992.
141 Harvey Morris, 'For the Kurds, no happy ending', *Independent Weekend*, 2 March 1991.
142 Malek Alloula, *The Colonial Harem* (Manchester, Manchester University Press), 1987, p. 4.
143 Mary Douglas, *Purity and Danger. An Analysis of the Concepts of Pollution and Taboo* (London, Routledge and Kegan Paul), 1978, p. 36.
144 *Ibid.*, p. 36.

10

Conclusion

Why is it important that British newspapers should sometimes display the body in states of pain, decay or dismemberment? What can be the purpose of such pictures other than to illustrate reports in sensational fashion? What is the point of body horror?

Horror has currency as an element of news. The idea and practice of news depend on fascination. News is something fresh and possibly electrifying. Photographs that accompany news reports will also be eye-catching, and may draw their strength from portraying scenes that otherwise would be incredible, or unimaginable. News is voyeuristic to its core.

Displays of the horror and hurt of bodies are a measure of the industry's mix of prurience and rectitude. The press errs on the side of caution in depicting death and destruction. It is careful to write more detail than it dares to show, and often uses the metonymic power of photographs to remove harm from flesh to objects. When the press decides to picture bodies, the imagery tends (with notable exceptions) to be restrained. Newpapers do not revolt audiences for the sake of it. On the contrary, disgust forms a small part of the stock-in-trade, and papers use it sparingly.

Representing horror stories is fraught with difficulties which, for the most part, the press appears to have resolved. The nature and extent of horror in hard news stories derive from the balance which is struck between gruesome stories and meeting the desire to see and know. It is quite conventional to restrict what may be said and seen in public places for reasons of good order. As public arenas for the display of bodies, newspapers are skilled at balancing propriety against sensation. Most accidents and murders are portrayed through various types of acceptable and successful formula. Few require graphic, unaccustomed detail. Most foreign horror stories, if they are covered at all, are treated less decorously. They form a kind of un-British, other-worldly baroque. Not

surprisingly, this says more about our own culture than it does about anything else.

The industry regulates horror, partly because it can never be certain how horror will be received. Journalists know that horror always relates to wider social perceptions of hope and belief, as well as to concern about what is dangerous in the world. Perspectives on horror change with time and place. What was once terrifying may become a curiosity; what was once horrible may become dull or irrelevant. Audiences may reject horror in the media or be thankful that they do not have to see or read about it, and do not have to think or change their minds because of it. Audiences, rather than be fearful, may be unmoved by representations of horrors which they consider no longer touch them. Audiences might turn away from journalism altogether if it sought to inform more than entertain. After all, not all horrible events are important to readers and viewers; not all disasters or catastrophes are the subject of controversy; not every audience can agree on what is controversial. They might justifiably ask, 'What is the point of *recalling* horror?'

One response may be that newspapers serve a purpose other than entertainment. They contribute to knowledge, to know-how, to knowing how to live. According to Jean-François Lyotard, knowledge includes criteria of efficiency, of justice, of happiness, of ethical wisdom, of the beauty of sound or colour: 'Understood in this way, knowledge is what makes someone capable of forming "good" denotative utterances, but also "good" prescriptive and "good" evaluative utterances.'[1] The news industry is a sign and measure of the extent and quality of that knowledge. Removed from the horror of bodily harm by censorship, squeamishness or politeness, the press might become poor in knowledge and so impoverish its readers. The role of photography in contributing to knowledge is limited for all the reasons I have mentioned, but it is not therefore useless. Photographs are traces of what once stood before the camera, and so complement other reports.

If the central moral as well as material fact of our time is the production of mountains of corpses, what is the role of newspapers in bringing these dead into existential focus? To the extent that they record events, newspapers form a basis for public knowledge and consequently for recollection. This is significant, because memory is not simply a trick or faculty of the mind without obligation. Memorials are not mere tokens or appeasements, since those re-membered in descriptions and images may insinuate themselves into the material world and even into the bodies of narrators and their audiences. As W. J. T. Mitchell writes in *Picture Theory*, 'We should recall here that the legendary origin of the rhetorical memory system involves Simonides' being asked to identify the disfigured bodies of those killed when the banqueting hall/memory palace collapses on them. Simonides has to convert the function of the memory from its proper function as an artificial aid to public performance into a mode of private, experiential recollection that will make possible, in its turn, the public commemoration of the dead ... Simonides as the lone survivor owes his listeners that much.'[2] The acts of memorialising and of remembrance are more than atonements: 'The Holocaust survivor narrative is also the payment of a debt owed to the dead; failure to bear witness may be even more unendurable than the act of recollection.'[3]

Failure to bear witness suggests that individuals enjoy a particular relationship with the present – one of immediacy and proximity – choosing to forget the world of obligation which for them remains distant. Bearing witness is the work of memory, a cultivation of historical sense and feeling. The cultivated memory is often seen at work in the press: the process of remembering uses the 'truth effect' of documentary photography, anchored by captions and surrounded by other information.

On the one hand, the absence of such imagery and eye-witness accounts, while not negating the experience, makes it impossible to share with others, or to recall in any of its specifics. This (mis)leads readers and viewers, drawing them away from recognising significant crimes: through no obvious fault of their own, these people simply do not know. On the other hand, the presence of imagery and reports means that forgetting about them or refusing to see them becomes a deliberate choice, a conscious act of citizenship: then people are choosing ignorance above knowledge. There is a big difference between never finding out and choosing to forget: the latter involves the recognition, and then the spurning, of unwelcome information. Body horror provides this unwelcome material for service in public spheres of controversy, with photographs relaying evidence of what-has-been for people to judge for themselves.

Focusing on horrible events seeks to establish, to borrow Sontag's words, 'ethical reference points'. It discounts the jibe that 'media significance means moral insignificance'. It requires that news should come from the body of the journalist-as-witness, and be tied to bodies in the story. This in turn requires editors and photographers to keep faith with the medium's relationship with the world, its (compromised) evidence of what-has-been, its capacity to represent flat fact. It matters morally and ethically whether audiences are confronting fact or fiction. Both language and photography have contracts with the world which may be suspended or broken, but there are circumstances where breaking them is unacceptable: 'The existence or absence of a real world, real body, real pain, makes a difference.'[4]

In this regard the decisions of editors, picture editors and journalists are important markers of certain kinds of civility. They utilise forms of rhetoric in the daily balance or compromise between decency and outrage. Of course, ways of representing horror are measures of economy and decorum in the choice of images and language used to present shocking news. Further than that, they indicate how grief may be public, how ghoulishness may be catered for and curtailed, and how different interpretations of restraint and abandon in depicting bodily harm suggest various, sometimes demeaning, attitudes towards the plight of others. Editors' daily decisions in story-telling and photography are made within the norms of an industry which (in seeking a public) contributes to morality. Audiences are justified in asking the media what it means to publish their normal diet of pictures and reports. What purpose does it serve? At the same time, what lies beyond the frame remains a source of anxiety and concern: how much has been left out of the account, and whose purpose does that serve? Such questions are always worth raising, but especially so in wartime, when the bludgeon of national interest (or national uninterest) knocks news stories into shape.

The idea of civility which is contained in the polite depiction of grief or disaster also covers the polite portrayal of violence, atrocity and war. When the news industry suppresses the horror of such crimes and wars – most clearly but not solely those involving the British – it reveals more about forms of public knowledge than it does about warfare. It is at this point, when war is sanitised or prettified, when knowledge is managed, that the notion of the 'public' is founded on the 'scoundrel' patriotism. Narrowly interpreted, this may reduce the basis of national concerns to 'little England', to caravanning and car-boot sales.

But civility sits uneasily with war – unless it is known to be describing official histories, censored reports and popular victories. How would the Holocaust be remembered if it existed only in 'civil' representations – those which were most discreet?

What would it mean for knowledge if the images ceased to circulate, or were never seen in the first place? What would it mean for civility if representations of war crimes were always polite? If prurience is ugly, what then is discretion in the face of barbarism?

Notes

1 Jean-François Lyotard, *The Postmodern Condition. A Report on Knowledge* (Manchester, Manchester University Press), 1984, p. 18.
2 W. J. T. Mitchell, *Picture Theory. Essays on Verbal and Visual Representation* (Chicago, University of Chicago Press), 1994, p. 202.
3 *Ibid.*, p. 202.
4 Stephen J. Greenblatt, *Learning to Curse. Essays in Early Modern Culture* (New York, Routledge Chapman and Hall), 1990, p. 15.

Select bibliography

Abject Art, Repulsion and Desire in American Art (New York, Whitney Museum of American Art), 1993.

Acland, Charles R., *Youth, Murder, Spectacle. The Cultural Politics of 'Youth in Crisis'* (Boulder, Colorado, Westview Press), 1995.

Adorno, Theodor W., *The Culture Industry. Selected Essays on Mass Culture* (London, Routledge), 1991.

Aksoy, Asu and Kevin Robins, 'Exterminating angels: morality, violence and technology in the Gulf War', *Science as Culture*, 2:3 (1991) 322–36.

Alloula, Malek, *The Colonial Harem* (Manchester, Manchester University Press), 1987.

Allthorpe-Guyton, Marjorie, *Effluvia—Helen Chadwick* (London, Serpentine Gallery), 1994.

Amnesty International, *When the State Kills* (London, Amnesty International), 1989.

Amnesty International Medical Commission and V. Marange, *Doctors and Torture* (London, Bellew Press), 1989.

Anderson, Benedict, *Imagined Communities: Reflections on the Origin and Spread of Nationalism* (London, Verso), 1989.

Ankersmit, Frank and Hans Kellner (eds), *A New Philosophy of History* (London, Reaktion Books), 1995.

Ariès, Philippe, *The Hour of our Death* (Harmondsworth, Penguin Books), 1981.

Article 19, 'Stop press: the Gulf War and censorship', *Censorship News*, 1:15 (February 1991).

'Baker praises Gulf War coverage', *UK Press Gazette*, 25 February 1991.

Barthes, Roland, *Mythologies* (St Albans, Granada), 1973.

Barthes, Roland, *Image/Music/Text* (New York, Hill and Wang), 1977.

Barthes, Roland, *The Eiffel Tower and other Mythologies* (New York, Hill and Wang), 1979.

Barthes, Roland, *Camera Lucida. Reflections on Photography* (London, Jonathan Cape), 1982.

Barthes, Roland, 'The reality effect', in Tzvetan Todorov (ed.), *French Literary Theory Today* (Cambridge, Cambridge University Press), 1982, pp. 11–17.

Bartov, Omer, *Murder in our Midst. The Holocaust, Industrial Killing, and Representation* (Oxford, Oxford University Press), 1996.

Bataille, Georges, *Les Larmes d'Éros* (Paris, Société des Editions Jean-Jacques Pauvert), 1961.

Bataille, Georges, *The Tears of Eros* (San Francisco, City Lights Books), 1992.

Baudrillard, Jean, *America* (London, Verso), 1988.

Baudrillard, Jean, *The Transparency of Evil* (London, Verso), 1993.

Baudrillard, Jean, *The Gulf War did not Take Place* (Sydney, Power Publications), 1995.

Bauman, Zygmunt, *Modernity and the Holocaust* (Cambridge, Polity), 1991.

Bauman, Zygmunt, *Postmodern Ethics* (Oxford, Blackwell), 1993.

Bazin, André, 'The ontology of the photographic image', in *What is Cinema?* vol. 1 (Berkeley, University of California Press), 1967.

Bell, Martin, *In Harm's Way. Reflections of a War Zone Thug* (London, Hamish Hamilton), 1995.

Bell, Martin, 'TV news: how far should we go?', *British Journalism Review*, 8:1 (1997) 7–16.

Belsey, Andrew and Ruth Chadwick, *Ethical Issues in Journalism and the Media* (London, Routledge), 1992.

Benjamin, Walter, *Illuminations* (London, Collins/Fontana), 1973.

Benjamin, Walter, *One Way Street and other Writings* (London, Verso), 1985.

Benthall, Jonathan, *Disasters, Relief and the Media* (London, I. B. Tauris), 1993.

Birch, Helen, 'If looks could kill: Myra Hindley and the iconography of evil', in Helen Birch (ed.), *Moving Targets. Women, Murder and Representation* (London, Virago), 1993, pp. 32–61.

Bird, S. Elizabeth and Robert W. Dardenne, 'Myth, chronicle, and story: exploring the narrative qualities of news', in James W. Carey (ed.), *Media, Myths, and Narratives. Television and the Press* (London, Sage), 1988, pp. 67–86.

Black, Joel, *The Aesthetics of Murder. A Study in Romantic Literature and Contemporary Culture* (Baltimore, Johns Hopkins University Press), 1991.

Bodman, Bob, 'Money talks …', *British Journal of Photography*, 7004 (14 December 1994) 13.

Bolton, Richard (ed.), *The Contest of Meaning. Critical Histories of Photography* (Cambridge, Massachusetts, MIT Press), 1989.

Boose, Lynda E., 'Techno-muscularity and the "boy eternal": from the quagmire to the Gulf', in Miriam Cooke and Angela Woollacott (eds), *Gendering War Talk* (Princeton, New Jersey, Princeton University Press), 1993, pp. 67–106.

Bourke, Joanna, *Dismembering the Male. Men's Bodies, Britain and the Great War* (London, Reaktion Books), 1996.

Braestrup, Peter, *Big Story. How the American Press and Television Reported and Interpreted the Crisis of Tet 1968 in Vietnam and Washington* (London, Yale University Press), 1978.

Briemberg, Mordecai (ed.), *It Was, It Was Not. Essays and Art on the War against Iraq* (Vancouver, New Star Books), 1992.

British Broadcasting Corporation, *Producers' Guidelines* (London, BBC), 1996.

Bronfen, Elisabeth, *Over her Dead Body. Death, Femininity and the Aesthetic* (Manchester, Manchester University Press), 1992.

Brothers, Caroline, *War and Photography. A Cultural History* (London, Routledge), 1997.

Buchanan, Ian, 'Controversial Gulf War image withdrawn by *Life*', *British Journal of Photography*, 6812 (21 March 1991) 4.

Burgin, Victor, *The End of Art Theory. Criticism and Postmodernity* (Basingstoke, Macmillan), 1986.

Cameron, Deborah and Elizabeth Frazer, *The Lust to Kill. A Feminist Investigation of Sexual Murder* (Cambridge, Polity) 1987.

Campbell, David and Michael Dillon (eds), *The Political Subject of Violence* (Manchester, Manchester University Press), 1993.

Carroll, Noël, *The Philosophy of Horror, or, Paradoxes of the Heart* (London, Routledge), 1990.

Chibnall, Steve, 'The production of knowledge by crime reporters', in Stanley Cohen and Jock Young (eds), *The Manufacture of News. Deviance, Social Problems and the Mass Media* (London, Constable), 1981, pp. 75–97.

Chomsky, Noam, 'The media and the war: what war?' in Hamid Mowlana, George Gerbner and Herbert L. Schiller (eds), *Triumph of the Image. The Media's War in the Persian Gulf. A Global Perspective* (Boulder, Colorado, Westview Press), 1992, pp. 51–63.

Christ, Carol T. and John O. Jordan (eds), *Victorian Literature and the Victorian Visual Imagination* (Berkeley, University of California Press), 1995.

Clark, Ramsey, *The Fire this Time. US War Crimes in the Gulf* (New York, Thunder's Mouth Press), 1992.

Clark, Ramsey *et al.*, *War Crimes. A Report on United States War Crimes against Iraq* (Washington, D.C., Maisonneuve Press), 1992.

Clark, Ramsey, UN Food and Agriculture Organisation *et al.*, *The Impact of Sanctions on Iraq. The Children are Dying* (New York, World View Forum), 1996.

Clover, Carol J., *Men, Women and Chainsaws. Gender in the Modern Horror Film* (London, British Film Institute), 1992.

Cohen, Stanley and Jock Young (eds), *The Manufacture of News. Deviance, Social Problems and the Mass Media* (London, Constable), 1981.

Cohn, Carol, 'Sex and death in the rational world of defense intellectuals', *Signs. Journal of Women in Culture and Society*, 12:4 (1987) 687–718.

'Colombians angered by Amnesty advert picture', *British Journal of Photography*, 6978 (15 June 1994) 5.

Connell, Ian, 'Personalities in the popular media', in Peter Dahlgren and Colin Sparks (eds), *Journalism and Popular Culture* (London, Sage), 1992, pp. 64–83.

Coombes, Annie E. and Steve Edwards, 'Site unseen: photography in the colonial empire: images of subconscious eroticism', *Art History*, 12:4 (1989) 510–16.

Cowling, Mary, *The Artist as Anthropologist. The Representation of Type and Character in Victorian Art* (Cambridge, Cambridge University Press), 1989.

Crane, Jonathan Lake, *Terror and Everyday Life. Singular Moments in the History of the Horror Film* (London, Sage), 1994.

Crary, Jonathan, *Techniques of the Observer. On Vision and Modernity in the Nineteenth Century* (Cambridge, Massachusetts, MIT Press), 1990.

Creed, Barbara, *The Monstrous-Feminine. Film, Feminism, Psychoanalysis* (London, Routledge), 1993.

Crone, Tom, *Law and the Media* (London, Focal Press), 1995.

Cudlipp, Hugh, 'The camera cannot lie', *British Journalism Review*, 3:3 (1992) 30–5.

Cumberbatch, Guy and Dennis Howitt, *A Measure of Uncertainty. The Effects of the Mass Media* (London, John Libbey), 1989.

Curran, James and Jean Seaton, *Power without Responsibility. The Press and Broadcasting in Britain* (London, Routledge), 1991.

Curran, James, Angus Douglas and Garry Whannel, 'The political economy of the human-interest story', in Anthony Smith (ed.), *Newspapers and Democracy. International Essays on a Changing Medium* (Cambridge, Massachusetts, MIT Press), 1980, pp. 288–316.

d'Ancona, Matthew, 'Low warspeak', *Index on Censorship*, 20:4–5 (1991) 9.

Dahlgren, Peter and Colin Sparks (eds), *Journalism and Popular Culture* (London, Sage), 1992.

Daniels, Les, *Fear. A History of Horror in the Mass Media* (London, Paladin), 1977.

Davidoff, Leonore and Catherine Hall, *Family Fortunes. Men and Women of the English Middle Class 1780–1850* (London, Hutchinson), 1987.

De Landa, Manuel, *War in the Age of Intelligent Machines* (New York, Zone Books), 1991.

Deichmann, Thomas, 'The picture that fooled the world', *Living Marxism*, February (1997) 24–31.

Deppa, Joan, *The Media and Disasters. Pan Am 103* (London, David Fulton), 1993.

Doig, Alan, 'Retreat of the investigators', *British Journalism Review*, 3:4 (1992) 44–50.

Douglas, Mary, *Purity and Danger. An Analysis of the Concepts of Pollution and Taboo* (London, Routledge and Kegan Paul), 1978.

Druckrey, Timothy, 'Deadly representations, or apocalypse now', *Ten.8*, 2:2 (1991) 16–27.

Druckrey, Timothy (ed.), *Electronic Culture. Technology and Visual Representation* (New York, Aperture), 1996.

Dubin, Steven C., *Arresting Images. Impolitic Art and Uncivil Actions* (London, Routledge), 1992.

Eldridge, John, ' "Ill news comes often on the back of worse" ', in John Eldridge (ed.), *Glasgow Media Group Reader*, vol. 1, *News Content, Language and Visuals* (London, Routledge), 1995, pp. 27–38.

Eldridge, John (ed.), *Getting the Message. News, Truth and Power*, (London, Routledge), 1993.

Elliot, Gil, *Twentieth Century Book of the Dead* (London, Allen Lane, Penguin Press), 1972.

Ellis, Caroline, Saeeda Khanum and Steve Platt, 'Highway to hell', *New Statesman*, 4:156 (21 June 1991) 21–7.

Evans, Harold, *Pictures on a Page. Photo-journalism, Graphics and Picture Editing* (London, Heinemann), 1978.

Fiske, John, *Television Culture* (London, Methuen), 1987.

Foucault, Michel, *Discipline and Punish. The Birth of the Prison* (Harmondsworth, Penguin Books), 1979.

Freeland, Cynthia A., 'Realist horror', in Cynthia A. Freeland and Thomas E. Wartenberg (eds), *Philosophy and Film* (London, Routledge), 1995, pp. 126–42.

Gange, John and Stephen Johnstone, ' "Believe me, everybody has something pierced in California": an interview with Nayland Blake', in 'Perversity', *New Formations*, 19 (1993) 51–68.

Garber, Marjorie, Jann Matlock and Rebecca L. Walkowitz (eds), *Media Spectacles* (London, Routledge), 1993.

Gatrell, V. A. C., *The Hanging Tree. Execution and the English People 1770–1868* (Oxford, Oxford University Press), 1994.

Gauntlett, David, *Video Critical. Children, the Environment and Media Power* (London, John Libbey), 1997.

Gibson, Pamela Church and Roma Gibson (eds), *Dirty Looks. Women, Pornography, Power* (London, British Film Institute), 1993.

Giddens, Anthony, *Modernity and Self-identity. Self and Society in the Late Modern Age* (Cambridge, Polity), 1991.

Girardet, Edward R., 'Reporting humanitarianism: are the new electronic media making a difference?', in Robert I. Rotberg and Thomas G. Weiss (eds), *From Massacres to Genocide. The Media, Public Policy, and Humanitarian Crises* (Cambridge, Massachusetts, World Peace Foundation), 1996, pp. 45–67.

Goldhagen, Daniel, *Hitler's Willing Executioners. Ordinary Germans and the Holocaust* (London, Little Brown), 1996.

Goodman, Geoffrey, 'Brutality sells, OK …', *British Journalism Review*, 4:2 (1993) 3–4.

Goodman, Jonathan, *The Moors Murders. The Trial of Myra Hindley and Ian Brady* (Newton Abbot, David and Charles), 1986.

Gordon, A. David, John M. Kittross, Carol Reuss and John C. Merrill, *Controversies in Media Ethics* (White Plains, New York, Longman), 1996.

Gorer, Geoffrey, *Death, Grief, and Mourning in Contemporary Britain* (London, Cresset Press), 1965.

Gray, Chris Hables, Heidi J. Figueroa-Sarriera and Steven Mentor (eds), *The Cyborg Handbook* (London, Routledge), 1995.

Green, David, 'Veins of resemblance: photography and eugenics', *Oxford Art Journal*, 7:2 (1984) 3–16.

Greenblatt, Stephen J., 'Towards a poetics of culture', in H. A. Veeser (ed.), *The New Historicism* (London, Routledge), 1989, pp. 1–14.

Greenblatt, Stephen J., *Learning to Curse. Essays in Early Modern Culture* (New York, Routledge Chapman and Hall), 1990.

Griffiths, Philip Jones, *Dark Odyssey* (New York, Aperture), 1996.

Grundberg, Andy, *Crisis of the Real. Writings on Photography, 1974–89* (New York, Aperture), 1990.

Gusterson, Hugh, 'Nuclear war, the Gulf War, and the disappearing body', *Journal of Urban and Cultural Studies*, 2:1 (1991) 45–55.

Hagerty, Bill, 'Showdown at the Last Chance saloon', *British Journalism Review*, 3:3 (1992) 26–9.

Halberstam, Judith and Ira Livingston (eds), *Posthuman Bodies* (Bloomington and Indianapolis, Indiana University Press), 1995.

Hall, Stuart, Chas Critcher, Tony Jefferson, John Clarke and Brian Roberts, *Policing the Crisis. Mugging, the State and Law and Order* (London, Macmillan), 1978.

Hamilton, Robert, 'Image and context: the production and reproduction of the execution of a VC suspect by Eddie Adams', in Jeffrey Walsh and James Aulich (eds), *Vietnam Images. War and Representation* (Basingstoke, Macmillan), 1989, pp. 171–83.

Hamilton, Robert, 'Pools, minders, unilaterals and Scud studs: war reporters in the news', in Jeffrey Walsh (ed.), *The Gulf War did not Happen. Politics, Culture and Warfare Post-Vietnam* (Aldershot, Arena), 1995, pp. 159–69.

Hammock, John C. and Joel R. Charny, 'Emergency response as morality play: the media, the relief agencies, and the need for capacity building', in Robert I. Rotberg and Thomas G. Weiss (eds), *From Massacres to Genocide. The Media, Public Policy, and Humanitarian Crises* (Cambridge, Massachusetts, World Peace Foundation), 1996, pp. 115–35.

Hartley, John, *The Politics of Pictures. The Creation of the Public in the Age of Popular Media* (London, Routledge), 1992.

Haskell, Thomas L., 'Capitalism and the origins of the humanitarian sensibility', Part 1, *American Historical Review*, 90:2 (1985) 339–61.

Haskell, Thomas L., 'Capitalism and the origins of the humanitarian sensibility', Part 2, *American Historical Review*, 90:3 (1985) 547–66.

Henderson, Caspar, 'The filtered war', *Banned* (London, Channel 4, *New Statesman*, BFI) (April 1991) 16–17.

Henderson, Lisa, 'Access and consent in public photography', in Larry Gross, John Stuart Katz and Jay Ruby (eds), *Image Ethics. The Moral Rights of Subjects in Photographs, Film and Television* (New York, Oxford University Press), 1988, pp. 91–107.

Highsmith, Patricia, 'Child's Play 4?', *Times Literary Supplement*, 22 April 1994.

Hill, Annette, *Shocking Entertainment. Viewer Response to Violent Movies* (London, John Libbey), 1997.

Hillier, Sally, 'The grim reality: editors' dilemma when handling news pictures', *Ariel*, 6 June 1995.

Hillman, Harold, 'The possible pain experienced during execution by different methods', *Perception*, 22 (1993) 745–53.

Hiro, Dilip, *Desert Shield to Desert Storm. The Second Gulf War* (London, Paladin), 1992.

Hodgson, F. W., *Modern Newspaper Practice* (Oxford, Focal Press), 1996.

Horton, Susan R., 'Were they having fun yet? Victorian optical gadgetry, modernist selves', in Carol T. Christ and John O. Jordan (eds), *Victorian Literature and the Victorian Visual Imagination* (Berkeley, University of California Press), 1995, pp. 1–26.

House of Commons Defence Committee, *The Handling of Press and Public Information during the Falklands Conflict*, HC 17–I and HC 17–II (London, HMSO), 1982.

Hukanovic, Rezak, *The Tenth Circle of Hell. A Memoir of the Death Camps of Bosnia* (London, Little Brown), 1997.

Hull, Roger, 'Emplacement, displacement, and the fate of photographs', in Daniel P. Younger (ed.), *Multiple Views. Logan Grant Essays on Photography 1983–89* (Albuquerque, University of New Mexico), 1991, pp. 169–92.

Human Rights Watch, *Needless Deaths in the Gulf War. Civilian Casualties during the Air Campaign and Violations of the Laws of War* (Middle East Watch, New York), 1991.

Hüppauf, Bernd, 'Modernism and the photographic representation of war and destruction', in Leslie Devereaux and Roger Hillman, *Fields of Vision. Essays in Film Studies, Visual Anthropology, and Photography* (Berkeley, University of California Press), 1995, pp. 94–124.

Hurley, Kelly, 'Reading like an alien: posthuman identity in Ridley Scott's *Alien* and David Cronenberg's *Rabid*', in Judith Halberstam and Ira Livingston (eds), *Posthuman Bodies*

(Bloomington and Indianapolis, Indiana University Press), 1995, pp. 203–24.

Ignatieff, Michael, 'Is nothing sacred? The ethics of television', *Daedalus*, 114:4 (fall 1985) 57–78.

Index on Censorship (1991) Warspeak: the Gulf and the News Media, 20, 4–5.

Jacobs, David L., 'The art of mourning: death and photography', *Afterimage*, 24:1 (1996) 8–11.

Jameson, Fredric, *The Political Unconscious* (London, Methuen), 1981.

Jameson, Fredric, *Signatures of the Visible* (London, Routledge), 1992.

Jay, Martin, *Downcast Eyes. The Denigration of Vision in Twentieth-century French Thought* (Berkeley, University of California Press), 1993.

Jeffords, Susan and Lauren Rabinovitz (eds), *Seeing through the Media. The Persian Gulf War* (New Brunswick, New Jersey, Rutgers University Press), 1994.

Jones, Lynne, *File on 4*, Programme No. 91VY3015LHO (London, BBC Radio), 9 and 10 April 1991.

Keane, John, ' "Liberty of the press" in the 1990s', *New Formations*, 8 (1989) 35–53.

Keane, John, *The Media and Democracy* (Cambridge, Polity), 1991.

Keane, John, *Reflections on Violence* (London, Verso), 1996.

Keeble, Richard, *The Newspapers Handbook* (London, Routledge), 1994.

Kellner, Douglas, *The Persian Gulf TV War* (Boulder, Colorado, Westview), 1992.

Kellner, Douglas, *Media Culture, Cultural Studies. Identity and Politics between the Modern and the Postmodern* (London, Routledge), 1995.

Kelly, Michael, *Martyrs' Day. Chronicle of a Small War* (Basingstoke, Macmillan), 1993.

Kember, Sarah, 'Surveillance, technology and crime: the James Bulger case', in Martin Lister (ed.), *The Photographic Image in Digital Culture* (London, Routledge), 1995, pp. 115–26.

Kember, Sarah, ' "The shadow of the object": photography and realism', in Lindsay Smith (ed.), 'Photography and cultural representation', *Textual Practice*, 10:1 (1996) 145–63.

Kendrick, Michelle, 'Kicking the Vietnam syndrome: CNN's and CBS's video narratives of the Persian Gulf War', in Susan Jeffords and Lauren Rabinovitz (eds), *Seeing through the Media. The Persian Gulf War* (New Brunswick, New Jersey, Rutgers University Press), 1994, pp. 59–76.

Kennedy, Liam, *Susan Sontag. Mind as Passion* (Manchester, Manchester University Press), 1995.

Kingston, Angela, *Freedom* (Edinburgh, Amnesty International Glasgow Groups Exhibition), 1995.

Kirby, Lynne, 'Death and the photographic body', in Patrice Petro (ed.), *Fugitive Images. From Photography to Video* (Bloomington and Indianapolis, Indiana University Press), 1995, pp. 72–84.

Klare, Michael T., 'Weapons of mass destruction in Operation Desert Storm: the non-nuclear equivalent of Hiroshima and Nagasaki', in Cynthia Peters (ed.), *Collateral Damage. The New World Order at Home and Abroad* (Boston, Massachusetts, South End Press), 1992, pp. 217–28.

Knight, Graham and Tony Dean, 'Myth and structure of news', *Journal of Communication*, spring (1982) 144–61.

Knightley, Phillip, *The First Casualty. From the Crimea to Vietnam: the War Correspondent as Hero, Propagandist, and Myth Maker* (New York, Harcourt Brace Jovanovich), 1975.

Knightley, Phillip, 'The loneliness of the long-distance lens', *British Journalism Review*, 2:1 (1990) 49–52.

Knightley, Phillip, 'Here is the patriotically censored news', in 'Warspeak: Media Management in the Gulf war', *Index on Censorship*, 20:4–5 (1991) 4–5.

Knightley, Phillip, 'Access to death', *British Journalism Review*, 7:1 (1996) 6–11.

Kozloff, Max, *Photography and Fascination* (Danbury, New Hampshire, Addison House), 1979.

Kozloff, Max, 'Gilles Peress and the politics of space', in the author's *Lone Visions, Crowded Frames. Essays on Photography* (Albuquerque, University of New Mexico Press), 1994, pp. 170–7.

Krauss, Rosalind E., *The Originality of the Avant-garde and other Modernist Myths* (Cambridge, Massachusetts, MIT Press), 1986.

Kristeva, Julia, *Powers of Horror. An Essay on Abjection* (New York, Columbia University Press), 1982.

Kuhn, Annette, *Cinema, Censorship and Sexuality 1909–25* (London, Routledge), 1988.

Laqueur, Thomas W., 'Bodies, details, and the humanitarian narrative', in Lynn Hunt (ed.), *The New Cultural History* (Berkeley, University of California Press), 1989, pp. 176–204.

Laqueur, Thomas W., 'Crowds, carnivals and the English state in English executions, 1604–1868', in A. L. Beier, David Cannadine and James M. Rosenheim (eds), *The First Modern Society. Essays in Honour of Lawrence Stone* (Cambridge, Cambridge University Press), 1989, pp. 305–55.

Laqueur, Thomas W., 'The past's past', *London Review of Books*, 18:18 (1996) 3–7.

Lesberg, Sandy, *Violence in our Time* (New York, Peebles Press International), 1977.

Lesy, Michael, *Wisconsin Death Trip* (London, Allen Lane), 1973.

Lewis, Tim and Josie Brookes, *The Human Shield. British Hostages in the Gulf and the Work of the Gulf Support Group* (Lichfield, Staffordshire, Leomansley Press), 1991.

Lingis, Alphonso, *Foreign Bodies* (London, Routledge), 1994.

Linklater, Magnus, 'Why Dunblane *was* different', *British Journalism Review*, 7:2 (1996) 15–19.

Lipstadt, Deborah, *Denying the Holocaust. The Growing Assault on Truth and Memory* (Harmondsworth, Penguin Books), 1994.

Lister, Martin, (ed.), *The Photographic Image in Digital Culture* (London, Routledge), 1995.

Lyotard, Jean-François, *The Postmodern Condition. A Report on Knowledge* (Manchester, Manchester University Press), 1984.

MacArthur, Brian, 'The British keep reading despite the box', *British Journalism Review*, 3:4 (1992) 65–7.

MacArthur, Brian, 'The news is not all bad', *British Journalism Review*, 3:3 (1992) 74–6.

MacArthur, John R., *Second Front. Censorship and Propaganda in the Gulf War* (Berkeley, University of California Press), 1993.

Marcuse, Herbert, *One-dimensional Man* (London, Routledge), 1991.

Masters, Brian, *Killing for Company* (London, Coronet), 1986.

Masters, Brian, *'She Must Have Known'. The Trial of Rosemary West* (London, Doubleday), 1996.

McCabe, Eamonn, ' "The stuff of nightmares" ', *British Journalism Review*, 2:3 (1991) 23–6.

McCabe, Eamonn, 'The electronic lie-machine?', *British Journalism Review*, 2:4 (1991) 24–6.

McCabe, Eamonn, 'Photographers in the front line', *British Journalism Review*, 3:1 (1992) 34–5.

McCauley, Elizabeth Anne, *Industrial Madness. Commercial Photography in Paris 1848–71* (New Haven, Yale University Press), 1994.

McClintock, Anne, *Imperial Leather. Race, Gender and Sexuality in the Colonial Contest* (London, Routledge), 1995.

McConnell, Brian, 'James Bulger: victim of a legend?', *British Journalism Review*, 5:4 (1994) 60–2.

McCullin, Don, *The Destruction Business* (London, Open Gate Books), 1971.

McCullin, Don, *Unreasonable Behaviour. An Autobiography* (London, Vintage), 1992.

McCullin, Don, *Sleeping with Ghosts. A Life's Work in Photography* (London, Jonathan Cape), 1994.

McGrath, Roberta, 'Medical police', *Ten.8*, 14 (1984) 13–18.

McNamara, Martin, 'Muffled response teams', *UK Press Gazette*, 25 March 1991.

Miller, William Ian, *The Anatomy of Disgust* (Cambridge, Massachusetts, Harvard University Press), 1997.

Millett, Kate, *The Politics of Cruelty. An Essay on the Literature of Political Imprisonment* (London, Viking), 1994.

Mitchell, W. J. T., *Iconology. Image, Text, Ideology* (Chicago, University of Chicago Press), 1986.

Mitchell, W. J. T., *Picture Theory. Essays on Verbal and Visual Representation* (Chicago, University of Chicago Press), 1994.

Mitchell, William J., *The Reconfigured Eye. Visual Truth in the Post-photographic Era* (Cambridge, Massachusetts, MIT Press), 1992.

Morgan, Jean, 'Iraq pack may be made Saddam's pawns ... but eyewitness accounts are vital', *UK Press Gazette*, 11 February 1991.

Morrison, Blake, *As If* (London, Granta Books), 1997.

Morrison, David E., *Television and the Gulf War* (London, John Libbey), 1992.

Morrison, David E. and Howard Tumber, *Journalists at War. The Dynamics of News Reporting during the Falklands Conflict* (London, Sage), 1988.

Mowlana, Hamid, George Gerbner and Herbert L. Schiller (eds), *Triumph of the Image. The Media's War in the Persian Gulf. A Global Perspective* (Boulder, Colorado, Westview Press), 1992.

National Heritage Committee, *Privacy and Media Intrusion* (London, HMSO), 1993.

National Heritage Committee, *Privacy and Media Intrusion. The Government's Response* (London, HMSO), 1995.

Nichols, Bill, *Representing Reality. Issues and Concepts in Documentary* (Bloomington and Indianapolis, Indiana University Press), 1991.

Nichols, Bill, *Blurred Boundaries. Questions of Meaning in Contemporary Culture* (Bloomington and Indianapolis, Indiana University Press), 1994.

Nohrstedt, Stig A., 'Ruling by pooling', in Hamid Mowlana, George Gerbner and Herbert L. Schiller (eds), *Triumph of the Image. The Media's War in the Persian Gulf. A Global Perspective* (Boulder, Colorado, Westview Press), 1992, pp. 118–27.

Norfleet, Barbara P., *Looking at Death* (Boston, Massachusetts, David R. Godine), 1993.

Norris, Christopher, *Uncritical Theory. Postmodernism, Intellectuals and the Gulf War* (London, Lawrence and Wishart), 1992.

Norris, Margot, 'Only the guns have eyes: military censorship and the body count', in Susan Jeffords and Lauren Rabinovitz (eds), *Seeing through the Media. The Persian Gulf War* (New Brunswick, New Jersey, Rutgers University Press), 1994, pp. 285–300.

Olin, Margaret, 'Gaze', in Robert S. Nelson and Richard Shiff (eds), *Critical Terms for Art History* (Chicago, University of Chicago Press), 1996, pp. 208–19.

Orwell, George, *Nineteen Eighty-four* (Harmondsworth, Penguin Books), 1954.

Orwell, George, 'Decline of the English murder', *Decline of the English Murder and other Essays* (Harmondsworth, Penguin Books), 1965.

Peress, Gilles, *Telex Iran* (Paris, Contrejour), 1984.

Peress, Gilles, *Farewell to Bosnia* (New York, Scalo), 1994.

Peress, Gilles, *The Silence* (New York, Scalo), 1995.

Perkes, Dan, *Eyewitness to Disaster* (Mapplewood, New Jersey, Hammond), 1976.

Peters, Cynthia (ed.), *Collateral Damage. The New World Order at Home and Abroad* (Boston, Massachusetts, South End Press), 1992.

Petley, Julian, 'In defence of "video nasties"', *British Journalism Review*, 5:3 (1994) 52–7.

Petro, Patrice (ed.), *Fugitive Images. From Photography to Video* (Bloomington and Indianapolis, Indiana University Press), 1995.

Phillips, David, 'Modern vision', *Oxford Art Journal*, 16:1 (1993) 129–38.

Philo, Greg, 'From Buerk to Band Aid: the media and the 1984 Ethiopian famine', in John Eldridge (ed.), *Getting the Message. News, Truth and Power* (London, Routledge), 1993, pp. 104–25.

Philo, Greg and Greg McLaughlin, 'The British media and the Gulf War', in Greg Philo (ed.), *Glasgow Media Group Reader*, vol. 2, *Industry, Economics, War and Politics* (London, Routledge), 1995, pp. 146–56.

Platt, Steve, 'Casualties of war', *New Statesman*, 4:139 (22 February 1991) 12–13.

Pollock, Griselda, 'Feminism/Foucault – surveillance/sexuality', in Norman Bryson, Michael Ann Holly and Keith Moxey (eds), *Visual Culture. Images and Interpretations* (Hanover, New Hampshire, Wesleyan University Press), 1994, pp. 1–41.

Postman, Neil, *Amusing Ourselves to Death* (London, Methuen), 1987.

Press Complaints Commission, *Code of Practice*, Press Complaints Commission Briefing (London, Press Complaints Commission) 1990.

Rabinowitz, Paula, *They must be Represented. The Politics of Documentary* (London, Verso), 1994.

Reid, Roddey, ' "Death of the family," or, Keeping human beings human', in Judith Halberstam and Ira Livingston (eds), *Posthuman Bodies* (Bloomington and Indianapolis, Indiana University Press), 1995, pp. 177–99.

Ritchin, Fred, 'Photojournalism in the age of computers', in Carol Squiers (ed.), *The Critical Image. Essays on Contemporary Photography* (Seattle, Bay Press), 1990, pp. 28–37.

Ritchin, Fred, 'The end of photography as we have known it', in Paul Wombell (ed.), *Photovideo. Photography in the Age of the Computer* (London, Rivers Oram Press), 1991, pp. 8–15.

Robins, Kevin, 'Into the image: visual technologies and vision cultures', in Paul Wombell (ed.), *Photovideo. Photography in the Age of the Computer* (London, Rivers Oram Press), 1991, pp. 52–77.

Robins, Kevin, 'Will image move us still?', in Martin Lister (ed.), *The Photographic Image in Digital Culture* (London, Routledge), 1995, pp. 29–50.

Robins, Kevin, *Into the Image. Culture and Politics in the Field of Vision* (London, Routledge), 1996.

Robins, Kevin and Les Levidow, 'Socializing the cyborg self: the Gulf War and beyond', in Chris Hables Gray, Heidi J. Figueroa-Sarriera and Steven Mentor (eds), *The Cyborg Handbook* (London, Routledge), 1995, pp. 119–25.

Rock, Paul, 'News as eternal recurrence', in Stanley Cohen and Jock Young (eds), *The Manufacture of News. Deviance, Social Problems and the Mass Media* (London, Constable), 1981, pp. 64–70.

Rosler, Martha, 'In, around, and afterthoughts (on documentary photography)', in Richard Bolton (ed.), *The Contest of Meaning. Critical Histories of Photography* (Cambridge, Massachusetts, MIT Press), 1989, pp. 303–40.

Rosler, Martha, 'Image simulations, computer manipulations: some considerations', *Ten.8*, 2:2 (1991) 52–63.

Ross, Andrew, *No Respect. Intellectuals and Popular Culture* (London, Routledge), 1989.

Ross, Andrew, 'The ecology of images', *South Atlantic Quarterly*, 91:1 (winter 1992) 215–38.

Ross, Stephanie, 'What photographs can't do', *Journal of Aesthetics and Art Criticism*, 41:1 (fall 1982) 5–17.

Rotberg, Robert I. and Thomas G. Weiss (eds), *From Massacres to Genocide. The Media, Public Policy, and Humanitarian Crises* (Cambridge, Massachusetts, World Peace Foundation), 1996.

Rusbridger, Alan, *The Freedom of the Press, and other Platitudes*, James Cameron Memorial Lecture 1997, *Guardian*, 1997.

Rusbridger, Alan, 'Why are we the libel capital of the world?', *British Journalism Review*, 8:3 (1997) 25–30.

Said, Edward, *Orientalism* (Harmondsworth, Penguin Books), 1978.

Saintsbury, George (ed.), *Shorter Novels. Elizabethan* (London, J. M. Dent and Sons), 1964.

Sampson, Anthony, 'The crisis at the heart of our media', *British Journalism Review*, 7:3 (1996) 42–51.

Sante, Luc, *Evidence* (New York, Farrar Straus and Giroux), 1992.

Scarry, Elaine, *The Body in Pain. The Making and Unmaking of the World* (Oxford, Oxford University Press), 1985.

Scarry, Elaine, 'Watching and authorizing the Gulf War', in Marjorie Garber, Jann Matlock and Rebecca L. Walkowitz (eds), *Media Spectacles* (London, Routledge), 1993, pp. 57–73.

Schlegel, Amy, 'My Lai: "We lie, they die", or , A small history of an "atrocious" photograph', *Third Text*, 31 (1995) 47–66.

Sekula, Allan, 'On the invention of photographic meaning', in *Photography against the Grain. Essays and Photoworks 1973–83* (Halifax, Nova Scotia, Press of the Nova Scotia College of Art and Design), 1984, pp. 3–21.

Sekula, Allan, 'Dismantling modernism, reinventing documentary (notes on the politics of representation)', in *Photography against the Grain. Essays and Photoworks 1973–83* (Halifax, Nova Scotia, Press of the Nova Scotia College of Art and Design), 1984, pp. 53–75.

Sekula, Allan, 'The traffic in photographs', in *Photography against the Grain. Essays and Photoworks 1973–83* (Halifax, Nova Scotia, Press of the Nova Scotia College of Art and Design), 1984, pp. 77–101.

Sekula, Allan, 'The body and the archive', *October*, 39 (1986) 3–64.

Sekula, Allan, 'War without bodies', *Artforum*, 30:3 (1991) 107–10.

Serrano, Andres, *The Morgue* (Paris, Galerie Yvon Lambert), 1993.

Shahak, Israel, *Open Secrets. Israeli Foreign Policy and Nuclear Policies* (London, Pluto Press), 1997.

Shapiro, Michael J., 'That obscure object of violence: logistics and desire in the Gulf War', in David Campbell and Michael Dillon (eds), *The Political Subject of Violence* (Manchester, Manchester University Press), 1993, pp. 114–36.

Shaw, Martin, *Civil Society and Media in Global Crises. Representing Distant Violence* (London, Pinter), 1996.

Shaw, Martin and Roy Carr-Hill, *Public Opinion, Media and Violence. Attitudes to the Gulf War in a Local Population*, Gulf War Report Project, Report No. 1 (Hull, University of Hull), 1991.

Shaw, Martin and Roy Carr-Hill, 'Public opinion and media war coverage in Britain', in Hamid Mowlana, George Gerbner and Herbert L. Schiller (eds), *Triumph of the Image. The Media's War in the Persian Gulf. A Global Perspective* (Boulder, Colorado, Westview Press), 1992, pp. 144–57.

Shearer, Ann, *Survivors and the Media* (London, John Libbey), 1991.

Shepherd, Elaine, *Decisive Moments*, BBC Television, 1995.

Shohat, Ella, 'The media's war', in Susan Jeffords and Lauren Rabinovitz (eds), *Seeing through the Media. The Persian Gulf War* (New Brunswick, New Jersey, Rutgers University Press), 1994, pp. 147–54.

Simpson, John, *From the House of War* (London, Hutchinson), 1991.

Slater, Don, 'Photography and modern vision: the spectacle of "natural magic" ', in Chris Jenks (ed.), *Visual Culture* (London, Routledge), 1995, pp. 218–37.

Smith, W. Eugene and Aileen M. Smith, *Minamata* (New York, Holt Rinehart and Winston), 1975.

Snoddy, Raymond, *The Good, the Bad and the Unacceptable* (London, Faber and Faber), 1992.

Sobchack, Vivian, 'Inscribing ethical space: ten propositions on death, representation, and documentary', *Quarterly Review of Film Studies*, 9:4 (1984) 283–300.

Solomon-Godeau, Abigail, *Photography at the Dock. Essays on Photographic History, Institutions, and Practices* (Minneapolis, University of Minnesota), 1991.

Sontag, Susan, *On Photography* (New York, Farrar Straus and Giroux), 1977.

Soothill, Keith and Sylvia Walby, *Sex Crime in the News* (London, Routledge), 1991.

Sounes, Howard, *Fred & Rose. The full story of Fred and Rose West and the Gloucester House of Horrors* (London, Warner Books), 1995.

Stallabrass, Julian, 'Sebastião Salgado and fine art photojournalism', *New Left Review*, 223 (1997) 131–61.

Tagg, John, *The Burden of Representation. Essays on Photographies and Histories* (Basingstoke, Macmillan), 1988.

Tarrant, Jon, 'The real face of war', *Professional Photographer*, 32:4 (1992) 23.

Taylor, Ian, 'Hillsborough, 15 April 1989: some personal contemplations', *New Left Review*, 177 (1989) 89–110.

Taylor, John, *War Photography. Realism in the British Press* (London, Routledge), 1991.

Taylor, Philip M., *War and the Media. Propaganda and Persuasion in the Gulf War* (Manchester, Manchester University Press), 1992.

Taylor, Simon, 'The phobic object: abjection in contemporary art', in *Abject Art. Repulsion and Desire in American Art* (New York, Whitney Museum of American Art), 1993, pp. 59–83.

Tejaratchi, Sean (ed.), *Death Scenes. A Homicide Detective's Scrapbook* (Portland, Oregon, Feral House), 1996.

Tester, Keith, *Media, Culture and Morality* (London, Routledge), 1994.

'The role of the press at war', *UK Press Gazette*, 18 February 1991.

Tilzey, Paul, *Decisive Moments*, BBC Television, 1996.

Tropp, Martin, *Images of Fear. How Horror Stories Helped Shape Modern Culture 1818–1918* (Jefferson, North Carolina, McFarland), 1990.

Tunstall, Jeremy, *Newspaper Power. The New National Press in Britain* (Oxford, Oxford University Press), 1996.

Twitchell, James B., *Dreadful Pleasures. An Anatomy of Modern Horror* (Oxford, Oxford University Press), 1985.

van der Gaag, Nikki and Cathy Nash, *Images of Africa. The UK Report* (Oxford, Oxfam), 1987.

Vance, Carole S., 'The pleasures of looking: the Attorney General's Commission on Pornography versus visual images', in Carol Squiers (ed.), *The Critical Image. Essays on Contemporary Photography* (Seattle, Bay Press), 1990, pp. 38–58.

Vidal-Naquet, Pierre, *Assassins of Memory. Essays on the Denial of the Holocaust* (New York, Columbia University Press), 1992.

Virilio, Paul, *War and Cinema. The Logistics of Perception* (London, Verso), 1989.

Vulliamy, Ed, ' "This war has changed my life" ', *British Journalism Review*, 4:2 (1993) 5–11.

Vulliamy, Ed, *Seasons in Hell. Understanding Bosnia's War* (London, Simon and Schuster), 1994.

Walker, Ian, 'Desert stories or faith in facts?', in Martin Lister (ed.), *The Photographic Image in Digital Culture* (London, Routledge), 1995, pp. 236–52.

Walker, Ian, 'Documentary fictions?', *Photography in the Visual Arts, Art & Design* (September 1995) 28–36.

Waller, Gregory A. (ed.), *American Horrors. Essays on the Modern American Horror Film* (Urbana and Chicago, University of Illinois Press), 1987.

Walsh, Jeffrey (ed.), *The Gulf War did not Happen. Politics, Culture and Warfare Post-Vietnam* (Aldershot, Arena), 1995.

Warburton, Nigel, 'Photographic communication', *British Journal of Aesthetics*, 28:2 (spring 1988) 173–81.

Warburton, Nigel, 'Varieties of photographic representation, documentary, pictorial and quasi-documentary', *History of Photography*, 15:3 (1991) 203–10.

Wark, McKenzie, *Virtual Geography. Living with Global Media Events* (Bloomington and Indianapolis, Indiana University Press), 1994.

Webb, Alex, *Under a Grudging Sun. Photographs from Haiti Libéré 1986–88* (London, Thames and Hudson), 1989.

Whelan, Richard and Cornell Capa, *Robert Capa Photographs* (London, Faber and Faber), 1985.

Williams, Linda, *Hard Core. Power, Pleasure, and the 'Frenzy of the Visible'* (London, Pandora), 1990.

Williams, Val, and Greg Hobson, *The Dead* (Bradford, National Museum of Photography, Film and Television), 1995.

Witkin, Joel-Peter, *Harm's Way* (Santa Fe, New Mexico, Twelvetree Press), 1994.

Wombell, Paul, (ed.), *Photovideo. Photography in the Age of the Computer* (London, Rivers Oram Press), 1991.

Worcester, 'Robert, 'Who buys what—for why?', *British Journalism Review*, 2:4 (1991) 46–52.

Zaidi, Sarah and Mary C. Smith Fawzi, 'Health of Baghdad's children', *Lancet*, 346:8988 (1995) 1485.

Zelizer, Barbie, *Covering the Body. The Kennedy Assassination, the Media, and the Shaping of Collective Memory* (Chicago, University of Chicago Press), 1992.

Index